The Palace Museum's Essential Collections

CHINESE
ANTIQUE FURNITURE

The Commercial Press

CHINESE ANTIQUE FURNITURE

Chief Editor	Hu Desheng 胡德生
Deputy Chief Editors	Rui Qian 芮謙 , Hunang Jian 黃劍 , Song Yongji 宋永吉
Photographers	Hu Chui 胡錘 , Liu Zhigang 劉志崗 , Zhao Shan 趙山 , Feng Hui 馮輝 , Yu Ningchuan 余寧川 , Si Bing 司冰
Translator	Chan Sin-wai 陳善偉
Editorial Assistant	Florence Li 李穎儀
Editorial Consultant	Hang Kan 杭侃
Project Editors	Xu Xinyu 徐昕宇 , Qiu Yinqing 仇茵晴
Cover Design	Zhang Yi 張毅
Published by	The Commercial Press (Hong Kong) Ltd. 8/F., Eastern Central Plaza, 3 Yiu Hing Rd, Shau Kei Wan, Hong Kong http://www.commercialpress.com.hk
Printed by	C & C Offset Printing Co., Ltd. C & C Building, 36 Ting Lai Road, Tai Po, N.T., Hong Kong
Edition	First Edition in March 2017
	© 2017 The Commercial Press (Hong Kong) Ltd.
	All rights reserved.
	ISBN 978 962 07 5681 8
	Printed in Hong Kong

Introducing the Palace Museum to the World

SHAN JIXIANG

Built in 1925, the Palace Museum is a comprehensive collection of treasures from the Ming and Qing dynasties and the world's largest treasury of ancient Chinese art. To illustrate ancient Chinese art for people home and abroad, the Palace Museum and The Commercial Press (Hong Kong) Ltd. jointly published *The Complete Collection of Treasures of the Palace Museum*. The series contains 60 books, covering the rarest treasures of the Museum's collection. Having taken 14 years to complete, the series has been under the limelight among Sinologists. It has also been cherished by museum and art experts.

After publishing *The Complete Collection of Treasures of the Palace Museum*, it is understood that westerners, when learning about Chinese traditional art and culture, are particularly fond of calligraphy, paintings, ceramics, bronze ware, jade ware, furniture, and handicrafts. That is why The Commercial Press (Hong Kong) Ltd. has discussed with the Palace Museum to further co-operate and publish a new series, *The Palace Museum's Essential Collections*, in English, hoping to overcome language barriers and help more readers to know about traditional Chinese culture. Both parties regard the publishing of the series as an indispensable mission for Chinese history with significance in the following aspects:

First, with more than 3,000 pictures, the series has become the largest picture books ever in the publishing industry in China. The explanations show the very best knowledge from four generations of scholars spanning 90 years since the construction of the Museum.

Second, the English version helps overcome language and cultural barriers between the east and the west, facilitating the general public's knowledge of Chinese culture. By doing so, traditional Chinese art will be given a fresher image, becoming more approachable among international art circles.

Third, the series is going to further people's knowledge about the Palace Museum. According to the latest statistics, the Palace Museum holds more than 1.8 million pieces of artefacts (among which 228,771 pieces have been donated by the general public and purchased or transferred by the government since 1949). The series selects nearly 3,000 pieces of the rare treasures, together with more than 12,000 pieces from *The Complete Collection of Treasures of the Palace Museum*. It is believed that the series will give readers a more comprehensive view of the Palace Museum.

Just as *The Palace Museum's Essential Collections* is going to be published, I cannot help but think of Professor Qi Gong from Beijing Normal University; famous scholars and researchers of the Palace Museum Mr. Xu Bangda, Mr. Zhu Jiajin, and Mr. Liu Jiu'an; and well-known intellectuals Mr. Wu Kong (Deputy Director of Central Research Institute of Culture and History) and Mr. Xu Qixian (Director of Research Office of the Palace Museum). Their knowledge and relentless efforts are much appreciated for showing the treasures of the Palace Museum to the world.

Looking at History through Art

YANG XIN

The Palace Museum boasts a comprehensive collection of the treasures of the Ming and Qing dynasties. It is also the largest museum of traditional art and culture in China. Located in the urban centre of Beijing, this treasury of ancient Chinese culture covers 720,000 square metres and holds nearly 2 million pieces of artefacts.

In the fourth year of the reign of Yongle (1406 A.D.), Emperor Chengzu of Ming, named Zhu Di, ordered to upgrade the city of Beiping to Beijing. His move led to the relocation of the capital of the country. In the following year, a grand new palace started to be built at the site of the old palace in Dadu of the Yuan Dynasty. In the 18th year of Yongle (1420 A.D.), the palace was completed and named as the Forbidden City. Since then the capital of the Ming Dynasty moved from Nanjing to Beijing. In 1644 A.D., the Qing Dynasty superceded the Ming empire and continued using Beijing as the capital and the Forbidden City as the palace.

In accordance with the traditional ritual system, the Forbidden City is divided into the front part and the rear part. The front consists of three main halls, namely Hall of Supreme Harmony, Hall of Central Harmony, and Hall of Preserving Harmony, with two auxiliary halls, Hall of Literary Flourishing and Hall of Martial Valour. The rear part comprises three main halls, namely Hall of Heavenly Purity, Hall of Union, Hall of Earthly Tranquillity, and a cluster of six halls divided into the Eastern and Western Palaces, collectively called the Inner Court. From Emperor Chengzu of Ming to Emperor Puyi, the last emperor of Qing, 24 emperors together with their queens and concubines lived in the palace. The Xinhai Revolution in 1911 overthrew the Qing Dynasty and more than 2,000 years of feudal governance came to an end. However, members of the court such as Emperor Puyi were allowed to stay in the rear part of the Forbidden City. In 1914, Beiyang government of the Republic of China transferred some of the objects from the Imperial Palace in Shenyang and the Summer Palace in Chengde to form the Institute for Exhibiting Antiquities, located in the front part of the Forbidden City. In 1924, Puyi was expelled from the Inner Court. In 1925, the rear part of the Forbidden City was transformed into the Palace Museum.

Emperors across dynasties called themselves "sons of heaven", thinking that "all under the heaven are the emperor's land; all within the border of the seashore are the emperor's servants" ("Decade of Northern Hills, Minor Elegance", *Book of Poetry*). From an emperor's point of view, he owns all people and land within the empire. Therefore, delicate creations of historic and artistic value and bizarre treasures were offered to the palace from all over the country. The palace also gathered the best artists and craftsmen to create novel art pieces exclusively for the court. Although changing of rulers and years of wars caused damage to the country and unimaginable loss of the court collection, art objects to the palace were soon gathered again, thanks to the vastness and long history of the country, and the innovativeness of the people. During the reign of Emperor Qianlong of the Qing Dynasty (1736–1796), the scale of court collection reached its peak. In the final years of the Qing Dynasty, however, the invasion of Anglo-French Alliance and the Eight-Nation Alliance into Beijing led to the loss and damage of many art objects. When Puyi abdicated from his throne, he took away plenty of the objects from the palace under the name of giving them out as presents or entitling them to others. His servants followed suit. Up till 1923, the keepers of treasures of Palace of Established Happinesss in the Inner Court actually stole the objects, set fire on them, and caused serious damage to the Qing Court collection.

Numerous art objects were lost within a little more than 60 years. In spite of all these losses, there was still a handsome amount of collection in the Qing Court. During the preparation of construction of the Palace Museum, the "Qing Rehabilitation Committee" checked that there were around 1.17 million items and the Committee published the results in the *Palace Items Auditing Report*, comprising 28 volumes in 6 editions.

During the Sino-Japanese War, there were 13,427 boxes and 64 packages of treasures, including calligraphy and paintings, picture books, and files, transferred to Shanghai and Nanjing in five batches in fear of damages and loot. Some of them were scattered to other provinces such as Sichuan and Guizhou. The art objects were returned to Nanjing after the Sino-Japanese War. Owing to the changing political situation, 2,972 pieces of treasures temporarily stored in Nanjing were transferred to Taiwan from 1948 to 1949. In the 1950s, most of the antiques were returned to Beijing, leaving only 2,211 boxes of them still in the storage room in Nanjing built by the Palace Museum.

Since the establishment of the People's Republic of China, the organization of the Palace Museum has been changed. In line with the requirement of the top management, part of the Qing Court books were transferred to the National Library of China in Beijing. As to files and essays in the Palace Museum, they were gathered and preserved in another unit called "The First Historical Archives of China".

In the 1950s and 1960s, the Palace Museum made a new inventory list for objects kept in the museum in Beijing. Under the new categorization system, objects which were previously labelled as "vessels", such as calligraphy and paintings, were grouped under the name of "*gu* treasures". Among them, 711,388 pieces which belonged to old Qing collection were labelled as "old", of which more than 1,200 pieces were discovered from artefacts labelled as "objects" which were not registered before. As China's largest national museum, the Palace Museum has taken the responsibility of protecting and collecting scattered treasures in the society. Since 1949, the Museum has been enriching its collection through such methods as purchase, transfer, and acceptance of donation. New objects were given the label "new". At the end of 1994, there were 222,920 pieces of new items. After 2000, the Museum re-organized its collection. This time ancient books were also included in the category of calligraphy. In August 2014, there were a total of 1,823,981 pieces of objects in the museum's collection. Among them, 890,729 pieces were "old", 228,771 pieces were "new", 563,990 were "books", and 140,491 pieces were ordinary objects and specimens.

The collection of nearly two million pieces of objects were important historical resources of traditional Chinese art, spanning 5,000 years of history from the primeval period to the dynasties of Shang, Zhou, Qin, Han, Wei, and Jin, Northern and Southern Dynasties, dynasties of Sui, Tang, Northern Song, Southern Song, Yuan, Ming, Qing, and the contemporary period. The best art ware of each of the periods was included in the collection without disconnection. The collection covers a comprehensive set of categories, including bronze ware, jade ware, ceramics, inscribed tablets and sculptures, calligraphy and famous paintings, seals, lacquer ware, enamel ware, embroidery, carvings on bamboo, wood, ivory and horn, golden and silvery vessels, tools of the study, clocks and watches, pearl and jadeite jewellery, and furniture among others. Each of these categories has developed into its own system. It can be said that the collection itself is a huge treasury of oriental art and culture. It illustrates the development path of Chinese culture, strengthens the spirit of the Chinese people as a whole, and forms an indispensable part of human civilization.

The Palace Museum's Essential Collections Series features around 3,000 pieces of the most anticipated artefacts with nearly 4,000 pictures covering eight categories, namely ceramics, jade ware, bronze ware, furniture, embroidery, calligraphy, paintings and rare treasures. The Commercial Press (Hong Kong) Ltd. has invited the most qualified translators and academics to translate the Series, striving for the ultimate goal of achieving faithfulness, expressiveness, and elegance in the translation.

We hope that our efforts can help the development of the culture industry in China, the spread of the sparkling culture of the Chinese people, and the facilitation of the cultural interchange between China and the world.

Again, we are grateful to The Commercial Press (Hong Kong) Ltd. for the sincerity and faithfulness in their co-operation. We appreciate everyone who has given us support and encouragement within the culture industry. Thanks also go to all Chinese culture lovers home and abroad.

Yang Xin former Deputy Director of the Palace Museum, Research Fellow of the Palace Museum, Connoisseur of ancient calligraphy and paintings.

Contents

List of Chinese Antique Furniture

QING DYNASTY FURNITURE

An Introduction to the Furniture Collection of the Ming and Qing Dynasties in the Palace Museum

HU DESHENG

Traditional furniture craftsmanship in China started around the Shang and Zhou periods and, based on documentary and pictorial evidence, has over three thousand years of history. In the Ming and Qing periods, China's traditional furniture developed into items for daily use that were highly scientific, artistic, and functional. They gradually formed two main categories: "Ming-style furniture" and "Qing-style furniture". They are not only treasured by the Chinese people, but also known for their uniqueness in the world of furniture.

Antique furniture of different dynasties collected in the Palace Museum are mostly treasures of the Ming and Qing periods. In terms of materials, there is valuable hardwood and lacquer furniture as well as the relatively general but common firewood furniture. In terms of types, basically all kinds of traditional furniture such as the bed, couch, throne, desk, teapot, long table, chair, stool, mound, cabinet, and partition are covered. The completeness of the types and fine quality of the works are matchless within and outside China. In *The Palace Museum's Essential Collections*, we have selected 259 pieces of work and put them into one volume based on the period of their construction and categories. We hope this book helps readers gain an understanding of the traditional furniture of China.

I. Periodic Background Leading to the Production of the Ming-style Furniture

1. The development of furniture craftsmanship in the Song Dynasty laid the foundation for the Ming-style furniture.

From the Shang and Zhou to the Han and Wei periods, the living style of the Chinese people was sitting on the floor. Their daily life centred around the mat or bed. The furniture they used, such as the teapoy and long table, was relatively short and small. During the Southern and Northern Dynasties, high seats began to emerge. By the time of the Tang and Five Dynasties, people sat on the floor as well as on high seats with hanging feet, so furniture suitable for both living styles existed at the same time. Though furniture of this early period is no longer existent, a glimpse of its form and shape could still be seen in the extant works of art, such as paintings and murals, from the same periods.

The Song Dynasty is a period in which Chinese furniture made great advances in development, and it is also a period in which furniture enjoyed

unprecedented popularity. During this period, there was a fundamental change in people's living style, and tall furniture like square tables, tall recessed-leg tables, chairs, stools, and embroidery stools was prominent. All the shops and stores in the famous Song painting "Along the River during the Qingming Festival" are placed with various kinds of furniture, of which square tables and benches are most common. Furniture of a higher class can be seen in the court. Various kinds of chairs that appeared in the portraits of the Song emperors and empresses, for example, have beautiful decorations, but judging from their looks, the materials used are rather coarse, and the chairs are far from perfect. Obviously, such a generalization cannot be made about the Song furniture. Items of the Song furniture, including tables unearthed in Julu in Hebei and Jiangyin in Jiangsu, are relatively perfect representative items which show the artistic level of the Song furniture. It can be said that the so-called "Ming-style furniture", which is actually based on the foundation of the Song furniture, is formed by enhancing the strengths, avoiding the weaknesses, discarding the dross, and keeping the essence of the Song furniture, with the result of leading the Chinese traditional furniture craftsmanship to a scientific stage.

2. The handicraft boom in the Ming Dynasty promoted the growth of the Ming-style furniture

The status of craftsmen in the Ming Dynasty, in comparison with that of the Yuan Dynasty, was greatly improved. The Ming government divided craftsmen into two types: craftsmen on shifts and craftsmen in residence. Except for the specified period in which they had to serve the country, they were free to do their own work based on market demand. This was obviously different from the Yuan Dynasty, in which craftsmen had to work all year round in the government handicraft workshops. This, to a certain extent, raised the initiative of craftsmen and fostered the development of handicrafts. Craftsmen not only increased in number from the previous dynasty, but also had better skills. Against such a background, furniture craftsmanship in the early and middle periods of the Ming Dynasty developed apace.

During the early Ming Dynasty, institutions were set up one after another to serve the court and meet the daily needs of the imperial family. They consisted of twelve directorates, four offices, and eight bureaus. The Directorate for Palace Accoutrements was in charge of making or buying things needed by the court, including woodwork like screens, beds and couches, and other items for play made of purple sandalwood, ivory, ebony, and mother-of-pearl. The Imperial Workshop, under the Directorate of Ceremonial, was specifically responsible for making palace furniture, such as imperial beds, imperial tables, boxes, and cabinets. Naturally, no expense was spared to make furniture for the court. The demands on craftsmen, materials, and technique were immense. All these, to a certain extent, help to advance furniture craftsmanship.

In the Ming Dynasty, there was great advancement in the theoretical level of craftsmanship, and there was a gradual increase in the number of publications on the skills and experience on various kinds of crafts. During the reign of Longqing (1567 A.D. – 1572 A.D.), the *Digest of Traditional Lacquer* compiled by Huang Cheng gave a comprehensive discussion on the history, workmanship, categories, and features of lacquering crafts (such crafts had been shown in the lacquer furniture of the Ming Dynasty). The book is an important publication for the study of the history of lacquering craft, and is now still of value to scholars. A recommended monograph on wooden furniture is *The Luban Guidebook on Carpentry*, which was compiled by Wu Rong, an official of the Ministry of Works, during the reign of Wanli (1573 A.D. – 1620 A.D.). The book is divided into two parts – architecture and furniture, in which furniture is categorized in detail and, under each category, different styles of furniture are discussed. The detailed requirements and descriptions on the selection of materials, tenon joint structures, furniture specifications, decorative designs, and mouldings are also given in the book. It can be said that this publication sums up the experience of construction techniques and styles and furniture making, and serves the important role of promoting the development of furniture in the Ming Dynasty. Other publications on furniture also include *Treatise*

on Superfluous Things compiled by Wen Zhenheng, and *Eight Treatises on Following the Principles of Life* compiled by Gao Lian. These books provided guidelines on furniture design, enhanced its craftsmanship, and enriched the theoretical system of the crafts.

3. The development of overseas trading provided the material requirements for the creative production of the Ming-style furniture

At the beginning of the Ming Dynasty, with the revival of economy, the booming of handicrafts, the advances in shipbuilding techniques, and the elevation in the technological level of meteorological observation and map drawing related to navigation, favourable conditions were created for the development of overseas trade.

Japan and South-east Asian countries were the major regions engaged in overseas trading in Ming times. In the early years of the Ming, the government concluded treaties with the Japanese government with the stipulation that Japan would pay tribute to China once every ten years, and such tribute was actually a kind of licensed trade. Among the "articles of tribute", Japanese lacquer furniture was greatly loved by people at that time. It was expensive but the supply was unable to meet the demand, so counterfeit furniture was made. In the *Eight Treatises on Following the Principles of Life*, under the title "Incense Burner Teapoy" it reads, "For a small teapoy to be placed on a writing desk, the one made by the Japanese is the best." In chapter 6 of *Treatise on Superfluous Things*, under the heading "Tea Tables" it reads, "Those [furniture] made by the Japanese are of different types and sizes, all are elegant, refined … and expensive. Recently, some good products are made by imitating the old ones."

The Ming Dynasty had closer connections with various Southeast Asian countries. During the period between the reigns of Yongle and Xuande, the Three Jewels Eunuch Zheng He was sent on seven diplomatic missions to the West to publicize the nation's strength. These voyages continued for twenty-eight years from 1405 A.D. to 1433 A.D., visiting thirty-seven countries as far west as to the east coast of Africa. From then on, various countries one after another sent envoys to pay tribute to China (i.e., licensed trade). Among the goods they brought to China, there was often a small amount of timber. Based on statistics in the *Records of Audiences and Tributes from the Western Ocean* by Huang Xingzeng, *Accounts of the Eastern and Western Oceans* by Zhang Xie, both of the Ming Dynasty, and *Record of Southeast Asia and the Eastern and Southern Ocean Islands* by Chen Shoupeng in modern times, the timber mainly included ebony, rosewood, mahogany, sandalwood, ironwood, teak, and purple sandalwood, most of which are high-quality hardwood.

However, the tributary cycle of these small nations was rather long, and there was no guarantee that timber would be brought to China every time. Such a small amount of timber was just a drop in the ocean compared with the demand of the huge Chinese furniture market. Therefore, no record of using high-quality timber to make furniture has been found in literature before the middle Ming Dynasty. During the reign of Jiajing (1522 A.D. – 1566 A.D.) in Middle Ming when the powerful minister Yan Song's property was confiscated by the court, it was recorded that he had only forty plainly lacquered rosewood beds and 6,896 pairs of ebony chopsticks. Rosewood was used to construct the base of the bed, the surface of which was lacquered. This shows that rosewood was not very valuable at that time. The estimated price for furniture at that time was not expensive, just a tael of silver for one bed. In addition, contemporary research has pointed out that there are over one hundred kinds of plants that belong to the purple sandalwood species, but only about twenty of which could be grown as tree timber for making furniture. Among these twenty kinds of purple sandalwood, only one is generally recognized as the standard purple sandalwood, commonly known as the "small-leave sandalwood", which grows only in Andhra Pradesh, the far south of India. All other kinds of trees that belong to the purple sandalwood species are put under the group of grass rosewood. Furthermore, based on historical sources, it was until the Longqing period (1567 A.D. – 1572 A.D.) that China lifted the maritime embargo and private traders could go overseas. The development of

overseas trading experienced unprecedented progress and high-quality timber of the Southeast countries could thus enter the China market in bulk. The main stream of Chinese traditional furniture then started to change from lacquered articles to hardwood ones.

4. The impact of residential and garden architecture on furniture

As the Ming Dynasty was socially stable and economically developed, and people were affluent, officials, landlords, and wealthy merchants rushed to build luxury mansions, gardens, and houses. These mansions and gardens were huge in size and often had dozens or even hundreds of rooms for different purposes. Therefore, various types of furniture were needed according to how these rooms were used. Some men of letters and artists directly participated in the design and construction of these gardens and mansions. They also put forward many aesthetic requirements and criteria on the style and pattern of the furniture. This new trend had inevitably given impetus to the development of furniture craftsmanship.

II. When did the hardwood furniture of the Ming and Qing periods start to become popular?

When did the hardwood furniture of the Ming and Qing periods start to become popular? As mentioned above, the maritime embargo was lifted during the reign of Longqing and high-quality timber could then enter China in large quantities. Therefore, high-quality hardwood furniture actually sprang up during the reign of Wanli (1573 A.D. – 1620 A.D.). The following three points support this argument:

(1) As indicated in the book *Yunjian Jumu Chao* by Fan Lian of the Ming Dynasty, "When I was young, I had not seen any hardwood furniture such as writing tables and meditation chairs, and people only used ginko gilded square tables. The pieces of hardwood furniture used by Mo Tinghan and the two sons of the Gu and Song families were bought from the Wu family. Since the Longqing and Wanli periods, even slaves and poor families used hardwood furniture. Small carpenters in Anhui competed with each other to set up shops in the province, selling dowries and miscellaneous utensils. The rich people who led a luxurious life did not regard beech as valuable. Their beds, cabinets, teapoys, and tables were all made from rosewood, burl, ebony, acacia, and boxwood, which were very expensive, costing them thousands of coins." ("Joinery" here means hardwood furniture.) This historical document serves to show that hardwood furniture did not exist during the reign of Jiajing. Emperor Longqing's reign lasted only six years. During the Wanli period, the trend changed, hardwood furniture began to appear on the market, and the rich people rushed to buy it.

(2) No records about hardwood furniture have ever been found in historical materials before the Wanli period.

(3) As stated above, the corrupt official Yan Song's property was confiscated in the last year of Jiajing. It was recorded that he had a total of 8,871 pieces of furniture. In addition to forty plain lacquered rosewood beds and 6,896 pairs of ebony chopsticks, no hardwood furniture was listed, but there was some carved lacquer furniture with mother-of-pearl inlay. Given the status and position of Yan Song (Senior Grand Secretary and the Minister of the Rites and Personnel, in the favour of Jiajing Emperor for over twenty years), if he did not have hardwood furniture at home, then it was impossible for civilians to have any. It appeared that the palace did not have such furniture. This helped to work out a definite time for high-quality hardwood furniture. Basically it could be said, though not absolutely, that there was no high-quality hardwood furniture before Longqing and Wanli periods of the Ming Dynasty.

III. The style and features of the Ming-style furniture

It should be pointed out here that the concepts of "Ming-style furniture" and "furniture of the Ming Dynasty" are different. "Ming-style furniture" is an artistic concept and not constrained by time. Even during the reign of Emperor Kangxi of the Qing Dynasty, the style and design of the Ming Dynasty were used in the furniture of the time. Therefore, the furniture made before the Kangxi period can still be considered Ming-style furniture. However, the "furniture of the Ming Dynasty" is a concept of time, indicating that the furniture was actually produced in the Ming Dynasty.

Ming-style furniture produced in the Ming Dynasty generally has two kinds of style: the plain and the ostentatious. The former type is more prominent, focusing mainly on mouldings. The latter, being more decorative, usually has beautiful carving and patterns, or uses small components to connect different parts to form large doors and railings. There is extensive carving used on the furniture and its workmanship is refined. The connection system is elaborate but highly regular, giving an overall luxurious and ostentatious impression without being excessive. The features of Ming-style furniture can be in general summed up as follows.

First, the sturdy splayed legs of the furniture are apparent, generating visually a feeling of steadiness. A bench, from the front, appears like a galloping horse (commonly known as "horse-running splay"). Taking a lateral view, the two legs also splay as if a person riding on a horseback (therefore commonly known as "horseback-riding splay"). All the legs of the bench splay out (this is collectively known as "four splittings and eight splays"), whether from a front or lateral view, and this happens most in furniture using round-shape materials. Though this is also true to furniture using square-shape materials, the extent of the splay is smaller.

Second, its plain and unfolding shape gives an artistic effect of simplicity and elegance. Ming-style furniture has a simple structure and each component is functional without any unnecessary additions.

Third, the materials are of high quality. Ming-style furniture is mostly made from valuable timber such as yellow rosewood, purple sandalwood, ironwood, *jichi* wood, and *nanmu* wood. These types of timber are extremely hard and steady. They can be processed into rather small components and intricate mortise-and-tenon joints, and the finished products are exceptionally solid.

Fourth, attention should be paid to the colour effects of the furniture. As far as possible, the parts of the timber of fine quality and beautiful colours are used to make the surface or front and prominent areas of the item. Only after deliberate consideration will the craftsman start to set his hand to make his product. Therefore, the elegant shape of furniture and the natural grain, colour, and lustre of the timber itself add considerable artistic attraction to Ming-style furniture.

Fifth, the metal decorations are usually exquisite and harmoniously tinted. They not only reinforce the furniture, but also enhance its beauty.

In terms of regional characteristics in the making of Ming-style furniture, products made in Suzhou, Beijing, and Shanxi (Jin) were representative, and were then known as the best three types of Ming-style furniture.

Suzhou-style furniture has an earlier beginning. This was because Suzhou, being at the centre of the middle and lower reaches of the Yangtze River, had been the economic and cultural centre of China ever since the Song Dynasty, and it was also the centre of the handicraft industry. By the Ming Dynasty, with the prosperity of its economy, development of city building and the art of landscape gardening, and more importantly, the involvement of many literati and artists in the creation of furniture, rich cultural connotations had been injected into the art of furniture.

Beijing-made furniture had a unique style as

compared to other regions. Outstanding artisans were recruited from all over China to serve in the palace. The Orchard Factory, which produced lacquerware especially for the imperial family, was established at the southwest corner outside the Forbidden City. The lacquer furniture made there was of the highest standard; this was later also true of the hardwood furniture made there. The Beijing-made furniture therefore enjoyed a high reputation and important status of all Ming-style furniture.

Jin-made furniture focused mainly on lacquerware, and the most famous was large lacquer furniture with mother-of-pearl inlay. What is so special about this piece of furniture is that both the lacquer plaster and mother-of-pearl inlay were rather thick. This type of furniture looked steady, dignified, beautiful, and majestic. Besides lacquerware, the "Jin-made" products included a certain amount of hardwood furniture. For ordinary people, walnut and elm furniture was most common. Under the influence of Buddhist art, the legs and feet of furniture, such as beds, couches, tables, recessed-leg tables, and cabinets often had incense-burner legs, and the decorative pattern of this type of furniture was mainly of honeysuckle designs.

IV. An overview of the furniture in the Qing Dynasty

The development of furniture craftsmanship in the Qing Dynasty is mainly divided into three phases. During the reign of Shunzhi and Kangxi (1644 A.D. – 1722 A.D.), the style and features of Ming furniture remained, though there were some subtle changes. Therefore the craftsmanship at this phase should still fall within the scope of Ming-style furniture. Then during the period of Yongzheng and Qianlong (1723 A.D. – 1795 A.D.), there were fundamental changes in furniture craftsmanship, and a unique style of Qing furniture took shape, which was therefore known as "Qing-style furniture". Then from the reign of Jiaqing (1796 A.D. – 1820 A.D.) and Daoguang (1821 A.D. – 1850 A.D.) onwards, the national strength of China declined. There were both internal and external troubles, and national handicrafts were seriously affected. It was impossible to nurture skilled craftsmen in such social conditions. Worse still, there was a lack of valuable timber, so the quality of craftsmanship gradually declined, entering into a phase of decline.

Qing-style furniture is different from the Ming-style in the following ways. First, the material used is thick and heavy. The overall size of Qing-style furniture is larger, and thus the sizes of its various parts are also larger. Second, Qing-style furniture adds beautiful decorations, mainly in the form of inlay, carving, and colour painting. It gives the impression of being dignified, sophisticated, sumptuous, and beautiful, which is in sharp contrast to Ming-style furniture, which is simple, austerely elegant, graceful, and comfortable. On the one hand, Qing-style furniture is not as practical as Ming-style furniture. It is thick and heavy, but not delicate, and gives an impression of bulkiness. On the other hand, as the standard of Qing-style furniture is based on splendour, luxury, and steadiness, many methods, materials, and forms are skilfully applied to the furniture with great success. Qing-style furniture can therefore still be regarded as a kind of outstanding work of Chinese furniture.

Guangzhou, Suzhou and Beijing were the three main regions producing Qing-style furniture and each had their own special characteristics. The furniture of these regions are considered the best three types of Qing-style furniture. The Guangzhou-style was seen as the most outstanding and was highly regarded by the imperial family.

1. Guangzhou-style furniture

From the late Ming to the early Qing period, missionaries from the West came to China one after another. They brought to China advanced science and technology as well as the cultural art of Europe, i.e., the

so-called "eastward movement of Western learning". To a certain extent, this encouraged the development of these areas in China. Thanks to its geographical advantage, Guangzhou became the important door to China's foreign trade and cultural exchange. The flourishing trade sped up the development of local handicrafts. In addition, Guangdong was a major hub for producing, importing, and distributing valuable timber, so there were abundant materials for making furniture. All these favourable conditions endowed Guangzhou-style furniture with its own unique flavour.

One feature of Guangzhou-style furniture is the use of thick, large, and plentiful materials. For various components of the furniture, the curved edges are often dug out from a large piece of wood. If it is an important load-bearing part, then no matter how great is its curvature, it will be dug out from one piece of wood as usual practice instead of being made by combining two pieces of wood. Furthermore, to maintain consistency in the quality of wood, a piece of furniture is usually made from one type of wood, and will never mix it with different types of wood. In addition, Guangzhou-style of furniture is not decorated with lacquer. The bare wood is exposed in pursuit of the natural beauty of the wood.

Another prominent feature of Guangzhou-style furniture is the well engraved decorations on the product which are accomplished through sophisticated carving skills and meticulous polishing techniques. To a certain extent, the style of these decorative patterns reflects the influence of Western architectural carving. The patterns bulge rather high and certain parts are almost carved in a three-dimensional way. In the process of carving, all the parts other than the decorative patterns will be smoothed using a knife and then polished to make them neat and levelled. When the grain and texture of wood is complicated and the shovel is blocked here and there, it is not easy to get the background levelled as carving at that time was done by hand. In addition, the polishing work is so meticulous that the surface of the patterns is made as smooth as jade and no tool marks remain.

The influence of Western art on the patterns of Guangzhou-style furniture is rather obvious. At the time of late Ming and early Qing, Western architecture, carving, painting, and other skills were gradually adopted in China. During the reigns of Yongzheng and Qianlong, the trend of modelling Western architecture prevailed. Many structures in the Imperial Gardens of Beijing, for instance, were built in the Western style. To decorate these Western-style palace halls, the Qing court purchased or custom-made a large quantity of furniture from Guangzhou every year, and it also selected outstanding artisans from Guangzhou to go to Beijing for making complementary furniture especially for the imperial family. These furnishings were produced by means of Chinese traditional craftsmanship with Western-style decorative patterns like "passionflowers". Of course, in addition to these Western motifs, many traditional Chinese patterns were also used to decorate Guangzhou-style furniture, such as clouds and dragons, waves and cliffs, phoenixes, flowers on entwining branches, and various kinds of decorative borders. On some furniture, both Chinese and Western types of decorative patterns were used.

Yet another feature of Guangzhou-style furniture is its distinctive craft of inlay. With respect to inlay, people usually associate it with lacquerware as lacquer is often used as the background in the Chinese craft of inlay. However, the practice of not using lacquer in inlay was a prominent feature of Guangzhou-style furniture. The inlaid products are usually screens and cabinets, and the raw materials are mainly wood carving, ivory carving, cloisonné, and glass painting. The themes are often about natural scenery, landscape, trees, rocks, flowers, birds, animals, myths, and local customs and practices. Among these, it is worth mentioning a type of furniture which is decorated with glass painting. Screens were the most common type. Oil painting on glass is to do a painting in oil at the back of a piece of glass, but the painting is to be seen from the front. The painting technique is to draw the near scene first, then draw the distant scene, and then the distant scene is used to overwhelm the near scene. It is very difficult to create a vivid picture. Painting on glass was introduced into China during the late Ming and early Qing. It became popular first

in Guangzhou and went into production. Extant glass paintings in China were mostly made in Guangzhou except those directly imported from foreign countries.

2. Suzhou-style furniture

Suzhou-style furniture of the Qing Dynasty emphasizes decorations, yet it also embodies the concept of economy. The railing of a bed, couch, and chair is often made with rectangular spirals making up of small pieces of wood. In this way, the purpose of decoration is well served while the materials are also used to their fullest potential. The seats are often made in rattan as rattan is resilient and highly permeable, and the use of rattan saves wood. Also in order to save wood, hidden components of Suzhou-style furniture of the Ming and Qing dynasties are often made in different types of wood. This is frequently seen in a penetrating transverse brace (a component for widening a board) of an article. In general, the hidden parts of Suzhou-style furniture are lacquered to serve two purposes: first, to avoid the penetrating transverse brace from being dampened and deformed; and second, to "cover up", which is to hide the contrast in material quality between the components made from different types of wood and the hardwood used.

For Suzhou-style furniture of the Qing Dynasty, inlay and carving are mainly applied to cabinets and screens. Take a general cabinet as an example. The frame of a general cabinet is usually made of hardwood, a board from pine or Chinese fir is mounted on it, and the lacquering process is applied to give it a plain lacquer surface. After the lacquered surface is dried in the shade, a rough sketch will be first prepared, and grooves will be excavated based on the outline drawn. Lastly the inserts made based on the sketch will be filled in the grooves and stuck tight with wax. The inserts used for Suzhou-style furniture are usually small fragments of jade, ivory, mother-of-pearl, and coloured stones. There are also some wood carvings, usually in *jichi* wood. The advantage of this kind of inlay is that it makes the best use of the materials, even a scrap of jade or mother-of-pearl as small as a soybean would not be discarded.

Most decorative motifs on Suzhou-style furniture are drawn from works of master painters of various dynasties, mostly on pine trees, bamboos, plum blossoms, mountains, rocks, flowers, birds, landscapes, and myths. Next are traditional designs and patterns, such as "seas and cliffs", "flying dragons chasing a pearl", and "prosperity brought from the dragon and the phoenix". Floral sprays are also common and many use homonyms to imply auspices. Decorations on different parts of the furniture mainly use lotus flowers and peonies on entwining branches, but Western designs are rare. In general, the pattern of lotus flowers on entwining branches as used in the Suzhou style and the pattern of passionflowers as used in the Guangzhou style have become a prominent feature differentiating the two styles of furniture.

3. Beijing-made furniture

Beijing-made furniture refers generally to furniture made by the Construction Section of the Qing court. This Section had its own Guangzhou-made wooden furniture unit which recruited outstanding craftsmen from Guangdong to serve in it, and many articles produced there manifested the Guangzhou-style furniture. However, as most timber was transported from Guangzhou, it took several months to get this material to Beijing, which naturally involved human resources, physical resources, and expenses. To save timber, the Construction Section had to draw a picture of the furniture and submit it to the emperor for endorsement before making it. It was often recorded in comments made by the emperor that: after looking at the picture, the emperor thought that the materials to be used for certain parts were a bit too much and made an instruction to reduce them. With the passage of time, it became a feature that less material was used for Beijing-made furniture than Guangzhou-made furniture. Most craftsmen of the general wooden furniture unit of the Construction Section were recruited from Jiangnan. The workmanship of this unit tended to be in the Suzhou style, but the differences were that the furniture made by the Construction Section used more material than that made in Suzhou, and that the mixture of different types of wood was not common.

In terms of decorations, Beijing-made furniture has its unique style as compared to other regions. It often drew inspiration from the ancient bronzeware collected by the imperial family and the art of rock carving. The classic, elegant, or mysterious designs are ingeniously decorated on the furniture. In the Ming Dynasty these designs and decorations were confined to adorning the apron of a table with everted flanges and the inset panel between the table legs. By the Qing Dynasty, however, these were widely used on tables, chairs, and cabinets. In the Ming Dynasty, the carvings were mostly *kui*-dragons and *chi*-tigers (Most Beijing artisans called them "rectangular-spiral dragons" or "grass dragons"), while in the Qing Dynasty, the carvings were varied, including *kui*-dragons, *kui*-phoenixes, rectangular spirals, hornless dragons, young dragons, animal masks, thunders, and cicadas.

It is worth noting that during the period from late Kangxi to early Qianlong in the Qing Dynasty, the ports of Ningbo and Xiamen were once opened up to trade with overseas countries. Japanese mercantile ships came and went most frequently, and many of the goods they carried were Japanese lacquer furniture which the imperial family became quite fond of when it was brought to the palace. As shown in the Qing palace tribute archive, except for furniture directly imported from Japan, a large quantity of imitation foreign lacquer furniture was made in Ningpo, Huai'an, Fuzhou, Jiujiang and Changlu to be sent as tribute to the palace during this period. Fuzhou in particular ranked first in the country in lacquerware industry as it was famous for gold lacquering and colour painting, and the decorations it used were mostly Western designs.

V. Categories of Ming and Qing furniture

Based on their use and functions, the furniture of the Ming and Qing dynasties can mainly be divided into six categories: bedding (beds and couches), seats (chairs and stools), articles of daily life (tables and recessed-leg tables), storage (coffers and cabinets), screen shielding (screens), and hanging and support (platforms and stands).

1. Category of beds and couches

In the Ming and Qing period, beds and couches were mainly divided into three types: canopy beds, alcove beds, and arhat beds.

The canopy bed gets its name because it has a top canopy. It usually has a post at each of its four corners, and it has railings at its two sides and the rear. The four sides at the upper posts are installed with lintels and on the top is a canopy. For some canopy beds, two more posts are added along the edge of their front, and a square railing is installed respectively at the right and left ends of the front. In some cases, the design of the canopy bed is ingenious. Small pieces of wood are skilfully joined into a large lattice panel

at the front of the bed, and only an oval-shaped full-moon opening is left in the centre for getting on or off the bed. The bed base has two levels, the lower one is a palm base and the upper one is a rattan mattress. The palm base can protect the rattan mattress and lend support to its load-bearing strength. In certain cases, though rarely, only the palm base will be used. The apron underneath the edge of the bed often has relief carving. The apron board adopts the high waist craft. It is divided into several sections using short posts, an ornamental panel is inserted in the centre and there is relief carving of birds, animals, flowers, and other decorations on it. The canopy bed is usually used in Southern China as it is warm there and has many flies and mosquitoes. The canopy serves to hang curtains. It is cold in the North and people usually sleep on a heated *kang*-bed. Even if they use a bed, they just need to install short bed railings at its two sides and the rear.

The alcove bed is a kind of canopy bed but it has a peculiar shape as it appears it is sitting on a wooden platform, and the front of the platform is two

or three feet forward from the front of the bed. There is a post at each of the four corners of the platform, and wooden railings are installed against these posts. Some alcove bedsteads have windows at its two sides, forming a veranda in front of the bed to place small pieces of furniture such as tables and stools.

The arhat bed is actually a couch that we usually mention, and it evolved from the Han Dynasty. Originally the couch was specially a seat, then it developed through the Five Dynasties, Song and Yuan periods. It became larger in size so that it could even accommodate several people on it together, and could be used for both seating and lying down. Later on, railings were added to the two sides and the rear of the seat and it became the arhat bed. This type of beds has large ones and small ones. The larger bed is usually called a "Luohan bed" and the smaller version is called a "couch" or "Arhat couch". As a kind of very meticulous furniture, the arhat bed is suitable for both seating and lying down. A *kang*-teapoy is generally placed in the middle of the bed, and cushions and hidden pillows are put at the two sides. The arhat bed is set in a hall to serve guests. The *kang*-teapoy can be used for both leaning and holding things.

There is yet a smaller bed which is suitable only for seating but not lying down. It is commonly known as a "bed-like chair", while it was called "throne" in the Ming and Qing palace. Rarely in pairs, the throne was often set alone in the main hall of various palaces, and specially used by the emperor, empress, or other wives of the emperor. Together with other furnishings such as the screen, incense stand, palace fan, incense cylinder, and the auspicious animal Luduan, the throne looks exceptionally dignified and solemn. In terms of the shape and construction, the throne is the same as the arhat bed, except that the former is smaller than the latter. Therefore, there are certainly good reasons why some people say that it has evolved from the bed.

2. Chairs and stools

There were many different forms of names for chairs and stools during the Ming and Qing periods.

The chairs include folding chairs, armchairs with curved rests, official's hat armchairs, side chairs, and rose chairs. The stools include square stools, long benches, round stools, pentagonal seats (hexagonal seats), plum-blossom-shaped seats, and begonia-shaped seats. In addition, there were also various kinds of embroidery stools.

The folding chair has its front and rear legs crossed, with the intersecting points as pivots. Strings traverse between the two upper beams to form the seat of the chair which can be folded. The chair has a curved rest at its back. It is called "folding chair" because it has crossed legs. In the Ming and Qing dynasties, chairs with a curved rest at the back were called "folding chairs", while those without were called "folding stool" (or "*mazha*"). Folding chairs were not only for indoor use, but also were portable for outdoor activities. Most of such extant folding chairs were produced before the Ming Dynasty or mid-Qing period. After that, people rarely produced such folding chairs, though those made previously were still in use.

Armchairs with curved rests evolved from the folding chair. The curved rest and arms of the folding chair are not separate but of the same unit. When seated, people had support for their elbows and arms. This style of chair became popular, and gradually developed into an armchair with a curved rest which was used indoors. The armchair with a curved rest has four separate legs rather than crossed legs, and a wooden board as its seat which is not much different from the base of a general chair. However, the parts above the seat keep the same form as the folding chair. This kind of armchair was usually arranged in pairs and seldom used alone.

As the curved rest of this kind of armchair is an arc, it makes more sense using round-shape timber, often plain without designs or just with simple patterns in relief carving at the centre of the splat. The splat is designed in "S" shape based on the natural curve of the human spine, and this makes the typical proof of the scientific quality of Ming-style furniture. In the late Ming Dynasty, some armchairs with a curved rest still kept the wood at the end of

the arms that should have been discarded. This piece of wood was even decorated with openwork carving. As such, the furniture was not only beautified, but also reinforced. In the Ming Dynasty, this style of furniture was highly praised and often called "Grand Tutor chair". There is another style of this kind of armchair whose splat is higher than the curved rest and bends slightly backward, allowing people to rest their heads on it and face upward. This headrest is called the "top rail" of the chair. There is still another style of this kind of armchair whose curved rest does not go all the way through to the arms but stops at the side posts. In this case this kind of armchair is known as a "semi-armchair with a curved rest", which is actually armless. This kind of armchair was common in the Ming Dynasty and was still in production in the mid-Qing period. However, as it maintained the style of the Ming Dynasty, it still belongs to Ming-style furniture.

The official's hat armchair is so named because it looks like the hat of an ancient official. The Ming-style chairs are divided into two types: Southern official's hat armchair and armchair with four protruding ends. The Southern official's hat armchair has a soft round corner formed at the joint of the back post and top rail. The two back posts are put under the top rail. This design is also used on the arms. The splat is made from thick wood in the shape of a wish-granting scepter handle based on the natural curve of the human spine. This style of chair is more common in southern China and often made of rosewood and round timber, making it look natural and graceful. With respect to the armchair with four protruding ends, the top rail and arms continue to stick out passing the posts and slightly bend outward at their ends, which are polished smooth and round. Apart from these characteristics, this style of armchair is the same as the Southern official's hat armchair.

The rose-shaped chair, which could be seen in famous paintings of the Song Dynasty, was more common in the Ming Dynasty, and it was still produced in the mid-Qing period. This kind of chair is unique in shape but is actually a kind of Southern official's hat armchair. Its back is usually lower than other kinds of chairs and not much higher than the arms of the chair. When it is placed indoors near a window, its back is not higher than the windowsill. When it is set out together with a table, its back is not higher than the edge of the table. Such design saves space and will not affect users' other activities, therefore it attracted many people and was widely popular though it was not comfortable. The name "rose-shaped chair" was commonly used between Beijing's craftsmen, while in Southern China it was more commonly known as a "writing chair". However, there was no historical record of these two names. The two-word Chinese term "*mei gui*" ("rose") in general refers to beautiful gems, and the second word "*gui*" also means "treasure". In terms of style, characteristics, and shape, the rose-shaped chair is really unique. Its four legs, backrest, and arms are all made into round and straight wood pieces, making it more novel and delicate than other styles of chairs. It is unusual and pretty, and its name "*mei gui*" reflects people's high praise of the chair.

By the time of the Qing Dynasty, the official's hat armchair changed from its Ming style to become square and straight, free or almost free of inclination at its back. Its back and arms were mostly perpendicular to the seat, using square wood pieces and it had frames with inset boards which might be decorated with carving, inlay, colour painting, or others.

The side chair is one with a backrest but without arms. It is divided into two types: the stele-shaped chair and the lamp-hanger chair. The stele-shaped chair has the same style of backrest and top rail as the Southern official's hat armchair, while the lamp-hanger chair has the same style of backrest as the armchair with four protruding ends. The lantern-hanger chair is so named because its beam protrudes pass the two side posts and slightly raises upward, making it look like the rod that hangs the lantern. The side chair is smaller than the official's hat armchair, and is light, flexible, and easy to use. If we judge the side chair by the concepts of hierarchy and ethics, this kind of armless chair is lower in rank than the armchair.

The stool, bench, and embroidery stool are seats without a backrest. The stool and bench do not

have any intrinsic difference. The stool is divided into two types: waisted and waistless ("waisted" refers to the indentation below the top of the furniture for decoration.) A waisted stool uses square-shape wood pieces and seldom uses round ones, while a waistless stool uses both square and round pieces. A waisted stool may use cabriole legs while a waistless stool will use straight legs. The legs of a waisted stool end with inward- or outward-curving horse-hoof feet, while a waistless stool rarely has decorations on its feet regardless whether it uses square- or round-shape legs.

There are different types of stools, including the rectangular stool, long bench, and round stool. The rectangular stool has similar length and width and is generally called a square stool. The stool that can accommodate two or three people is usually known as a long narrow bench. As it often appears in ancient paintings which depict sexual intercourse, it is also called a "love bench (*chun deng*)". Furthermore, as it had a rather broad seat, it could also serve as a low table, making it a multi-purpose furniture item that is suitable for both seating and holding objects. The round stool, which is usually seen in the Ming Dynasty, looks sturdy and elegant. Unlike the square stool which has four legs due to the constraints of its number of sides and corners, the round stool has at least three legs and at most eight legs as it has no problem with sides and corners. The one with three legs is usually waistless, while the one with four or more legs often has a waist.

The embroidery stool is also a kind of seat without a backrest. It is characterized by a drum-shaped base under its seat instead of having four legs. This stool is shaped into a waist drum with its two ends being small while the middle part bulging. Both upper and lower ends are carved with a round of string mouldings and the nipple nails that symbolize drum heads. The embroidery stool is also known as the "drum stool" as it looks like a drum. For ease of carrying, four decorative begonia-shaped openings are made in the middle part of the stool. The diameter of the Ming-style embroidery stool is generally longer, giving it a dignified and graceful look, while the Qing-style embroidery stool is shorter, making it look

delicate. In addition to wood, the embroidery stool can be made of grass, bamboo, rattan, lacquer, and ceramics.

3. Tables and recessed-leg tables

Tables can be divided mainly into two types: waisted and waistless. The waist can be further divided into high waist and low waist. For low-waisted tables, humpback stretchers or giant's arm braces are usually to be added under the apron, otherwise it is necessary to install continuous floor stretchers under the feet to provide extra reinforcements. For high-waisted tables, pillar-shaped struts are placed under the top and divided into several sections. The upper part of the four legs can be seen at the four corners and mingle with the pillar-shaped struts. Ornamental panels are put between these struts, and stepped apron moulding is placed underneath. The central parts of the ornamental panels are adorned with carvings. This shows that the high waist is not only for decoration, but more importantly increasing the distance between the apron and the top, effectively securing the four legs so that not many additional reinforcements are necessary under the apron. The four feet of the waisted table are made into inward- or outward-curving horse-hoof feet, and in some cases, wings with clouds are made at the middle part of the legs. These have become its basic features.

The shape of a recessed-leg table is different that of a table. The prominent difference is that the legs of a recessed-leg table are not placed at the four corners of the top, but on its two sides with some indentation from the edge. The top a recessed-leg table has two styles: with everted flanges at its two ends, and flat top. Between the legs on the two sides are usually mounted panels with various kinds of carvings or installed with different types of four-sided inner frames. There are two approaches to making the feet of a recessed-leg table: first, the feet do not directly touch the floor, but stand on long strips of continuous floor stretchers. In another approach, a recessed-leg table does not have continuous floor stretchers, and its feet directly stand on the floor, slightly frontward-curving. The upper

parts of the legs are connected by aprons which together support the top of the recessed-leg table, and the legs on the two sides have obvious splayed feet. There is yet another type of furniture which is slightly different in shape from a recessed-leg table. It has no continuous floor stretchers underneath the legs on the two sides, nor any four-sided inner frames or engraved inset panels, but it is installed with two side stretchers between the legs on its two sides. This type of furniture, whether large or small, is called a recessed-leg table if it has everted flanges on the two ends of its top. On the other hand, if it has no everted flanges, people were used to call the large one as a recessed-leg table, and the small one, a table. Strictly speaking, this type of furniture should in fact be called a recessed-leg table as it has more features of a recessed-leg table in terms of its shape and structure. In general, the item with its legs on the four corners of its top is called a "recessed-leg-table-type structure", while the one with its legs indented from the edges of its two sides (instead of on the four corners) is called a "table-type structure".

The incense stand is specially used for placing the incense burner, and is in general placed in a set or in pairs. In the Buddha worshipping hall, it is sometimes put in a set of five for placing the five sacrificial utensils, but it can also be used individually. The incense stand was often set out in an ancient study room for holding beautiful stones and vases, or just one incense burner. The shape of this stand is rather like a vase, and it usually has cabriole legs.

The *kang*-table, *kang*-recessed-leg table, and *kang*-teapoy all belong to low-rise furniture. As they are usually placed on the *kang*-bed or bed for use, they are given the word "*kang*". The *kang*-table is usually put on the centre of the bed or couch, serving like a modern teapoy, and people sit on the two sides of the *kang*-table.

4. Coffers and cabinets

Coffers and cabinets are furniture in a living room for storing clothes. Besides coffers and cabinets, chests, stands, and shelves also fall into this category.

The coffer is similar to a recessed-leg table in form and structure. There are two types of coffers: recessed-leg-table-shaped and table-shaped. Drawers are installed under the coffer top. When a coffer has two drawers, it is called a two-drawer coffer; when it has three drawers, a three-drawer coffer. In some cases, there is a concealed storage area under the drawer. On the whole, coffers are of similar shape as tables, but have extra uses.

Cabinets refer to furniture that has a door in the front and that contains shelves inside that are used for storage of things.

Cupboards refer to furniture that combines the functions of a coffer and a cabinet. There are two types of cupboards: table-shaped and recessed-leg-table-shaped. Cupboards are like installing a cabinet door at the lower part of a coffer, having the functions of the coffer, cabinet and table at the same time.

Compound cabinets are a type of furniture that was commonly seen in the Ming Dynasty. Compound cabinets are composed of a lower cabinet and an upper cabinet, and set in pairs. As these wardrobes sometimes are displayed side by side, they are often made in straight form to avoid any crevices in between.

Round-corner cabinets are also known as round-feet cabinets. They have conspicuous splayed legs and swing doors. The central board of a round-corner cabinet is often made from a single piece of wood with a beautiful grain. A removable stile is fixed between the doors, which are matched with a strip of face plate. For this kind of cabinet, no metal hinges are used between the two doors of the cabinet and the frame of the cabinet. Door pivots are used instead, and this is often the case with Ming-style furniture.

Book shelves are shelves for storing and putting books. Book shelves usually do not install doors at the front, but only have short railing boards at the rear and two ends at each shelf for keeping the books orderly. Two drawers are fitted at the centre of the front to reinforce the book shelf as well as enhance its functions.

Display cabinets combine the forms of a cabinet, a coffer, and a shelf into one piece of furniture. The

lower part have two swing doors, behind which is a panel to divide the area into the upper and lower tiers. On top of the cabinet door are a row of two or three drawers. Further up are one or two tiers of open shelves and on the front and two sides of which are mounted short railings. The lower part stores a variety of objects and the upper part is used to display a few antique objects, creating a feeling of lustre in the living room. The curio shelves that emerged during the reign of Yongzheng of the Qing Dynasty evolved from the display cabinet.

Chests are also for storing things. Chests in general are not too large and have handles on both sides to make them portable. When a chest is frequently moved, it is easily damaged, therefore its corner areas are often wrapped with brass leaves. Larger chests are often put directly on the floor in a room. They are usually fitted with a base (also called a "continuous floor stretcher") to avoid the chest's bottom becoming wet. There is also a kind of chest known as "dressing case", which is a special species of Ming Dynasty furniture and is used for storing things during travelling. For smaller chests, when their lids are opened, there are adjustable shelves inside. At the front are two swing doors, behind which are drawers. The upper edges of the doors have indented box lids. After closing the doors and the lid of the chest, all four sides are then fixed. There are handles on the two sides of the chest and a lock at its front.

5. Screens

Screens can be divided broadly into three types: the screen set in stand, folding screen, and hanging screen. There are a variety of screens which can fully reflect the superb craftsmanship of Qing Dynasty furniture.

The screen set in a stand is divided into two types: multi-panel screens and single-panel screens. Multi-panel screens vary in size from three, five, seven or nine panels, but the rule is to use an odd number of panels, which use removable tenons to connect. The bolt underneath the screen is inserted into a character-*ba*(eight)-shaped base stand, and at the top there is a screen cap. The single-panel screen is also known as a removable panel screen, which is inserted into a specially made base stand. This kind of screen varies in size. A large screen one can block a door, while a small one can be placed on a recessed-leg table to decorate a room.

A folding screen is a movable furniture item. Between each panel are installed with buttonhooks or mounted with silk, and the screen can be folded freely. It can be opened out when in use, and folded up for storage when not in use. It is light and flexible, so light wood is usually used to make the frame of this kind of screen. The central panel is mounted with paper or silk, on which designs are painted in colour or embroidered. Some panels have lacquer ornamentation, on which patterns are carved.

A hanging screen refers to a strip of screen that is stuck on a framed panel or inlaid in a glass frame for hanging. It emerged in the early Qing period and often replaced a painting scroll for hanging on the wall, serving simply as a decorative furniture item. It is generally used in pairs or groups, for example a group of four is called a four-panel screen, a group of eight is called an eight-panel screen, and in some cases a couplet is placed on the two sides of a central large panel. These types of settings prevailed in the reigns of Yongzheng and Qianlong, and were nearly seen everywhere in imperial sleeping palaces of emperors and empresses.

6. Stands and platforms

This category of furniture refers to items used for hanging things and support in daily life. It mainly includes clothes racks, washbasin stands, lamp stands, mirror platforms, and dressers.

The clothes rack in ancient times was different from hangers generally used in modern times. It usually adopted the cross-bar type. There are posts on the two sides and a wooden base at the bottom. Between the two posts a crossbeam and a central panel are mounted, and on top of the posts lies a crossbeam protruding the two posts. Ancient people often wore robes and they hung them on the beam after taking them off.

A washbasin stand is divided into two types: the tall washbasin stand and the short washbasin stand. The tall washbasin stand is a stand with a towel rack. The two posts behind the washbasin are higher than the edge of the basin. On the two posts a crossbeam and a central panel are mounted for hanging towels. For the other type, its posts are not higher than the edge of the basin.

A lamp stand is usually of the adjustable type and is rather narrow and tall. The upper rim has a hole through which a post passes. The bottom of the post is connected to an adjustable crossbar so that the post can go up and down. Placed at the top of the post is a wooden plate used for holding the lamp. A lampshade is needed outside the plate to prevent the light from being blown out by the wind.

A mirror platform is also known as a mirror support. There are a platform at the base, several drawers on the front, and railings on the four sides of the mirror top. An opening is left at the front side of the railings, and a three- or five-panel little screen is set within the railings at the rear. The panels at the two ends of the screen draw frontward, and the bronze mirror is put at the centre. The mirror can be put away when not in use, and the little screen can also be taken down and put aside.

7. Lacquer furniture

The Chinese lacquering art has a long history. By the end of the primitive society, our ancestors had knowledge of lacquer and used it to paint and decorate articles of daily use. After continuous development and innovation for thousands of years, the lacquering art at the Ming and Qing periods had evolved to 14 categories and 87 types. Lacquer furniture is a major category of Chinese furniture with many varieties. The following 11 types of lacquer furniture can be found in the collections of the Palace Museum.

(1) Single-colour lacquer furniture. Also known as plain lacquer furniture, this category refers to furniture that is painted with one colour of lacquer. The common colours are black, red, purple, yellow, green, and brown. Black, bright red, and purple were most popular. Black lacquer is also called dark lacquer.

Black is the original colour of lacquer, therefore there is an ancient saying: "It means black when the colour of lacquer is not mentioned." Consequently sheer black lacquer-ware is the standard for use in lacquerware. Other colours are all mixed and processed.

The production craft of lacquer furniture is to first make the framework using light timber (because it is easier to lacquer soft wood than hard wood). A coat of raw lacquer is then applied, and before it dries, a layer of linen is pasted on it, which is then pressed hard with a pressing tool. This allows the raw lacquer underneath to penetrate through the holes of the linen. When dry, lacquer cement putty is applied – generally two or three times and divided into coarse, middle, and fine cement. The lacquer cement needs to be polished for each layer. Then several layers of coloured lacquer are applied, and lastly a coat of clear lacquer is given. A finished product is then made.

(2) Carved lacquer furniture. Carved lacquer, also known as "carved with lacquer", is found in colours such as red, yellow, green, or black. This craft is to lacquer repeatedly on the furniture and apply lacquer cement putty around eighty and ninety times, or even hundred times. Each time when the lacquer is half or 70 percent dry, another layer will be applied. The next task after this process is to draw the design on the surface which will then be carved out. Then the furniture is left to dry in the shade to allow the lacquer to harden. Lastly the furniture will be given a polish to complete the whole process.

(3) Gold-painted black lacquer furniture. This involves applying coloured lacquer to pure black lacquer furniture, and the colour lacquer is made by mixing with translucent lacquer. The design is then drawn the design on the lacquer background and the piece is placed in a temperature and humidity-controlled room. When the lacquer is dry, adhesive is applied to the design, then a cotton ball is used to stick the finest of gold powders on the design. The gold design looks magnificent against the black lacquer background.

(4) Gold lacquer furniture. The craft involves wrapping the entire body of the lacquer furniture

with gold foil, then applying a coat of clear lacquer on the gold foil. The Gold Lacquer Dragon Throne set in the Hall of Supreme Harmony of the Forbidden City is a typical example of gold lacquer furniture.

(5) Cement stacking furniture. Lacquer cement is stacked to form various kinds of designs on the plain lacquer furniture surface. Then carving id done, followed by painting or tracing in gold. This craft features bulging designs of different levels, like relief carving.

(6) Lacquered furniture carved with gold. Inlaying with lacquer, and engraving and filling in with gold are two different approaches used in lacquering. Inlaying with lacquer means using various lacquers of a different colour. First, a knife tip or a needle is used to carve hollow designs on the plain lacquer background. Then designs are filled with the required colour lacquer. When the lacquer is dry, it is polished, which makes the designs distinct from the lacquer background. Engraving and filling in with gold or silver operates essentially the same as the inlay with lacquer. First, a needle or knife tip is used to draw fine designs on the plain or inlaid lacquer ground. Then adhesive is inserted into the hollow design and gold leaf is pasted into the depression. This approach differs from the lacquer inlay method in the way that the designs and the lacquer back ground are not at the same level, and traces of the hollow designs remain.

(7) Furniture with lacquer carving. Lacquer carving is also known as "deep carving with filling". Black lacquer is generally used as a background on which a design is drawn. The lacquer ground within the profile of the design is dug out with a knife into the depth of the lacquer cement, and that is why it is called "lacquer carving". The hollow design is then filled with different colours of paint, gold or silver, based on decoration requirements. The characteristic of this craft is that the design is lower than the profile surface and gives the appearance of a woodcut. This craft was rather common in the Ming Dynasty, and extant works are common, and range from small boxes to large 12-panel freestanding screens of over two metres in height.

(8) Black lacquer furniture inlaid with thick mother-of-pearl (hard mother-of-pearl). Mother-of-pearl means shells. This craft first follows the production process of plain lacquer furniture. Before the second coat of lacquer cement is applied, slices of mother-of-pearl are ground into the required forms of the designs and then stuck on the cement ground with lacquer. When dry, another coat of lacquer cement (getting thinner for each layer) is applied, making the lacquer surface at the same level as the design. The lacquer cement slightly shrinks after it dries, and then several layers of raw lacquer are applied. When the lacquer dries, it is polished to make the design distinct. Fine engraving is then done on the mother-of-pearl to enhance the decorative effect and form the furniture.

(9) Black lacquer furniture inlaid with thin mother-of-pearl (soft mother-of-pearl). The inlay used is the inner cuticle of a kind of very thin shell. The thin mother-of-pearl commonly seen is as thin as the newspaper currently used. As it is so thin, its size is not large. During the process, the design is done on the final coat of varnish of the plain lacquer. When sticking on the design, craftsmen differentiate the shell colour and apply colours based on the requirements of the design, which creates a colourful effect.

(10) Furniture sprinkled and inlaid with gold, silver, or mother-of-pearl pieces. When applying the final coat of lacquer, gold or silver leaf or mother-of-pearl pieces are sprinkled on the lacquer ground before the lacquer dries. When the lacquer is dry, sweep the superficial bits off and the piece is polished.

(11) Comprehensive crafts. Apart from works that only use one technique, there are also lacquer furniture that use multiple decorative techniques. There are few extant works of this kind and are therefore very valuable.

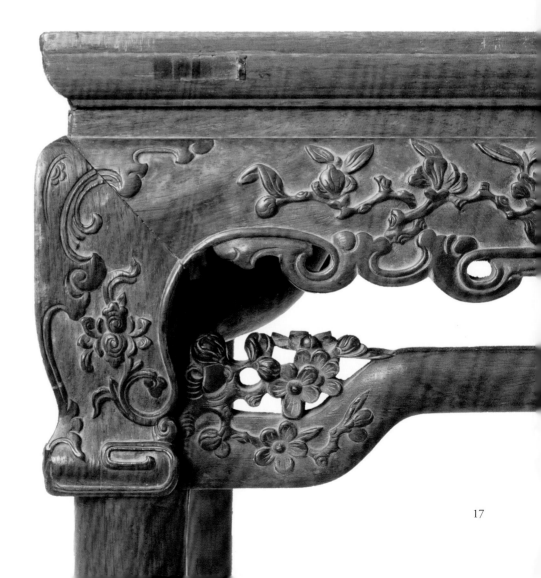

MING DYNASTY FURNITURE

Beds and Couches

Chairs and Benches

Tables

Chests and Cabinets

Screens

Platforms and Stands

1

Yellow Rosewood Canopy Bed
with a Full-moon Opening Cover

Height 231 cm Length 218.5 cm
Width 147.5 cm

The full-moon opening cover of this bed is composed of the upper half, lower left, and lower right fans, which are linked to short railings on the three sides of the bed and canopy lattices with *sihe ruyi* cloud patterns joined with crossed members. It is high-waisted under the surface of the bed, with ornamental panels which are inlaid and carved with flowers and birds. The apron with a pot-door-shaped opening is carved with clouds and dragons. The apron of the canopy lattice is carved with clouds and cranes. This bed has cabriole legs and inward-curving horse-hoof feet.

This bed was obtained from Shanxi, but it is more typically a product of the Suzhou district. The decoration of the *sihe ruyi* cloud patterns, for example, carries the connotation of luck, and the bed could fully utilize short and small pieces of materials. But the making of this bed was time-consuming, labourious, and technically difficult. The use of beech to make the post on the rear-left corner, in particular, is an auxiliary proof of its being a Suzhou product.

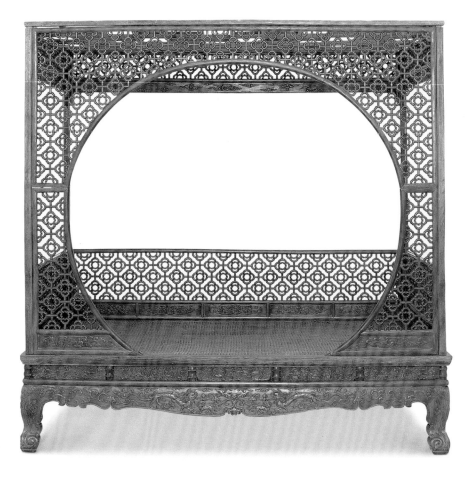

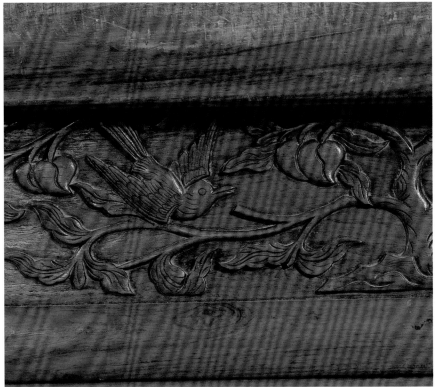

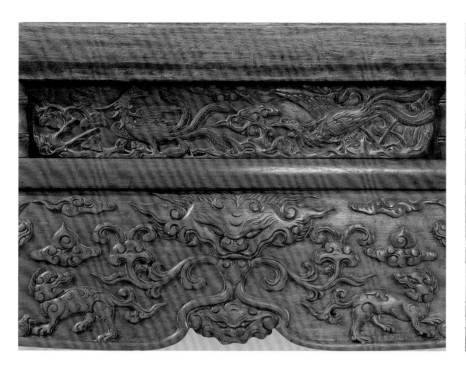

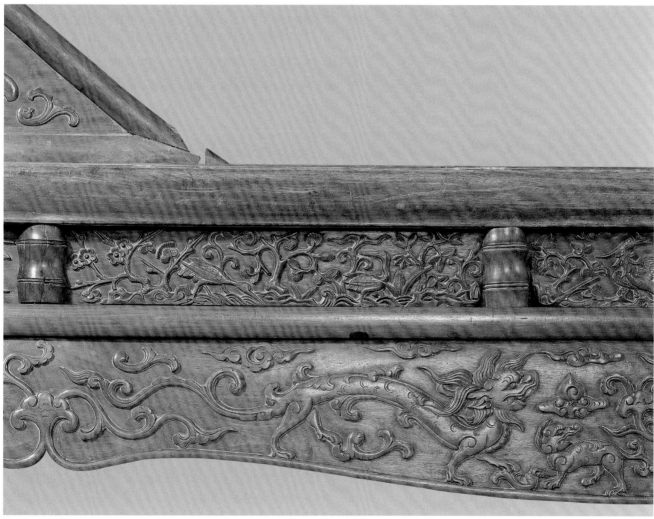

2
Yellow Rosewood Canopy Bed
with Swastikas (卍)

Height 231 cm Length 218.5 cm
Width 147.5 cm

Erected on the four sides above the surface of the bed are four posts, on which a top frame is placed. Two door pillars are added to the front side, which are linked to the door railings and corner posts, and the bed therefore is called a "six-post" bed. The bed railings formed neat swastika characters (卍) with the use of short timber. The lattices on the four sides on the top of the bed are composed of hollowed-out ornamental panels. The posts of the bed frame, its side stretchers, and both sides of the swastika-character (卍) railings create a concave arc-surface, known as a "concave moulding" (dawa). The surface of the bed is rattan. Decorated under its waist is a curved-edge apron with a pot-door shaped opening, which forms a circle with the inner corner lines of its feet. This bed has cabriole legs and inward-curving horse-hoof feet.

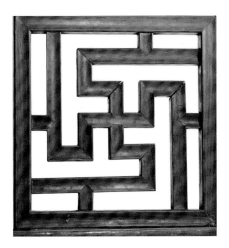

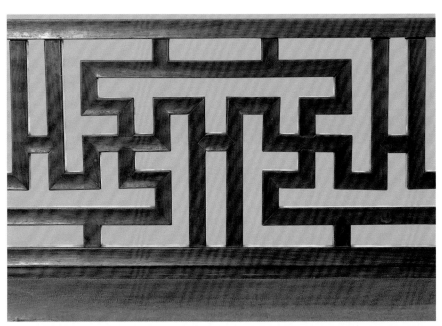

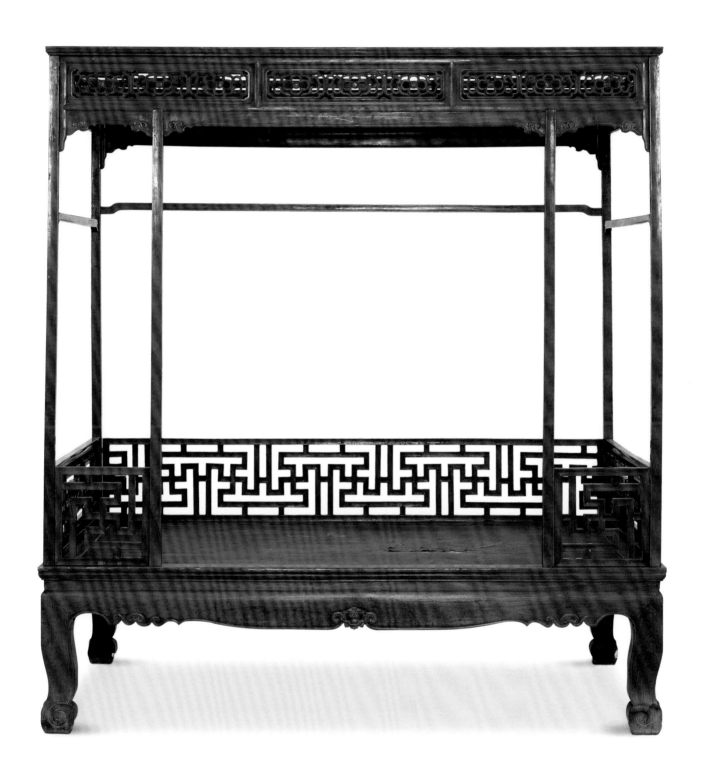

3

Black Lacquer Canopy Bed
Inlaid with Mother-of-pearl, Flowers, and Butterflies

Height 212 cm Length 207 cm
Width 112 cm

This bed is in a straight form. It has rectangular posts erected on the four corners, and inlaid between the two posts at the rear edge is a large piece of backboard. The four sides of the bed frame have hanging spandrels, which are joined together with hook-and-plug tenons, pressing the top of the bed from above. The legs of the bed are short and strong, in the shape of flat horse-hoofs, with their exteriors wrapped in copper sheaths. Inlaid in the entire body of the black-lacquered bed are hard mother-of-pearl and colourful flowers and butterflies. The middle of the backboard is decorated with seasonal flowers, such as peonies, plum blossoms, peach blossoms, and osmanthus flowers, and its edges are decorated with butterflies, dragonflies, cave stones, and clusters of flowers. Both sides of the short railings are also decorated with colourful flowers and butterflies.

This bed was made in Shanxi. Mother-of-pearl and lacquer were applied to the entire body, displaying an air of elegance and splendour and adding a sense of stability to its structure.

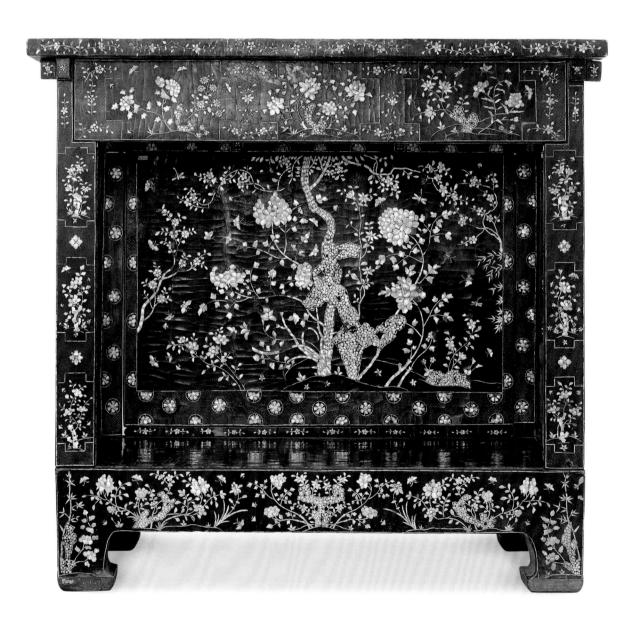

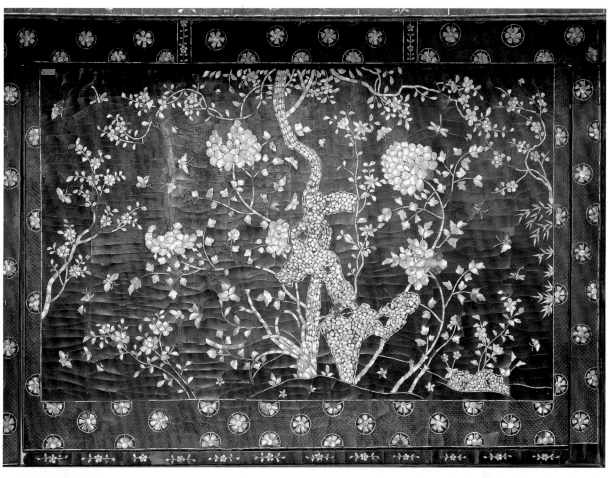

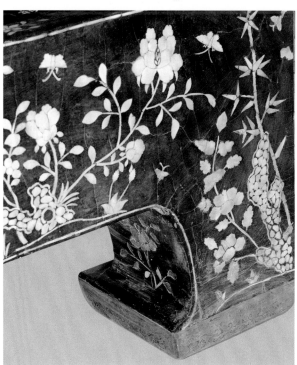

4

Yellow Rosewood Arhat bed
with a Solid Board Railing

Height 79 cm Length 218.5 cm
Width 114 cm

The bed railing is made of three pieces of whole timber, with soft indented corners on the edges of the board. It is waisted under the surface of the bed, and the middle of the apron with a pot-door-shaped opening is carved in openwork with clouds. The inner sides of the legs have overturned horse-hoof feet, and the edges of the apron and legs have a round moulding.

Whole timber is used for this bed, with little carving decoration, so that the beautiful grains of the yellow rosewood could stand out.

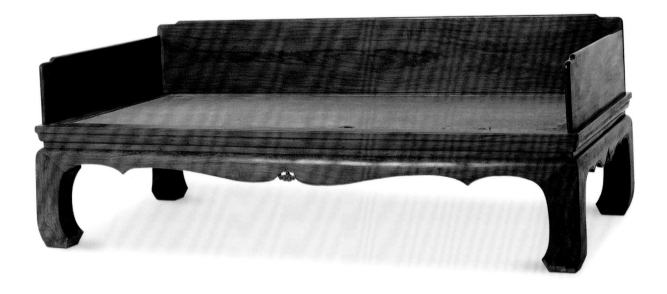

5

Yellow Rosewood Arhat bed

Height 88 cm Length 218 cm
Width 100 cm

This bed has a three-screen railing, with each side having a sihe inner frame with a pot-door-shaped opening. It has rattan on the surface of the bed. Under the surface is an apron with a pot-door-shaped opening and carved with curling tendrils. This bed has cabriole legs and whorl-patterned feet, and both the legs and feet are also decorated with curling tendrils.

The shape of this bed is plain and stretchy, and its sihe inner frame with a pot-door-shaped opening and railing are rather spiritually free, which is typical of Ming furniture.

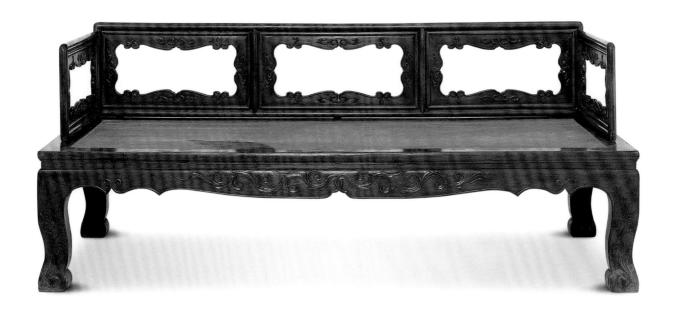

6

Yellow Rosewood Arhat Bed
with Openwork Lattices

Height 89.5 cm Length 198.5 cm
Width 93 cm

The bed railing is made by joining the square with a cross-shaped pattern. A Taiwan mat is pasted on the wooden plank of the surface of the bed. Under the surface is a waist, inward-curving horse-hoof cabriole legs, and the feet are carved with cloud heads.

The reason for pasting the wooden plank of the surface of the bed with a Taiwan mat is that the original rattan was soft, the shelf was ruined, and it had to be redone. The distribution of the decorative strut of the upper layer of the middle railing is uneven, and the two pieces at the end corners were not pasted to the frames, so it is suspected that the mat was added later. It is standard for an arhat bed to have the rear railing to be higher than its two sides, and it is a common practice for a canopy bed to have the three railings of the same height. It is possible that this bed was made from a canopy bed.

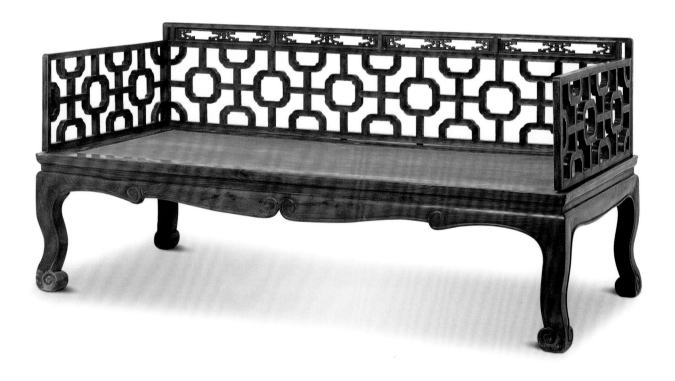

7

Filled Lacquer Arhat Bed
with Engraved Gold
(*Qiangjin*) Designs of Clouds
and Dragons

Height 85 cm Length 183.5 cm
Width 89.5 cm

The bed railing is made of a single piece of timber, under which it is waistless. It has a broad apron, four thick strong legs, and flat horse-hoof feet. The entire body is decorated with patterns filled with lacquer and engraved in gold. The apron is carved with the motif of "two dragons chasing a pearl", and the spaces between the dragons and the pearl are decorated with clouds. The bed railing is carved with sea water and cliffs, with a frontal dragon in the middle holding high a treasure bowl with its two claws. On each of its two sides is a strolling dragon, interspersed with bright clouds and various treasures. Carved on the back of the rear board are cape jasmine flowers, plum blossoms, and magpies. Engraved in gold on the upper edge of the middle part are the characters in regular script "made in the year of *xinwei* during the reign of Chongzhen in the Ming Dynasty". The *xinwei* year of Chongzhen is the fourth year of Chongzhen, or 1631 A.D.

Lacquer furniture of the late Ming period with a signature is rarely seen. The signature of this bed is legible, and the craftsmanship is superb, which is helpful in assigning lacquer furniture to the late Ming period.

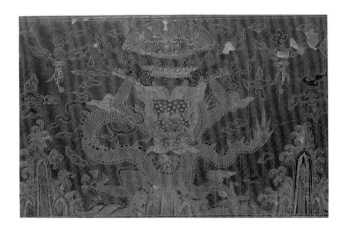

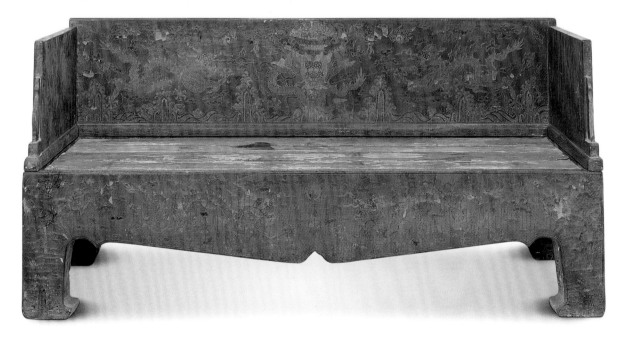

29

8

Black Lacquer Arhat Bed
Inlaid with Mother-of-pearl Flowers and Birds

Height 84.5 cm Length 182 cm
Width 79.5 cm

The body of this bed is in a straight form and evenly flat, with three whole board railings. The apron under the surface of the bed is rather broad, and, together with the legs and feet, forms a curve with a pot-door-shaped opening. The horse-hoof feet are short and flat. The entire body is coated with black lacquer and decorated with mother-of-pearl inlay. The railing is inlaid with hard mother-of-pearl flowers and birds, such as peonies, lotus flowers, osmanthus flowers, golden pheasants, and magpies. The apron, legs, and feet are inlaid with mother-of-pearl peonies on branches.

This bed was produced in Shanxi. It goes with "Black Lacquer Canopy Bed Inlaid with Mother-of-pearl Flowers and Butterflies" (Picture 3) in a set.

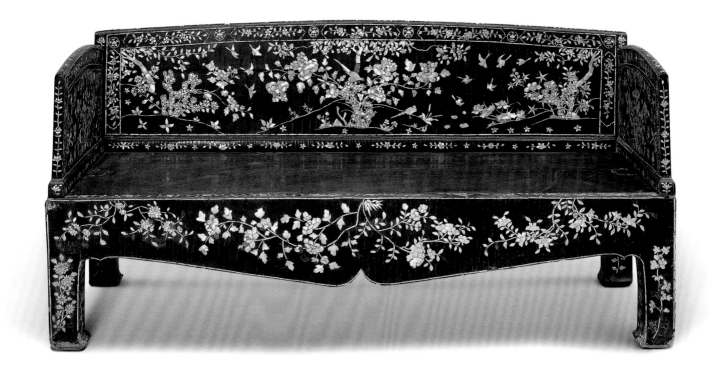

9

Yellow Rosewood Folding Bed

with Six Feet

Height 49 cm Length 208 cm
Width 155 cm

The surface of this bed has no railing. The large side is made into two parts, which are joined by metal hinges and are foldable. It has six legs, with the two legs in the middle being vase-shaped horse hooves. The upper part is an inserted shoulder joint, which closes up with the apron when unfolding. The four corners have cabriole legs and inward-curving hose-hoof feet. The bed, when folded, can be placed against the apron, which is carved with flowers on branches, birds, and two deer patterns. The legs and feet are carved with flower vases, caves, rocks, flowers, and grass.

The design of this bed is exquisite. It is easy to carry around and store, and its decorative patterns are typical of the Ming style.

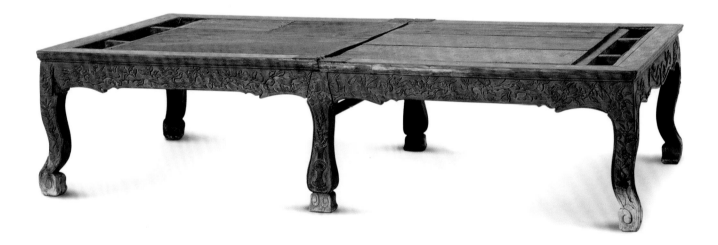

10

Carved Cinnabar Lacquer Throne
with a *Kui*-dragon Holding up the Character "*Shou*" (Longevity)

Height 102 cm Length 101.5 cm
Width 67.5 cm
Qing court collection

This throne has a stepped apron moulding, a vertical apron, a bulging leg, an outward-curving apron, and a leg with an inward-curving pearl, and it has a continuous floor stretcher under it to support it. Its top rail is decorated with patterns of curves, its rest openwork carving with a *kui*-dragon holding up the character "*shou*" (longevity), its armrests on both sides with openwork carving of *kui*-dragons, the frame of the surface of the throne, angular spirals, and its waist, continuous swastika characters (卍). The backrest, armrest, surface, legs, and apron of the throne are decorated with carved cinnabar lacquer peonies with entwining branches.

The carved cinnabar lacquer peonies with entwining branches are so dense that the ground is not exposed, which is the style of late Ming and early Qing.

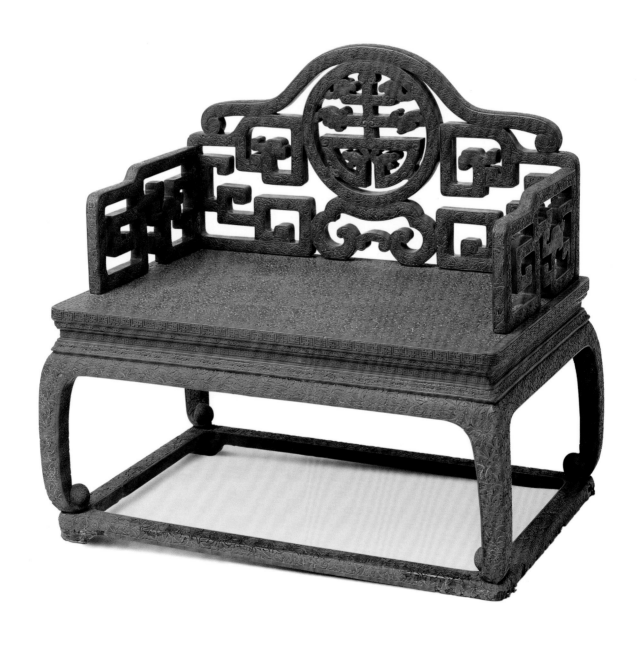

11
Yellow Rosewood Rose Chair
with Curling Tendrils

Height 83.5 cm Length 58 cm
Width 46 cm

Fixed on the empty space between the backrest and armrest of the chair is an arch-shaped apron with a pot-door-shaped opening, carved with curling tendrils, *ruyi* cloud heads, and its edges have raised beadings. Fixed on the surface of the chair is a pillar-shaped strut railing. Fixed on the upper part of the spaces between the legs is a humpback stretcher, with its upper end reaching the surface of the chair; the lower part has stepped chair stretchers, with the frontal, left, and right sides adding humpback stretchers.

"Rose chairs" are the lightest among all armchairs. They are called "rose chairs" in the north, but "writing chairs" in the south. The chair's backrest is not higher than the windowsill so that it can be placed near the window. The appearance of the chair is basically fixed, but the backrest, armrest, and the decorative parts under the surface of the chair have great varieties.

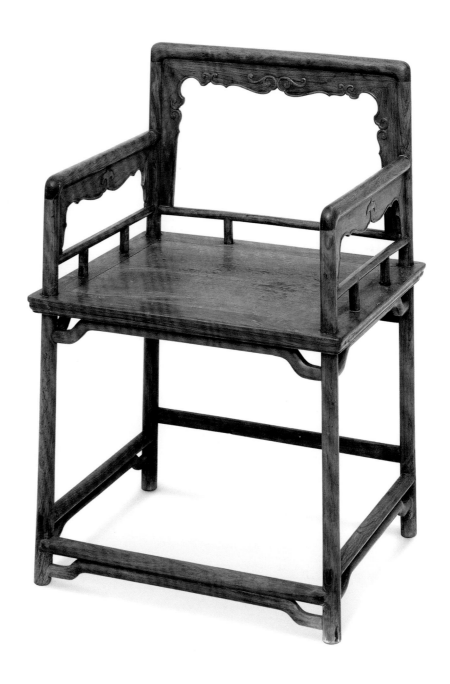

12

Yellow Rosewood Rose Chair
with Six *Chi*-dragons Holding up the Character *"Shou"* (Longevity)

Height 88 cm Length 61 cm
Width 46 cm

The backrest of the chair is a panel, carved in openwork with six *chi*-dragons holding up the character *"shou"* (longevity), under which is a round-shaped *chi*-dragon with decorative struts. Fixed under the cross beam of the armrest is an arch-shaped apron with a pot-door-shaped opening, carved in relief *chi*-dragons and angular spirals. This chair has round legs and straight feet. The base stretcher between the legs gradually rises from front to back, and is thus known as a "stepped chair stretcher", meaning "elevating step by step".

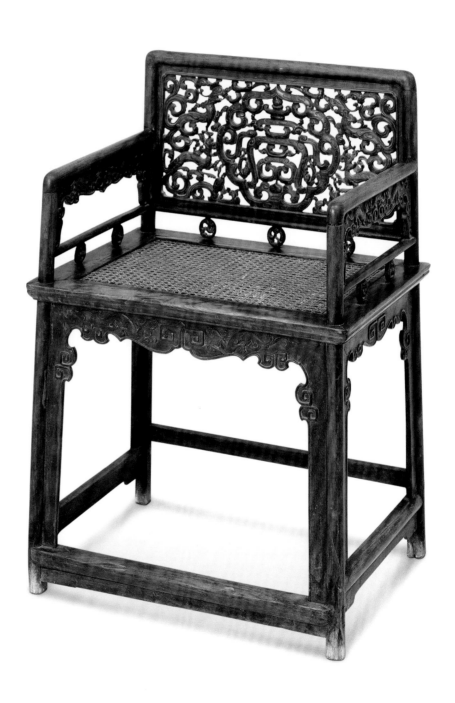

13

Yellow Roswood Rose Chair
with *Chi*-dragons in Openwork Carving

Height 80.5 cm Length 58 cm
Width 46 cm
Qing court collection

The backrest of this chair uses two posts as the frame, and the back panel has a side stretcher added to form a mortised-and-tenoned frame. The upper part is a rectangular medallion, the middle part, patterns of two *chi*-dragons with their tails touching each other carved in relief and coiling into clouds, and the lower part, cloud patterns with a brightening-the-feet opening. Fixed between the armrests on both sides is a railing, under which there is a pillar-shaped strut joining the seat of the chair. The seat is mounted with a hard panel. Fixed under the surface of the chair is the apron made of wood other than purple sandalwood, and between the legs, stepped chair stretchers.

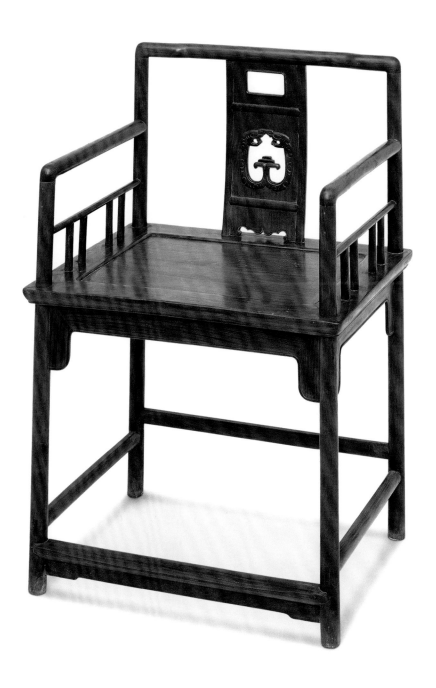

14

Yellow Rosewood Official's Hat Armchair
with Four Protruding Ends

Height 120 cm Length 59.3 cm
Width 47.3 cm

The middle part of the top rail of the armchair is protruded, and the ends are curved up. Fixed between the armrest and the surface of the seat are side posts. The intersection of the gooseneck and arms have spandrel supports. Fixed under the seat is a humpback stretcher, and the upper part is fixed with a pillar-shaped strut. Between the legs are stepped chair stretchers.

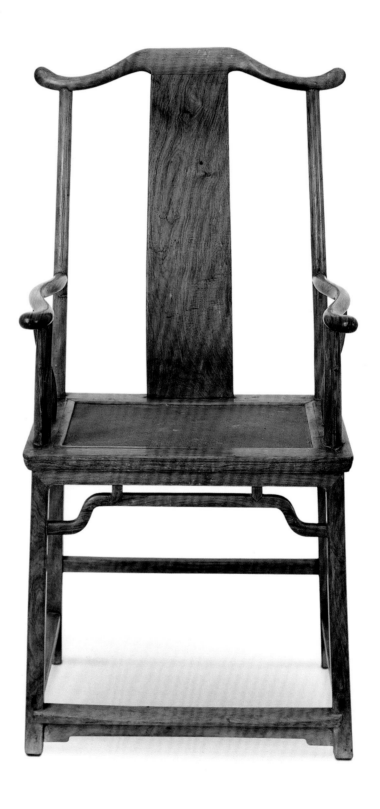

15

Yellow Rosewood Southern Official's Hat Armchair

with the Character *"Shou"* (Longevity) in the Shape of a Treasure Tripod

Height 109 cm Length 60 cm
Width 46.5 cm

The upper and lower ends of the backrest panel of the armchair are carved in openwork with *ruyi* cloud heads and vajra patterns respectively, and the middle part is carved the character "*shou*" (longevity) in the shape of a tripod. The armrest and the surface of the seat are joined by a pillar-shaped strut. The seat has a recessed panel. Fixed below the seat is an arch-shaped apron, carved with curling tendrils, and its edges have raised beadings. This chair has round legs and straight feet, and fixed between the legs is a stepped chair stretcher.

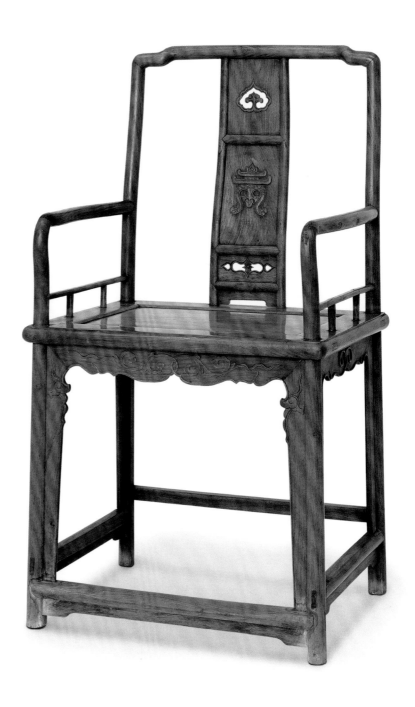

16

Yellow Rosewood Armchair
with a Curved Rest Decorated with *Chi*-dragons

Height 103 cm Length 63 cm
Width 45 cm

The curved rest of this armchair is arc-shaped, and this shape stretches from the top rail to both sides, through the rear side post downward, forming the armrest. The back panel bends slightly backward, forming a slanting angle of the back, which gives a feeling of comfort. Carved in full on the back panel are double *chi*-dragons. The posts on the four corners and the legs are joined by a piece of timber, forming "S-shaped" side posts. The seat of the chair is rattan. Fixed under the surface is an arch-shaped inner frame with a pot-door-shaped opening, carved with curling tendrils. The four legs are splayed, known as "the sides are contracted and the centre is splayed" (cejiaoshoufen), which enhances the stability of the armchair. Fixed between the legs are stepped chair stretchers.

Armchairs with curved rests were common in the Ming Dynasty. They developed from folding chairs, and this can be seen from the upper part of the chair.

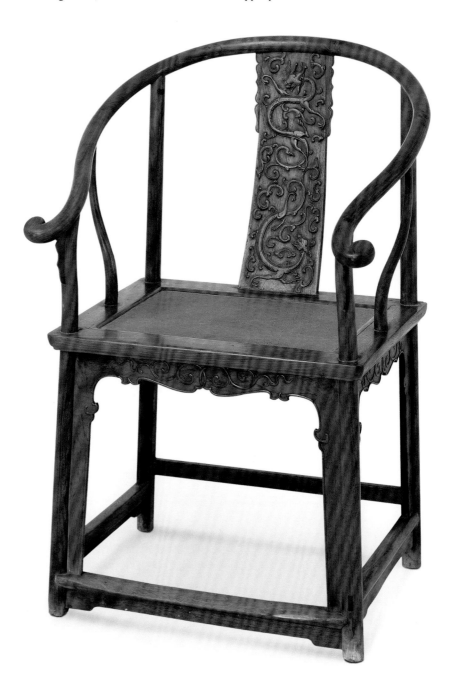

17

Purple Sandalwood Armchair
with a Curved Rest in a Scrolled Book

Height 101 cm Length 73 cm
Width 59 cm
Qing court collection

The back panel of the armchair is higher than the curved rest, and the top rail is scrolled like a book. The four legs have their sides contracted and the centre splayed. Fixed on the upper part of the legs of the armchair is a humpback stretcher, linked with the seat of the armchair by two decorative struts, and the lower part is fixed with a stepped chair stretcher. Fixed on the front side of the pedestal is an apron.

The shape of this armchair is full of changes. The protruding backrest board is very special, representing a creative piece of work amongst armchairs with curved rests.

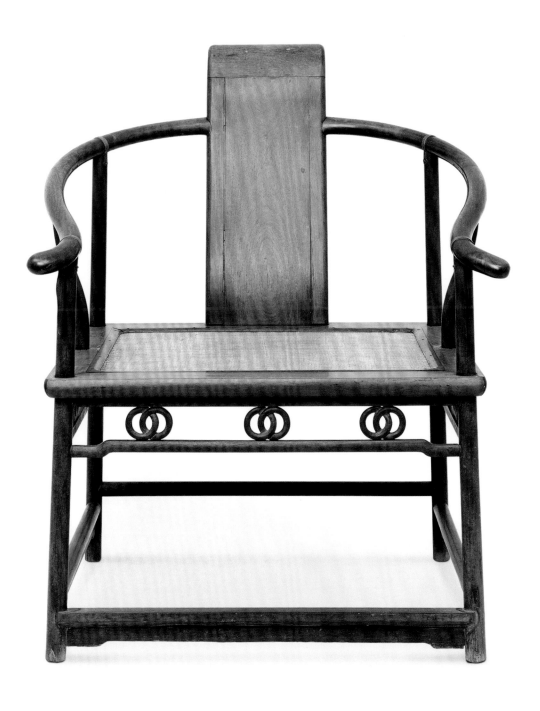

18

Yellow Rosewood Armchair
with a Curved Rest Decorated with *Ruyi* Cloud Heads

Height 100 cm Length 61.3 cm
Width 49 cm

The rest board of the chair is designed in an "S" shape based on the natural curve lines of the back of a human body. Carved on the upper part of the back board are *ruyi* cloud heads, and the lower part is carved with an arch-shaped inner frame with a pot-door-shaped opening and a brightening-the-feet opening. The part which connects the post on the seat and the curved rest is inlaid with curved-edge aprons. This chair has round legs and straight feet, and the spaces between the legs form an arch-shaped inner frame with a pot-door-shaped opening and three aprons carved with flowers. The apron under the base stretcher is also made into the shape of a pot-door-shaped opening.

Armchairs are a kind of costly seats. The decorations of aprons of this chair are quite exquisite.

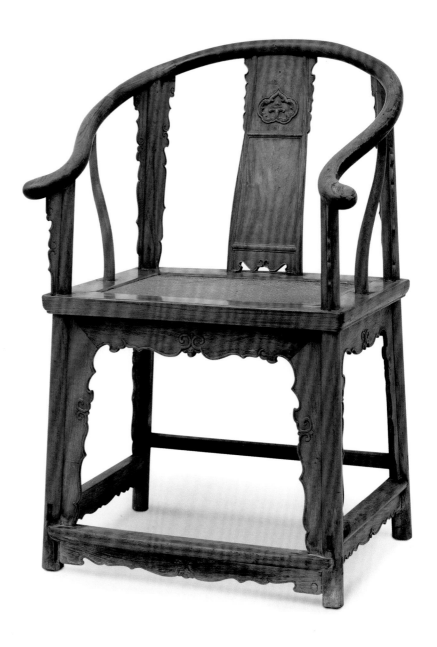

19

Yellow Rosewood Armchair
with a Curved Rest Decorated with Chinese Unicorns (*qilin*)

Height 103 cm Length 59.5 cm
Width 49 cm

The backrest of the chair has a round medallion which are carved in openwork with Chinese unicorns (*qilin*). The connected part of the backboard and the curved rest and the head of the armrest are decorated with small aprons. The side posts of the armchair are shaped like the handle of a sickle. The surface of the seat is a wooden plank which is glued with a straw mat. Fixed on the three lower parts of the surface of the seat are arch-shaped aprons, and carved on the aprons are curling tendrils. The chair has round legs and straight feet.

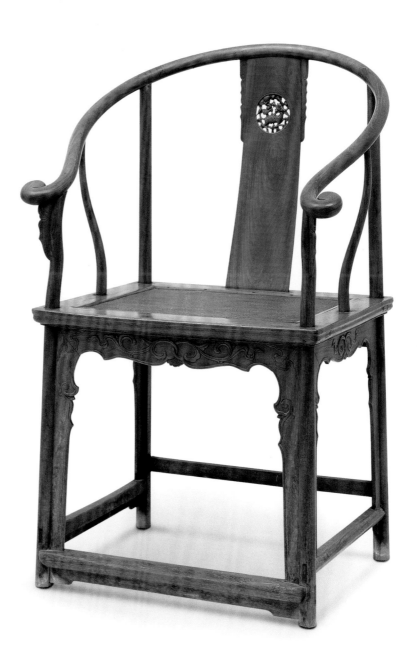

20

Yellow Rosewood
Folding Chair

Height 104 cm Length 69.3 cm
Width 47.5 cm

The splat of this folding chair is slightly curved, on which are carved *ruyi* cloud heads. The turn-around place of the rear leg has spandrels filling with two *chi*-dragons to brace it. The soft mat of the surface of the seat is made of silk strings, and there is a footstool under the chair

The folding chair is called as such because its crossing legs can be folded and it was popular during the Ming Dynasty. This is a typical folding chair of the Ming Dynasty. The intersecting parts of the chair and the surface of the footstool are strengthened by iron decorations.

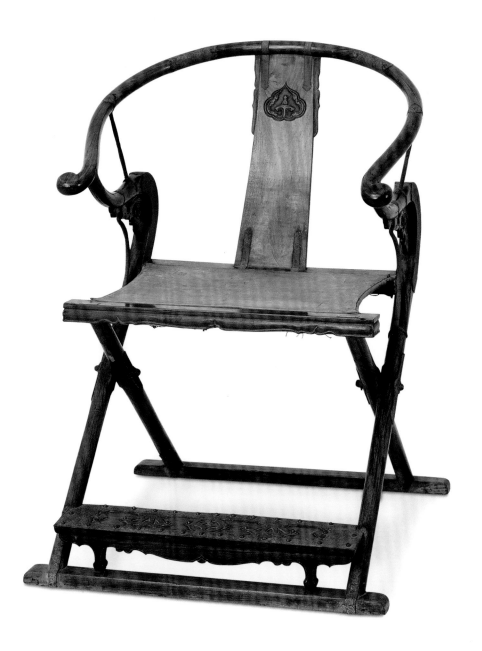

21

Yellow Rosewood Hexagonal-seat Chair

Height 83 cm Length 78 cm
Width 55 cm
Qing court collection

The surface of this chair is hexagonal. The backboard is divided into three sections to join frames and assemble mortised-and-tenoned frames. The upper section has *ruyi* cloud heads carved in openwork, the middle section is bright and simple, and the lower part has clouds to brighten the feet. The top rail, arms of the chair, the upper section of the legs and feet, and the side posts of the armchair have melon-shaped mouldings. Double convex mouldings with flat edges of a moulding are used for the surface of the seat. Under the surface are corresponding six legs and feet, whose external sides have melon-shaped mouldings. The base stretcher is made of split mouldings.

This chair is a variation of the southern official's hat armchair and is usually found in a set of four. As it is hexagonal and its arms are splayed, the chair looks dignified and magnanimous, and these chairs are normally placed in symmetry in a sitting hall.

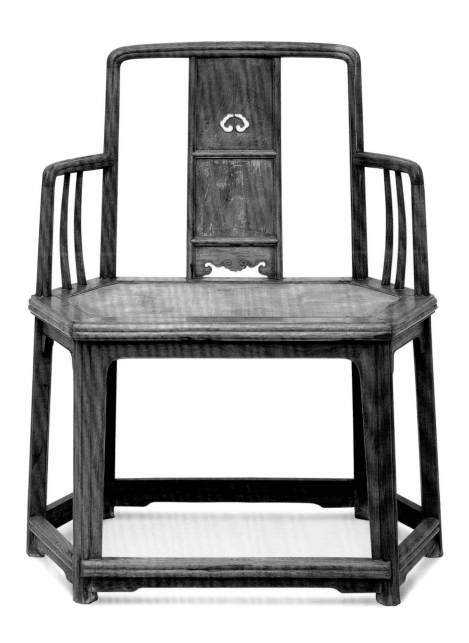

22

Large Yellow Rosewood Square Rattan Stool

Height 51 cm Length 63 cm
Width 63 cm
Qing court collection

The four corners of the surface of the seat of this square stool are joined with the frames, and the heart is inlaid with a soft mat, with two arc-shaped stretchers supporting from below. The edges of the apron under the surface have raised beadings, and cloud patterns are carved out on the apron-head spandrel. The four legs are sprayed, externally round and internally square, each of them having raised beadings to create two convex mouldings. The ends of the humpback stretchers between the legs form the shape of scrolling clouds, with the middle part slightly concave downward, assuming the shape of a bow.

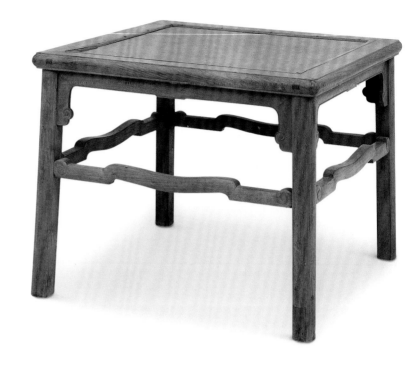

23

Large Purple Sandalwood Square Stool

with a Lacquer Core

Height 49.5 cm Length 63.5 cm
Width 63.5 cm
Qing court collection

This square stool has purple sandalwood as its frame, which is inlaid with a core board, the face of which is coated with black lacquer. The frames on the four sides of the surface of the seat are linked to the stool legs with a mortise-and-tenon joint, and the middle part of the frame droops to form the shape of a fish's belly. The lower ends of the legs are splayed to form four splittings and eight splays. Fixed between the legs is a humpback stretcher, with inward-curving horse-hoof feet.

Judged by the shape and craftsmanship of this stool, it is a typical piece of Ming furniture, and it should belong to the late Ming period.

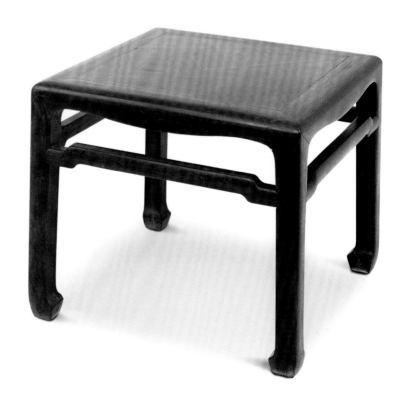

24

Purple Sandalwood Square Stool
with Bulging Legs and Outward-curving Aprons

Height 51 cm Length 57 cm
Width 57 cm
Qing court collection

The four sides of the surface of the seat of this square stool are joined with the frames, and this stool is inlaid with a core board with a floating panel with raised centre and recessed sides. Under the surface are a concave-moulding waist, bulging legs, and an outward-curving apron. The middle of the apron has concave mouldings and a concave belly, and fixed on the place between the legs and their included-angle intersection are spandrels with cloud patterns and inward-curving horse-hoof feet.

The making of this stool is elegant and skilful. The curved lines of the arc of its legs look slightly exaggerated, and more materials were thus used. This is the way Guangdong furniture is made, and this is also the style of Ming furniture.

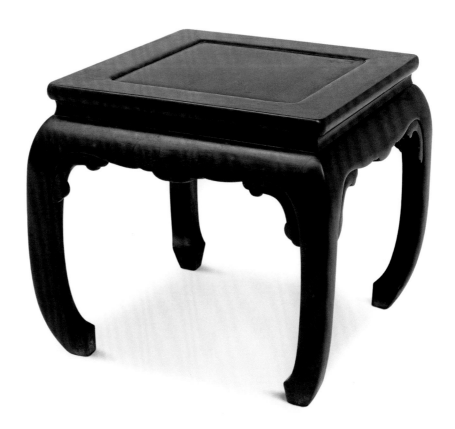

25

Red Lacquer Round Stool

Inlaid with an Enamel Surface Decorated with Dragons Chasing a Pearl

Height 44 cm Diameter 42.5 cm
Qing court collection

The entire body of this round stool is coated with red lacquer, and the surface of round seat of the stool has an enamel core decorated with two dragons chasing a pearl. It is waisted under the surface and is inlaid with an ornamental panel, which has, on its upper part, a rectangular medallion, and on its lower part, a stepped apron moulding. It has bulging legs, outward-curving aprons, an apron with a pot-door-shaped opening, and inward-curving feet decorated with scrolling clouds, which step on a round pearl below, and are supported by a continuous floor stretcher below.

Round stools originated from hourglass-shaped (*quanti*) stools of the periods of Han and Wei. They gradually evolved into things to sit on. They were most popular during the Ming and Qing periods and were used mainly in sitting rooms in combination with round tables.

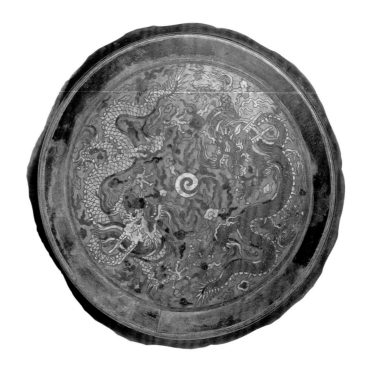

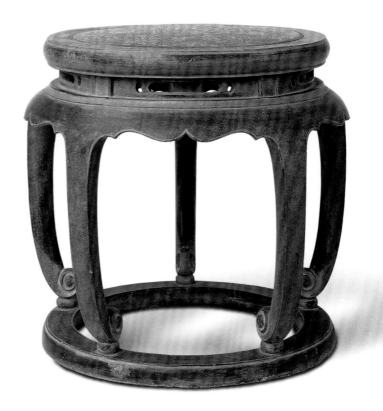

26

Round Stool Sprinkled
with Mother-of-pearl
Inlaid with an Enamel Surface Decorated
with Two Dragons Chasing a Pearl

Height 41 cm
Diameter of Surface 42.5 cm
Qing court collection

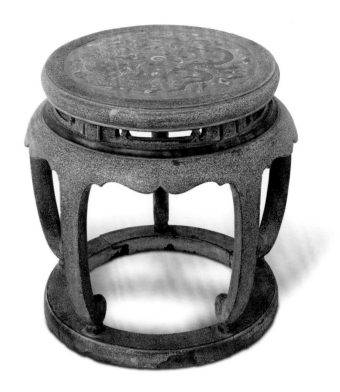

The entire body of this round stool is coated with red lacquer, which is sprayed with mother-of-pearl as decoration. The heart of the surface of the seat is inlaid with round cloisonné enamel with two dragons chasing a pearl. Under the edges of the surface are raised beadings. The stool is waisted, and inlaid, section by section, with ornamental panels and decorated with, between sections, indented corner rectangular medallions. Under its waist are an apron with a pot-door-shaped opening, a circle formed by an apron and a leg line, and an inward-curving toe, resting on a round continuous floor stretcher.

27

Yellow Rosewood Folding Stool

Height 55.5 cm Length 66 cm
Width 29 cm
Qing court collection

Blue velvet is used to knit the soft mat with angular spirals on the surface of the seat of the campstool. Touching the floor are two transverses with a flat and broad base. The places where the transverses appear, gold-foil leaves are used to wrap the legs and are strengthened with nails. Washers are padded on the places where the metal pivots pierce through the rivet.

Folding stools, known as *ma zha* and also called *jiao wu*, were known in ancient times as "barbarian seat" (*hu chuang*). They are foldable and easy to carry about.

28

Purple Sandalwood Sedan Chair
with *Kui*-dragons

Height 107.5 cm Length 64 cm
Width 58 cm
Qing court collection

Hanging on the backrest board, gooseneck front posts, and side posts of the sedan chair are aprons with decorations of *kui*-dragons. Under the backrest board is a brightening-the-feet opening, and the three sides have ornamental panels with four sections inlaid with firecracker-shaped openings. The surface of the seat is fixed with rattan. It has a high waist under the surface of the seat, which is the place where carrying poles are held, and the waist is fixed with ornamental panels. The tip of the foot stamps on a high-waisted rectangular stand. The surface of the seat, waist, and four sides of the stand are inlaid with gilded copper corner plates.

Sedans were a means of transportation for rich families. The front and rear each have a person carrying the sedan with poles, with the master sitting in the sedan.

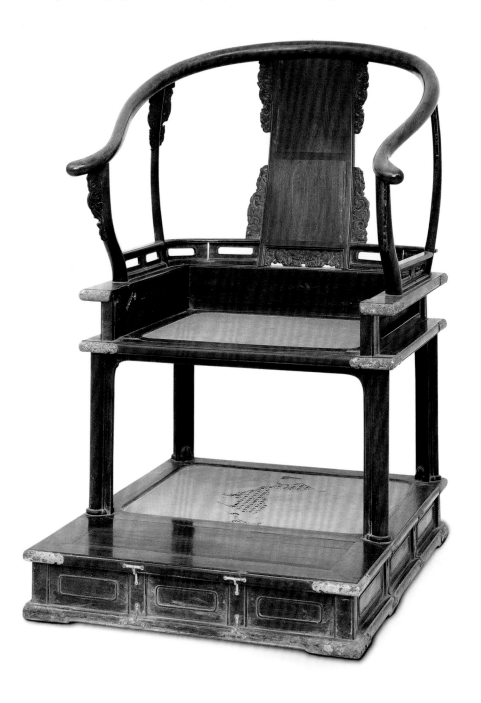

29

Embroidery Stool
with Clouds and Dragons
in Underglaze Blue

Height 33.8 cm
Diameter of Surface 21.2 cm

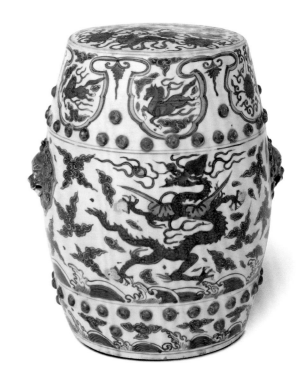

This embroidery stool is made of ceramic. The surface of the seat is painted with lions playing with an embroidery ball. Decoration of the belly has three levels: the high level has patterns of heavenly steeds soaring across the the sky and lotus flowers, the middle part is decorated with a dragon chasing after a flaming pearl amidst clouds, and the lower level has patterns of sea water and clouds.

This embroidery stool is drum-shaped, and this is why it is also called the "drum stool". The name "embroidery stool" is frequently seen in the archives of the Qing Dynasty, referring to the embroidery mat that was used on a seat. The embroidery stools of the Ming Dynasty are relatively large and rough, while those of the Qing Dynasty tend to be slim and long.

30

Embroidery Stool
with a Dragon Chasing a Flaming Pearl
in Underglaze Blue

Height 37.8 cm
Diameter of Surface 20.5 cm

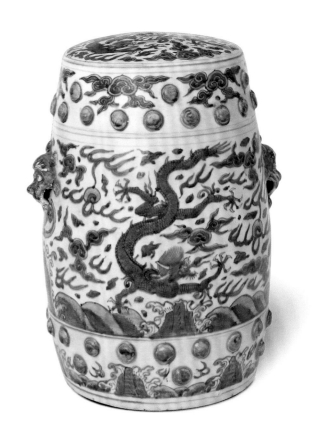

This embroidery stool is made of ceramic. The surface of the seat is painted with two dragons chasing a flaming pearl. The belly is carved in three levels: the upper level has clouds, the middle level has a dragon chasing a flaming pearl, and the lower level has sea water and cliffs.

31

Yellow Rosewood Banquet Table
with Copper Corner Plates

Height 40.5 cm Length 159 cm
Width 89 cm
Qing court collection

The four sides of the surface of the table has water-stopping mouldings, and the four corners have copper corner plates. Under the surface is a high waist, and the upper parts of the table legs are exposed at the four corners. The two sides are decorated with raised beadings, and under the stepped apron moulding are edges. The apron with a pot-door-shaped opening, cabriole legs, the flowery apron carved on the inside of the apron and legs, and the edges of the inner sides are all connected by raised beadings. This table has square-bucket feet, which rest on the pearl below for support.

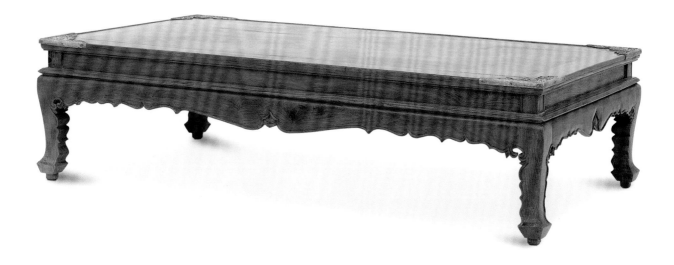

32

Yellow Rosewood Leg-encircling Long Table

Height 71 cm Length 111 cm
Width 54.5 cm

The edge of the surface of the table and the apron forms a unity, and split mouldings are used to encircle the legs. It has round legs and straight feet. Fixed between the spaces of the legs is a leg-encircling humpback stretcher, the upper part of the stretcher support the apron, and it also forms the entity with split moulding aprons.

The way of decorating this table is unique, and the use of the leg-encircling split moulding to make the apron stretcher gives it an effect similar to that of bamboo and rattan furniture.

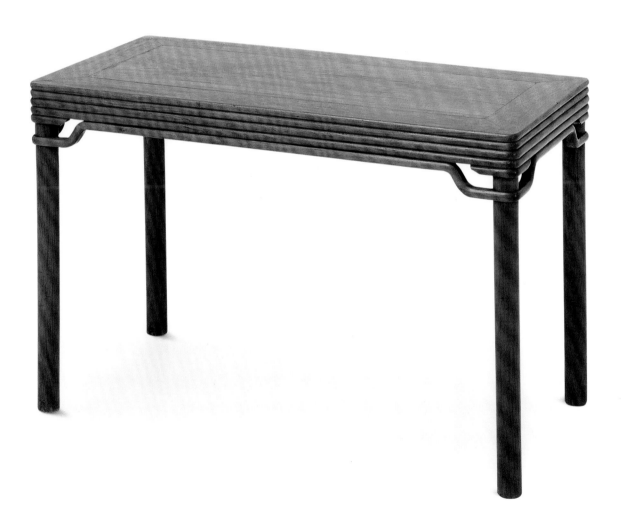

33

Yellow Rosewood
Square Table
with Plum Blossoms

Height 86 cm Length 93.5 cm
Width 91.5 cm

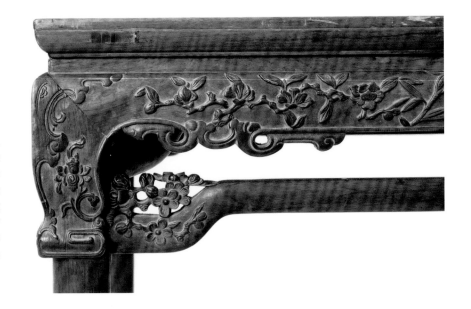

The table is waisted under the surface. The straight apron is carved with plum blossoms in relief, with the two ends carving out flowery aprons. The four legs are extended, with the upper part being spandrel cabriole legs with outward-curving horse-hoof feet, and the lower part columnar legs. Fixed between the legs are humpback stretchers, the ends of which are carved with plum blossoms in relief.

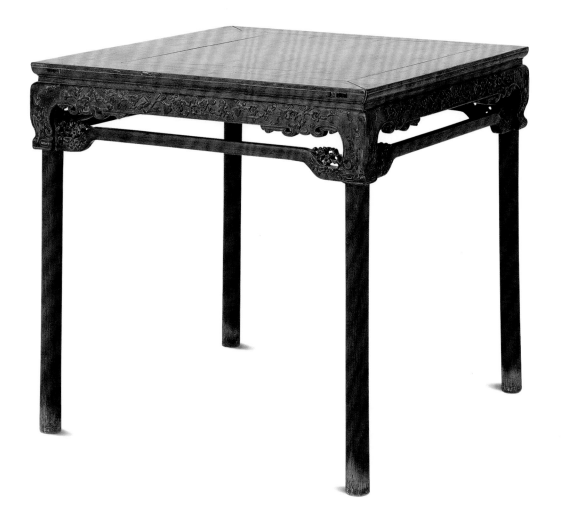

34

Yellow Rosewood Square Table
with Cloud Heads

Height 86 cm Length 90 cm
Width 90 cm

The surface of this table has a protruding top. Fixed under the surface is an apron, and the four corners have spandrels, which directly combine with the upper ends of the table legs. Fixed under the apron is a humpback stretcher. All these are known as "a humpback stretcher with three spandrels to one leg". The apron-head spandrel is carved with curling tendrils, and the humpback stretcher is carved with a small curved and pointed section. Fixed on the stretcher is a decorative strut with cloud heads. The edges of the apron and stretcher have raised beadings. The legs and feet have edges and segments, forming four split moulds.

The decoration of this table is exquisite and simple. The shape of "a humpback stretcher with three spandrels to one leg" was a popular design of the square tables in the Ming Dynasty. What is known as "*pen mian*" (protruding top) refers to the edges of the four sides of the surface of the table, which are broader than the legs of the table.

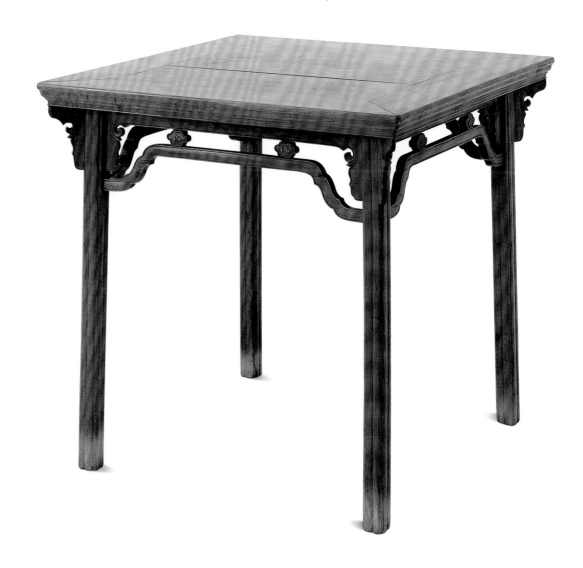

35

Yellow Rosewood Square Table

Height 70 cm Length 82 cm
Width 82 cm
Qing court collection

The edge charges of the surface of the table are rather wide. Under the ice-plate edges are raised beadings. There are three aprons and spandrels at the joining point of each table leg and the surface, which is called "three spandrels to one leg" (*yituisanya*). The table has round legs and straight feet, with obvious contraction of the sprayed legs. Fixed between the legs is a high humpback stretcher, and the upper horizontal edges of the stretcher are closely joined by the apron.

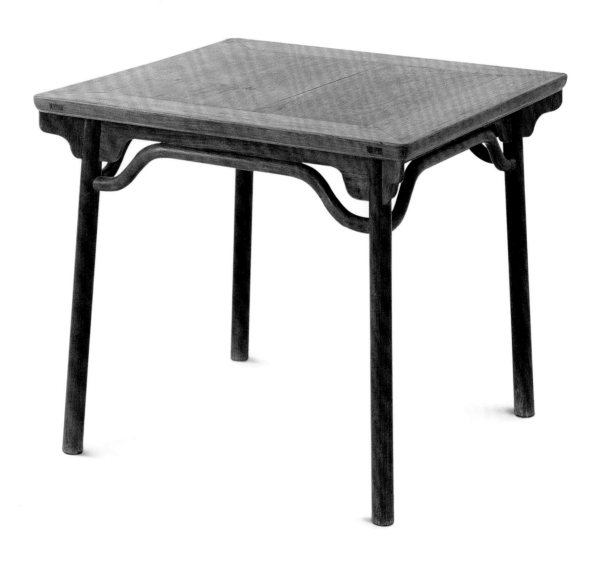

36
Yellow Rosewood *Kang* (Heatable) Table

Height 31 cm Length 57 cm
Width 39 cm

The surface of the table is joined by the frame. The apron-head spandrel and apron under the surface are made from a single piece of wood. The apron-head spandrel is larger and is carved with cloud-head flowery aprons and rolled flowers. The four legs are sprayed and contracted. The legs and aprons are of an elongated bridle joint structure. Fixed between the legs are single side stretchers, and the two ends of the stretchers are longer than the table.

The structure and workmanship of this table are simple, which is typical of the Ming style furniture.

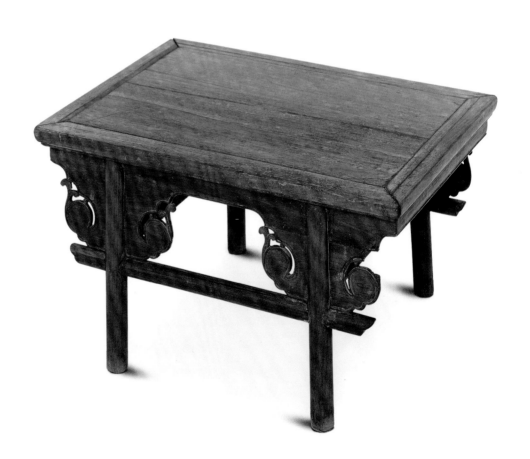

37

Purple Sandalwood Long Table

Height 88.5 cm Length 231 cm
Width 69 cm

The surface of the table is a protruding top, under which is a waist. It has a humpback stretcher joint and lattice apron, above which there are pillar-shaped struts to block out empty spaces. It has straight legs and square feet, and inward-curving horse-hoof feet. The edges of the surface, apron, legs, and feet are decorated with lines of concave mouldings

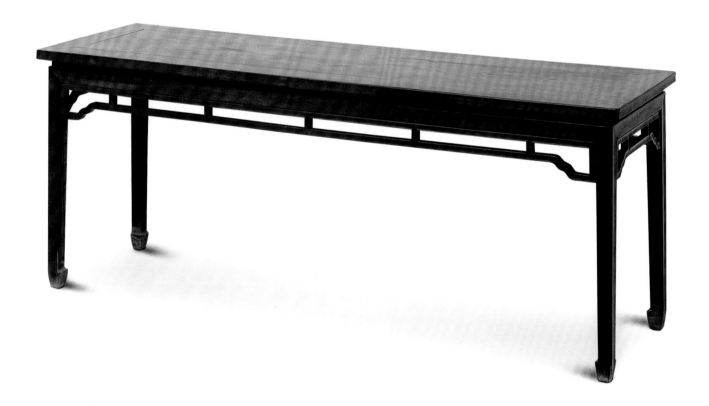

38

Purple Sandalwood Protruding-top Square Table

Height 86 cm Length 92 cm
Width 92 cm

This square table has purple sandalwood for its frame. A variety of materials are used for the frames of the surface of the table. The inner sides have grooves, carved with birch and burl wood at the core of the surface. The outside edges of the surface of the table are flat and straight. There is a waist under the surface and a hidden drawer in the middle of each side. It has a straight apron, under which a humpback stretcher and a pillar-shaped strut are fixed. This table has a square leg right down and inward-curving horse-hoof feet. Members such as the legs, feet, and stretchers are all decorated with concave mouldings.

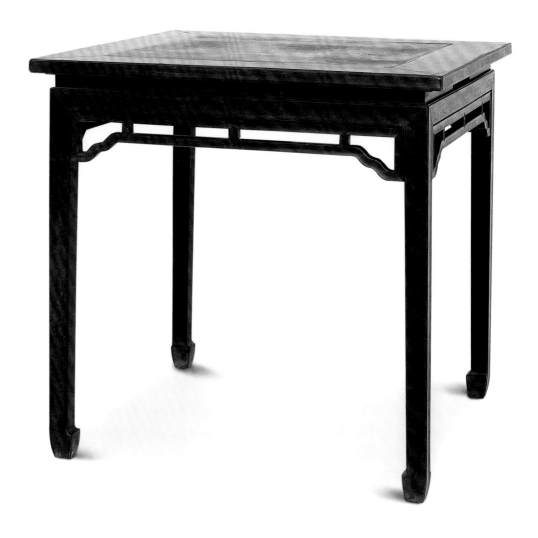

39

Black Lacquer Chess Table
with Three Linked Panels on its Surface

Height 84 cm Length 84 cm
Width 73 cm
Qing court collection

This chess table is on a table surface with three linked panels on loose tenons. There is a protruding humpback stretcher style apron under the surface. The middle of the surface is a removable centre board, and a go chessboard with a black ground and red crosses can be seen when the board is opened. On both sides of the board are a go box with a lid, which contains pieces of go made of black and white glass. Under the chessboard, there is a square trough, which has two drawers in which there are wooden boxes containing 24 pieces of Chinese dominoes carved in jade, 32 pieces carved in bone, two sets of dice in bone, two sets of paper chips, one set of dice chips, one set of wooden knives and tweezers each, and two strings of tin money.

There were tables specially made for playing go during the Song and Yuan periods. Chess tables with such a new structure and exquisite workmanship are unprecedented.

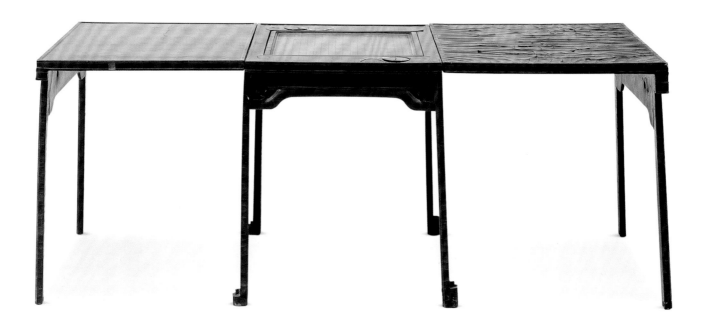

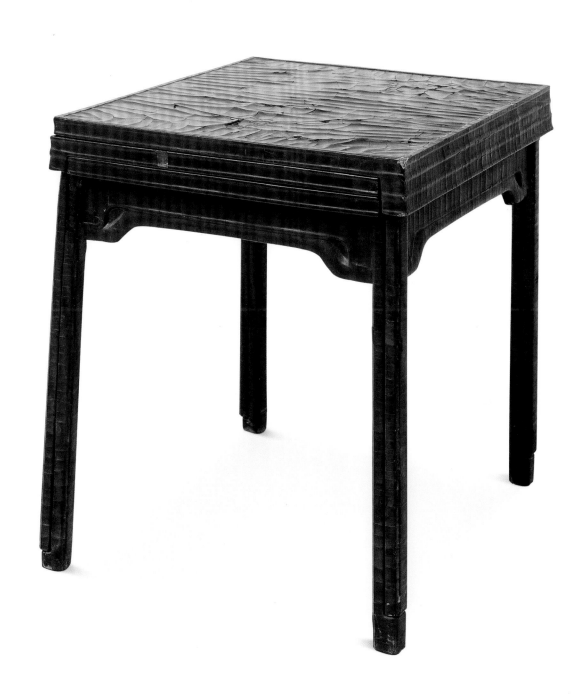

40

Filled Lacquer Lute Table

with Engraved Gold (*Qiangjin*) Designs of Clouds and Dragons

Height 70 cm Length 97 cm
Width 45 cm
Qing court collection

The surface of this table is rectangular. It is waisted under the surface. It has an apron with a pot-door-shaped opening, straight legs, and inward-curving horse-hoof feet. In the rectangular medallion on the middle of the surface of the table is a ground of black checks with brocade patterns, decorated with two dragons chasing a flaming pearl engraved in gold, and setting off on the four sides are carved and painted bright clouds and aprons. The edges of the surface on the four sides are lozenge-shaped medallions, and clouds and dragons are decorated on the engraved gold checks with brocade patterns. The edges on the sides are decorated with clouds filled with colours, the waist is decorated with patterns of flowers on the branches engraved in gold and filled with colours, and the apron side board is decorated with two dragons chasing a flaming pearl engraved in gold. The surfaces of the legs are decorated with dragons chasing a pearl engraved in gold and filled with colours, and the spaces in between are decorated with a brocade ground with black swastika (卍) checks. The interior sides of the legs are a plain ground filled with patterns of colourful clouds. Below the table is the back in plain black lacquer, separated from the surface by a gap, which has a voice box with carved out coins fixed to it.

The decorations of this Chinese lute table are magnificent. The back of the table has a voice box, which enhances the sound effect of the Chinese lute. This design is scientific.

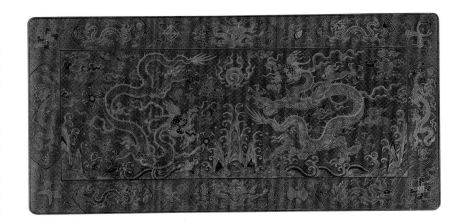

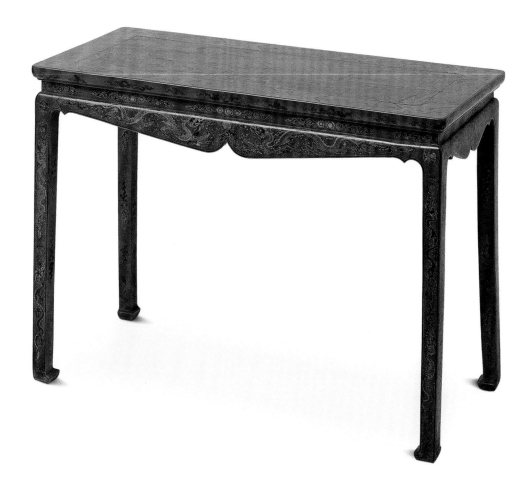

41

Plain Black Long Table Sprinkled with Mother-of-pearl and Two Dragons Chasing a Pearl

Height 79.5 cm Length 111 cm
Width 79 cm
Qing court collection

The surface of the table is rectangular. The apron with a pot-door-shaped opening and the legs are of an inserted shoulder joint structure. Their edges form a continuous flow. The four legs are splayed, the side angle is contracted, and it has square copper horse-hoof feet. Fixed between the side surface and the two legs are two side stretchers. The entire body of this long table is decorated with black paint sprinkled with mother-of-pearl. On the apron and the legs of the table are patterns of gold-coated double dragons chasing a pearl. The penetrating transverse brace at the bottom part of the table has the words "made in the Wanli years of the Ming Dynasty", cut by knife in regular script.

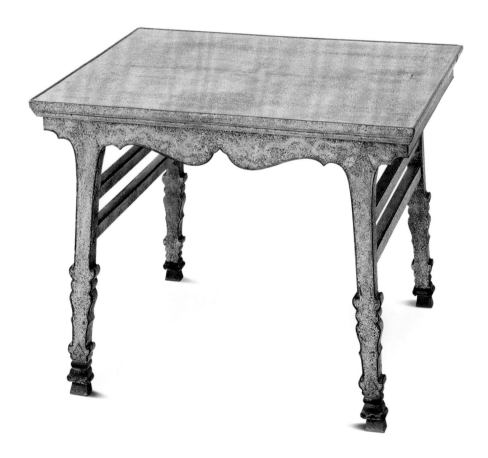

42

Yellow Rosewood Flat-top Narrow Recessed-leg Table

Height 78 cm Length 92.5 cm
Width 52.5 cm
Qing court collection

The edges of the surface of the table have water-stopping mouldings, and the side edges with a convex surface have double-side mouldings. The apron under the surface of the table, the apron-head spandrel, the leg-protection aprons on both two sides of the legs are of the double-mitred tenon combination, and the head of the apron is carved into the shape of scrolling clouds. Fixed between the side surfaces and the two legs are double side stretchers. The four legs are sprayed, and the side feet are contracted. Rising from the middle of the leg surface are two-incense-stick beadings, the two sides have convex surfaces, and the edges of the sides also have convex mouldings, thus forming two groups of convex-surface double edge beadings, echoing the side edges of the surface of the table.

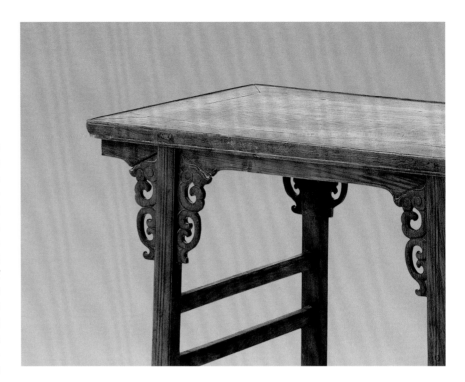

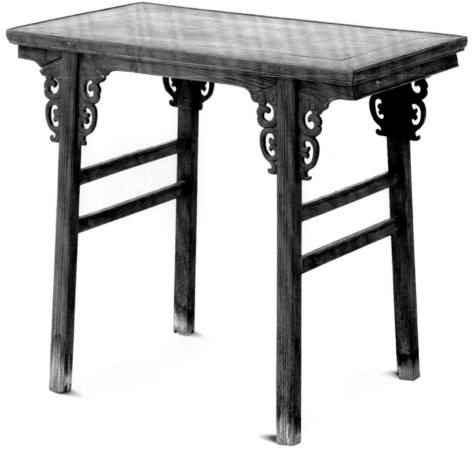

43

Yellow Rosewood Flat-top Narrow Recessed-leg Table

with *Kui*-phoenixes

Height 84 cm Length 168.5 cm
Width 51.5 cm
Qing court collection

The surface of this table has ice-plate edges, and the lower part has convex mouldings. The apron and apron-head spandrels are made from one single piece of timber. The apron-head spandrel has *kui*-phoenixes carved in openwork, which joins with the edges of the apron with raised beadings, and this has an elongated bridle joint structure. Fixed between the spaces of the two sides of the legs are roundwood double side stretchers.

This table is plain and neat, making the decorations on the apron stand out more prominently.

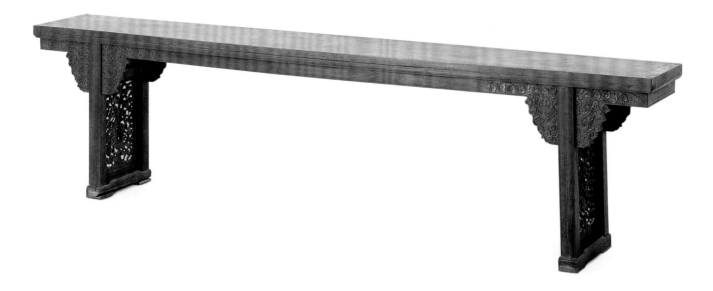

44

Purple Sandalwood
Flat-top Narrow Recessed-leg Table
with Curling Tendrils

Height 91.5 cm Length 305 cm Width 64 cm
Qing court collection

The surface of the table is made up of pieces of boards pasted together. The apron under the surface pierces through the legs of the table and forms a continuous flow with the apron stops, and above the surface are carved curling tendrils and phoenixes. The place where the apron intersects with the legs is an apron-head spandrel. The upper ends of the table legs have troughs, holding the apron-head spandrels to join with the surface of the table, which is known as a "chuck tenon". The front sides of the legs of the table have double convex surface edge mouldings, and their side has two side stretchers, one above and the other below, joining each other and creating two checks, all of which are fixed with an ornamental panel with *chi*-dragons. It has a continuous floor stretcher below for support.

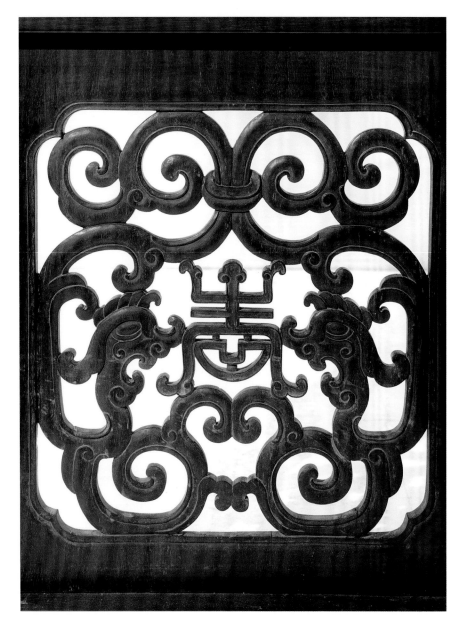

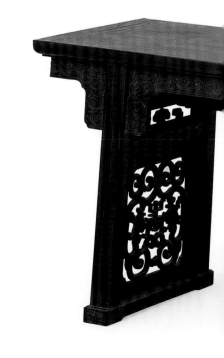

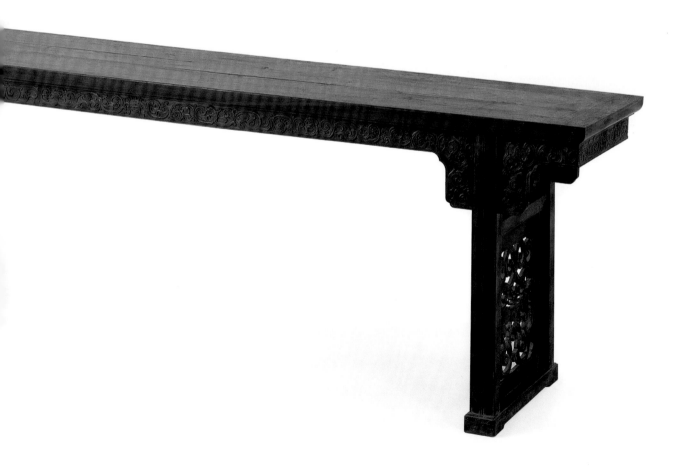

45

Rosewood
Recessed-leg Table
with *Kui*-phoenix Patterns

Height 91 cm Length 225 cm
Width 53 cm

Qing court collection

The two ends of the table have everted flanges, and the side edges have concave mouldings. The apron and apron-head spandrel are made of one piece of timber. The apron-head spandrel has a *kui*-phoenix carved in openwork, and the apron and legs form a chuck tenon structure. The legs are square and straight. Their front sides are carved with double leather-strip mouldings, and an ornamental panel is inlaid in the space between the two sides and the legs, decorated with a *kui*-phoenix carved in openwork. The feet stand on a continuous floor stretcher, and there is a small pot-door-shaped opening under the stretcher.

This table, though made in the Ming Dynasty, was still used in the Qing Dynasty. According to the archives, it had for a time been placed in the Chonghua Palace.

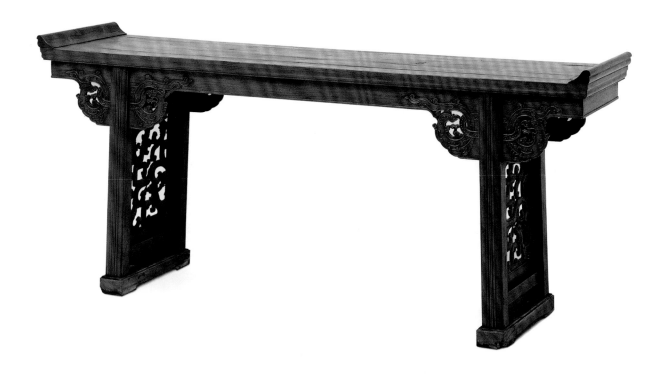

46

Yellow Rosewood Recessed-leg Table

Height 80 cm Length 120 cm
Width 41 cm

The surface of the table has everted flanges. The aprons and the chuck tenon structure of the legs of the table intersect. The apron joins the apron stops to form a loop, and the apron-head spandrel is carved into the shape of a cloud head. The straight legs are splayed, and its side corners are contracted and decorated with three leather-strip mouldings and double convex surface edge beadings. Fixed between the two sides of the legs are two stretchers.

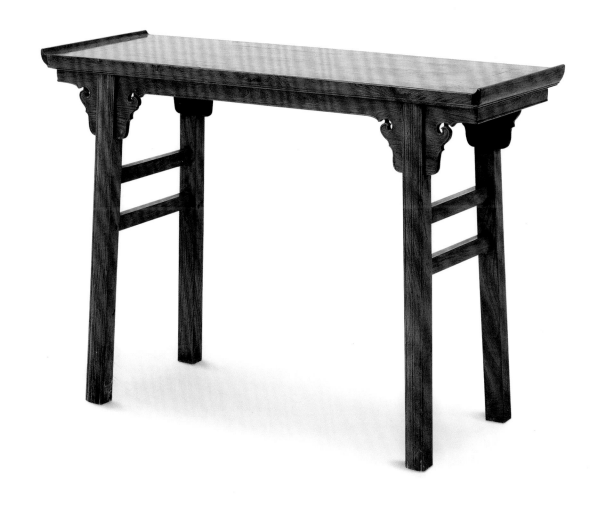

47

Ironwood Recessed-leg Table
with *Chi*-dragons

Height 84 cm Length 217 cm
Width 38 cm

The surface of the table has everted flanges. The apron is carved in relief with *chi*-dragons and angular spirals, and the apron-head spandrels are carved in relief with *chi*-dragons. The spaces between the two legs have two side stretchers. The space between the two stretchers are decorated with sihe inner frame medallions. Under the bottom stretcher are dividing-the-heart flowery aprons. The feet of this table are splayed.

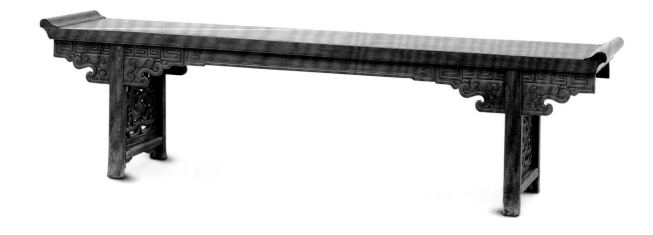

48
Purple Sandalwood Flat-top Narrow Recessed-leg Table

Height 86 cm Length 236 cm
Width 42 cm

The surface of the table has joined frames and panels, and its side surface has ice-plate edges. It is waistless under the surface, and the long apron is closely connected to the surface of the table. The two ends of the apron have apron-head spandrels with clouds. The table has round legs and straight feet, with its side corners contracted. The upper parts of the legs have troughs, which are joined with the surface of the table with elongated bridle joints. Fixed on the spaces between the two legs of the side surfaces are two side stretchers.

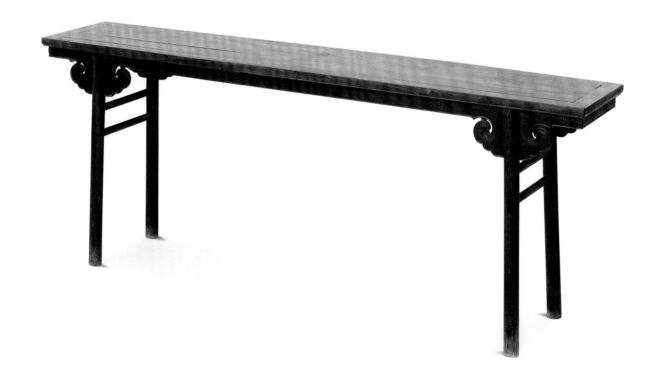

49

Black Lacquer Recessed-leg Table
Inlaid with Mother-of-pearl and Flowers and Butterflies

Height 82 cm Length 260 cm
Width 56.5 cm

The surface of the table has everted flanges at its two ends, and the apron-head spandrels have carved out *ruyi* cloud heads. The four legs are thick and strong, slightly splayed and contracted. The surface of the table is inlaid with mother-of-pearl. The middle of the surface is a lozenge-shaped medallion, whose two sides have a hexagonal medallion inlaid with peonies and butterflies as decorations inside. The edges of the surfaces, the apron, and legs and feet are inlaid with hard mother-of-pearl and flowers on branches as decorations.

This kind of hard mother-of-pearl furniture has thicker paint and belongs to mother-of-pearl inlay lacquer ware in lacquer craftsmanship, and it is a piece of work produced in Shanxi in the Ming Dynasty.

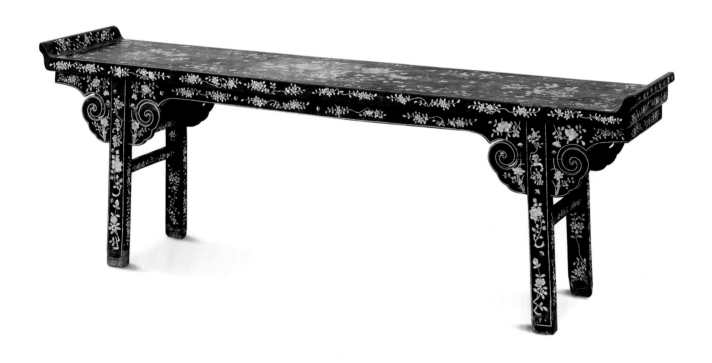

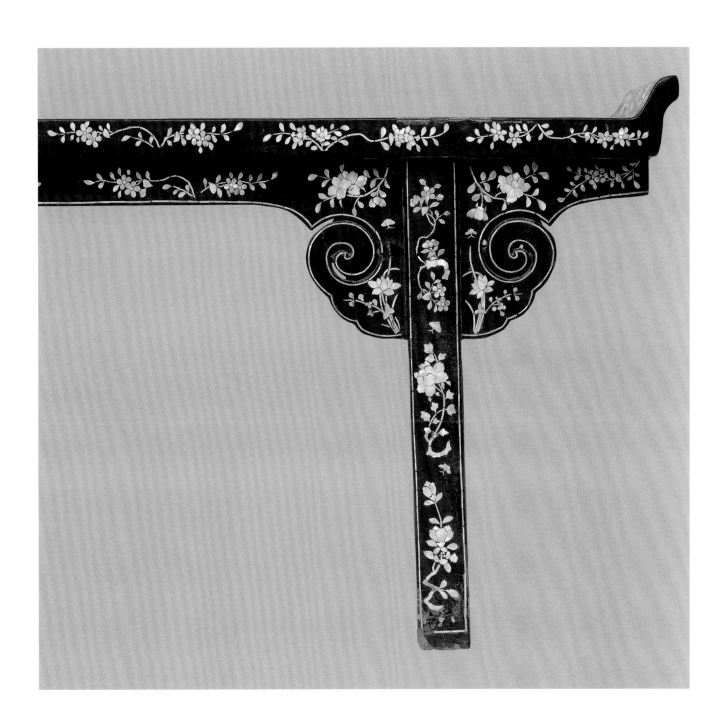

50

Black Lacquer Table
Inlaid with Mother-of-pearl and Patterns
of Clouds and Dragons

Height 78.5 cm Length 125.5 cm Width 47 cm

The edges of the surface of the table have water-stopping mouldings. This table has legs like the handle of a sword. The spaces between legs are inlaid with an arched apron in the style of a pot-door-shaped opening. The entire body is coated with black lacquer as ground, and the heart of the surface and the edge beadings around are decorated with thin mother-of-pearl filled and inlaid with clouds and dragons. The dragon patterns on the apron, legs, and feet are painted with colour lacquer and coated with gold. The dragon motif on the inside of legs and feet and side stretchers are decorated with flowers with the application of the technique of painting with colour lacquer and tracing with liquid gold. The bottom of the surface of the table has the inscription "made in the years of Wanli in the Ming Dynasty", cut by knife and filled with gold.

The workmanship of this table is exquisite, and the decorative patterns are refined. This table is a lacquerware masterpiece of the Wanli period in the Ming Dynasty.

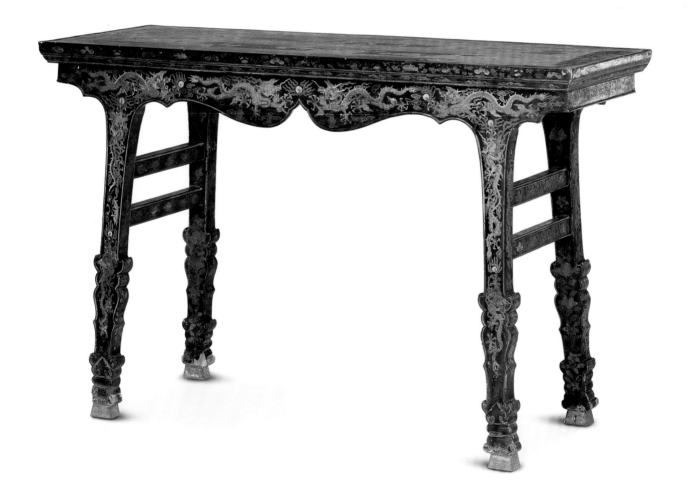

51
Black Lacquer Writing Table
with Mother-of-pearl Inlay
Height 87 cm Length 197 cm Width 53 cm

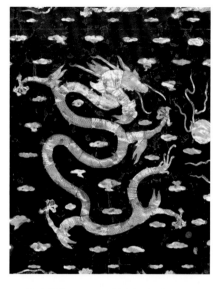

The entire body of this table is painted with black lacquer, on which are grooves decorated with mother-of-pearl inlay. The edges of the table top have patterns of two dragons chasing a pearl; the centre has five dragons on a background of cloud patterns, the middle one being a frontal view dragon with two dragons on each of its two sides, one up and one down with both their heads facing the middle. The end edges of the table top are decorated with patterns of two dragons chasing a pearl. Under the table top are elongated bridle joints and ruyi-cloud-head aprons and spandrels. The aprons are also decorated with patterns of two dragons chasing a pearl, and the two dragons on the apron-head spandrels are standing back to back. The four legs of the table have convex mouldings and are splayed. The mouldings are each decorated with a dragon chasing a pearl. The ends of the table feet are wrapped in copper covers with ruyi-heads. Between the legs on the two sides are mounted with inset panels which have a background full of cloud patterns and a ruyi-head medallion which has a frontal view dragon in it. The inside of the table is painted with red lacquer, in the middle of which between the penetrating transverse braces there is a vertical inscription marked "Made in the reign of Wanli in the Ming Dynasty", written in regular script and inlaid with mother-of-pearl.

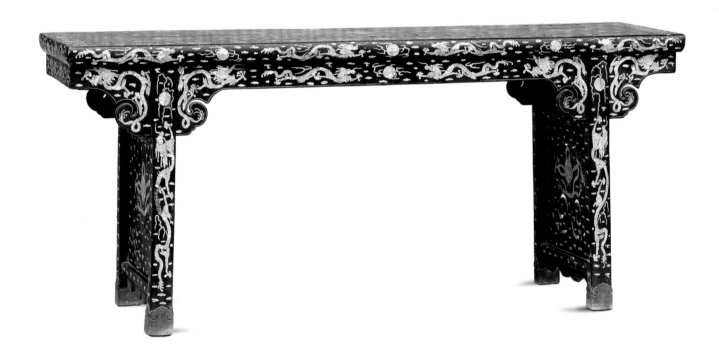

52

Yellow Rosewood Lotus-leaf-shaped Incense Stand

Height 73 cm Length 50.5 cm
Width 39.5 cm

The surface of this stand is in the shape of a lotus leaf. It has two levels with a high waist, two-level ornamental panels, and a stepped apron moulding. The ornamental panels are formed by sectional inlays, with the upper level carved in openwork with curling tendrils and the lower level having a fish-cave opening. The apron also has sections, carved into the shape of a lotus leaf, covering the spandrel. This stand has cabriole legs. The tips of the feet are carved with curling leaves. The feet are supported by pearls from below, falling on the seat of the incense stand.

The decorations of this incense stand are elaborate, and its structure is rather special. It is slightly different from other similar stands.

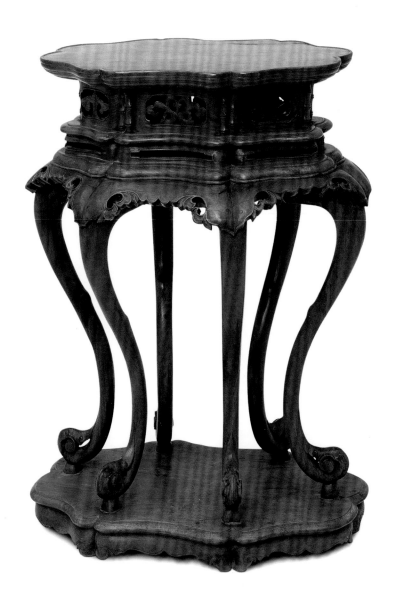

53

Black Lacquer Incense Stand
Inlaid with Mother-of-pearl and Patterns of Two Dragons Chasing a Pearl
Height 82 cm Diameter of Surface 38 cm
Qing court collection

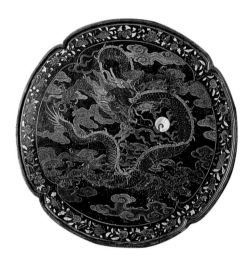

The surface of this incense stand is begonia-shaped. It has feet that resemble the legs of a crane and the nose of an elephant, resting on the stand that resembles a Buddhist pedestal. The ground of the black lacquer on the surface of the table is painted in colour and inlaid with mother-of-pearl and two dragons chasing a pearl, with its four sides decorated with flowers on branches. The side boards of the edges all have medallions, which are decorated with flowers on branches in sketches. The legs are inlaid with mother-of-pearl and sketches of two dragons chasing a pearl in colour, interspersed with flowers on branches. The seat of the stand is painted with patterns of fish and waterweeds. The inside is black lacquer, and on one side is is engraved with an inscription "made in the Xuande years of the Ming Dynasty", cut by knife.

In the Ming Dynasty, it was customary to burn incense indoors, and the incense stand was a receptacle to place the incense burner. This stand has an inscription and is a representative piece of work of the early Ming furniture.

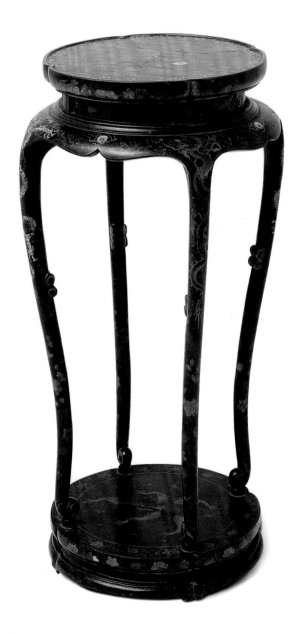

54

Carved Cinnabar Lacquer Incense Stand
with Peacocks and Peonies

Height 84 cm Length 57 cm
Width 57 cm

The surface of the stand is in the shape of a silver ingot with indent corners. It has a waist and a spandrel, and the four sides of the side boards have pot-door-shaped openings. It has crane-shaped legs and webfeet, stepping on the continuous floor stretchers below. The entire body of the stand is carved with cinnabar lacquer as decoration, and the surface of the stand is decorated with two flying peacocks, peonies, travertines, and a concave heart angular spiral brocade ground. The edges of the surface, waist, aprons, legs, feet, and floor stretchers are decorated all over with peonies. This stand has black and plain lacquer inside and is engraved with an inscription "made in the Xuande years of the Ming Dynasty".

Furniture with inscriptions is rarely seen, and even more rare is to have extant work from the early Ming period. This stand can be used to assign furniture to specific imperial categories.

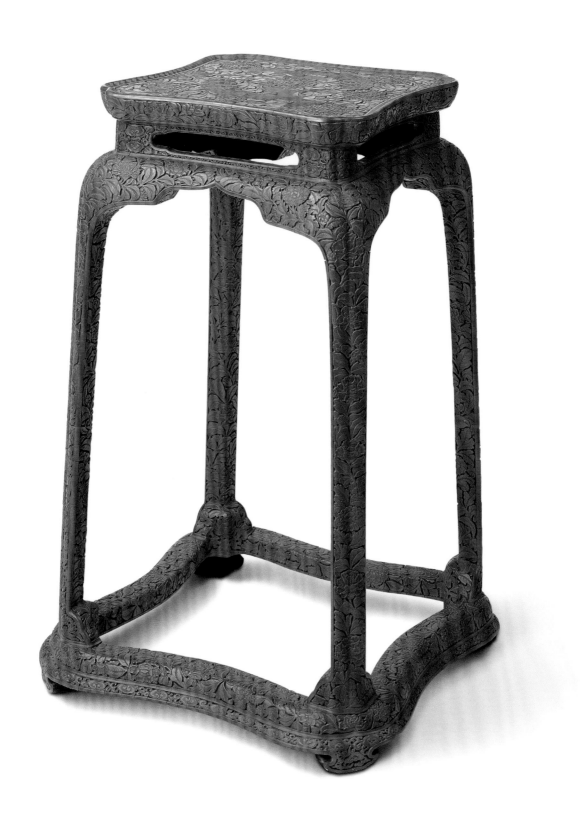

55

Yellow Rosewood Three-drawer Cabinet

Height 91 cm Length 215 cm
Width 60.5 cm

This cabinet is of table-shaped structure, with the two heads of the surface of the cabinet warping. The part that joins the two ends under the surface with the body of the cabinet have flowery aprons. Under the surface of the cabinet are three drawers, fixed with white copper pulls, bolts, and lock knobs. Under the drawers is the cabinet, with two doors opposite to each other, and beside the door is a detachable outer panel. The four legs are splayed, sprayed, and contracted.

This cabinet functions both as a table and a cabinet. It can store things and also be used as a cabinet.

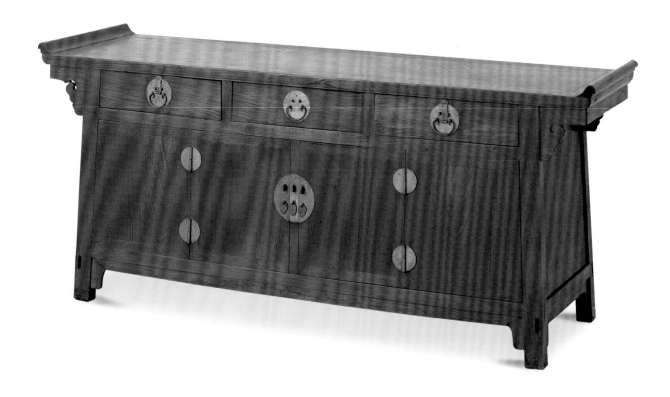

56

Yellow Rosewood
Two-layer Book Shelf

Height 117 cm Length 119 cm
Width 50 cm

The upper part of this book shelf is a two-layer open shelf with nothing on all sides. It is fixed with an arch-shaped frame with a pot-door-shaped opening. Under the open shelf are three drawers placed side by side. The cabinet on the lower part has doors opening opposite to each other. Inside the cabinet is a shelf which is nailed to the cabinet with two brass buttons. When the door of the cabinet is closed, the buttons pass through the large edge and copper hinges and expose themselves, which can be bolted with nails and added with a lock.

The decorative copper items of this cabinet are mostly lying on troughs and inlaid flatly, which is to flatten the surface of the furniture to become troughs according to the appearance and thickness of the decorative items. The inlay of nails on decorative items in troughs aligns the surface of the item and the surface of the furniture so that the surface of the shelves are straight and neat. As this style was popular during the Wanli years in the Ming Dynasty, it was commonly known as "Wanli shelves".

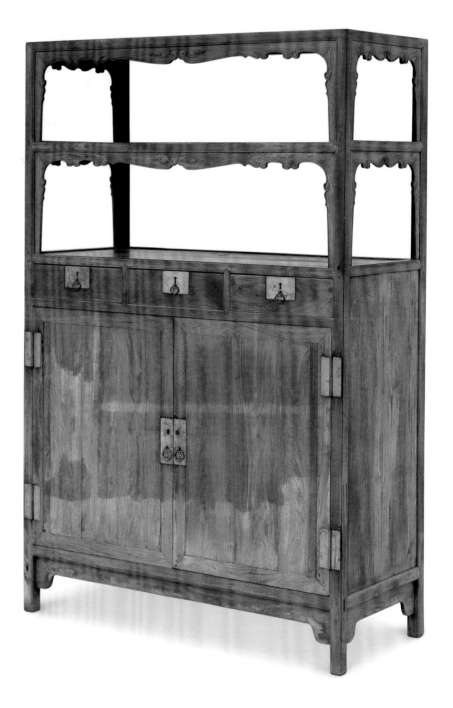

57

Yellow Rosewood Vertical Cabinet

Inlaid with a Hundred Treasures and a Picture of Barbarians Bringing in Treasures

Height 272.5 cm Length 187.5 cm
Width 72.5 cm
Qing court collection

This vertical cabinet uses miscellaneous timber for its frame, and the three sides of the yellow rosewood are wrapped and carved. It is divided into the upper and lower parts. The upper and lower parts of the front side have each fixed with four doors. The middle part can be opened, and the two sides can be taken off. Pyrophyllite and mother-of-pearl have been applied to the surface of the cabinet to carve out human figures, strange animals, mountain rocks, flowers, and trees. The upper part is a historical scene, and the lower part is a picture showing barbarians bringing in treasures.

This kind of cabinet is also known as a "compound cabinet", as it has a bottom cabinet and a top cabinet. As they are displayed in pairs, they are also known as "four-set cabinets". The decorative inlays of this cabinet are higher than those of the top board, creating a three-dimensional impression. Carving and inlaid decorations on yellow rosewood are uncommon.

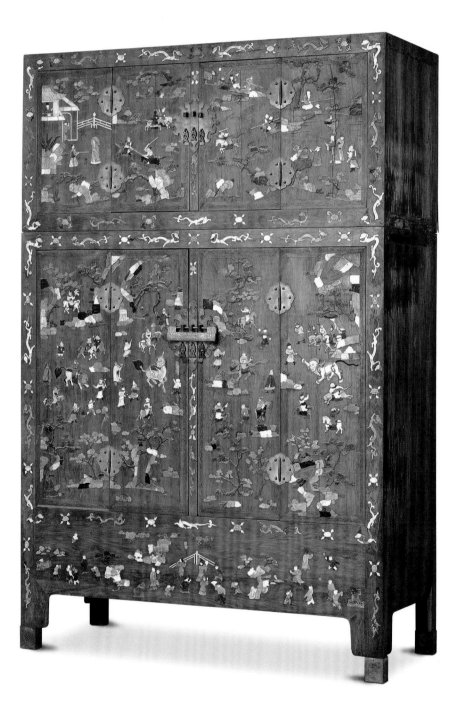

58

Black Lacquer Vertical Cabinet

with Landscape Painting Traced with Liquid Gold

Height 207 cm Length 120.5 cm
Width 64.5 cm
Qing court collection

This vertical cabinet is divided into the upper and lower parts: the upper part is the top cabinet, and the lower part, a vertical cabinet. Both the top and vertical cabinets have two doors opening opposite to each other, and the doors have copper hinges, lock knobs, and handle hoops. The top cabinet has two layers inside, and the vertical cabinet has three layers inside. The spaces between the legs are aprons with pot-door-shaped openings. The top cabinet, the door of the vertical cabinet, and the apron have each painted and gold-traced lacquer painting of towers and pavilions, landscape, and figures, with the edges painted with flowers on branches. The side of the cabinet has painted flowers and grass including osmanthus flowers, Chinese roses, travertines, and orchids.

According to the archives, this cabinet was stored in the Palace Domestic Store-house (*sizhishiku*), which was one of the five northern storehouses (*beiwusuo*) of the Qing where the crowns, belts, bed curtains, and nets of the imperial family were stored.

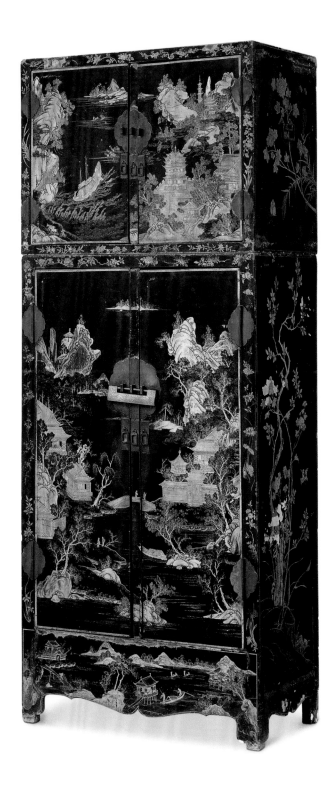

59

Filled Lacquer Cabinet
with Engraved Gold (*Qiangjin*) Designs of Clouds and Dragons

Height 174 cm Length 124 cm
Width 74.5 cm
Qing court collection

This cabinet is in a straight form and has two opposite-opening doors. Between the doors are a removable vertical bolt and a copper bowl style door hinge, and the inside of the cabinet are fixed with two layers of black lacquer drawer shelves. The upper and lower parts of the cabinet have lozenge-shaped medallions, which all have a brocade ground with black swastika (卍) checks, with the upper part decorated with two dragons chasing a pearl engraved in gold and filled with colourful aprons and the lower part decorated with a painting of a scene of a lotus pond. The four sides and the central bolt have medallions which are engraved in gold, painted in colour, and decorated with flowers. The sides of the cabinet are decorated with clouds and dragons and aprons engraved in gold and painted in colour, the edges are decorated with medallions and flowers filled with colours. The upper part of the back of the cabinet have peonies and butterflies filled with colours and engraved in gold, and the lower part has pine trees, deer, and peonies. In the inside of the black lacquer is a concave-carved and engraved gold inscription "made in the *dingwei* year of the reign of Wanli in the Ming Dynasty".

The workmanship of this cabinet is exquisite, and this cabinet is a representative piece of lacquer furniture of the Ming Dynasty. "The *dingwei* year in the reign of Wanli" is the 35th year of the reign of Wanli, or 1607 A.D.

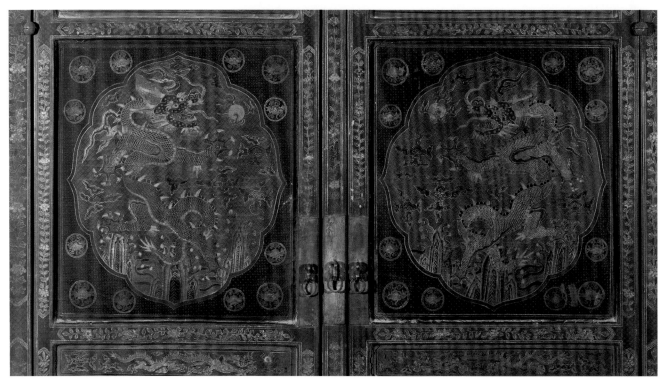

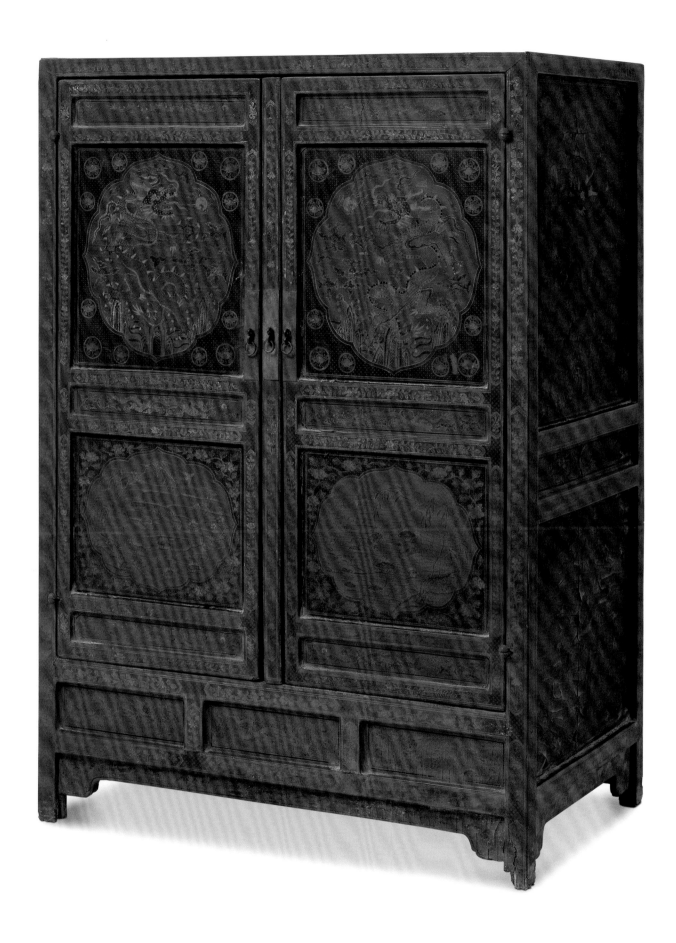

60

Filled Lacquer Cabinet
with Engraved Gold (*Qiangjin*) Designs of Two Dragons

Height 158 cm Length 92 cm
Width 60 cm
Qing court collection

This cabinet is flat-topped and vertical, and has two opposite-opening doors. It has a post in the middle and is joined below with an apron board. The spaces between legs are carved with arch-shaped aprons. Fixed inside the cabinet is a central panel. It has plain brass hinges and legs wrapped in copper. The entire body of the cabinet has a ground with red swastika (卍) check brocade. The cabinet doors are both carved with two rising dragons filled with purple lacquer and engraved in gold. The two dragons each stretch out one claw to hold up a treasure bowl, and the lower part of the cabinet is decorated with aprons. The frames of the cabinet doors and the centre strut are carved with branches of lotus engraved in gold. The apron board has two engraved gold dragons chasing a pearl. The mountain-shaped boards on the left and right sides are each carved with a frontal view dragon engraved in gold, interspersed with floating clouds. The ground of the back of the cabinet is in black lacquer, with its upper part decorated with the painting of "House beside the Water" (*haiwutianchou*) traced with liquid gold and painted with colour lacquer; its lower part is decorated with gold-coloured flowers and birds, and the cross frame of the backboard is carved in intaglio with an inscription "made in the *jiaxu* year in the reign of Xuande in the Ming Dynasty" in regular script.

It was found that there was no *jiaxu* year in the reign of Xuande (1426 A.D. – 1435 A.D.), the inscription is therefore a fake. By analyzing the lacquer colour, the decorative patterns, and the artistic features of this cabinet, it obviously has the artistic style of the Wanli period of the Ming Dynasty, and this cabinet should be a product of the Wanli period.

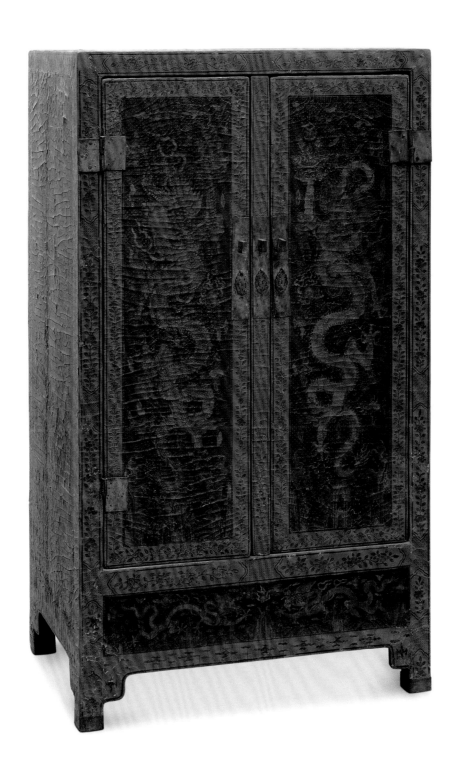

61

Ironwood Four-drawer Cabinet

Height 87 cm Length 174 cm
Width 51.5 cm

This four-drawer cabinet has a table-shaped structure. Under the surface of the cabinet are four drawers, the surfaces of which have medallions carved with flowers in branches and patterns of curling tendrils. The apron with a pot-door-shaped opening is carved with curling tendrils. The four legs are splayed, sprayed, and contracted. Fixed between the legs and the turning places of the surfaces of the cabinet are side spandrels with patterns of curling leaves. Fixed between the legs are single side stretchers.

This cabinet, also known as a "drawer-table", has the dual functions of a table and a cabinet. It can store things, and can also be used as a table.

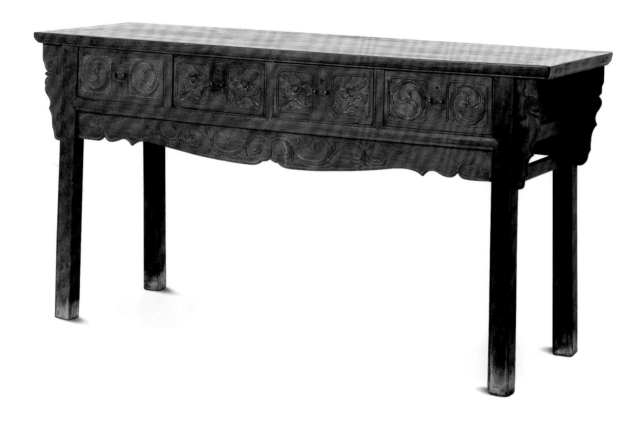

62

Purple Sandalwood Lattice Book Shelf

Height 191 cm Length 101 cm
Width 51cm

This book shelf is divided into three layers. The front side is open, and the other three sides are joined to form lattices made of short pieces of timber. The legs and feet are round outside and square inside. The main part is made of purple sandalwood, while the vertical board in the middle backrest is made of yellow rosewood.

The frame of this book shelf has the typical features of the Ming furniture. The joined lattices and the high brightening-the-feet opening, for example, all have the feeling of penetration and freshness. The convex surface of the top of the lattice and the legs and feet, which are round outside and square inside, are commonly seen in the Ming-style furniture.

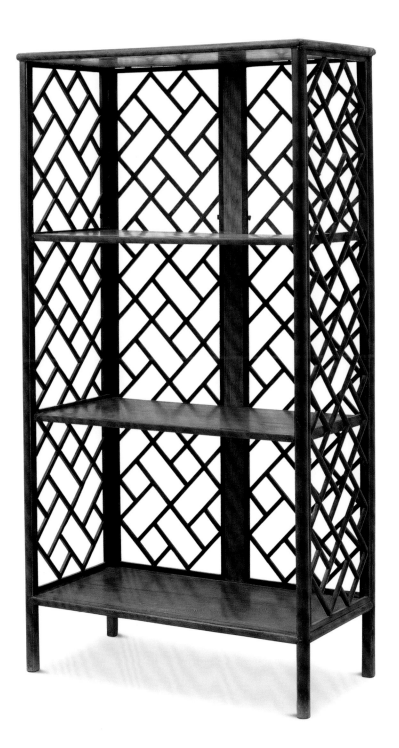

63

Black Lacquer Book Shelf Sprinkled
with Mother-of-pearl and Two Dragons Chasing a Pearl Traced with Liquid Gold

Height 173 cm Length 157 cm
Width 63 cm
Qing court collection

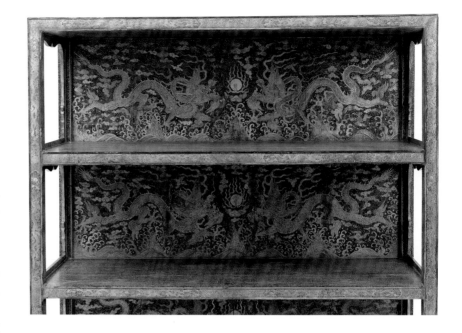

This book shelf has three levels and a backboard. The sides of the levels are fixed with arch-shaped aprons with pot-door-shaped openings. The spaces between its legs are inlaid with arch-shaped aprons, wrapped in brass. The entire body of the shelf has black lacquer as its ground, which are decorated with sprinkled mother-of-pearl and a painting traced with liquid gold. The front side of the backboard of each level in the shelf is decorated with two dragons chasing a pearl, interspersed with cloud aprons. In the frame medallion is a dragon chasing after a flaming ball, interspersed with square grids with brocade patterns as its ground. The drawer boards are decorated with flowing clouds, and the aprons with a pot-door-shaped opening on both sides are decorated with branch lotuses. The backs of the backboards are painted with Chinese roses, peach blossoms, pomegranates, flowers, and birds. The upper part of the first level is carved with an inscription "made in the Wanli years in the Ming Dynasty", traced with liquid gold.

This shelf was used for the palace book collection. It uses the mother-of-pearl-sprinkling, gold-gilding, silver-foiling, and gold-tracing techniques. This shelf is a masterpiece of the Ming lacquer furniture.

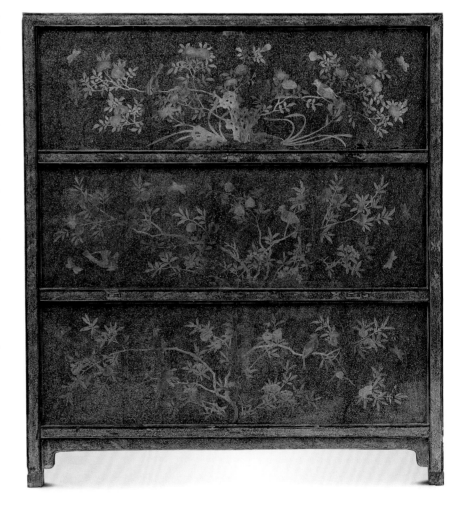

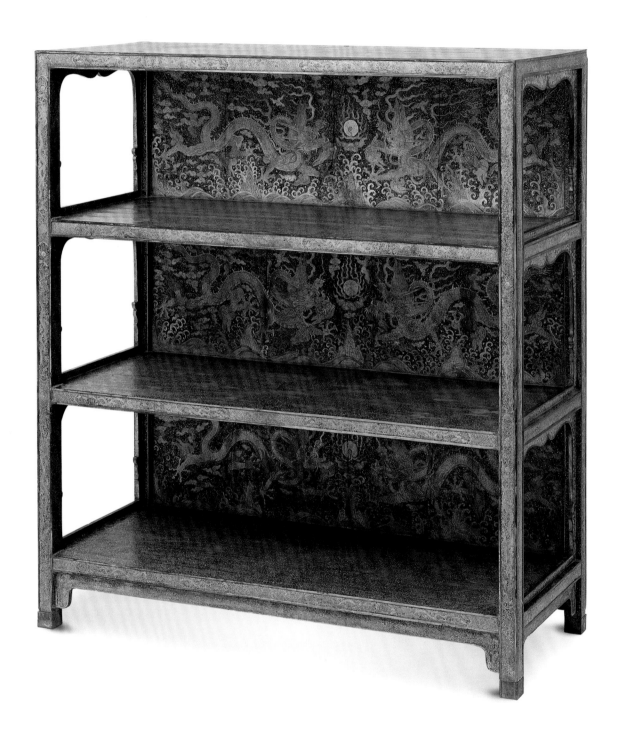

64

Red Lacquer Book Shelf
with Landscape Traced with Liquid Gold

Height 211 cm Length 192.5 cm
Width 48.5 cm
Qing court collection

This bookshelf is divided into four levels with three thick planks. The front side is totally open. Under the shelves are vertical aprons, bulging legs, protruding teeth, and short feet. The body of the shelves is painted with red lacquer, and the frames and frames of the side boards are decorated with landscape and human figures traced with liquid gold.

The landscape painting on the shelves has beautiful sceneries, with a number of people in it. The touch of the painting is superb, and the shelf is a rare masterpiece of lacquer furniture.

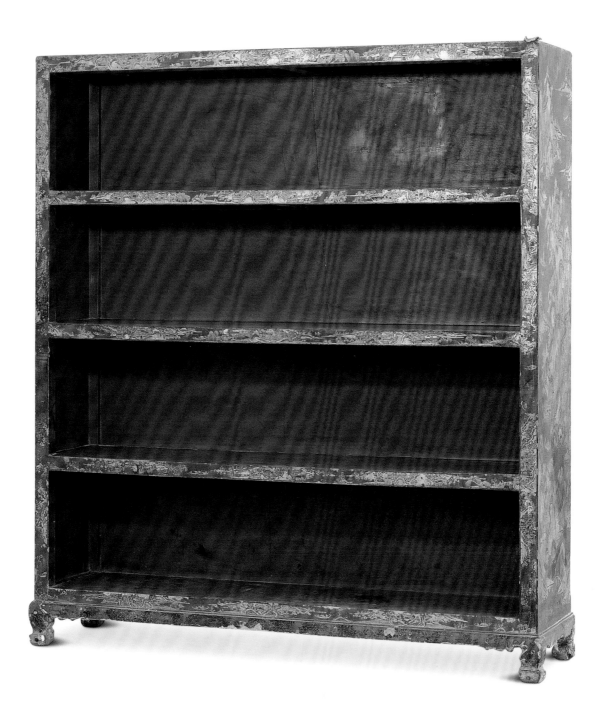

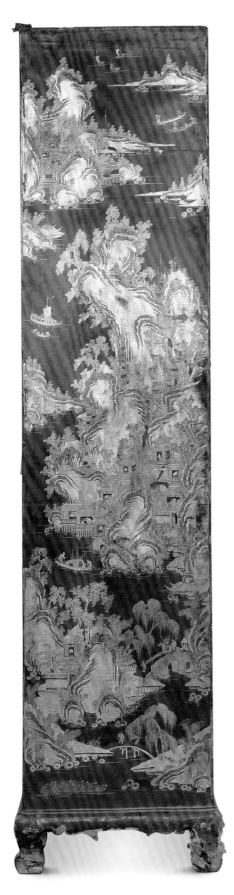

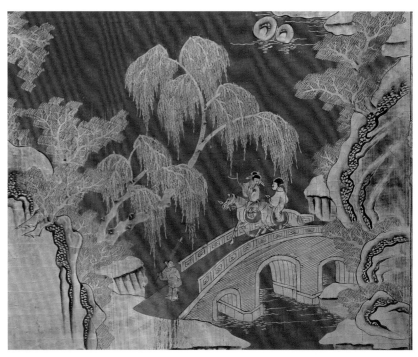

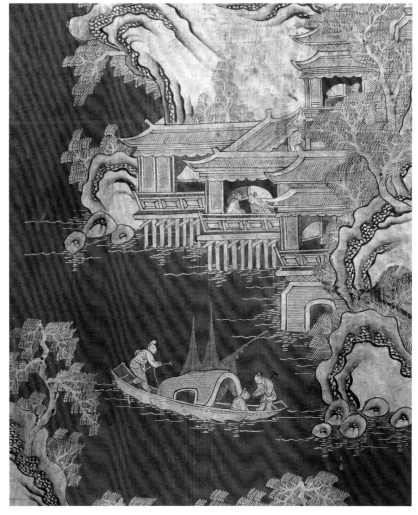

65

Yellow Rosewood
Dressing Case

Height 38 cm Length 37 cm
Width 26.5 cm

There is a lid on this chest which can be opened. In the lid there is a square shallow drawer. The front side of the entire body of the chest has a pair of opposite-opening doors. Inside the doors are three layers with five drawers. The lid of the chest and the doors are installed with copper decorative items. Both sides of the body of the chest are fixed with copper handles. Below the body is a stand, and the edges of the bottom are carved with edges with pot-door-shaped openings.

This case was used by officials for storing things when they had outings, and it was extensively used in the Ming period.

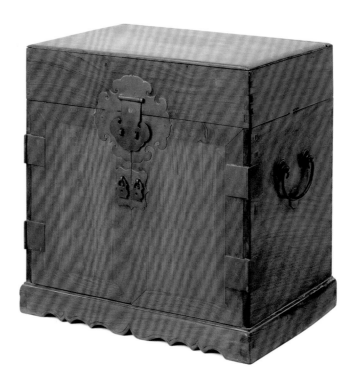

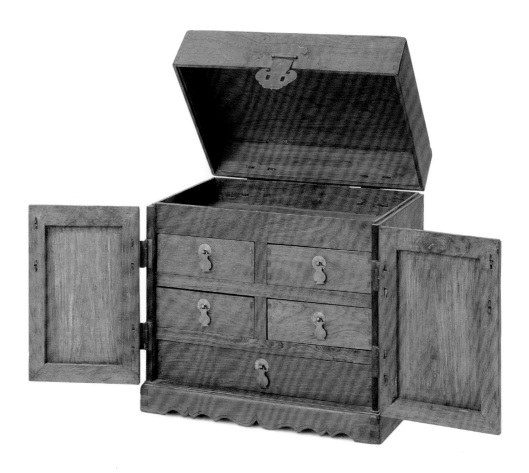

66

Purple Sandalwood Chest
with Two Dragons Chasing a Pearl

Height 32.5 cm Length 85.5 cm
Width 62.5 cm

This chest has a lid on the top. Its front side has round hinges and hasps, and its side is fixed with copper handles with rings. The front side of the chest is carved in concave with waves and cliffs, two dragons chasing a pearl, and the spaces in between are clouds. The two sides have carvings of antique objects and flowers in intaglio.

What is special about this chest is that there is a composite opening at the place where the lid joins with the body of the chest, which strengthens the chest. Other than this, at the outer edges where the lid of the chest joins with the body of the chest, there is a groove of raised beadings made of one piece of timber, which shows that the making of this chest has involved the use of a considerable amount of thick timber.

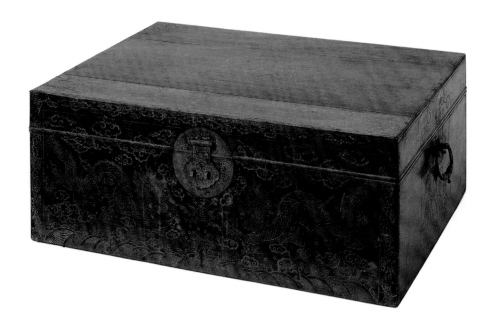

67

Carved Cinnabar Lacquer Chest
with Characters "*Shou*" and Pine Trees

Height 33 cm Length 36.3 cm
Width 26.6 cm
Qing court collection

The top of the chest has a lid, under which there are drawers. The front side of the chest are a bolted door in which there are six drawers. Craved on the door are three pine trees, with the pine tree in the middle having its trunks and branches curling into the "*shou*" (longevity) character, and appearing at the top end is the head of a dragon. Accompanying the pine trees on its left and right sides are Chinese roses and *lingzhi* fungi, carrying the propitious meaning of wishing somebody longevity. Decorations on the surface of the lid, both sides of the body of the chest, and the back of the chest are the same as those on the bolted door. The vertical edges of the lid are carved with clouds and dragons, and the vertical wall of the drawers inside the chest are carved with flowers on branches and waves and cliffs. The bottom of the chest is painted with black lacquer, and in the middle is an inscription "made in the years of Jiajing in the Ming Dynasty" which is cut by knife, traced with liquid gold, and in regular script.

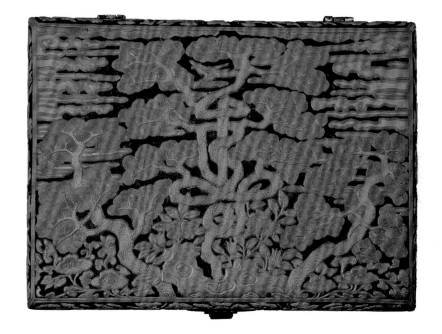

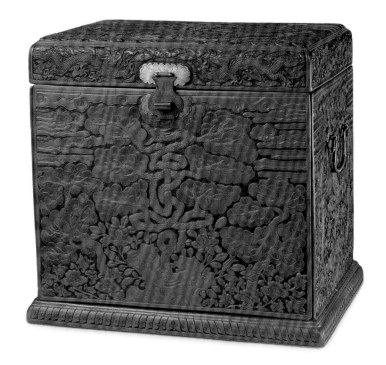

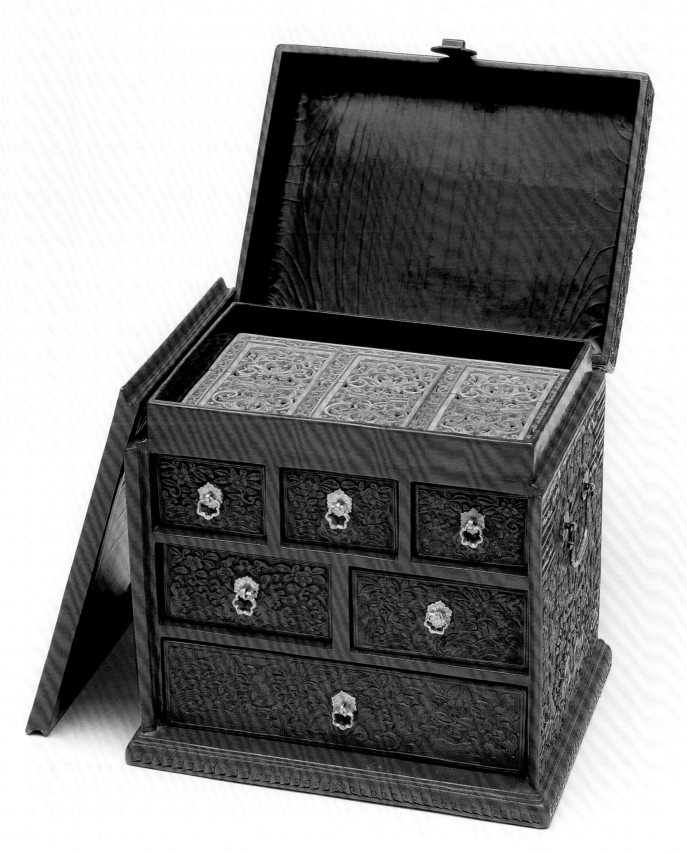

68

Black Lacquer Chest
with Dragons Traced with Liquid Gold

Height 63 cm Length 73 cm
Width 42 cm
Qing court collection

There is a lid at the top of the chest. Under the lid are drawers. The front side of the chest has opposite-opening doors. In the bolted doors are six drawers. The front edges of the lid are bolts, which can control the loose bolts between the doors. Under the lid is a chest stand. The entire body of the chest is lacquered in black, the four sides of the lid are decorated with a strolling dragon traced with liquid gold, and the spaces in between are decorated with peonies in branches. The horizontal beams under the lid of the chest and the four sides of the doors have brocade patterns with slanted checks and jujube flowers traced with liquid gold. The middle part has medallions, decorated with strolling dragons and clouds traced with liquid gold. The centre of the doors, the two-hill boards, the rear back, and the surface of the lid have lozenge-shaped medallions, decorated with two dragons chasing a pearl traced with liquid gold, and the spaces in between are decorated with entwining flowers. The four corners on the external edges of the medallions are decorated with entwining flowers. In the removable bolts of the doors, the horizontal beam in the middle has an inscription traced with liquid gold "made in the Wanli years of the Ming Dynasty".

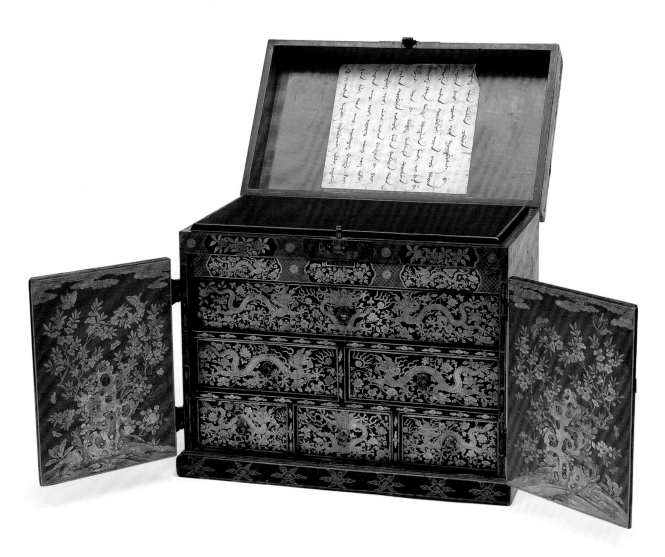

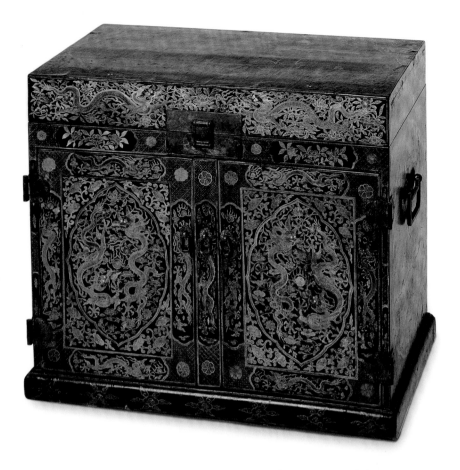

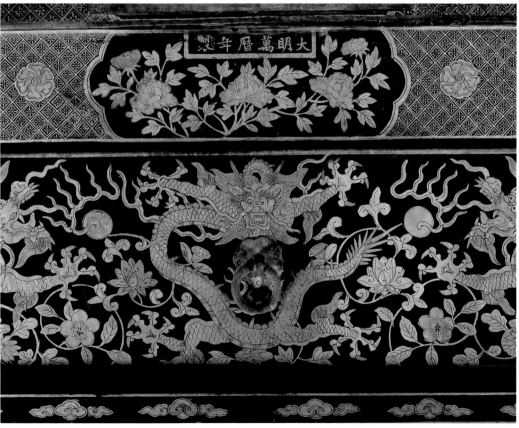

69

Carved Colour Lacquer Chest
with Clouds and Dragons

Height 61 cm Length 65 cm
Width 40 cm
Qing court collection

The top of the chest is a lid, and the front of the chest is a bolted door. Below the chest is a joined broad stand. The entire body of the chest has a brocade ground carved and lacquered in red, yellow, and green. The bolted door has cloud-head medallions, which are carved with two dragons chasing a flaming pearl. The flame of the pearl rises up, curling into the character "*shou*" (longevity), above which is the character "*wan*" (卍) and three stars. The outside of the medallion is decorated with entwining flowers and miscellaneous treasures. The two sides of the chest and the medallion on the surface of the lid are carved with two dragons chasing a pearl, and their outside is decorated with flowers in branches. The green sea ground at the back of the chest is carved with pine trees and cranes. The six cranes (*he*) either rest on the pine trees (*song*) or wheel in the air, carrying the meanings of "universal spring"(*liuhetongchun*) and "living as long as pine trees and cranes" (*songheyannian*). The inside of the chest and the lid are coated with red lacquer. There are five drawers inside. The surface of the drawers have two dragons chasing a pearl, and the inside of the drawer is painted with black

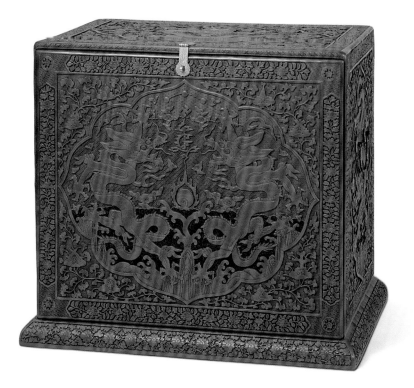

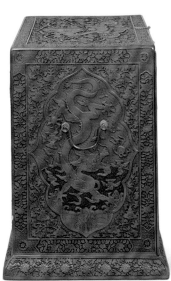

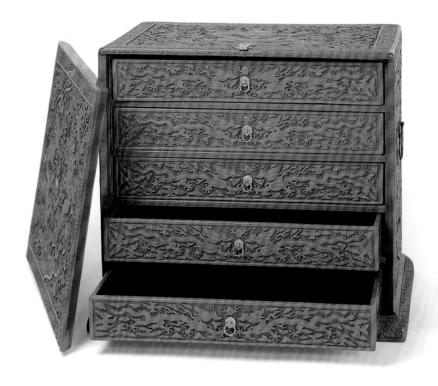

70

Filled Lacquer Chest
with Engraved Gold
(*Qiangjin*) Designs of
Clouds and Dragons

Height 42 cm Length 95 cm
Width 63 cm
Qing court collection

The top of the chest has an arc-shaped lid. The body of the chest is inlaid with iron and coated with gold and silver hinges, and it has handles, under which is a chest stand. The entire body has a red lacquer ground. The lid of the chest and the centre of the four walls have a yellow lacquer ground and begonia-shaped medallions engraved with gold. The inside is decorated with a swastika (卍) brocade ground, which is carved with two dragons chasing a pearl and aprons. The medallions on the edges are decorated and filled with entwining lotuses in colour, and the four corners have a brocade ground with swastika (卍) patterns, which are filled with *lingzhi* fungus balls and flowers painted with colour lacquer. The inside of the chest is lacquered in black.

Judged by the style of decoration and workmanship of this chest, it is from the Wanli period of the Ming Dynasty.

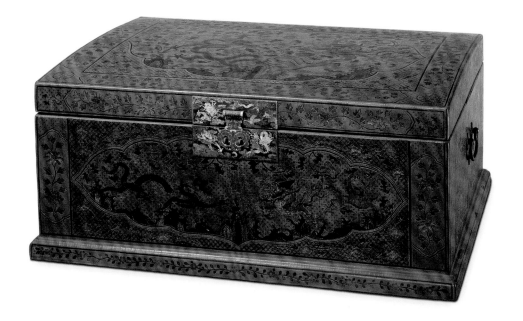

71

Black Lacquer Chest
Inlaid with Mother-of-pearl
and Two Dragons Chasing a
Pearl Traced with Liquid
Gold and *Pingtuo* Technique

Height 81.5 cm Length 66.5 cm
Width 66.5 cm
Qing court collection

The top of this chest has a lid with flat drawers inside. Fixed on the front side is a bolted door with five drawers inside. There are bolts inside the flat drawers, and the bolts reach directly to the upper side of the bolted door. The front side of the lid has copper buckles. At the sides of the buckles and the two sides of the chest are matching peach-shaped copper protective leaves, and fixed on the middle part of the walls on the two sides are copper handles. On the lid and at the four sides of the entire body of the chest are glossy lacquer and are decorated with two dragons chasing a pearl inlaid with the technique of mother-of-pearl and flatting (*pingtuo*). Dragon hair, dragon horns, dragon spines are inlaid with silver flakes, and the spaces in between are covered with silvery clouds traced with liquid gold. The inside of the bolted door is decorated with two dragons traced with coloured lacquer. It has black lacquer inside, and the middle of the inside of the lid has an inscription traced with liquid gold in regular script "made in the Wanli years of the Ming Dynasty".

This chest is one of a pair. It was a tool to store clothes when the emperor went hunting. It uses the techniques of carving, inlaying, and flatting, and the chest is an epitomic piece of lacquer workmanship of the Ming Dynasty.

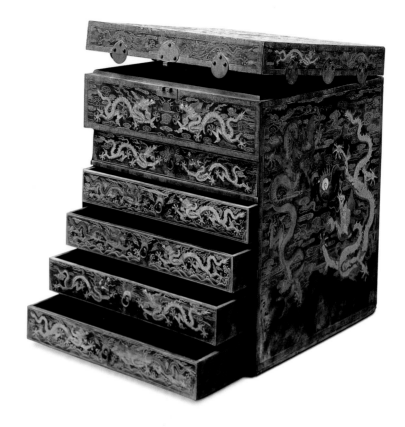

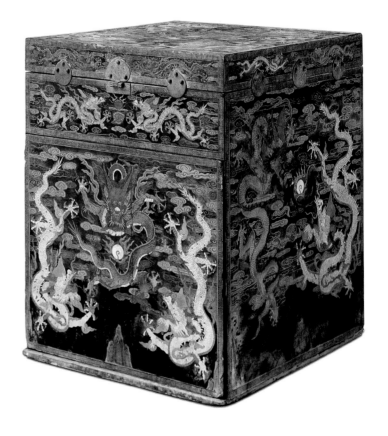

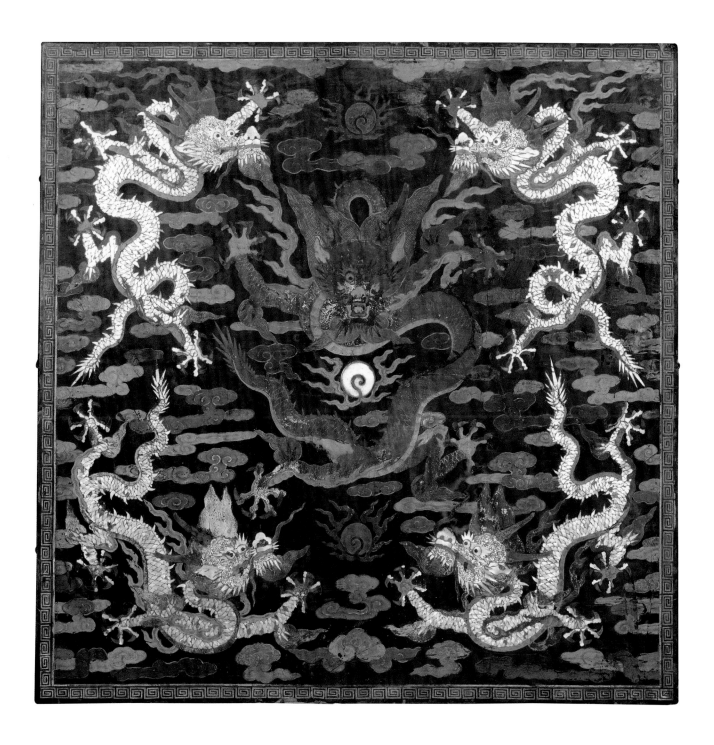

72

Carved Cinnabar Lacquer Two-level Rectangular Hand-carried Box

with Flowers, Birds, and Human Figures

Height 24.2 cm Length 25.8 cm
Width 17.2 cm
Qing court collection

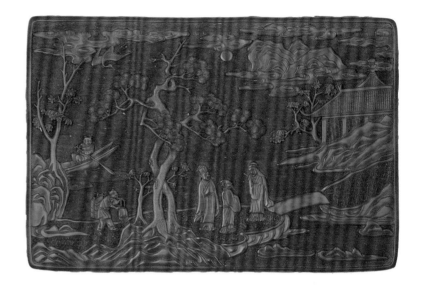

This hand-carried box has two levels with a carrying beam. Inside the upper level is a drawer in black lacquer. The entire body is carved in cinnabar lacquer, with the exception of the carrying beam and its stand, which have a red ground and *lingzhi* fungi in carved black lacquer. The surface of the box is carved with a painting of people. On the tip of the pine tree the morning sun rises. The crowned cranes dance. On the river shore there are three persons walking towards a wooden bridge, talking to each other, and a boy carrying wine utensils and food boxes following behind. In the middle of the river is a person holding an oar to anchor a boat. All these seem to indicate their intention to have an outing in the countryside. The front of the box and the rear wall are carved with a painting of swallows in an apricot orchard in spring, and the two sides of the wall are carved with pomegranate flowers. The inside and bottom of the box are painted with glossy black lacquer.

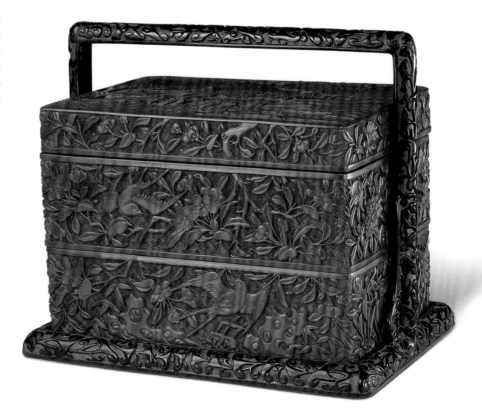

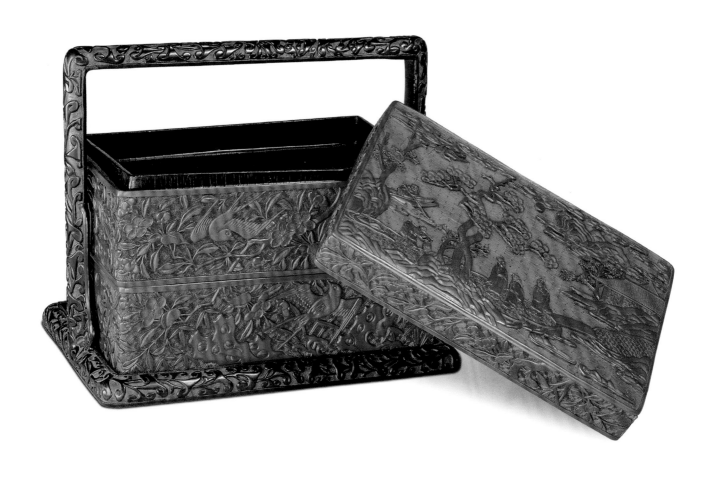

73

Red Lacquer Flat Chest Traced
with Liquid Gold

Height 26.5 cm Length 74.5 cm
Width 49 cm
Qing court collection

This chest has a foldable lid. The lid and the chest body is joined by copper hinges in the shape of a *ruyi* sceptre. The inside and outside of the entire body are painted with red lacquer as ground. Painted on the lid are flowers, birds, tress, and rocks in gold lacquer. Fixed on the front side are lozenge-shaped copper hinges, and *ruyi* cloud-head hasps. The two sides of the vertical wall are decorated with butterflies in gold lacquer and they are fixed with copper handles.

This chest is flat, long, and light, which is probably made especially for outings.

74

Carved Polychrome Lacquer Rectangular Box

with Characters "*Fu*" (Fortune), "*Shou*" (Longevity), "*Kang*" (Health), and "*Ning*" (Peace)

Height 8 cm Length 20.6 cm
Width 13.6 cm
Qing court collection

The lid of the box has round corners, and the bottom is concave inside. The entire body of the box is painted with black and red lacquer. The surface of the lid has two vertical lines, from right to left, of four characters "*fu*" (fortune), "*shou*" (longevity), "*kang*" (health), and "*ning*" (peace), cut by knife, and the four sides of the box, the walls of the lid, and the walls of the box are carved with *ruyi* cloud heads.

Carved polychrome items usually have *ruyi* cloud patterns as decoration. It is rare to see these items having additional characters connoting propitiousness.

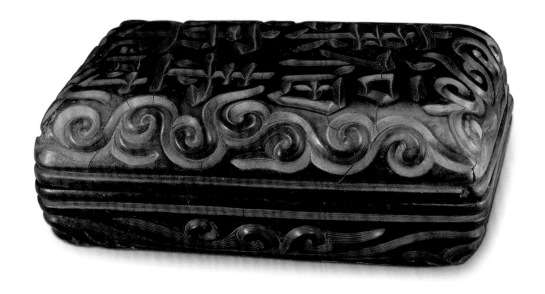

75

Large Yellow Rosewood Removable Panel Screen
with Ladies Watching Treasure

Height 245.5 cm Length 150 cm
Width 78 cm
Qing court collection

This removable panel screen has a large rectangular frame, with a minor frame in the middle as a divide to serve as the central panel. This central panel, which is loadable, is painted with an oil painting "Ladies Watching Treasure" on the glass. This painting was matched after the Qianlong period in the Qing Dynasty, and the four sides of the screen are inlaid with aprons with *chi*-dragons carved in relief. The bottom stand has two pieces of thick wood carved with embracing-drum bases and shoe feet, on which are erected vertical posts to support the standing spandrels. Fixed between the two posts are two side stretchers, with a short post in the middle, and the two sides are fixed with ornamental panels carved with *chi*-dragons in openwork. Fixed under the stretchers is a slanted apron in the shape of the character " 八 " (eight), and on the apron is carved with *chi*-dragons.

This removable panel screen is one of a pair. It is physically large, and the craftsmanship is exquisite. It is practical and can also be used for artistic display.

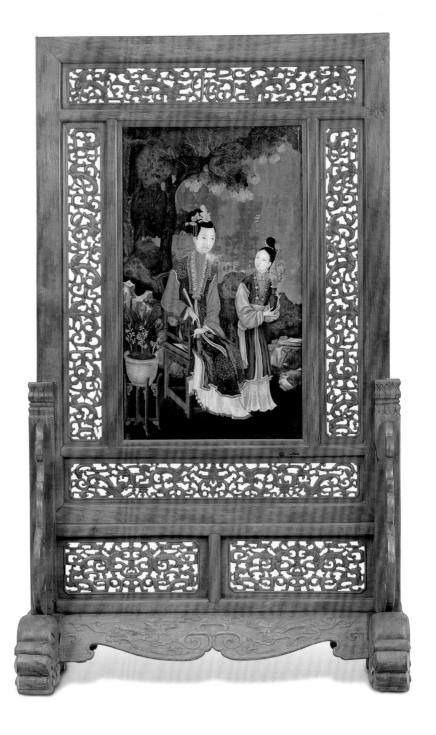

76

Red Lacquer Removable Panel Screen Carved
with Chinese Unicorns and Phoenixes

Height 62 cm Length 58 cm
Width 27 cm

The central panel of this removable panel screen is carved with Chinese unicorns and soaring phoenixes. The four sides are set off by contrast by pine trees, bamboos, flowers and grass, mountain rocks, the red sun in the sky, and miscellaneous treasures laying on the ground. The frames are inlaid with seven ornamental panels. These panels are medallions and inlaid inside with all sorts of wooden pieces, which are carved with flowers. It has a ladder-shaped mound, moving up along the steps, and fixed in the space of the mound is a side stretcher, with a slanted apron with cloud patterns.

This type of small screen is for decoration only and is placed on a writing desk in a study as an ornament for appreciation.

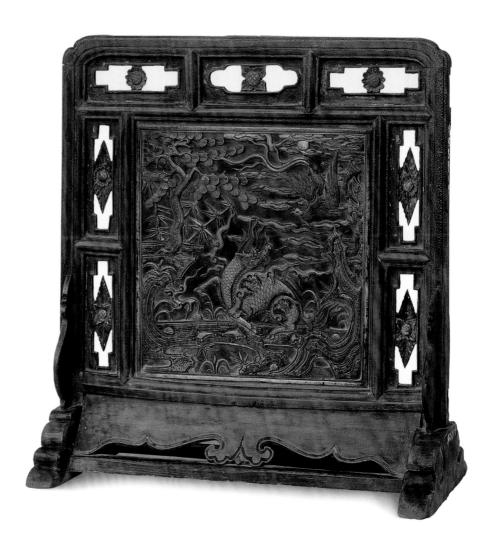

77

Black Lacquer Eight-panelled Screen
with a Hundred Birds Paying Homage to the Phoenix in Coromandel

Height 218.5 cm Length 351 cm

This screen has eight panels, joined by a hook. On one side of the central panel is a painting of "A Hundred Birds Paying Homage to the Phoenixes". The painting has a female phoenix and a male phoenix at the centre, surrounded by a hundred birds on their four sides and set off in contrast by rare flowers and exotic plants, trees, rocks, and flowing water. On the other side is a painting of hunting. Carved on the painting are distant mountains, nearby rivers, trees, rocks, flowers, grass, people, horses, banners, and barracks, and the four sides have edges with medallions with flowers and lozenges. Carved inside the medallions are *chi*-tigers and *lingzhi* fungi, and carved outside the medallions are antique objects and flowers.

The decorative patterns of this screen are rich, its carving and paintings are refined, and the colours are bright and extremely beautiful.

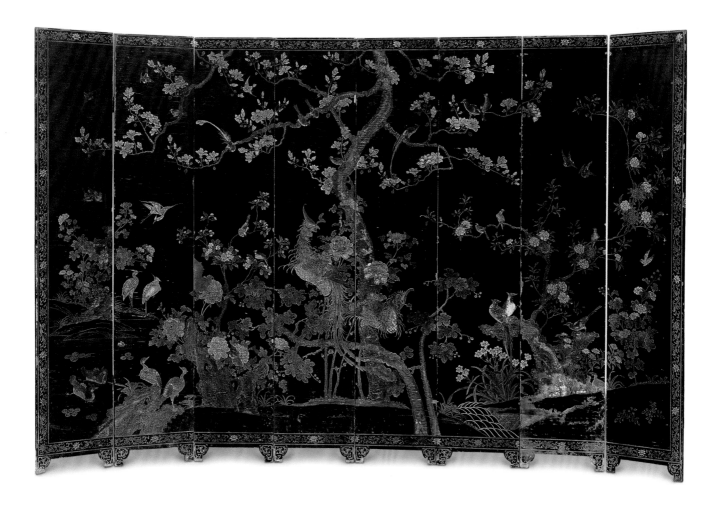

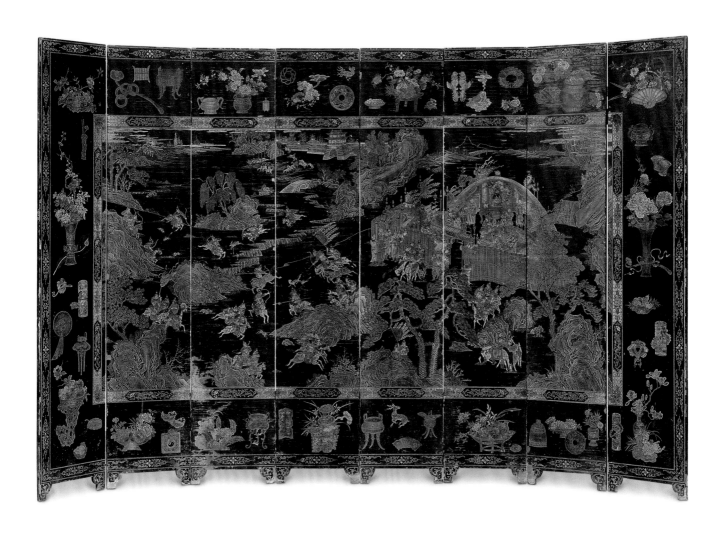

78

Yellow Rosewood Five-panelled Mirror Platform
with Dragons and Phoenixes

Height 77 cm Length 49.5 cm
Width 35 cm

Fixed to the stand of this mirror platform is a small five-panelled screen, circled into the shape of a fan. The central panel is highest, the panels on the two sides are lower, and they move forward in a spiral one by one. Mounted on the screen are decorative panels, with dragon and phoenix patterns and entwining lotus branches carved in openwork. The top rails are tall and above the head of the screen, and the head of the dragon is in three-dimensional carving. The four sides of the mirror platform have baluster columns, railings, and decorative panels inlaid with dragons carved in openwork. This mirror platform has opposite-opening doors and three drawers. Between the two legs are aprons with pot-door-shaped openings.

Mirror platforms are bedroom utensils. When used, the copper mirror is rested slanted on a small screen, with the lower part having a railing in the front platform to halt it. The making of this mirror platform is excellent, and the craftsmanship is superb. This is the only mirror platform in the collection of the Palace Museum.

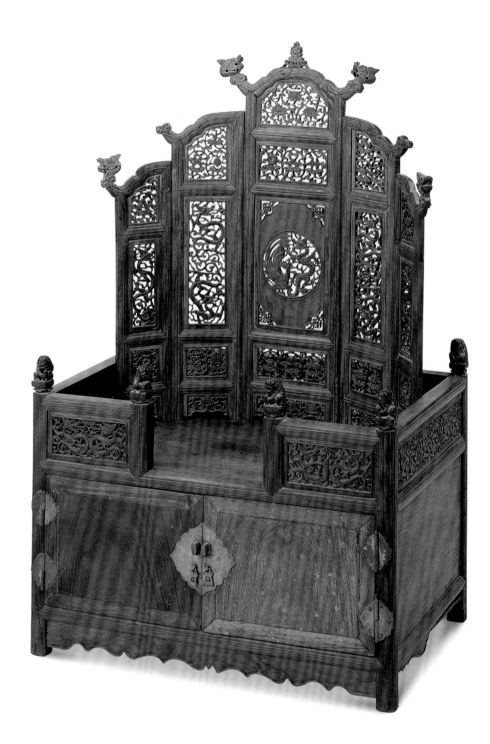

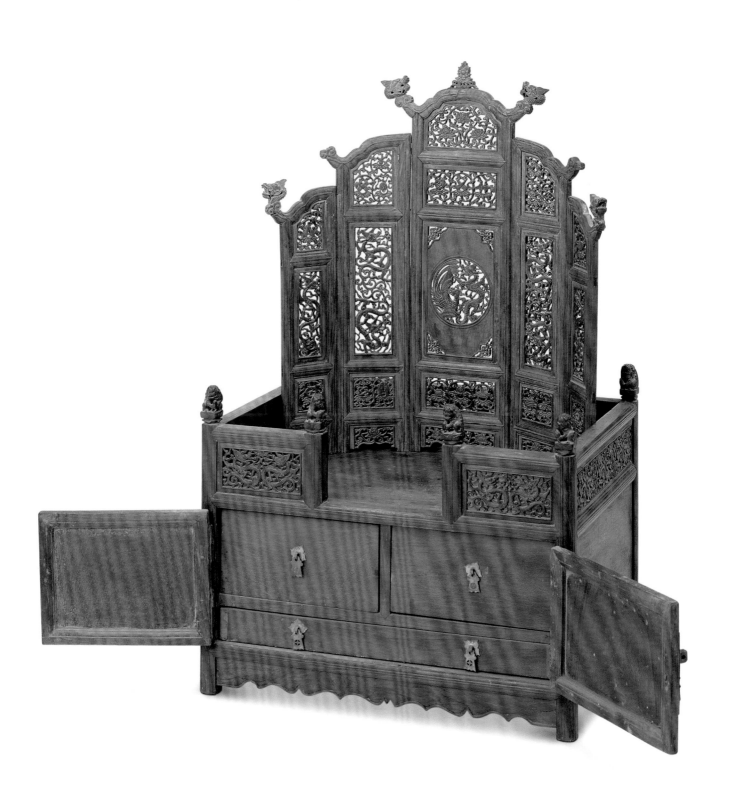

Yellow Rosewood Clothes Rack

Height 188 cm Length 191.5 cm
Width 57 cm

The two ends of the top rails of this clothes rack are carved with a dragon head with fluttering beards and hair. The central panel plate has an ornamental panel which has sections inlaid with *chi*-dragons carved in openwork. The lower ends of the two vertical posts has a standing spandrel with *chi*-dragons carved in openwork, and embracing-drum bases with *ruyi* cloud heads. In the spaces between the lower part of the central panel and the bottom mound, there was originally a side stretcher and lattice, and there are still remaining traces of blocked mortises. The mortises of various parts are all loose, which can be assembled and disassembled.

Clothes racks are furniture used in the bedrooms. In ancient China, people were used to wearing long gowns, which were put on the bar between the top rail and the central penal plate when taken off.

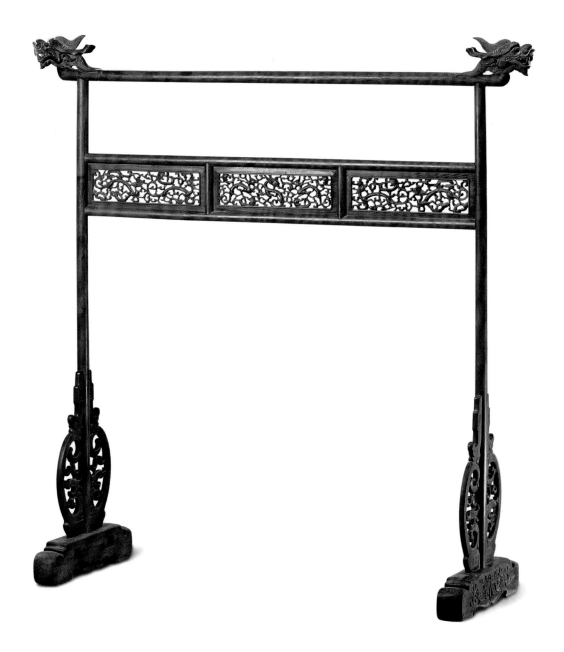

80

Carved Cinnabar Lacquer Rectangular Footstool
with Flower Motif

Height 15 cm Length 53 cm
Width 20.4 cm
Qing court collection

This footstool has a rectangular surface. It is waisted. It has flowery apron edges, outward-curving horse-hoof feet, and a continuous floor stretcher under as support. The entire body of the footstool has a plain yellow lacquer ground carved with flowers in red lacquer. The surface of the stool is carved with peonies, the wall of the stool is carved with camellias, peach blossoms, peonies, lotus flowers, chrysanthemums, pomegranates, cape jasmine flowers, and *lingzhi* fungi. The inside of the stool is coated with red lacquer.

The shape of this stool is simple and pure, its body is thick, and the flowers carved are the frequently used decorations of the early Ming period. This footstool has clear periodic features of the period.

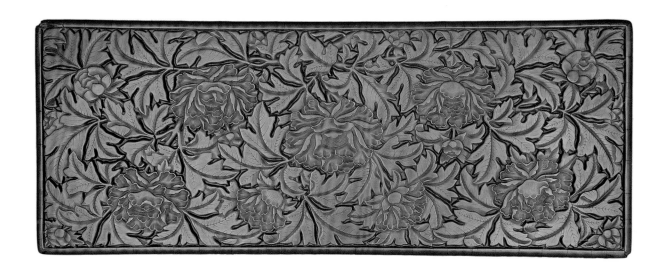

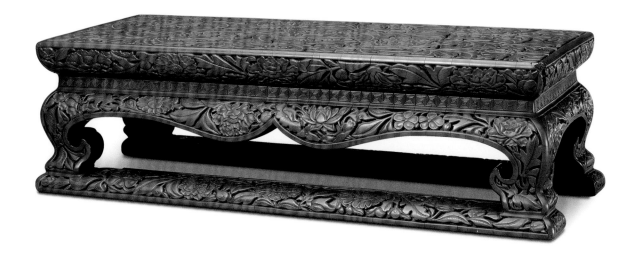

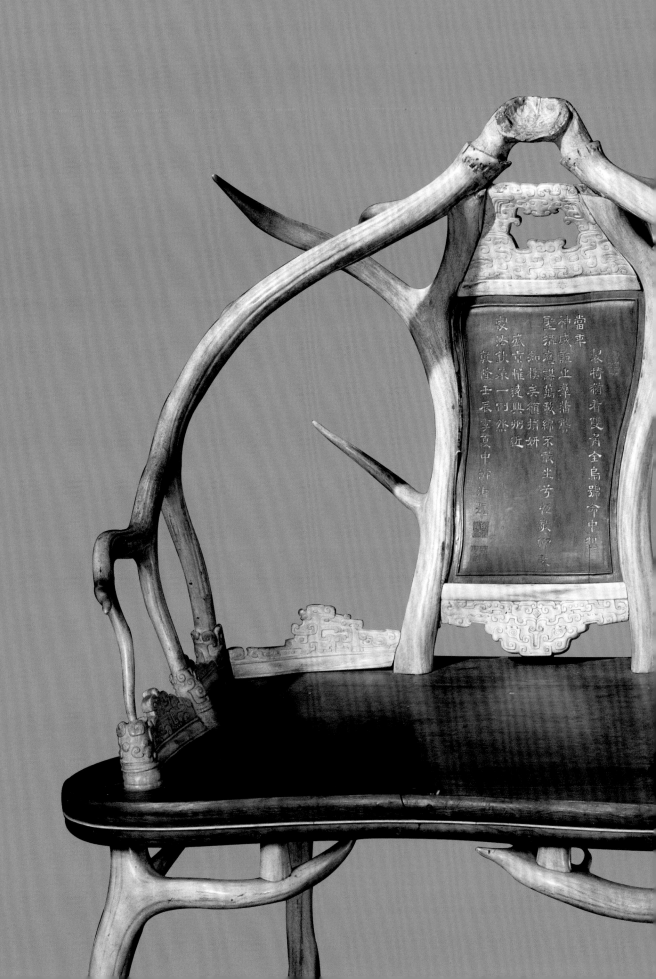

QING DYNASTY FURNITURE

Beds and Couches

Chairs and Stools

Tables and Desks

Chests and Cabinets

Screens

Platforms and Stands

81

Mahogany Canopy Bed Carved
with Dragons

Height 240.5 cm Length 256 cm
Width 169 cm
Qing court collection

The surface of this canopy bed has six posts carved with dragons. The tops of the posts have "Vairocana hats" carved with clouds and dragons in openwork. The hats are there to prevent dust. The lower side of the hat has a lintel panel carved with clouds and dragons in openwork and aprons hanging upside-down. The four sides of the surface of the bed are railings decorated with clouds and dragons. Carved on the edges of the surface are the eight auspicious symbols in Buddhism, including the wheel of the dharma, conch shell, victory banner, parasol, lotus flower, treasure vase, fish pair, and the endless knot. It is waisted under the surface. It has bulging legs, outward-curving aprons, and inward-curving horse-hoof feet. The aprons, legs, and feet are all decorated with clouds and dragons.

Many materials are used to make this bed and the workmanship is exquisite. An overall impression of this bed is that it is tall and huge but unclumsy. It is an exquisite piece of the Qing Dynasty furniture.

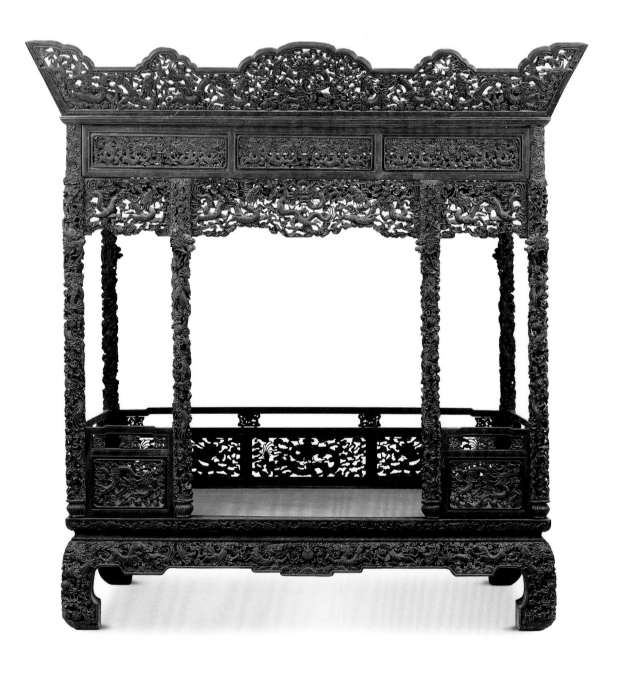

82

Purple Sandalwood Arhat Bed
Inlaid with Jade

Height 88 cm Length 210 cm
Width 105 cm
Qing court collection

Erected on the surface of this arhat bed is a three-screen railing, with the rear side slightly higher than that of the two sides. Fixed on the middle and upper parts of the railing are side stretchers, which are decorated with round and square decorative struts respectively with marble inlaid inside. Under the struts are posts separating sections, with each section having little jade posts spreading all over the place and the middle being inlaid with a square marble. The edges of the surface of the bed are convex mouldings, commonly known as "mud fish's back". Under the surface is a flat and straight waist. It has bulging legs and outward-curving aprons. The aprons are lower-centred, which are carved with rectangular spirals.

The workmanship of this bed is superb, and the shape of this bed is plain and simple. The carving and inlaying complement each other. This bed is a fine piece of early Qing furniture.

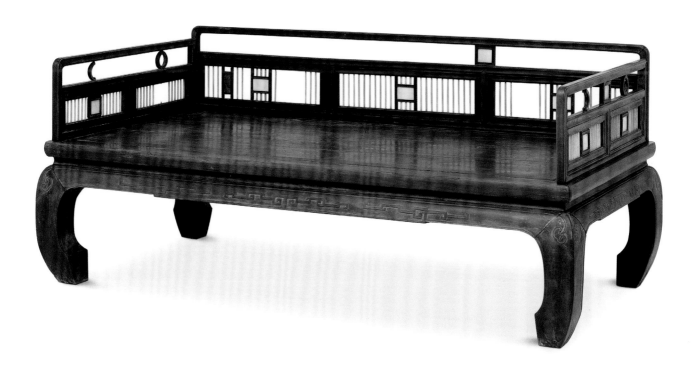

83

Purple Sandalwood Arhat Bed Carved with Lotus Flowers

Height 116.5 cm Length 224 cm
Width 132.5 cm

Erected on the surface of this arhat bed is a three-screen railing. The top rail is protruded, and the two sides extend forward, diminishing with each step. The lattice frame on the surface of the bed is inlaid with a mat at the centre, and it has ice-plate edges and a waist under the surface. It has bulging legs, outward-curving aprons, and inward-curving horse-hoof feet. Decorated all over the railing, legs, bed edges, waists, and lowered centre aprons are lotus seedpods and lotus flowers in openwork.

Rough and strong materials are used to make this bed. It has a strong structure, and the decorations are carved in detail. The railing and aprons, in particular, are carved with large materials, which are rare and valuable. This bed is truly a fine piece of furniture of the early Qing period.

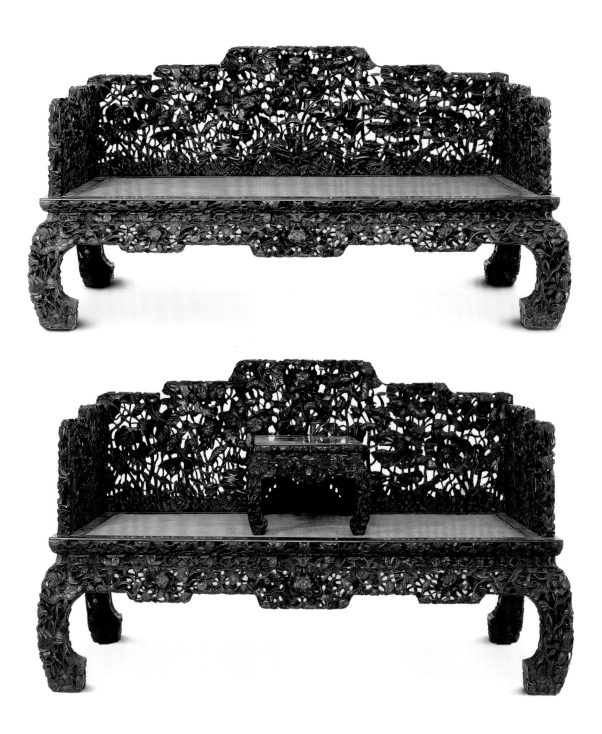

84

Purple Sandalwood Arhat Bed Carved
with *Kui*-dragons

Height 92.5 cm Length 200 cm
Width 103.5 cm
Qing court collection

On the surface of the bed is a seven-screen railing. The framework inside is inlaid with flowery aprons carved with *kui*-dragons in openwork. The lattice frame of the surface of the bed is inlaid with a mat at the centre, under the surface is a waist, and the upper and lower parts are fixed with stepped apron mouldings. The apron and legs of the bed have *kui*-dragons carved in relief. The place where there is the intersection angle is a side spandrel carved with a *kui*-dragon in openwork. It has whorl-shaped horse-hoof feet, supported by a continuous floor stretcher below.

This bed is a typical piece of Qing-style furniture made during the reign of Qianlong.

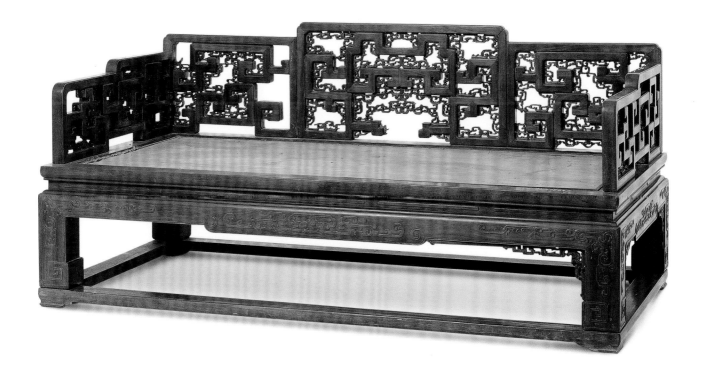

85

Purple Sandalwood Arhat Bed Carved
with *Kui*-dragons

Height 109 cm Length 200 cm
Width 93 cm
Qing court collection

There is a railing on three sides of the bed, forming a nine-panel screen. The back has a bulging top rail, and the two sides descend by steps. All the frames are made of purple sandalwood, the inside of which is inlaid with a central board carved with *kui*-dragons in relief to decorate the smoothed ground on all sides. The lattice frame on the surface is inlaid with a mat, under which is a waist. It has lowered centre aprons, straight legs, inward-curving horse-hoof feet, aprons, and legs and feet decorated with angular spirals. The bed is supported by a continuous floor stretcher.

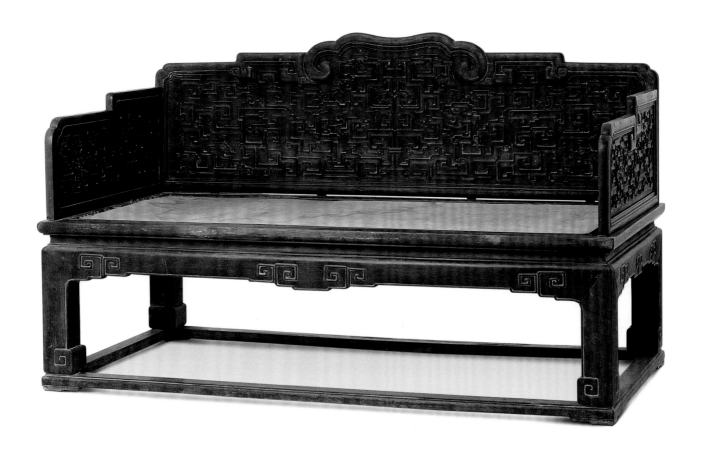

86

Purple Sandalwood Arhat Bed

Inlaid with Marble

Height 108 cm Length 200 cm
Width 93 cm
Qing court collection

The railing of this arhat bed has as many as 11 panels, with each panel using purple sandalwood to form lattice frames, and the middle part in the centre of the board inlaid with marble with natural landscape patterns. The lattice frame of the surface of the bed is inlaid with a wooden board centre. There are ice-plate edges on the two sides. Under the surface is a waist, and the upper and lower parts have stepped apron mouldings. The aprons have jade and pearl (*yubaozhu*) patterns carved in openwork. This bed has square straight legs, the outside edges have raised beadings, and it has horse-hoof feet in angular spirals.

This bed has more railings than other types of beds, and it is inlaid with marble of different sizes. This bed is a rare type of the Qing Dynasty arhat bed.

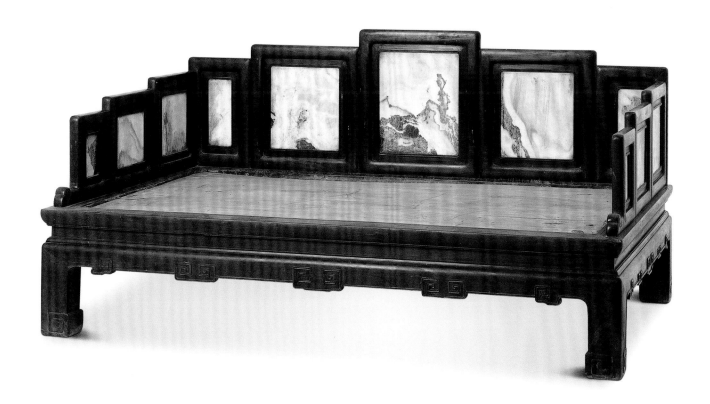

87

Purple Sandalwood Arhat Bed

Inlaid with *Nanmu* Wood, Landscape, and Human Figures

Height 108.5 cm Length 191.5 cm
Width 107.5 cm
Qing court collection

This arhat bed has a seven-screen railing, and its back has a protruding top rail with hooked-cloud patterns. The height of the two sides reduces gradually. The place where the screen and the two shoulders join has hooked-cloud patterns. The railing has purple sandalwood as its frame, which is carved with scenes of landscape and figures showing ploughing, fishing, and logging inlaid with boxwood. It has bed drawers with mat at the centre and is waisted under the surface of the bed. The aprons are carved with hooked-clouds and angular spirals. It has straight legs, and the edges between the legs and aprons have raised beadings which form a continuous flow. It has inward-curving feet with scrolling clouds, which are supported by rectangular tortoise-foot continuous floor stretchers.

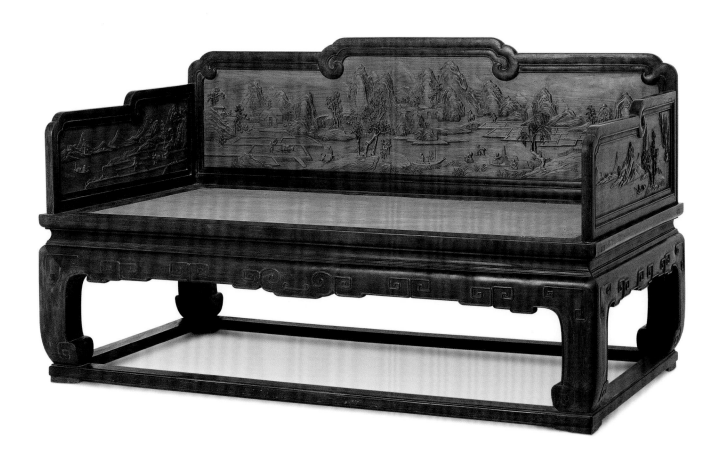

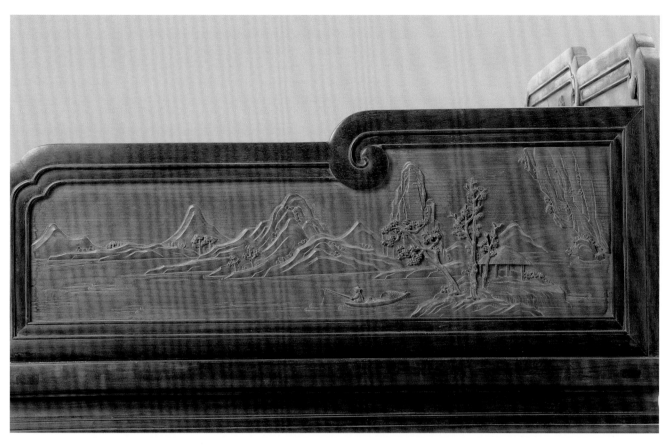

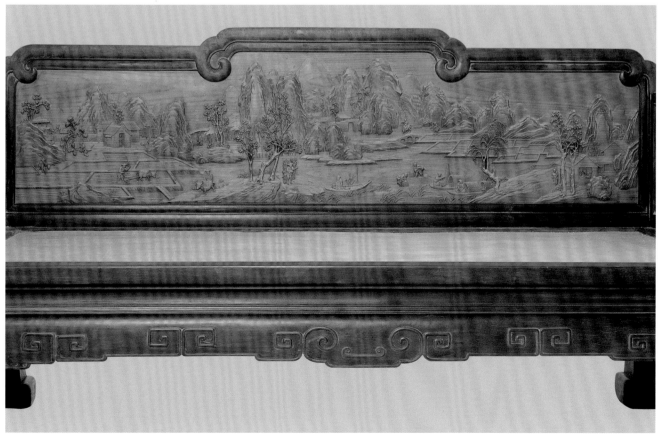

88

Purple Sandalwood Arhat Bed
Inlaid with Copper Flowers

Height 109.5 cm Length 188 cm
Width 154 cm
Qing court collection

This arhat bed has a seven-screen railing, inlaid with passion flowers in branches and swastikas (卍) made in copper. The lower part of the railing is decorated with aprons with pot-door-shaped openings carved with curling tendrils in relief, and the front end of the side of the railing has standing spandrels with clouds. The surface of the bed is broad and deep, and inlaid with a *nanmu* wood central panel. This arhat bed is waisted under the surface, and stepped apron mouldings are fixed to its upper and lower parts. Fixed in the middle of the waist are posts, cutting out three boxes, and inlaid inside the boxes are ornamental panels decorated with carved curling tendrils. It has bulging legs and outward-curving aprons. The aprons have a pot-door-shaped opening, on which are carved *kui*-dragons. The feet step on round pearls, and are supported by continuous floor stretchers below.

The structure of this bed is elaborate, the workmanship is refined, and the decorations on copper fittings are fine and smooth. This bed is a good example of how metal inlaying techniques can be combined with wooden furniture in the mid-Qing period.

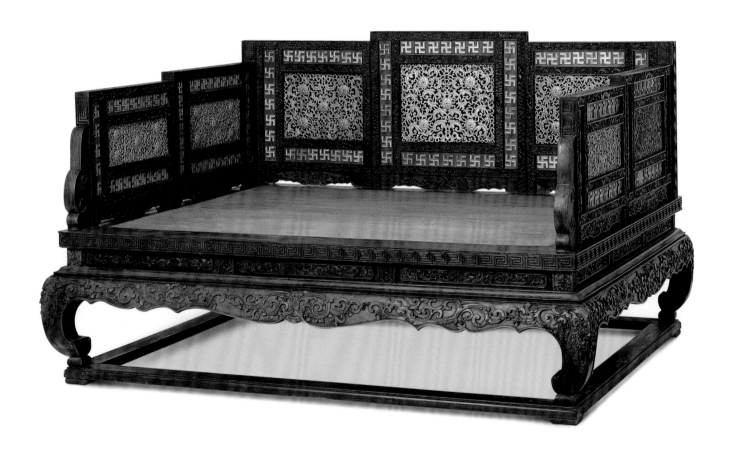

89

Natural Timber Arhat Bed

Height 114 cm Length 217 cm
Width 135.5 cm
Qing court collection

The railing of this arhat bed is made by joining three sections of natural timber stems, and the surface of the bed are carved with grooves and installed with boards with a small heatable stool (*kang ji*) made of natural timber standing on it. The aprons on the edges of the surface and the legs and feet of the bed are all made up of natural timber joining and inlaying together. Before the bed is a footstool made of natural timber.

The overall shape of this bed follows the contours of the human body which makes this an extremely comfortable bed.

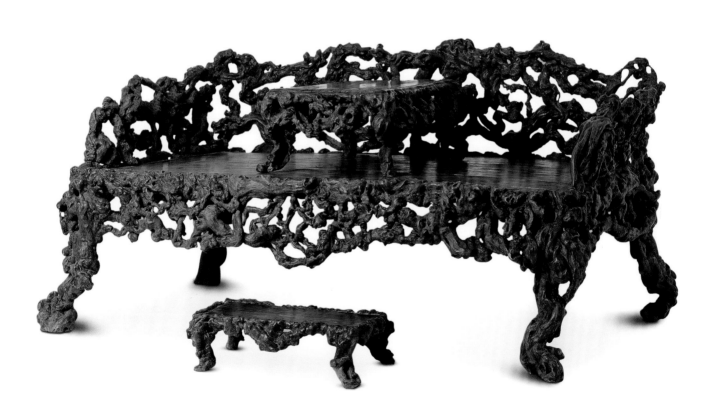

90

Carved Cinnabar Lacquer Arhat Bed
with Clouds and Dragons

Height 108.5 cm Length 231 cm
Width 125 cm
Qing court collection

This arhat bed has a three-screen railing, with its two sides decorated with a painting of "Fish Changing into a Dragon". The surface of the stand is decorated with five dragons traced with liquid gold, with one frontal dragon and four strolling dragons covered with sea water, and the edges of the bed are carved in relief with *chi*-dragons in sea water. Under the surface of the bed are waists and aprons with sea water. It has four inward-curving feet, with the support of a continuous floor stretcher carved with sea water below.

This throne is the largest carved cinnabar lacquer item that we have heard of to date.

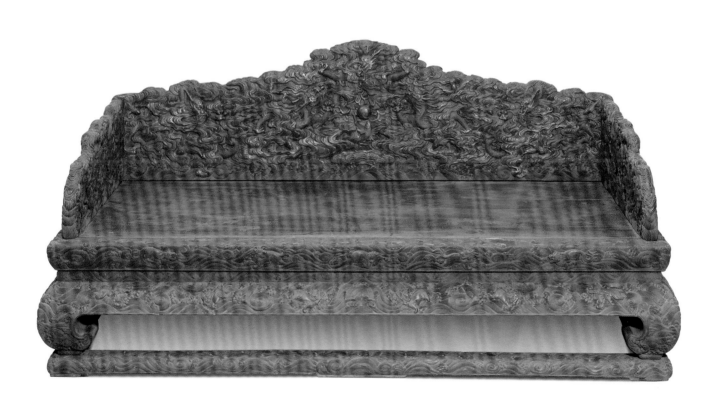

91

Purple Lacquer Arhat Bed
with Landscape Traced
with Liquid Gold

Height 90 cm Length 205 cm
Width 111 cm

This arhat bed has a five-screen railing. Fixed on this lattice frame is a core board. The central panel is decorated with landscape, figures, and pavilions, and the outside frame is decorated with angular spirals. The outer side of the railing and the back side are flowers in branches. The surface of the bed has soft mat drawers made of rattan, and the edges are decorated with flowers in branches. Under the surface is a waist, carved with curling tendrils. The aprons and the legs of the bed are decorated with clouds and bats, and the bed has inward-curving horse-hoof feet.

The craftsmanship of this arhat bed is superb, and the decorative patterns are fine and elaborate. It is a refined piece of furniture during the Yongzheng years of the Qing Dynasty.

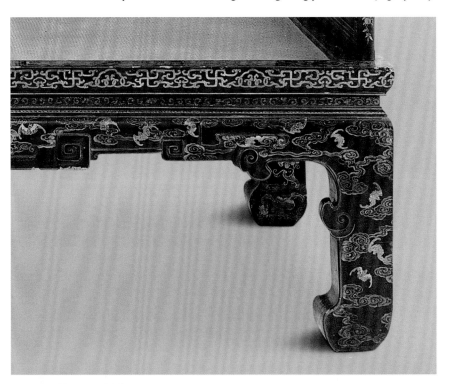

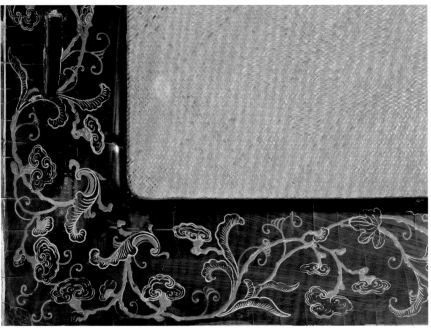

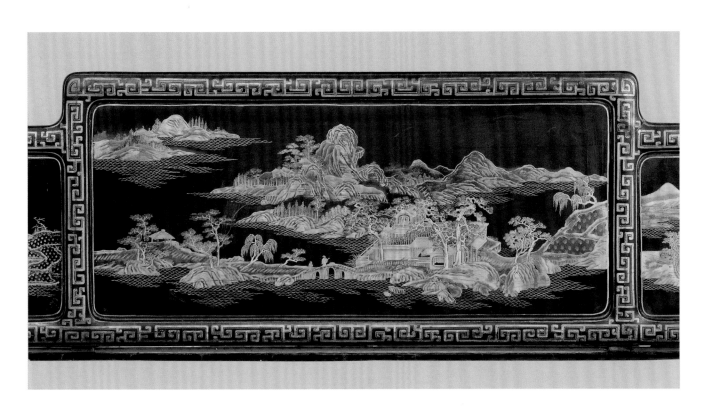

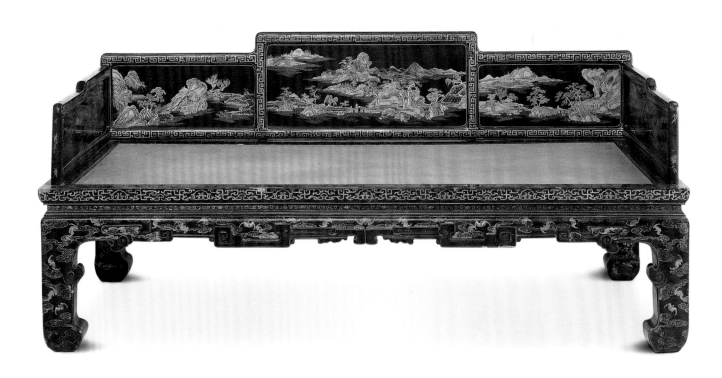

Ebony Arhat Bed
Inlaid with Lacquer Centre

Height 92 cm Length 248 cm
Width 131.5 cm
Qing court collection

This arhat bed has a seven-screen railing, and each screen has lattice frames inlaid with porcelain pieces decorated with flowers, mainly chrysanthemums, begonias, sunflowers, heavenly bamboo, grass, and insects. The centre of the surface of the bed has drawers with floating panels with raised centre and recessed sides, and convex surfaces on the edges. Under the surface is a waist. It has bulging legs and protruding aprons, lowered-centre aprons and inward-curving horse-hoof feet.

Though this bed is Qing furniture, judging by the shape of the bed, it is typical of the Ming period as it consists entirely of ebony without carved motifs.

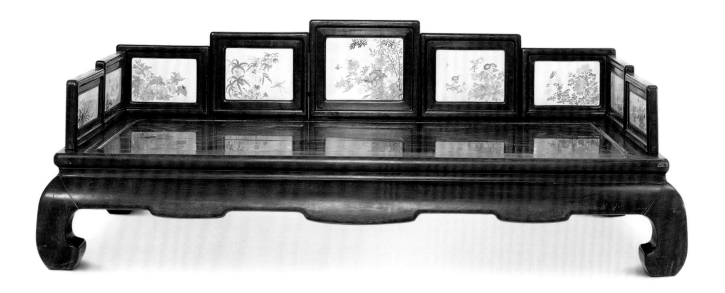

93

Purple Sandalwood Throne Carved
with Lotus Flowers

Height 109 cm Length 98 cm
Width 78 cm
Qing court collection

This throne has a seven-screen railing. It extends from the top rail to the armrest, reducing in height. The top rail is carved as a protruding overturned upward-facing lotus leaf. The backrest board and the armrest are carved with lotus flowers. Some lotuses are budding, others are blooming. The stems of the lotuses curl in intersection and are neat in their crossing. The face of the throne is plain. It is square but roundish. Under the surface are a waist, bulging legs, outward-curving aprons, and inward-curving horse-hoof feet, and under the feet is a continuous floor stretcher. Matched in front of the throne is a purple sandalwood footstool, the style of which is the same as the throne.

This throne has a fine appearance. The craftsmanship is smooth, and the flow is fluent. Judging from the material, shape, and skills, this piece of furniture is an outstanding piece, and is therefore listed as a national treasure.

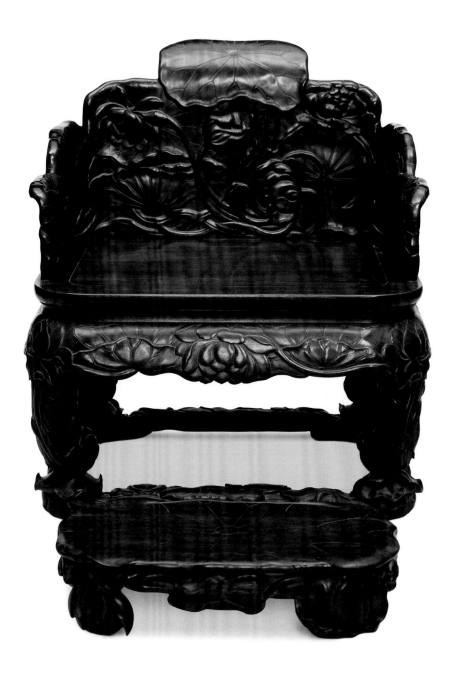

94

Purple Sandalwood Throne Carved
with Western Flowers

Height 107 cm Length 177 cm
Width 80 cm
Qing court collection

This throne has a three-screen railing. It has purple sandalwood frames and a centre board carved with passion flowers inlaid in boxwood. The top rail of the backrest is protruded, descending on the two sides. The end of the armrest is arch-shaped to make it easy to rest the hands. The surface of the throne has purple sandalwood side frames, the middle part is inlaid with a mat, and the surface has ice-plate edges. Under the surface is a waist, and the curved-edge aprons are carved with Western flowers in relief. It has cabriole legs, outward-curving horse-hoof feet, and a continuous floor stretcher under as support.

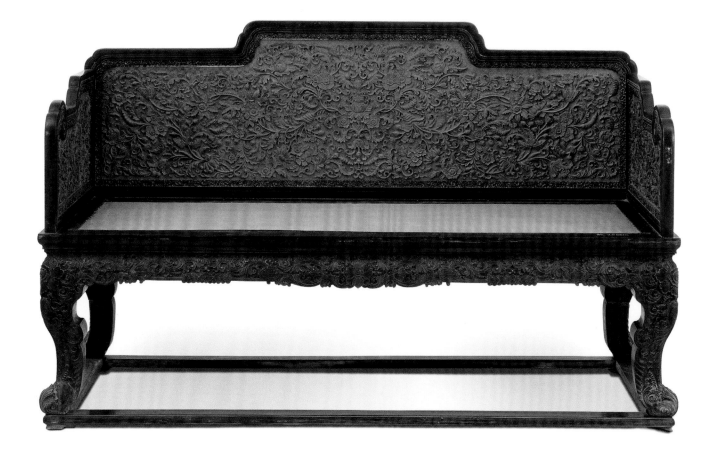

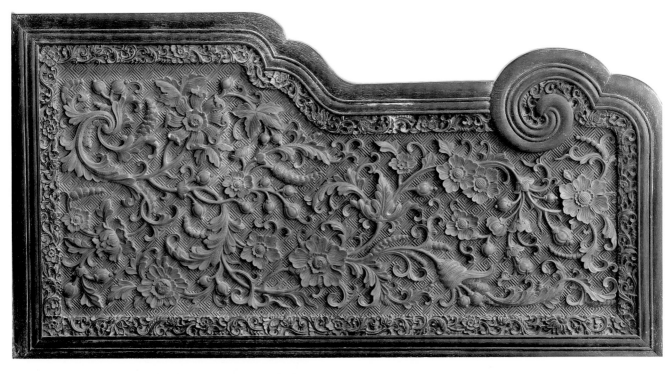

95

Purple Sandalwood Throne Carved
with White Jade Dragons

Height 104 cm Length 109 cm
Width 84 cm
Qing court collection

This throne has a three-screen railing, and the purple sandalwood frames have angular spirals carved in relief. On the top rail with hooked clouds is inlaid with white jade carved with bats. The back board and the armrest all take the green jade carved with clouds as their ground, which are inlaid with white jade carved with dragons and flames. The surface of the throne is inlaid with hard wooden planks in different colours, and they are joined together to form a brocade ground with the character swastika (卍). It is waisted under the surface, inlaid with linear enamel pieces. The lowered centre apron is inlaid with white jade carved with bundles of flowers, clouds, and bats. Fixed on the corner between the legs and aprons are enamelled side spandrels. It has cabriole legs and outward-curving feet with scrolling clouds, which are supported with a continuous floor stretcher from below. In the front part of the throne is a purple sandalwood footstool.

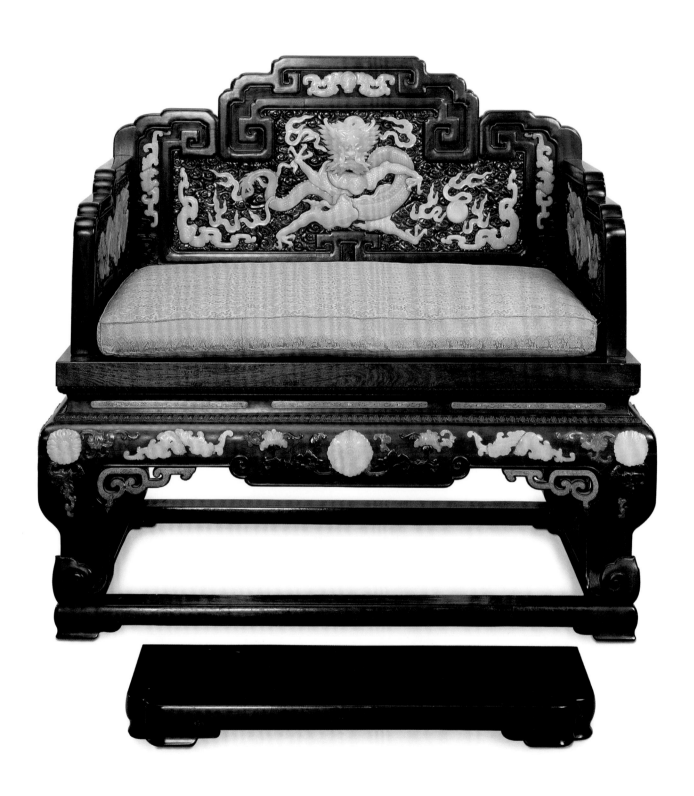

96

Purple Sandalwood Throne
Inlaid with Boxwood with Curling Tendrils and *Kui*-dragons

Height 113 cm Length 102 cm
Width 80 cm
Qing court collection

This throne has a three-screen railing. The top rail is carved into the Western Baroque style. A curved shape descending downward is formed from the two sides of the top rail to the two armrests, showing the shape of a wriggling *kui*-dragon. The armrests and back are inlaid with a boxwood core board, which are carved with passion flowers. Under the throne is a waist, carved with shuttle motifs. The protruding apron, spandrel, cabriole legs, and apron are carved with Western curling tendrils and *kui*-dragons. It has out-curving feet with curling tendrils, and the feet are support by a continuous floor stretcher below.

This throne has a Western flower pattern typical of the Baroque style, originally found in Saint Peter's Cathedral in the Vatican, and later became popular in the palaces of countries in Europe. During the reign of Kangxi, this type of design began to be popular in the Qing court. It was first used in architecture, and later in furniture, a fusion of Eastern and Western arts in furniture.

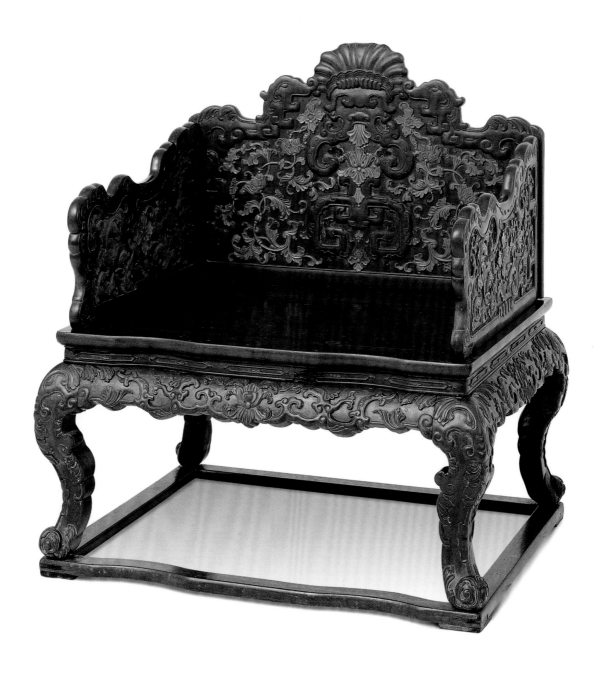

Mahogany Throne Carved
with Dragons

Height 132 cm Length 126 cm
Width 75 cm
Qing court collection

This throne has a three-screen railing, inlaid with a core board. The curved top rail is carved with auspicious clouds. The back board is carved with clouds, dragons, and sea water in relief. The lower frame is carved with curling tendrils, and the core board of the arms are carved with clouds and dragons in relief. The surface of the throne is plain, and its external side has ice-plate edges. Under the surface is a concave-moulding waist. The edges of the surface and waist are carved with eight auspicious symbols in Buddhism, comprising the wheel of the dharma, conch shell, victory banner, parasol, lotus flower, treasure vase, fish pair, and the endless knot. The cabriole legs, legs, and aprons are carved with clouds and dragons in relief. The centre of the apron has a lowered centre apron. This throne has outward-curving feet with scrolling clouds, which are supported below by a continuous floor stretcher carved with two coins in openwork.

The carving of this throne is slightly over-elaborate. It is a piece of work of the middle or the late Qing period.

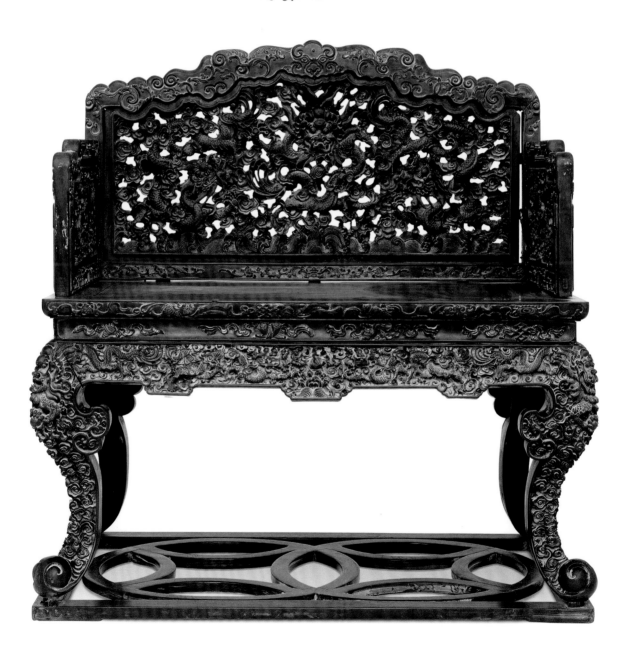

98

Carved Cinnabar Lacquer Throne
with Nine Dragons

Height 96 cm Length 131 cm
Width 80 cm
Qing court collection

This throne has a five-screen railing. Under the surface are a waist, an apron with a pot-door-shaped opening, bulging legs, protruding aprons, and four inward-curving feet, supported from below with a continuous floor stretcher. The entire body of the throne is coated with red lacquer. The backs of the five screens join together to form a picture of five dragons. The central screen is carved with a frontal dragon, with the upper part of this dragon carved with two *kui*-phoenixes surrounding a "萬" (*wan*) character, the flowery aprons of the two ends are carved with clouds and phoenixes, and the back of the armrest is carved with brocade. The surface of the throne is carved with soaring clouds and nine dragons, the edges are carved with *kui*-dragons, and the aprons and legs carved with clouds and dragons. The base of the throne is coated with black lacquer, and the edge has an imitation inscription "made in the Xuande years of the Ming Dynasty", cut by knife. Despite the fact that the shape of this throne is of the Ming style, the carved dragons have features which are typical of the Qing Dynasty. This throne undoubtedly belongs to the Qing furniture.

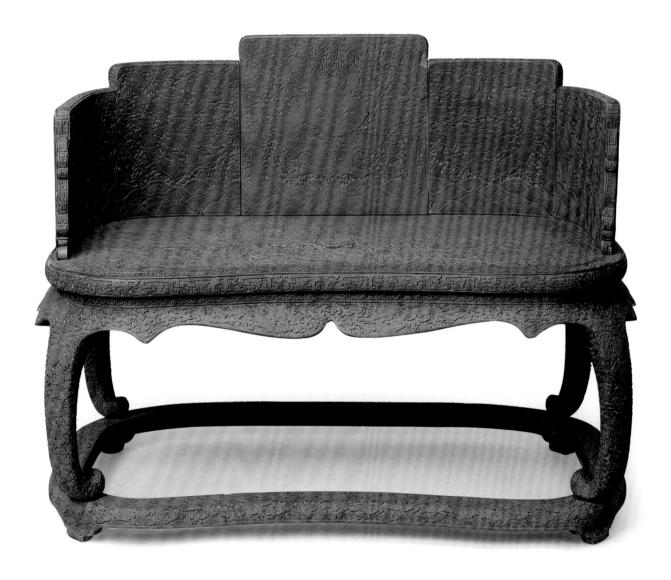

99

Gold Lacquer Throne
with Dragons

Height 165 cm Length 109 cm
Width 60 cm
Qing court collection

The entire body of this throne is made of wood covered with gold lacquer. It has a five-screen railing, the upper part of which has a screen cap carved with dragons in openwork, and the two ends of which have everted flanges with hanging-down clouds. The back panels of the three screens are divided into three sections fixed with ornamental panels. The upper and middle sections are carved with dragons, and the lower part is carved out with pot-door-shaped opening brightening feet. The surface of the throne is inlaid with hard boards. Under the surface are a waist, a smoothed ground with fruit-bearing flowers carved in relief, and the stepped apron moulding carved with lotus petals. The throne has bulging legs, protruding aprons, and outward-curving feet, making the posture of a dragon's claws grasping a pearl, and it is supported by a Buddhist pedestal below. The front of the throne is placed with a two-layer footstool.

This throne was used in the Hall for Ancestral Worship (Fengxian Dian) and was mainly used when making offerings to a memorial tablet.

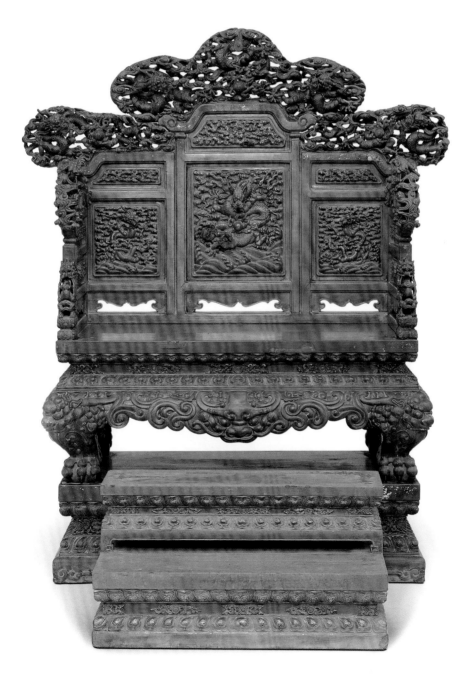

100

Throne Covered
with Gold Lacquer

Height 178 cm Length 155 cm
Width 96 cm
Qing court collection

This throne is made of *nanmu* wood, and the entire body is covered with gold lacquer. On the throne is a curved rest, and its frames have back boards carved with coiling gold dragons, wriggling to the upper part of the armrest on two sides. The lattice frame of the back of the chair is carved with a heart, the middle part has a round medallion carved with bats and round-shaped "*shou*" (longevity) characters, and the four sides have corner flowers decorated with *kui*-dragons. The side edges of the surface of the throne have a brocade ground carved with bats interspersed with slanted swastikas (卐), echoing with the surface of the throne. The four sides of the aprons are hanging down, carved with animal masks and clouds in relief. The spandrels on the four corners are carved with animal heads, three cabriole legs, and an outward-curving dragon grasping the flaming pearl with its claws. The feet below has a base in the shape of a Buddhist pedestal, with decorations which are the same as those on the waist. The front part of the throne has a footstool.

This throne is high and tall, magnificent, and solemn. It was originally placed at the Hall of Imperial Supremacy (Huangji Dian).

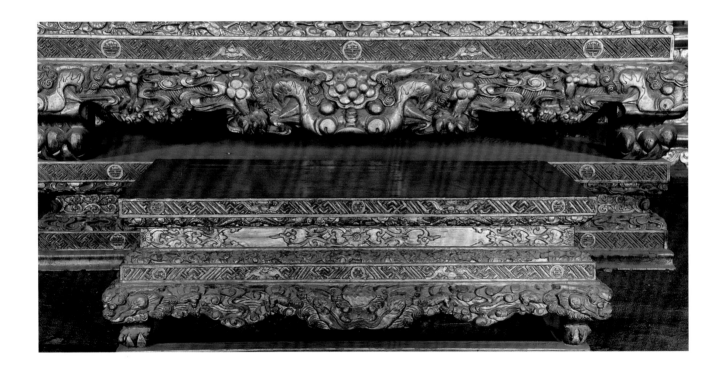

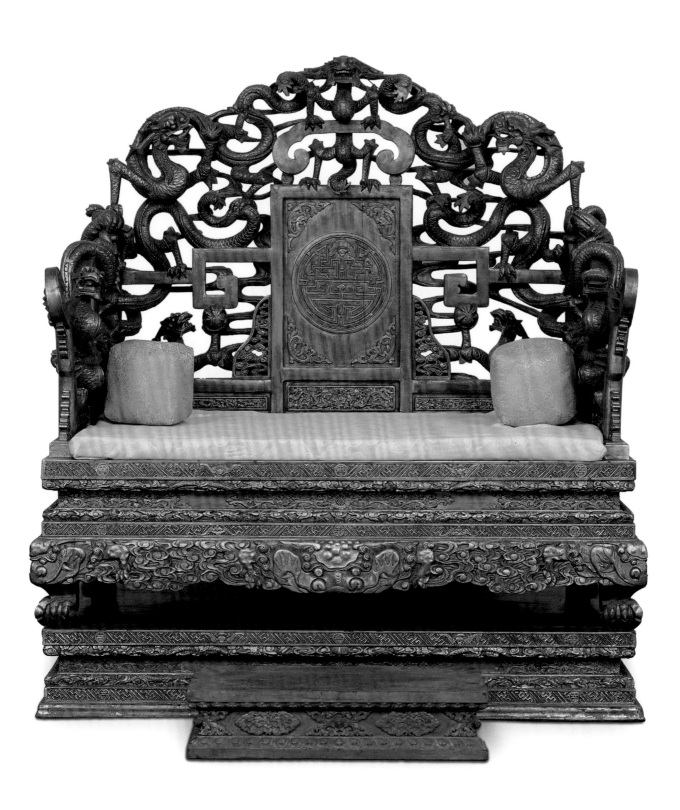

101

Yellow Rosewood Side Chair
with Rectangular Spirals

Height 121 cm Length 56 cm
Width 44 cm
Qing court collection

The two ends of the top rail of this side chair with scrolling clouds are protruded. The backrest board and posts are in a curved shape. The back board has rectangular spirals (*guaizi*) carved in relief, and the lower end is fixed with a spandrel. The place where the posts and top rail join has an apron hanging upside down, and the place where the posts and the surface of the chair meet has chair aprons. It has a recessed surface, with an apron carved with scrolling clouds below. It has square legs and straight feet, and is fixed with stepped chair stretchers.

A side chair with the two ends of the top rail protruding is known as a "lamp hanger style" chair.

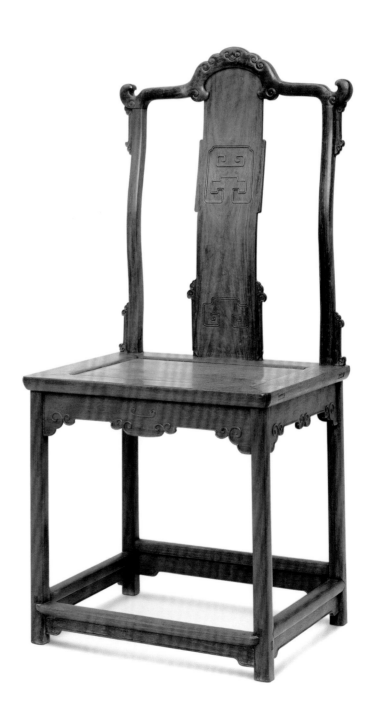

102

Jichi Wood Armchair
with *Chi*-dragons

Height 108.5 cm Length 66.5 cm
Width 50.5 cm
Qing court collection

The backrest of this armchair and the armrest are carved with *chi*-dragons. The centre of the backrest is inlaid with black jade, which is carved in concave with a frontal view dragon traced with liquid gold. Under the surface of the chair is a waist, with a spandrel carved with *chi*-dragons in relief. The side edges of the inside of the square legs have raised beadings, a straight-form base stretcher, and inward-curving horse-hoof feet with angular spirals.

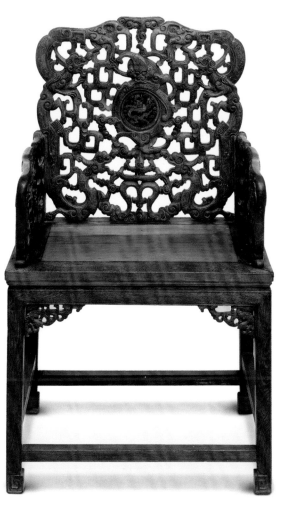

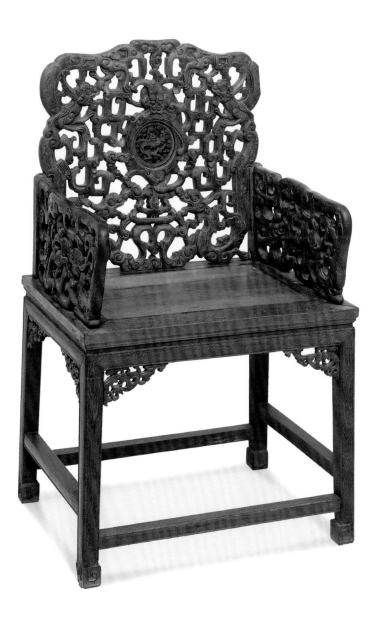

103

Purple Sandalwood Armchair
with a Curved Rest with Curling Tendrils

Height 99 cm Length 63 cm
Width 50 cm
Qing court collection

The curved rest of this armchair is formed by joining three sections. The backrest board is made of lattice frames. The upper part has a medallion carved with curling tendril in openwork, the middle part is inlaid with burl wood, and the lower part is an apron made up of two facing elephant heads and cloud patterns. The armrest is carved in openwork with outward-curving curling tendrils. The lattice frames of the surface of the chair is inlaid with rattan, and the sides have ice-plate edges. Under the surface are a waist, bulging legs and protruding aprons, and feet with inward-curving curling tendrils, supported by a continuous floor stretcher with tortoise feet below.

This armrest is a piece of early Qing furniture. The overall layout has the style of the Ming furniture, but its carving decorations obviously shift to the style of the Qing furniture.

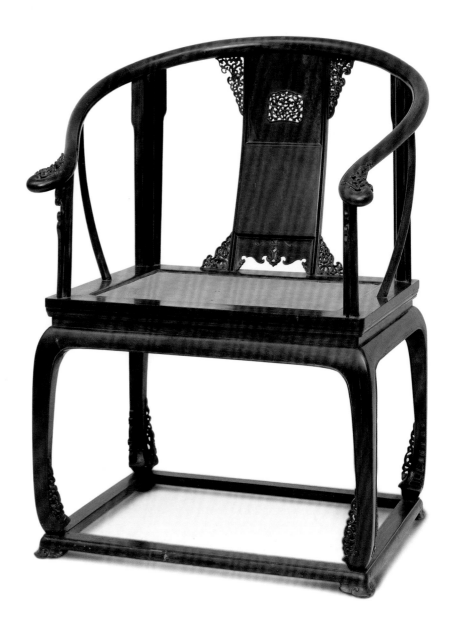

104

Purple Sandalwood Chair
with Fortune (*Fu*), Celebrations (*Qing*), and *Ruyi* Cloud Patterns

Height 108 cm Length 66 cm
Width 51.5 cm
Qing court collection

The top rail in the middle of the curved rest is protruded, and it leans back to roll into the form of a scrolled book. The middle of the curved backrest board is carved with bats, chimes, and *ruyi* cloud heads, with the connotation of "fortune and happiness as you wish". The two sides of the backrest board and armrest are carved with *kui*-dragons. Under the surface of the chair is a flat and straight waist, and the flowery aprons are made of short materials to form rectangular spirals. The inner side of the straight legs have raised beadings and a straight-form base stretcher, which is fixed underneath with an arch-shaped apron.

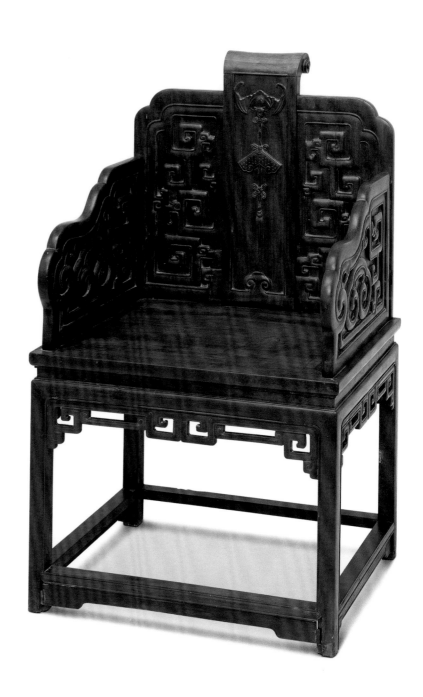

105

Purple Sandalwood Chair
with Fortune (*Fu*) and Longevity (*Shou*)

Height 108.5 cm Length 65.5 cm
Width 51.5 cm
Qing court collection

The top rail in the middle of the back of the chair is protruded. The backboard is made of short materials joining the straight to form a "*shou*" (longevity) character, and it is carved with bats and angular spirals. The armrest is also made of short materials joining the straight to form an angular spiral, the whole body highlighting the meaning of "fortune and longevity are boundless". The surface of the chair has purple sandalwood lattice frames, inlaid with plain hard wood. The side edges and waist are flat, straight, and plain. It has square legs and straight feet, and the corners between the legs and aprons are decorated with rectangular spirals and side spandrels. The bead-edged base stretcher has double raised beadings, and forms a continuous flow with the legs and the inner side of the aprons. The corners of the legs and stretchers are decorated with side spandrels carved with scrolling clouds in relief.

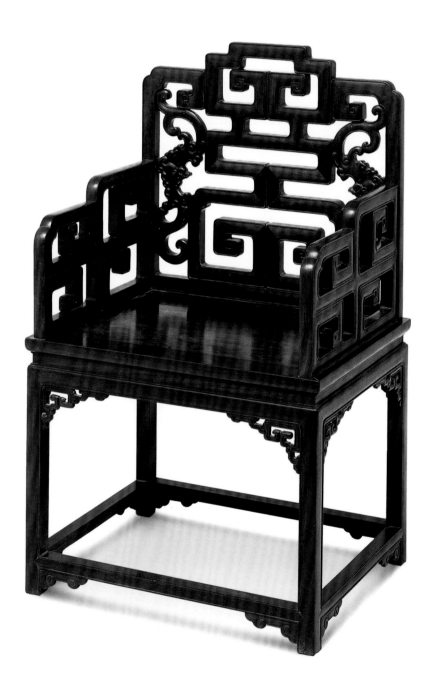

106

Purple Sandalwood Splat
Inlaid with Porcelain Screen

Height 88.5 cm Length 55.5 cm
Width 44.5 cm
Qing court collection

This chair has a seven-screen railing. All the frames are made of purple sandalwood, and the centre of the burl wood board inside is inlaid with birch. The top rail is protruded high, and turns backward to roll into the shape of a scrolled book. A ladder shape is formed from the shoulders to the armrest. The top rail, backrest, and the centre board of the armrest are all inlaid with porcelain pieces with a painting of flowers and birds in four seasons in colourful powder, which carries auspicious connotations. The surface of the chair has purple sandalwood side frames with a mat seat in the centre, and its sides has ice-plate edges. Under the surface is a burl wood waist, with its upper and lower parts fixed with stepped apron mouldings. The lowered centre apron has angular spirals carved in relief. It has straight legs, inward-curving horse-hoof feet with angular spirals, and between the legs are fixed with bead-edged base stretchers.

Judging from the shape of this chair, it should be of the Yongzheng period. The colour-powdered porcelain pieces were made especially for the Qing court by porcelain kilns of Jingdezhen.

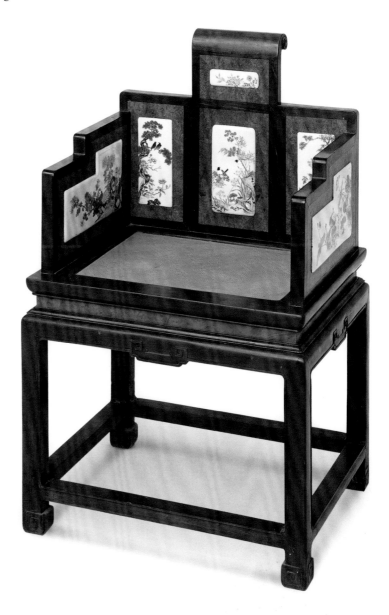

107

Purple Sandalwood Chair
Inlaid with Enamel (A Pair)

Height 114 cm Length 64 cm
Width 51.5 cm
Qing court collection

The backrest of this chair is in the shape of a precious vase used in worship. Its upper part has *ruyi* cloud patterns, with its centre inlaid with boxwood carved with chimes. The middle part is slightly square, inlaid with cloisonné enamel pieces which are decorated with flowers. The top rail and the armrests on the two sides are *qiu*-dragons carved in openwork. The surface of the chair has purple sandalwood frames, which are inlaid with a plain hardwood core board. Under the edges of the surface are a concave-moulding waist and straight legs. The legs of the chair and the inner side of the apron have single edge beadings which form a continuous flow, and they are inlaid with arch-shaped aprons. It has inward-curving horse-hoof feet with angular spirals.

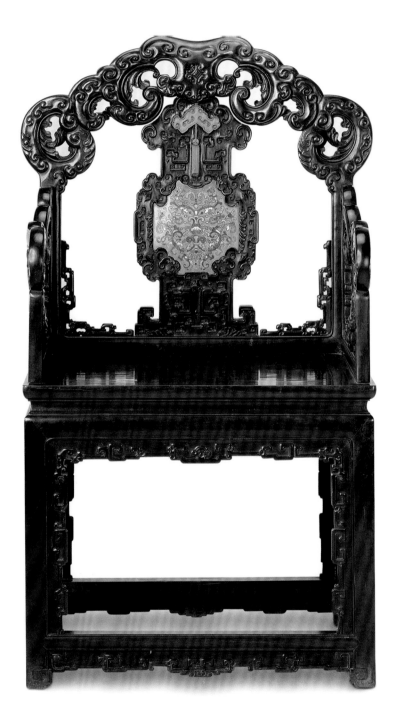

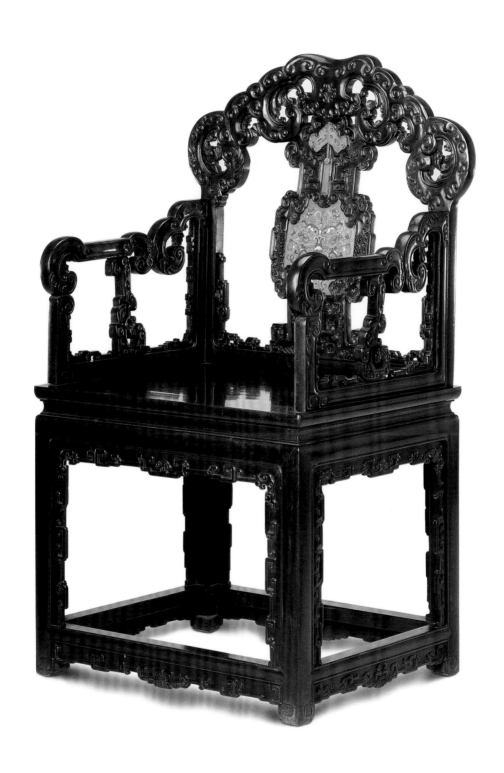

Purple Sandalwood Chair
with Western Flowers

Height 117.5 cm Length 66 cm
Width 51.5 cm
Qing court collection

The backrest board of the chair is in the shape of a precious vase for use in worship, which is carved with Western flowers. The frames of the backrest and armrests are also in the Western style, and they are joined with a Baroque top rail. The surface of the chair has lattice frames inlaid with a board, and under the surface is a waist carved with scrolling clouds. The curved-edge aprons are carved with Western flowers. It has cabriole legs and the spandrel parts are also decorated with Western flowers. It has outward-curving feet with an eagle grasping a pearl with its claws, and it is supported by a floor stretcher below.

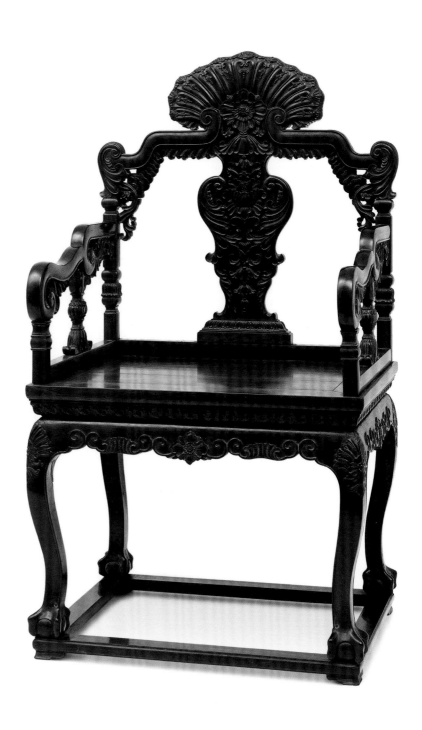

109
Natural Timber Chair
Height 95.5 cm Length 81 cm
Width 58 cm
Qing court collection

The backrest of this chair and armrests are formed by joining and inlaying tree stumps. The seat of the chair is inlaid and fixed with plain boards, and the four sides have tree stumps in complete veneer. The aprons, legs, and feet under the seat are formed by joining the tree stumps.

The overall layout of this chair followed the natural shape of the tree stumps.

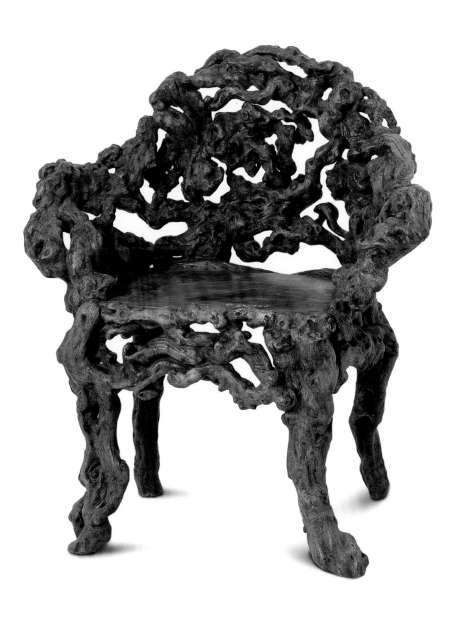

110

Deer-horn Chair

Height 130 cm Length 78.5 cm
Width 72 cm
Qing court collection

This chair is formed by joining deer horns. The back of the chair has deer horns as its frame, and the backrest board inside is inlaid with purple sandalwood. The middle of the board is carved with a poem by Emperor Qianlong, which was composed in the 28th year in the reign of Qianlong (1763 A.D.). It tells the significance of holding the annual imperial event of "hunting for deer in the Mulan paddock in autumn", and the reasons for making this chair. The seat is made of purple sandalwood, under which is a deer horn with the skull. The stump part is wrapped in purple sandalwood and carved with clouds. The forks of the horns face downward and are outward-curving. Its shape is like a bulging leg with the feet as its tips, joining the purple sandalwood floor stretcher.

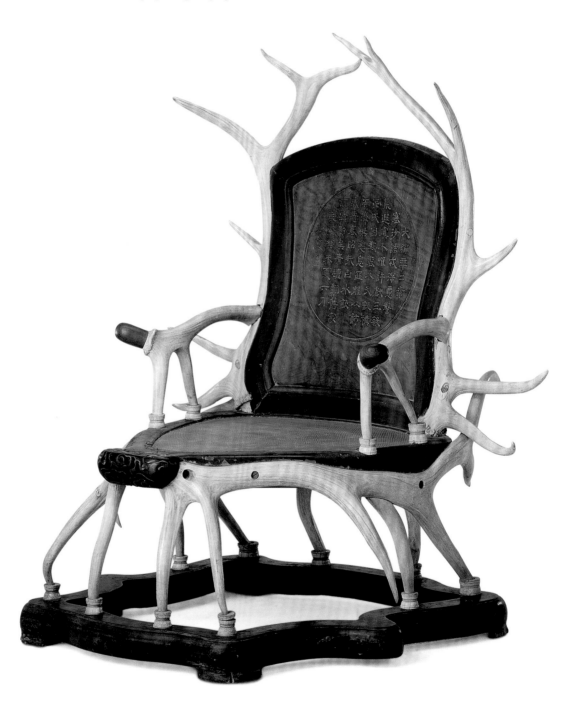

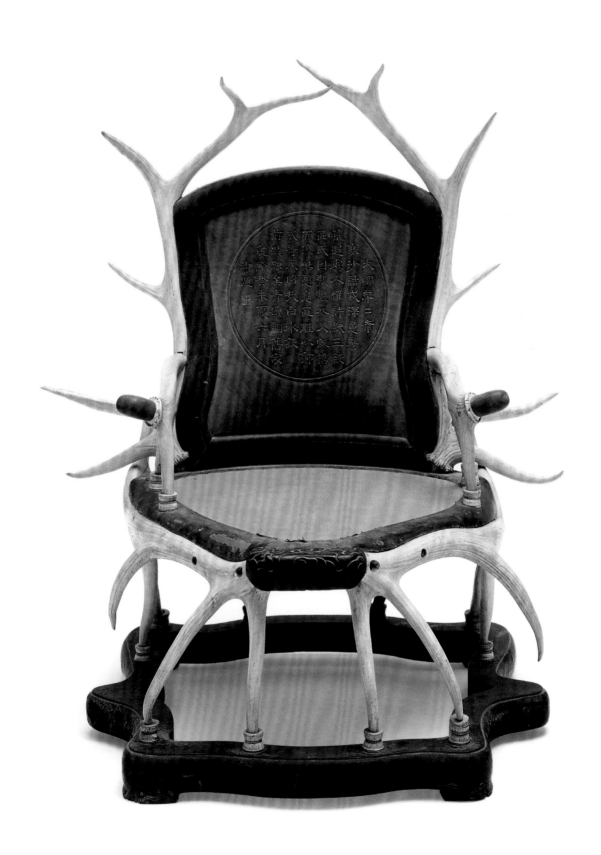

111

Deer-horn Chair

Height 131 cm Length 90 cm
Width 86.5 cm
Qing court collection

This is an armchair with a curved rest. The back of the chair is made of an intact horn of a deer, with the root of the deer linking to the skull. The branches of the horn skilfully substitute the gooseneck front posts and the handle of a sickle. The back of the rear has two deer horns as its support, and the centre is inlaid with a board, which is engraved with a poem written by Emperor Qianlong in regular script, entitled "Deer Horn Chair to Praise Imperial Ancestors". This poem was written in the 37th year in the reign of Qianlong (1772 A.D.), and it indicates that this chair was made of horns from the deer hunted by Emperor Kangxi. The seat of the chair is made of yellow rosewood. The front edges and the two sides are slightly concaved inward, the side edges are wrapped with ox horns, and the middle part is inlaid with an ivory apron as a dividing line. The two sides of the seat and the rear part are inlaid with seat spandrels carved with hooked clouds on bones, linking with the back of the chair with deer horns. The front and rear parts under the chair are made of back branch horns of two deer, the horn branches are symmetrically inward-facing which skilfully form a side spandrel support, and the roots of the horn, which is outward-facing, also form outward-curving horse-hoof feet. The front part of the chair has a footstool, with the four feet made with the horns of two small deer.

The shape and functions of this chair are skilfully combined with the natural outline of the deer horns, which shows the bold and creative spirit as well as the superb artistic abilities of the chair maker, making this type of chair a special type of furniture for the Qing court.

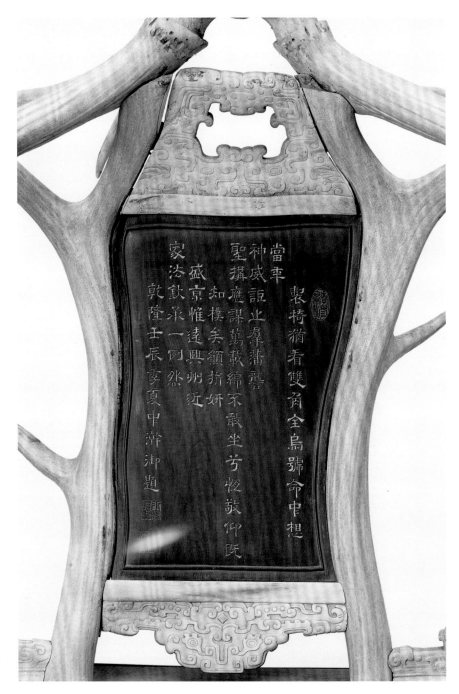

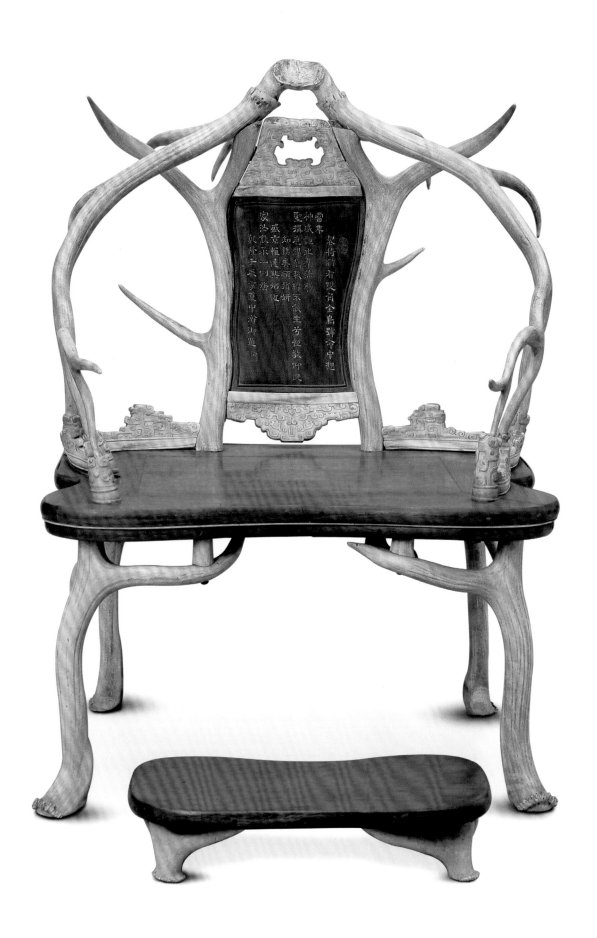

155

112

Black Lacquer Armchair

Height 98 cm Length 58 cm
Width 50 cm
Qing court collection

The entire body of this chair is painted with black lacquer. The chair is plain without any decorations. The top rail, armrest, and side posts are made of arc-shaped materials, and the backrest is slightly curved. The seat is inlaid with a recessed board. It has square legs and straight feet, and between the legs are stepped chair stretchers.

This chair belongs to plain lacquer furniture. The shape of this chair is plain and simple. It is a type of furniture made and used widely during the Ming and Qing periods. According to the Qing court archives, this chair was originally in the Prince's Study (*Shangshufang*), which is located on the left-hand side of the Gate of Heavenly Purity (*Qianqing Men*). The Prince's Study was set up during the reign of Yongzheng as a place for princesses and imperial children to study.

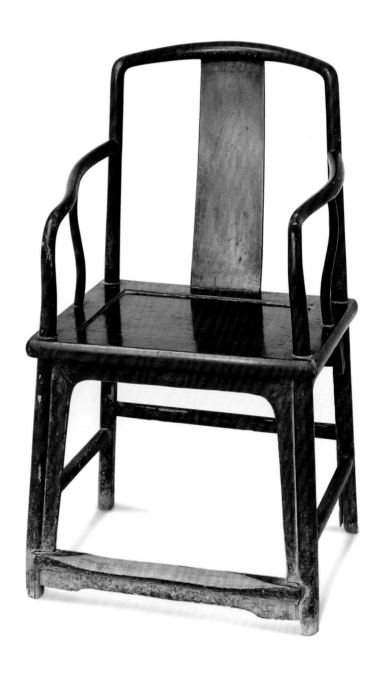

113

Purple Sandalwood Armchair
with Ten-thousand Fortune Traced with Liquid Gold

Height 104 cm Length 67 cm
Width 57 cm
Qing court collection

The backrest and armrest of the chair have small materials used to make rectangular spiral patterns. At the centre of the backrest is a swastika (卍) traced with liquid gold, and the frame is decorated with bats and flowers on branches traced with liquid gold which has the connotation of "ten-thousand blessings". The seat has a straw mat glued on it. Under the seat are a waist and an ornamental panel decorated with flowers traced with liquid gold and carved in relief. There is a stepped apron moulding below. The centre of the the apron has a lowered centre apron with openwork. Under the spandrel are clouds carved in relief. The corner position where the legs extend is fixed with spandrels decorated with scrolling clouds. The inward-curving horse-hoof feet are carved with angular spirals.

Qing-style armchairs put great emphasis on decorations and carving, but neglected the scientific aspects of furniture. Most of the armchairs have vertical backrests and do not have sprayed contracture, and the seats and rests are not comfortable.

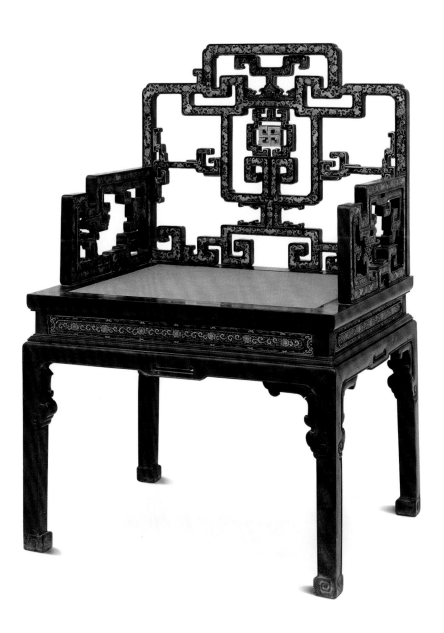

114

Black Lacquer Double Chair Traced
with Liquid Gold

Height 96 cm Length 96 cm
Width 42 cm
Qing court collection

The inner frames of the double backrest chair, the seat, and the front and rear legs of the inner side are joined together as a body. The backrest board is divided into three sections. The upper section is decorated with rolling waves traced with liquid gold and carved with round whirlpools. The middle section is a rectangular medallion, decorated with flowers and grass traced with liquid gold. The lower section is carved out with brightening feet in the shape of cloud heads, on which are flowers traced with liquid gold. Fixed on the lower part of the backrest board is a side stretcher, inlaid with an arch-shaped inner frame with a pot-door-shaped opening. Under the seat is a waist, and under the waist is an arch-shaped inner frame apron with *chi*-dragons traced with liquid gold. The four feet in the outside are inward-curving horse-hooves, and the two feet in the middle are double-curving horse-hooves.

This chair is for two persons to sit on at the same time. In ancient times, it was also known as a "love chair". The special feature of this double chair is that it is joined holistically, has double backrests and six legs and feet. This way of making the chair saves materials and shows the coherence of its overall layout, displaying great craftsmanship.

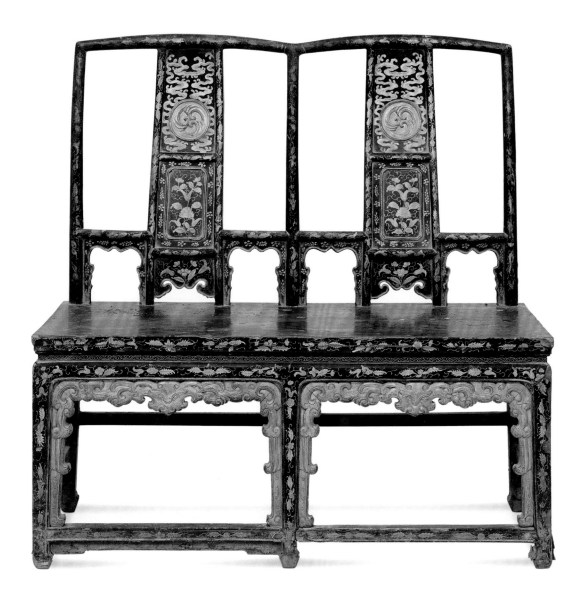

115

Folding Chair
with Dragons Lacquered in Gold

Height 105.5 cm Length 52.5 cm
Width 41 cm
Qing court collection

The five lozenge-shaped curved rests of this folding chair and the dragon heads at the front parts of the armrests are joined together, resembling two wriggling dragons. The front part of the backrest board is carved with a painting of "A Hoary Dragon Teaching Its Young Ones" (*canglongjiaozi*) painted with gold lacquer. The back of the board is carved with the painting of "The True Forms of the Five Sacred Mountains" (*wuyuezhenxing*), complemented with clouds and water. The Taoists believe that this painting symbolizes the five famous mountains in China, having the connotation of "turning ill luck into good". The spaces among the curved rests, back boards, and armrests are decorated with clouds in gold lacquer. The seat has rattan at the centre, and the two ends of the beam in front of the seat are carved with heads of *chi*-dragons. The space under the seat and legs are aprons with *kui*-phoenixes carved in openwork. The feet are supported by floor stretchers below. The front part has a footstool.

The folding chair is also known alternatively as a "barbarian bed" (*huchuang*). It has the front and rear legs crossing each other as the axis, and the seat of the chair can be folded. It originates from nomadic people, as it is portable and easy to use. Later it gradually developed into an item used by the guard of honour when the emperor was on tour. It is usually made of *nanmu* wood or catalpa wood, and its external side is coated with gold lacquer.

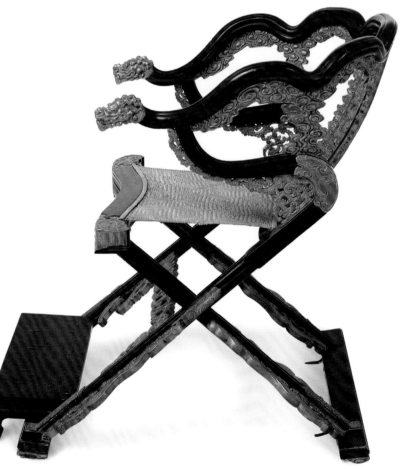

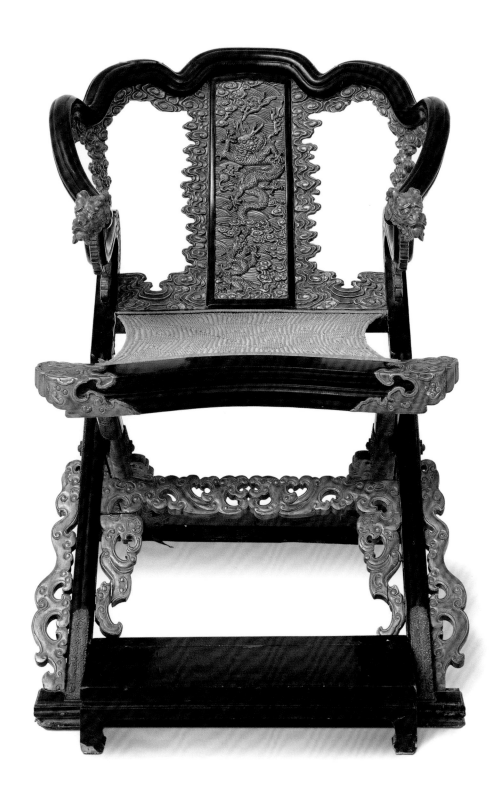

116

Large Folding Chair
with Dragons Lacquered in Gold

Height 121 cm Length 107.5 cm
Width 104 cm
Qing court collection

The five lozenge-shaped curved rests of this folding chair and sculptured *chi*-dragons' heads in the front part of the armrests are joined together, resembling two meandering *chi*-dragons. The back board is painted with gold lacquer, carved with a painting of "A Hoary Dragon Teaching Its Young Ones" (*canglongjiaozi*). One of the two dragons is at a high level and the other one is at a low level. The large dragon moves among the clouds, calling on the small dragons to soar into the sky. The seat has rattan at the centre. The apron under the seat is carved with clouds and dragons in relief. The spaces between the legs are aprons carved with *kui*-phoenixes in openwork. Under the feet is a support floor stretcher. There is a footstool in front of the chair.

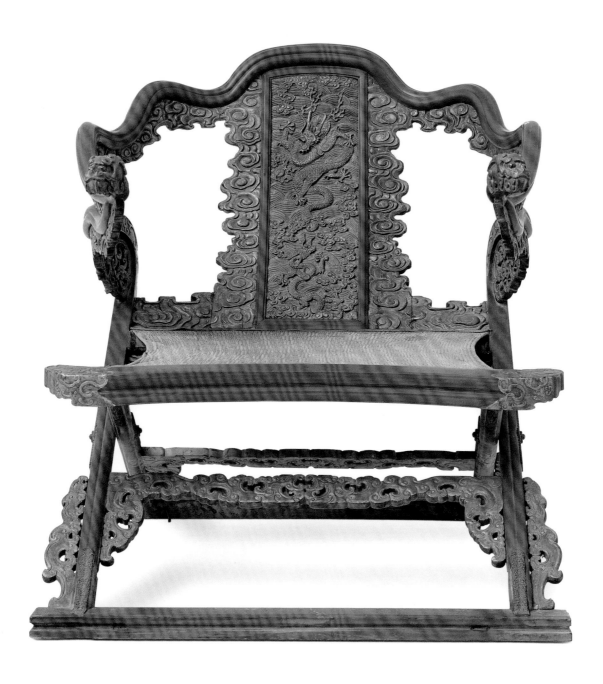

117

Nanmu Wood Round Stool
Inlaid with Porcelain at the Centre

Height 49 cm
Diameter of Surface 41 cm
Qing court collection

This round stool is inlaid with porcelain at the centre, which is painted with clouds and dragons in underglaze blue. It has bulging legs and outward-curving aprons, and the legs and aprons are joined with embracing-shoulder tenons. The lower parts of the four legs are joined with floor stretchers with double-mitred tenons, forming four medallions with pot-door-shaped openings. The ends of the feet have webs, and the lower part of the floor stretchers is decorated with turtle feet.

This round stool originally was one of the eight pieces in a set. At present, the Palace Museum and the Summer Palace each has four pieces.

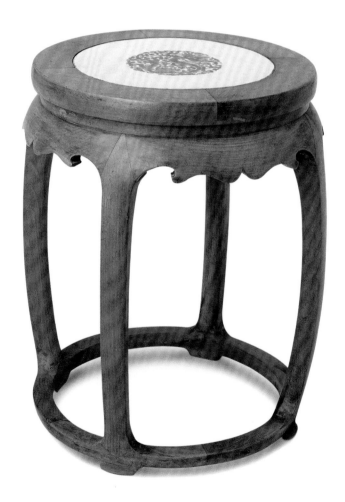

118

Nanmu Wood Stool

Height 67 cm Length 68 cm
Width 68 cm
Qing court collection

The four sides of the armrest of the wood stool and the backrest are flushed, like a sedan chair. There is a waist under the seat, and the middle part of the apron is carved with scrolling clouds. It has straight legs, four flat stretchers in the space between the legs , and feet carved with angular spirals.

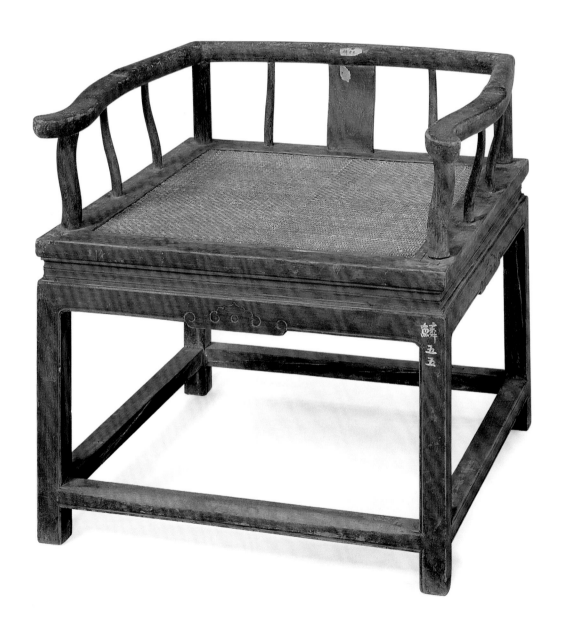

119

Purple Sandalwood Rectangular Stool
Inlaid with *Nanmu* Wood at the Centre

Height 41.5 cm Length 53 cm
Width 31.5 cm
Qing court collection

The seat of this rectangular stool has purple sandalwood lattice frames, and the core of the board is inlaid with *nanmu* wood. The sides have ice-plate edges. Fixed under the surface are humpback stretchers, and the large surface has two pairs of pillar-shaped struts. The sides are relatively narrow and can only have single pillar-shaped struts. The four round legs are contracted in the side corners. The lower end is fixed with a base stretcher.

The stool is made of quality materials with a shape that is simple and natural. It is a typical piece of Ming-style furniture. The *Jinsi nanmu* wood that is inlaid was usually used as a building material in the Ming Dynasty. During the years of Kangxi in the Qing Dynasty, the emperor held the view that extracting *nanmu* wood from the south was a waste of human resources. As a result, *nanmu* wood was gradually replaced by pine trees from Xing'an Mountain. From then on, *nanmu* wood furniture became increasingly precious.

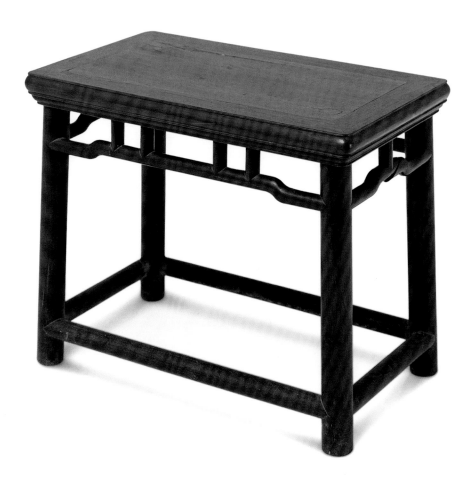

120

Purple Sandalwood Square Stool
with *Lingzhi* Fungi

Height 47.5 cm
Diameter of Surface 33.5 cm

The lattice frame of the surface of the stool is inlaid with a hardwood centre board. The edges and waist are all carved with *lingzhi* fungi. It has bulging legs and outward-curving aprons. The aprons and spandrels and stretchers in the horizontal and vertical directions are carved with overturned *lingzhi* fungi and lowered centre aprons, creating a balanced effect for all parts of the stool.

Judging from the shape of this square stool, it belongs to a type of Ming-style furniture. From an artistic point of view, the workmanship is refined, and the decorative patterns and carving are modestly brilliant, smooth, and plentiful, reaching the artistic level of attaining beauty in harmony.

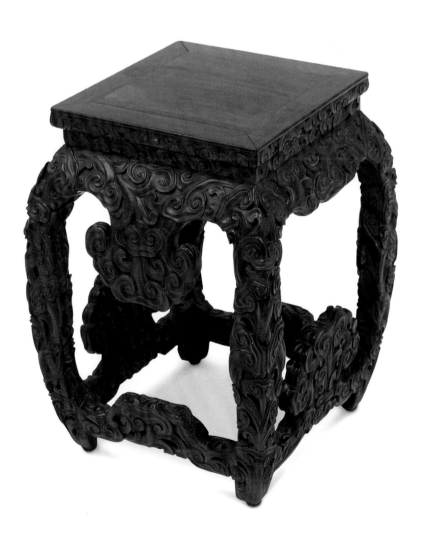

121

Purple Sandalwood Square Stool
Inlaid with Enamel Lacquer Surface with Flower Clusters

Height 43 cm
Diameter of Surface 38 cm
Qing court collection

The surface of this stool is decorated with bats, hooked lotus flowers, and flower clusters in black lacquer and traced with liquid gold. The four sides are decorated with *chi*-dragons traced with liquid gold. The side edges are carved with angular spirals, and the four corners are inlaid with enamel pieces, under which they are supported by posts in the shape of enamel bottles. Inlaid on the aprons and legs of the stool are copper enamel pieces decorated with *chi*-dragons. It has inward-curving feet with angular spirals, supported from below with a square floor stretcher with turtle feet.

This stool is one of a pair, and it forms a set of matching furniture with items in similar style such as long tables. This is a fine piece of furniture made by the Imperial Workshops of the Qing court during the Qianlong period.

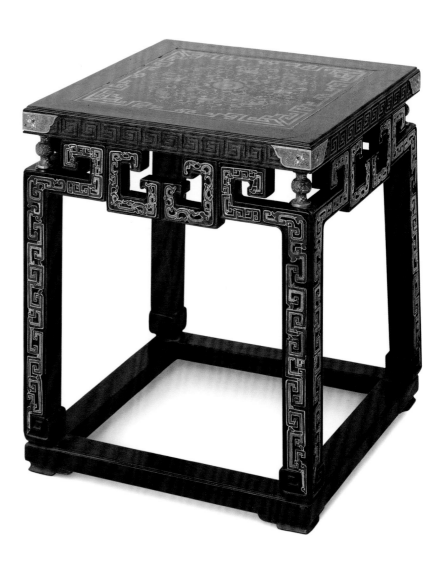

122

Purple Sandalwood Square Stool

Inlaid with Copper Mouldings

Height 41.5 cm
Diameter of Surface 37 cm
Qing court collection

The lattice frame of the surface of the stool is inlaid with a board, the side edges are carved with jade and pearl (*yubaozhu*) patterns in relief. Under the surface is a waist which has a rectangular medallion with raised beadings. It has square legs and straight feet, and the four sides of the legs have convex-surface double edge beadings. On the legs of the stool and the upper and lower parts of the side stretchers are open grooves inlaid with copper wire which forms a continuous flow. The feet rest on a round pearl.

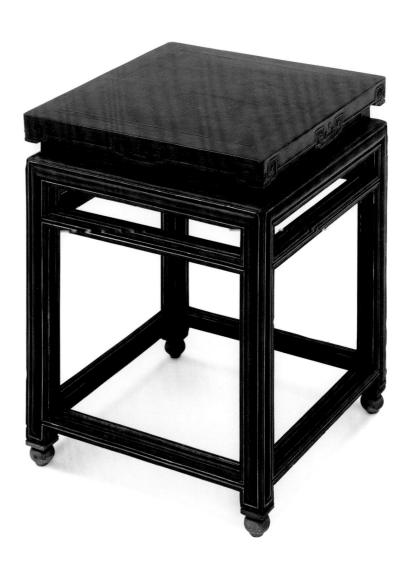

123

Purple Sandalwood Hexagonal Stool
Inlaid with Clusters of Flowers in Jade

Height 47 cm
Diameter of Surface 35.5 cm
Qing court collection

The surface of the stool is hexagonal, with its middle part inlaid with swastikas (卍) joined together by purple sandalwood planks. It has flat and straight side edges, under which is a concave-moulding waist, and it is inlaid with cloisonné enamel pieces with twelve strips of curling tendrils on a green ground. The upper and lower parts of the waist have stepped apron mouldings with lotus petals carved in relief. It has bulging legs, outward-curving aprons, and a drooping lowered centre apron. The legs and aprons are inlaid with white jade carved with bats, clusters of flowers, and *chi*-dragons. It has inward-curving scrolling-cloud feet, supported below by a floor stretcher with turtle feet.

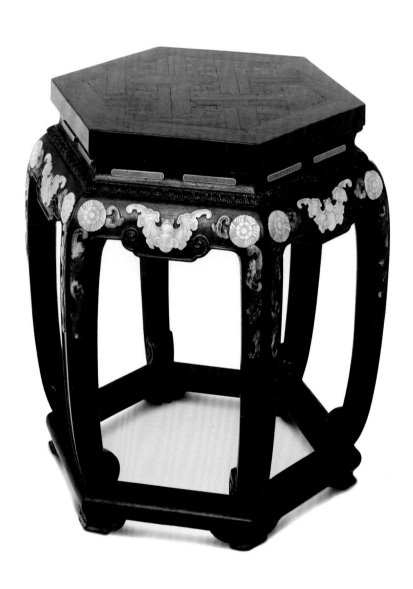

124

Purple Sandalwood Square Stool
with *Ruyi* Cloud Patterns

Height 43 cm
Diameter of Surface 37 cm
Qing court collection

The lattice frame of the surface of the stool is inlaid with a core board, and the four edges have ice-plate edges. Under the surface is a high waist, fixed with an ornamental panel, with each side having three medallions respectively. Under the waist is a floor stretcher, joining below the flowery apron with *ruyi* cloud heads in openwork. The split moulding is made into cabriole legs, and it has feet in the shape of outward-curving scrolling clouds. The feet are supported below by a floor stretcher with turtle feet.

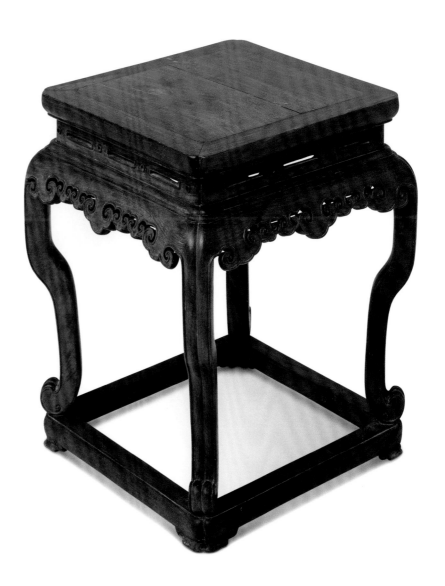

125

Purple Sandalwood Stool
Inlaid with Bamboo Sections and Plum Blossoms

Height 46 cm
Diameter of Surface 34 cm
Qing court collection

The surface of the stool is in the shape of a five-petal plum blossom. It has mouldings and grooves on the side edges, and inlay bamboo strands into the grooves. Under the surface is a concave moulding waist, with icy plums carved in relief. Fixed on the waist are stepped apron mouldings on the upper part and the lower part. The apron and the upper and lower parts of a hard-cornered humpback stretcher follow the surface of the stool to form the shape of a plum blossom. The surfaces of the apron, legs, and the stretcher have grooves to inlay bamboo strands.

The shape of this stool is new and its structure is delicate. The matching of purple sandalwood with bamboo strands create a stark contrast in colour, and the effects of decoration is very good.

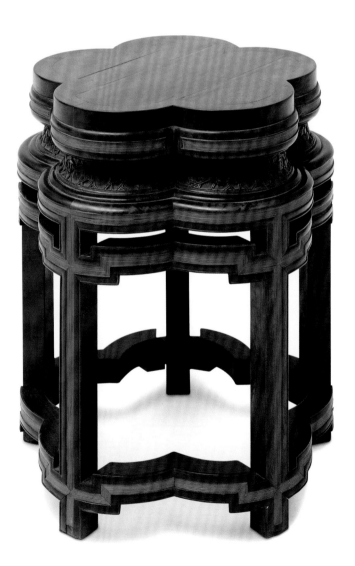

126
Square Stool
with Bamboo Inner Skin

Height 46 cm
Diameter of Surface 34.5 cm
Qing court collection

This stool is made of wood, and its entire body is wrapped and inlaid with bamboo. The surface of the stool is square and cornered, and there is a waist under it. The four sides of the waist have rectangular medallions. Fixed on the upper and lower parts of the waist are stepped-apron mouldings, bulging legs, outward-curving aprons, aprons with angular spandrels, and inward-curving horse-hoof feet, supported below by a floor stretcher. The stretcher also follows the square and cornered stool surface, with all parts of the stool in harmony.

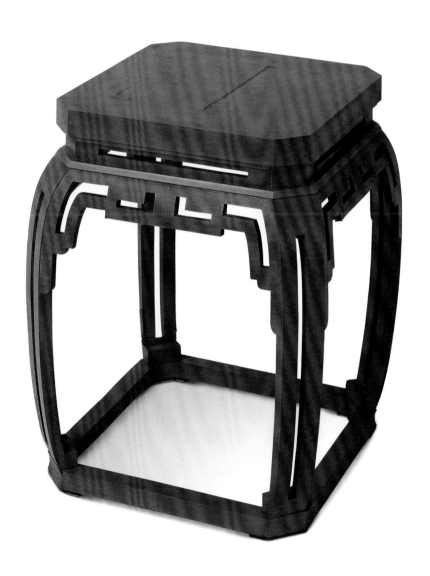

127

Carved Black Lacquer Stool
with Plum Blossoms Painted in Colour

Height 50 cm
Diameter of Surface 30 cm
Qing court collection

The surface of this stool is in the shape of a plum blossom. It has icy plum painted in colour and yellow sea water as the ground, which is decorated with white plum blossoms. The side edges are carved with angular spirals, and the side edges are decorated with angular spirals and plantain leaves. Below the surface is a waist with plantain leaves, the upper and lower stepped apron mouldings are carved with angular spirals, and the aprons are also carved with angular spirals and transformed plantain leaves. Spreading all over the legs are a hexagonal brocade carved with flowers and middle mouldings with angular spirals, and between the legs are fixed with stretchers with double-ringed twisted ropes. It has inward-curving horse-hoof feet, supported below with a floor stretcher in the shape of a plum blossom with a swastika (卐) brocade.

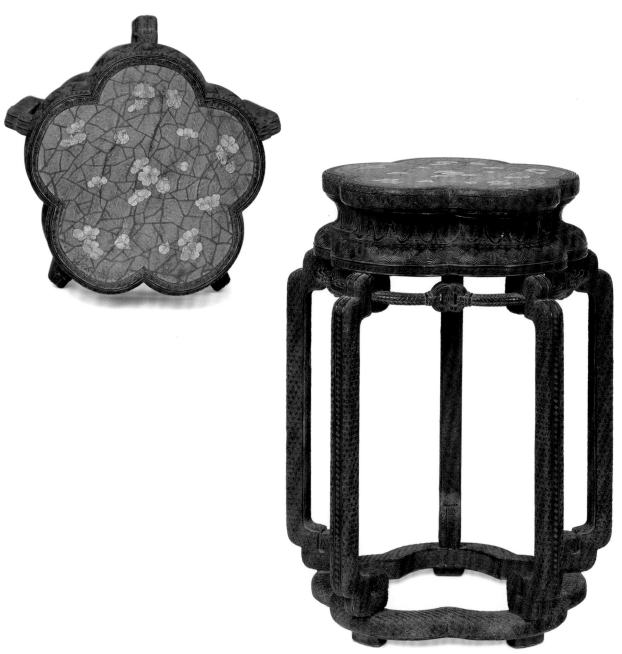

172

128

Yellow Rosewood Embroidery Stool
Inlaid with a Burl Wood Seat

Height 47 cm
Diameter of Surface 36 cm
Qing court collection

The surface of this embroidery stool is inlaid with a round burl wood seat. The two ends on the body of the stool have each carved with an arch, with a round of drum nails. The four legs join with the surface of the stool and the base by inserted shoulder points. The spaces between the four legs are decorated with arc-shaped circles made with imitation rattan products, which creates a strong decorative effect.

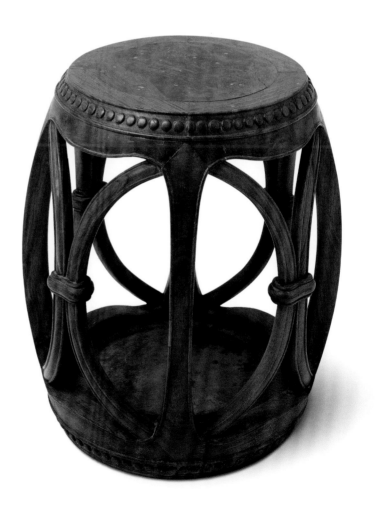

129

Jichi Wood Embroidery Stool with Five Medallions

Height 46.5 cm
Diameter of Surface 27.5 cm
Qing court collection

The upper and lower parts of the body of this embroidery stool have each carved out four arcs, and the middle part has two arcs with double mouldings. The spaces between the upper and lower arcs are each decorated with a round of drum nails. The middle part of the belly has five oval medallions carved in openwork and decorated with double mouldings.

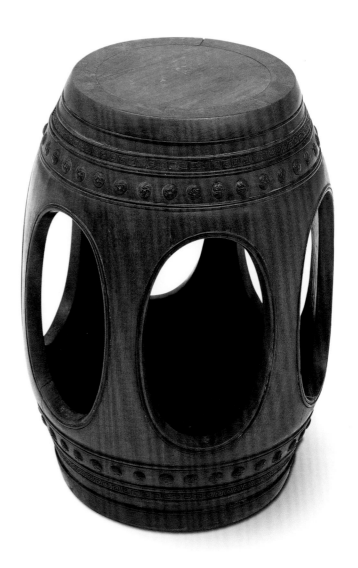

130

Purple Sandalwood Octagonal Embroidery Stool
with Animal Masks Holding a Ring in the Mouth

Height 52 cm
Diameter of Surface 37 x 31 cm
Qing court collection

The surface of this embroidery stool has purple sandalwood lattice frames in the shape of an octagon, which is inlaid with a hardwood core board. Under the surface is a plain, flat, and vertical waist, which is also octagonal, matching the stool wall which has eight sides. In the side frames of each side of the embroidery wall are fixed with ornamental panels carved with rolling leaves, *ruyi* sceptres, angular spirals, and animal masks holding rings in openwork. The base of the embroidery stool has eight small turtle feet.

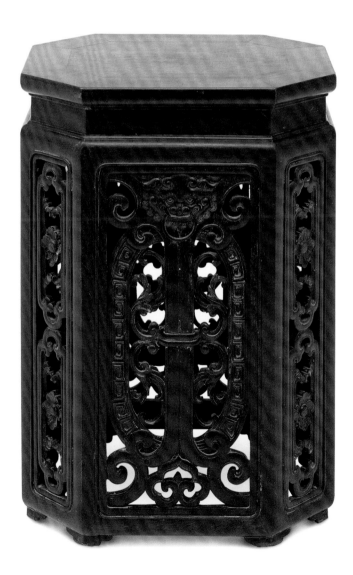

131

Purple Sandalwood Embroidery Stool
with *Kui*-Phoenixes

Height 50 cm
Diameter of Surface 34 cm
Qing court collection

The surface of this embroidery stool has purple sandalwood lattice frame, which is inlaid with a hardwood board seat. Under the surface is a concave-moulding waist. The spandrel is carved with a round of cicadas, and has *ruyi* cloud head medallions carved in openwork. The stool wall has four oval medallions with indented corners, and in the medallions are two *kui*-phoenixes tied with round rings carved in openwork. Carved on the indented corners of the medallions are two *qiu*-dragons. The two sides of the medallions are matched with flowers and leaves.

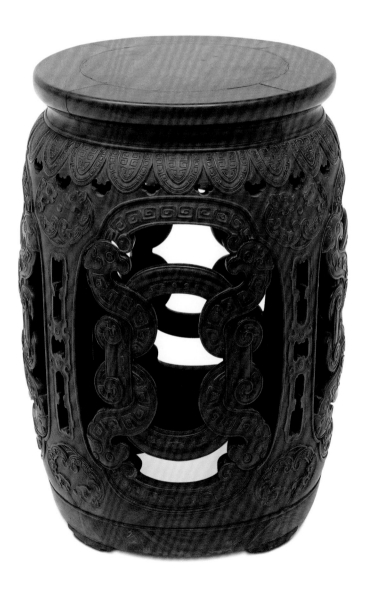

132

Purple Sandalwood Embroidery Stool
Inlaid with Enamel

Height 52 cm
Diameter of Surface 28 cm
Qing court collection

The surface of the embroidery stool and the stool walls are inlaid with cloisonné enamel pieces decorated with Western flowers. On the upper and lower ends of the stool walls are decorated with drum nails and arcs.

This embroidery stool, the purple sandalwood arhat bed inlaid with enamel, and the purple sandalwood throne inlaid with enamel are from the same set of matching furniture. They are refined pieces of furniture during the Qianlong years of the Qing Dynasty.

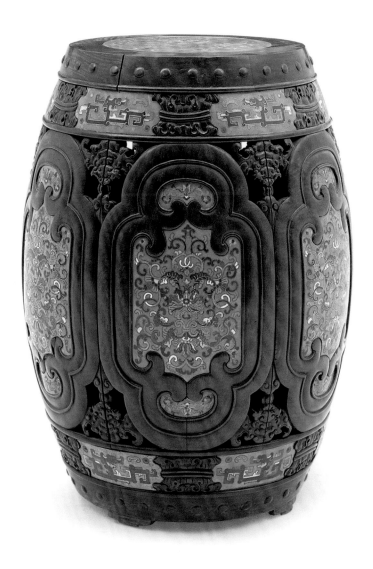

133

Purple Sandalwood Embroidery Stool
with Dragons, Phoenixes, and Endless Knots

Height 50 cm
Diameter of Surface 34 cm
Qing court collection
a plain hardwood core board

The surface of this embroidery stool is a hexagon with indented corners, fixed and inlaid with a hardwood core board. Under the surface is a concave-moulding waist, fixed with stepped apron mouldings on the upper and lower parts. The six sides of this embroidery stool are carved with *kui*-dragons, *kui*-phoenixes, and endless knots in openwork, having a connotation of "the country is in perpetual stability, and is long and lasting".

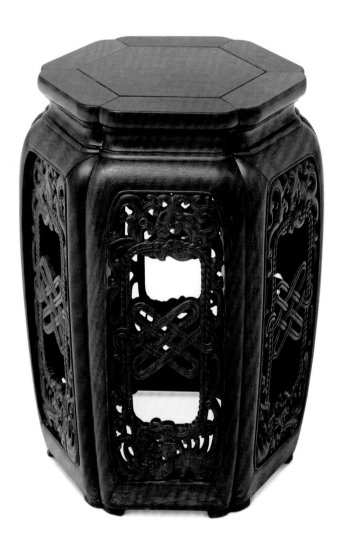

134

Black Lacquer Embroidery Stool
with Dragons and Phoenixes Traced
with Liquid Gold

Height 43 cm
Diameter of Surface 35.5 cm
Qing court collection

The surface of this embroidery stool is decorated with dragons and phoenixes traced with liquid gold, meaning "prosperity brought about by the dragon and the phoenix" (*longfengchengxiang*). The surface of the stool and the side edges of the base of the stool are all decorated with miscellaneous treasures traced with liquid gold, such as *ruyi* sceptres, lozenges (*fangsheng*), clouds, and chimes (*qing*). The waist is decorated with angular spirals traced with liquid gold, and the stool walls have *kui*-dragons carved in openwork with the hooked edges traced with liquid gold.

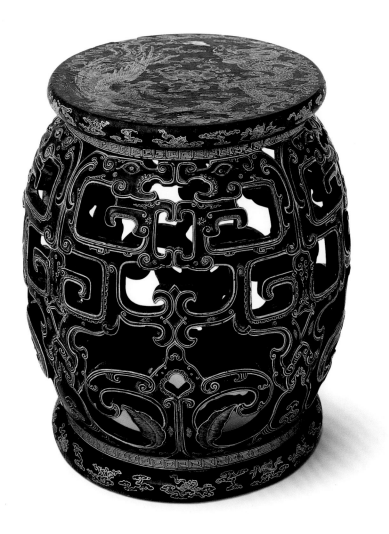

135

Embroidery Stool
with Lotus Flowers in Contrasting Colours

Height 55 cm
Diameter of Surface 32 cm
Qing court collection

The four sides of the surface of the embroidery stool have a purple ground decorated with flowers on branches, and the centre has a sky blue ground contrasting in colour with lotus flower decorations. The body of this tool is distributed evenly with four cloud-head medallions carved in openwork and traced with liquid gold. Decorated outside the medallions is a blue ground contrasting with colourful lotus flowers. The upper and lower parts of this stool each have a round of purple ground with weeds and drum nails in gold.

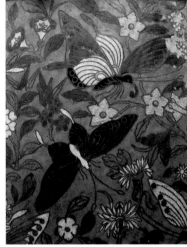

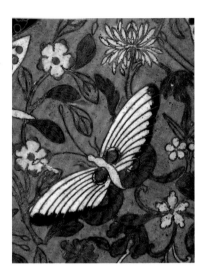

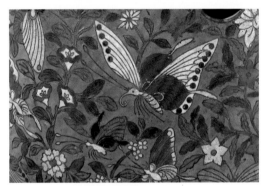

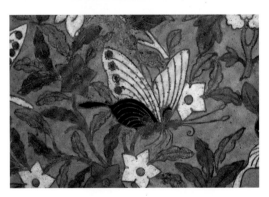

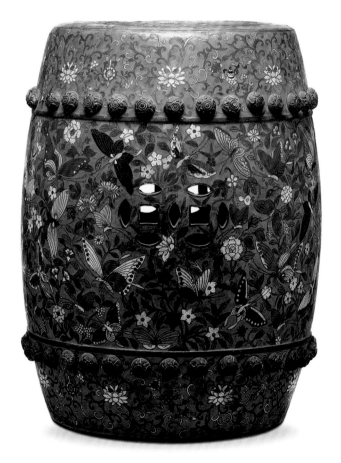

136

Purple Sandalwood
Two-drawer Long Table

with *Kui*-phoenixes

Height 88 cm Length 98.5 cm
Width 49.5 cm
Qing court collection

The lattice frames of the surface of the table is inlaid with a core board. Under the surface is a waist. Under the apron is a high humpback stretcher, and the decorative struts on the two ends are carved with *kui*-phoenixes and clouds. Fixed in the middle of the waist and aprons are two drawers, fixed with copper accessories. The square legs are straight and downward, and it has inward-curving horse-hoof feet. All the edges of the surface, aprons, legs, and feet have concave mouldings.

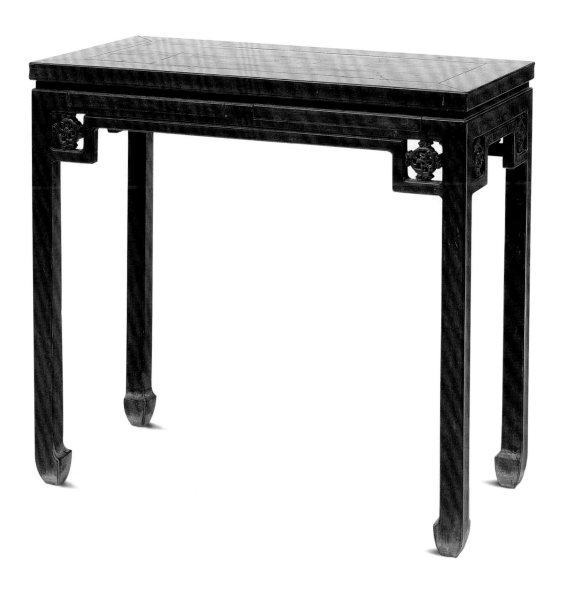

137

Purple Sandalwood Writing Table Carved
with Flowers

Height 87 cm Length 157.5 cm
Width 56 cm
Qing court collection

The recessed sides of the surface of this table is inlaid with a board, and the centre of the board is painted with pineapple lacquer. The centre of the board is in alignment with the frames, and its sides have ice-plate edges. Under the surface is a waist, carved with decorative struts, and lozenge-shaped medallions. Fixed under the waist is a stepped apron moulding. The arch-shaped aprons are carved with rectangular spirals. Fixed between the spaces between the two side legs is a side stretcher, forming the upper and lower shelves, with the upper shelf carved with a rectangular spiral inset panel, and the lower part carved with a rectangular spiral inner frame joined by small materials. The base stretcher is a humpback stretcher, with feet in the shape of a scrolled book.

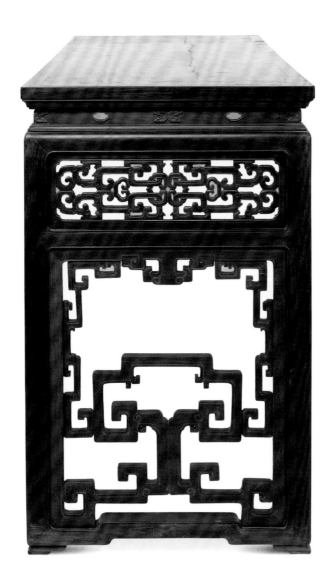

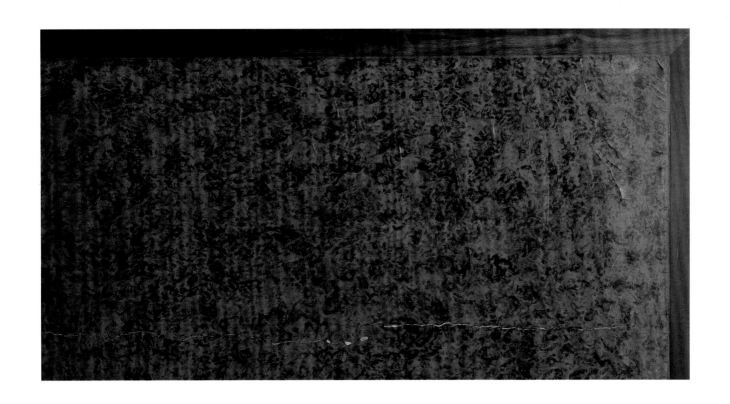

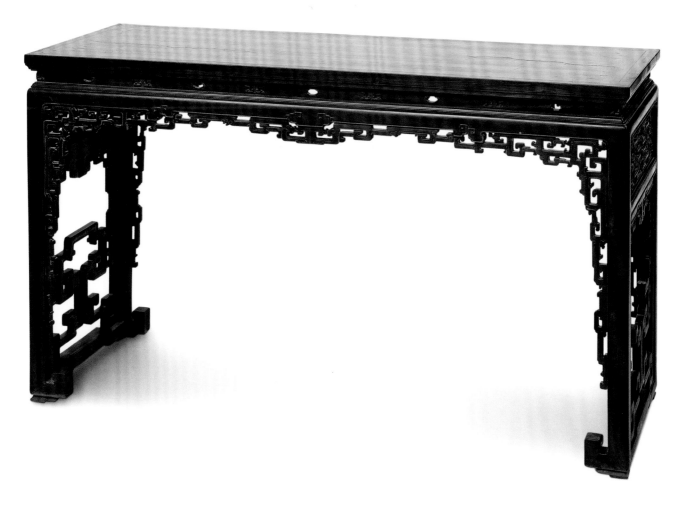

183

138

Purple Sandalwood Long Table
with an Inlaid Surface Board

Height 85 cm Length 180 cm
Width 74 cm
Qing court collection

The lattice frame of the surface of the table has an inlaid board, and the centre of the board is inlaid with swastikas (卍) interspersed with purple sandalwood and ebony. Under the surface is a high waist, and the apron is engraved with chained twisted ropes and string knots. The upper part of the straight legs are carved with a precious bottle and joined with the surface of the table, and the apron corners have side spandrels carved with clouds. It has inward-curving horse-hoof feet with angular spirals.

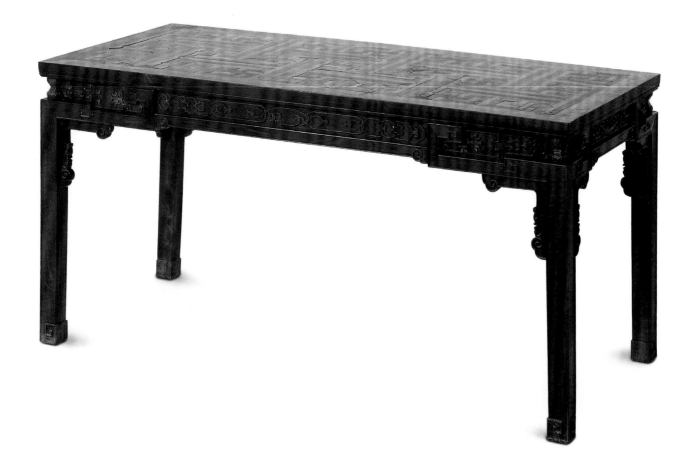

139

Purple Sandalwood Ladder-shaped Table
with Passionflowers

Height 90 cm Diameter of Surface 112 cm
Qing court collection

The surface of the table is in the shape of a ladder. Under the surface is a waist, which is carved with *ruyi* scepters and has lozenge-shaped medallions. Under the waist are stepped apron mouldings carved with lotus petals. The arch-shaped aprons are carved with passion flowers in openwork. Fixed between the legs is a beaded base stretcher, and the rebate of the inside of the base stretcher is fixed with a base stand carved with passion flowers in openwork. Fixed under the base stretcher is a flowery apron carved with jade and pearl (*yubaozhu*) patterns. It has outward-curving feet with scrolling clouds.

This table is one of a pair. The tables can be combined to form a hexagonal table, and they can also be placed inside a house in a symmetric pattern.

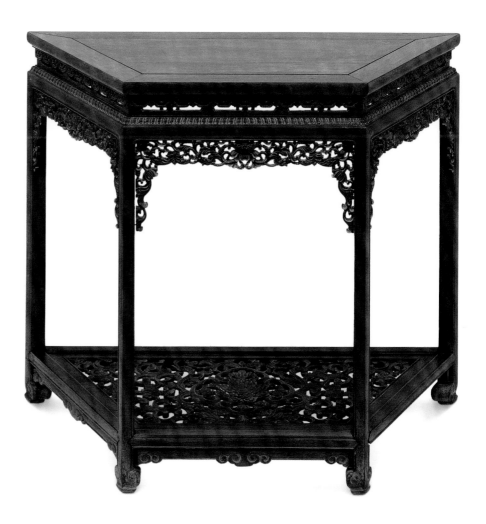

140

Purple Sandalwood Long Table
with Angular Spirals

Height 83 cm Length 132 cm
Width 42 cm
Qing court collection

The lattice frame of the surface of the table is inlaid with a core board. Under the surface is an arch-shaped apron, which is carved with angular spirals in relief. It has straight legs and inward-curving horse-hoof feet with angular spirals.

This table is simple in structure with neat decorations. It is a masterpiece of furniture made in the Qianlong period.

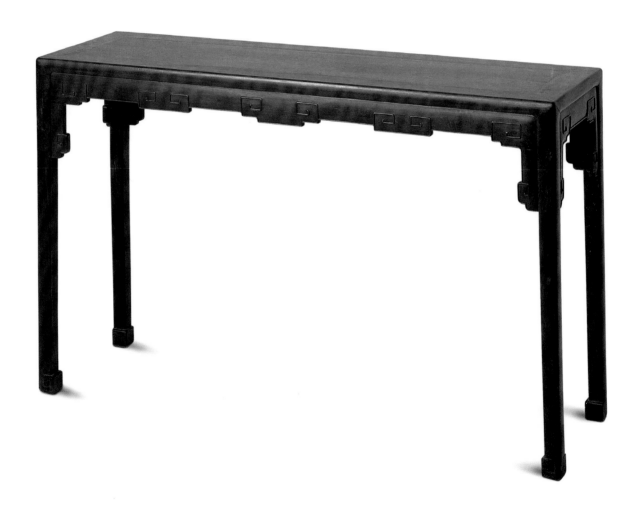

141

Purple Sandalwood Long Table
with *Lingzhi* Fungi

Height 86 cm Length 180 cm
Width 70 cm
Qing court collection

 This long table has a surface with the lattice frames on its four sides inlaid with a core board, and it has ice-plate edges. Under the surface is a waist, with its upper and lower parts fixed with stepped apron mouldings. Decorated all over the apron are *lingzhi* fungi, and the two sides are side spandrels carved with *lingzhi* fungi in openwork. The spandrel parts of the square legs are also decorated with *lingzhi* fungi, which are joined with embracing-shoulder tenons. It has inward-curving horse-hoof feet with angular spirals.

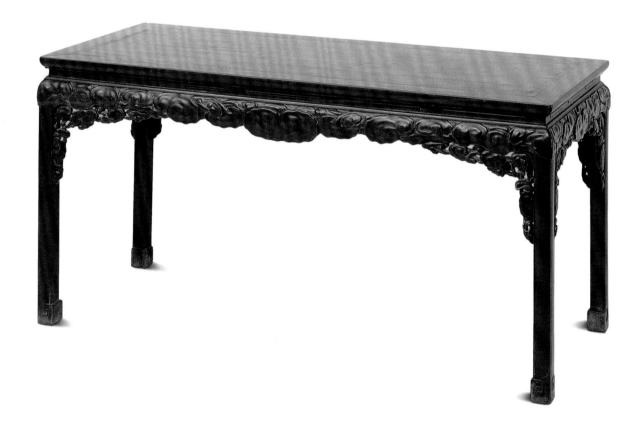

142

Purple Sandalwood Long Table
with Entwining Lotuses Carved in Openwork

Height 86 cm Length 192 cm
Width 44.5 cm

The lattice frames of the surface of the table is inlaid with a core board, and the side edges are decorated with swastika (卍) motifs. It is waistless under the surface. The aprons has intertwining lotus branches carved in openwork, which move upward along the edges to the surface of the table. It has square legs and straight feet, and the four sides of the surface of the table are joined with a mortise corner tenon. Carved all over the legs are swastikas (卍), and the spaces among the legs have a straight-form side stretcher.

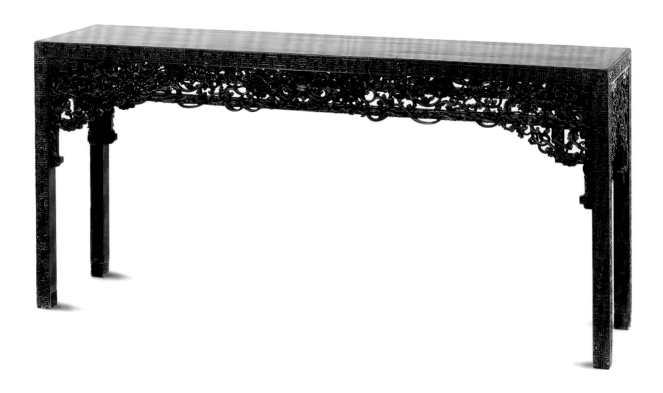

143

Purple Sandalwood Long Table
with Copper Corner Plates

Height 86.5 cm Length 144 cm
Width 39 cm

Qing court collection

The lattice frames of the surface of the table are inlaid with a core board, and the side surfaces have ice-plate edges. Under the surface are a concave-moulding waist, an apron with a *kui*-dragon carved in openwork, straight legs, and inward-curving horse-hoof feet. The four corners between the surface of the table and the waist and the spandrels between the apron and the legs are all wrapped with copper decorations.

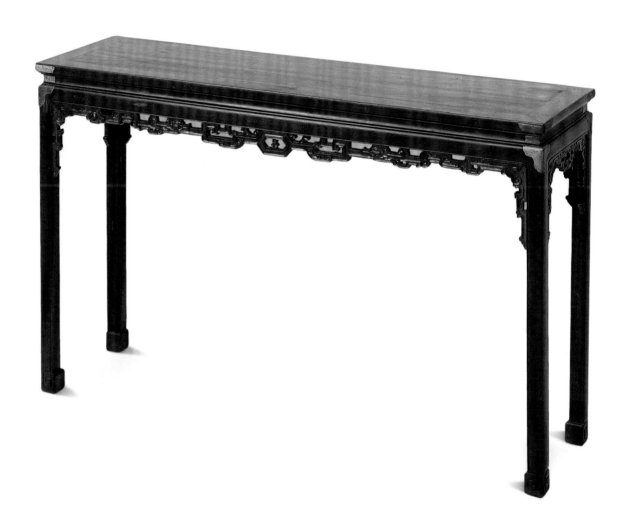

144

Purple Sandalwood Tripod-shaped Table
Inlaid with Copper Wires

Height 86.5 cm Length 115.5 cm
Width 48 cm

Qing court collection

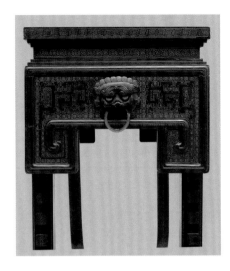

This table is in the shape of an imitation bronze tripod, with its entire body inlaid with copper wires. The side edges of the surface of the table are inlaid with angular spirals, and under the surface is a waist inlaid with angular spirals. The upper and lower parts of the stepped apron mouldings are decorated with ladder-shaped mouldings. The apron is broad and large, its side edges are protruded, and the frames have mouldings. Inside the frames it has a brocade ground with angular spirals, which are carved with *kui*-dragons. Inlaid on the middle parts of the aprons on the two sides are handles with holding rings in the form of animal masks. The four legs of the table are splayed, and the side edges have ridges, which are also decorated with angular spirals and two dragons.

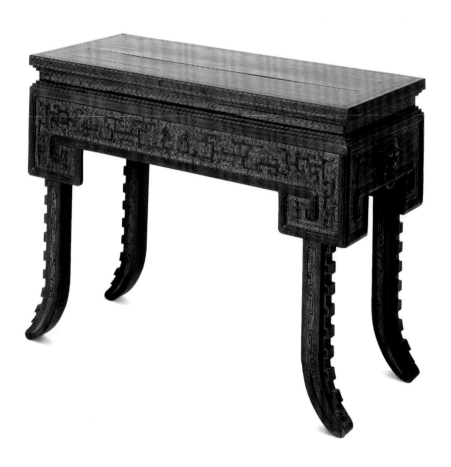

145

Purple Sandalwood Half-round Table
with Western Flowers

Height 84 cm Diameter 137 cm

The surface of the table is semi-circular. Short materials are joined to form lattice frames, with the middle inlaid with hardwood core board. Under the surface is a concave-moulding waist, the curved-edge aprons are joined with the legs of the table by hanging shoulder tenons, and on the aprons are carved with Western flowers in relief. The legs are arch-shaped, and the upper and lower ends are outward-curving and carved with passion flowers as decorations. Below the legs is a semi-circular floor stretcher as a support.

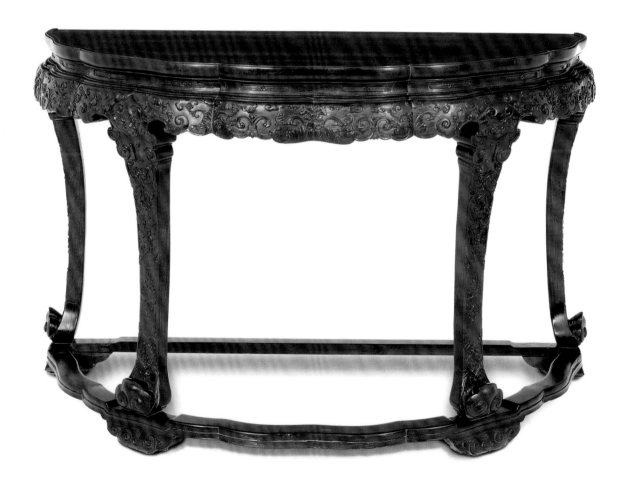

146

Suanzhi Wood Round Table
with a Marble Surface

Height 86 cm Diameter of Surface 102 cm
Qing court collection

The table has a circular top. It uses six pieces of *suanzhi* wood to carve out an arc-shaped frame, and to carve into the shape of a sunflower. The middle part is inlaid with a stone plate with the pink colour alternating with the white colour. The lower part of the stone plate has a bell in the shape of the character " 井 " (well) to serve as a support. The six arc-shaped posts join the surface of the table with the base stand, which are carved with curling tendrils. Fixed on the centre of the stand is a round plate, which are joined to the surrounding leg stretchers, showing that the legs of the table can be dismantled and folded. The stretcher of the base stand has ice-crack patterns, under which six feet are fixed.

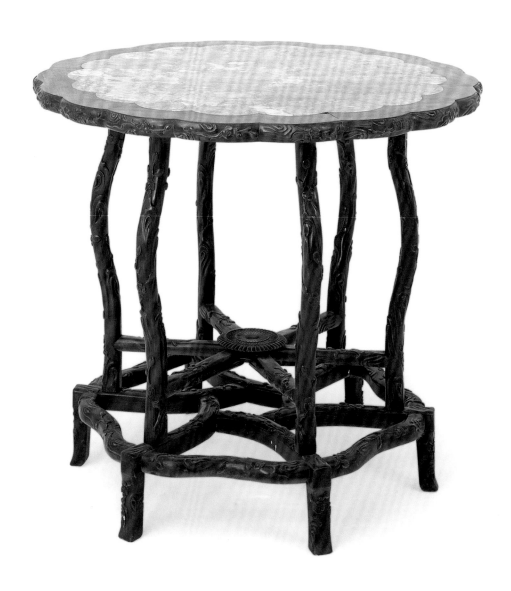

147

Small Natural Timber Round Table

Height 79 cm Diameter 97 cm
Qing court collection

The surface of the round table is formed by cutting from a single round piece of wood. The body of the table is formed by joining natural tree stumps. The surface and legs of the table are joined by inserted tenons. The upper part of the leg is a single post, under which there are three feet in different postures.

This kind of natural timber furniture is mostly placed in courtyard for outdoor use.

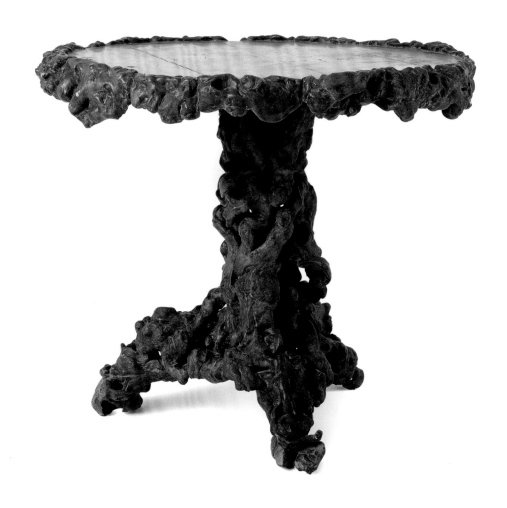

148

Purple Lacquer Long Table

Height 87.5 cm Length 136 cm
Width 84 cm
Qing court collection

The edges of the surface of this long table have raised beadings. The apron-head spandrels and aprons are joined by a piece of wood. The table has a round body and straight legs, and fixed on the inside of the four legs is a giant's arm brace. It has flat feet. The entire body is coated with purple lacquer.

According to archives, this table was originally in the Duanning Hall (Duanning Dian), which is located to the east of the Palace of Heavenly Purity (Qianqing Gong), where the crowns, gowns, belts, and shoes of the emperor were stored.

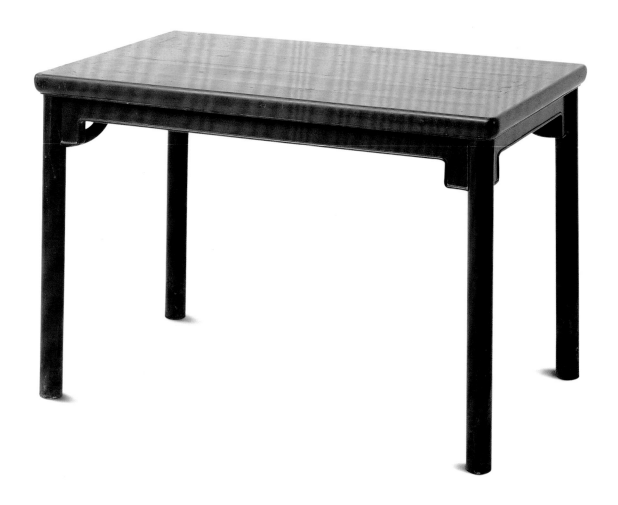

149

Red Lacquer *Kang* (Heatable) Table
Inlaid with Mother-of-pearl and a Hundred Characters "*Shou*" (Longevity)

Height 29 cm Length 96.5 cm
Width 63 cm
Qing court collection

The entire body of this *kang* table is coated with red lacquer. The middle of the surface of the table is inlaid with one hundred and twenty mother-of-pearl "*shou*" (longevity) characters. The side edges and end edges all have a brocade ground inlaid with mother-of-pearl swastikas (卐), meaning "many happy returns of the day to eternity" (wanshouwujiang). Under the surface is a waist, inlaid with encircled "*shou*" (longevity) characters and long "*shou*" (longevity) patterns. The apron and straight legs are inlaid with mother-of-pearl bats, birthday peaches, encircled "*shou*" (longevity), and square "*shou*" (longevity) patterns, meaning "enjoying both felicity and longevity" (fushoushuangquan). It has inward-curving horse-hoof feet.

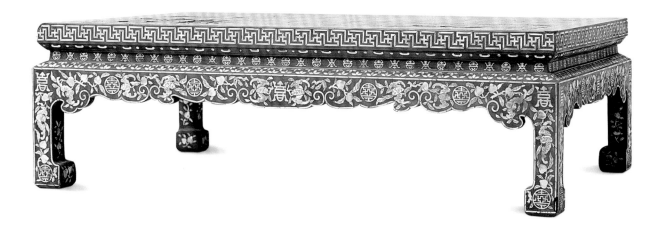

150

Filled Lacquer Rectangular Table

with Engraved Gold (*Qiangjin*) Designs of Landscape

Height 82 cm Length 106 cm
Width 76 cm
Qing court collection

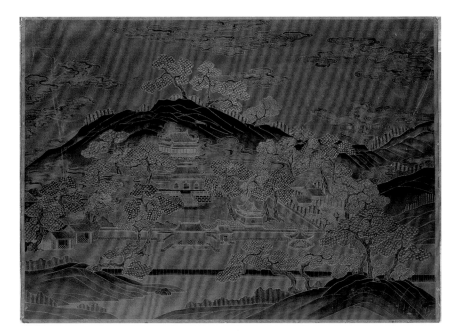

The surface of this table is rectangular. Under the surface are a waist and straight legs. Fixed on the inner corners of the four legs is a giant's arm brace, and the table has inward-curving horse-hoof feet. The entire wooden body is coated with red lacquer, then it is decorated with flower patterns using the filled lacquer and engraved gold techniques. The surface of the table is decorated with a painting of "Ancient Temples and Mountain Villas", the end edges and waist is decorated with angular spirals, and the apron and legs of the table are decorated with chrysanthemums.

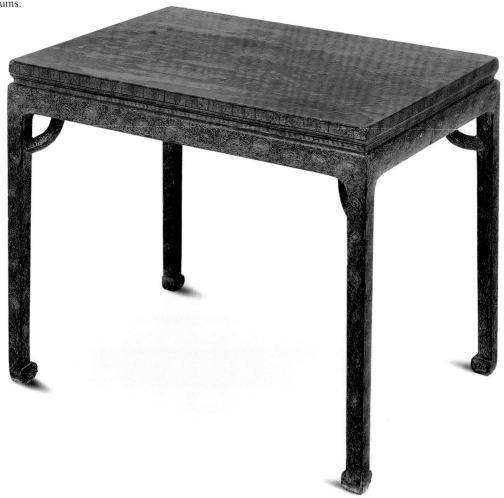

151

Filled Lacquer Rectangular Table

with Engraved Gold (*Qiangjin*) Designs of Landscape

Height 83 cm Length 101 cm
Width 66.5 cm
Qing court collection

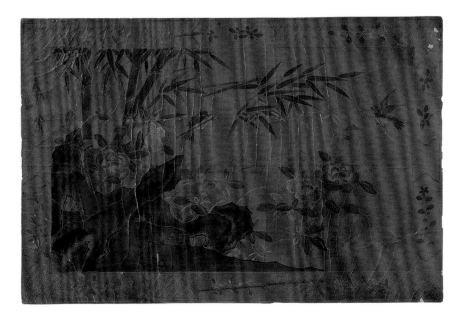

The surface of this table is rectangular. Under the surface is a waist. It has square and straight legs, fixed with a giant's arm brace, and it has inward-curving horse-hoof feet. Inside the medallions on the surface of the table are painted with Chinese roses, sparrows, green bamboo, cave rocks, the four sides are decorated with a brocade ground, and inside the sunflower-shaped medallions are decorated with flowers and grass. The edges of the surface are filled with flowers on branches in colour, and the aprons, legs, and feet are filled with flowers with rolled leaves in colour.

According to archives, this table was originally in the Palace of Tranquility and Longevity (Ningshou Gong).

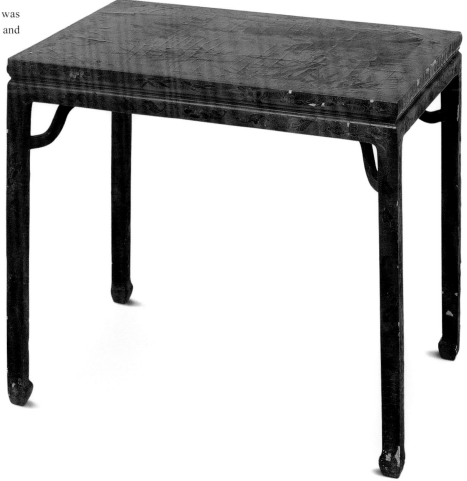

152

Filled Colour Lacquer Rectangular Table
with Engraved Gold (*Qiangjin*) Designs of Five Dragons Holding up Longevity

Height 85.5 cm Length 160.5 cm
Width 84.5 cm
Qing court collection

This table is in a straight form. The humpback stretchers fixed between the four legs are made of lattice corners, and the decorative struts with scrolling clouds are joined with the surface of the table. The four legs are carpenter's-square legs, with inward-curving horse-hoof feet. The surface of the table has five dragons holding up longevity filled with lacquer and engraved in gold, surrounded by waves and cliffs. The four sides have clouds, strolling dragons, and *kui*-dragons filled with lacquer and engraved in gold. The end edges, aprons, legs, and feet have strolling dragons, rising dragons, and *kui*-dragons filled with lacquer and engraved with gold.

This table is typical of the Ming style. Its decorative patterns are fine and elaborate.

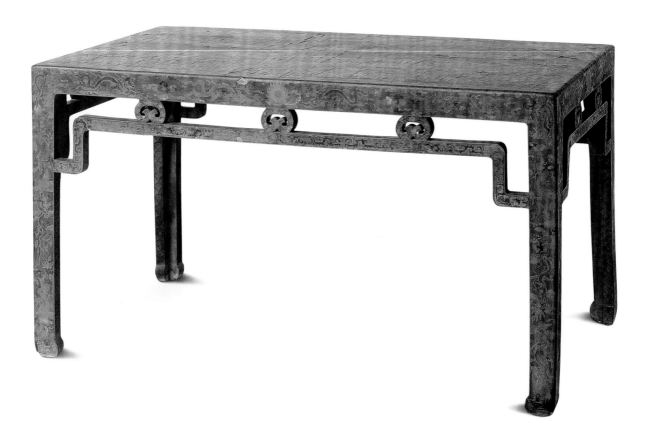

153

Engraved Gold (*Qiangjin*) Half-round Table

with Flowers (A Pair)

Height 80.5 cm
Diameter of Surface 64.5 cm
Qing court collection

The surface of this table is semi-circular. The upper part has engraved gold flowers, its end edges are decorated with bats and birthday peaches. Under the surface are a waist carved with rectangular spirals and curling tendrils and stepped apron mouldings with angular spirals. The aprons and apron-head spandrels are carved with scrolling clouds, and the four legs are decorated with bats and birthday peaches on branches. The lower part has a base plate carved with *chi*-dragons in openwork, and the base plate is fixed with aprons underneath.

This table is one of a pair. Two tables can be combined to form a round table, and they are usually placed on the two ends of the hall in a symmetric pattern.

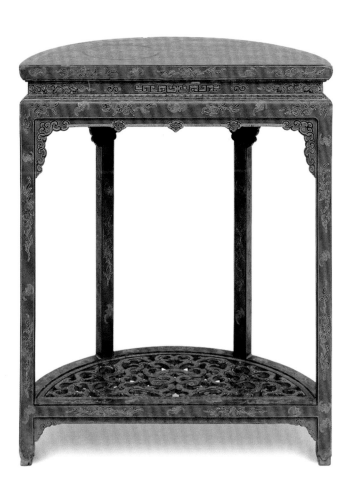
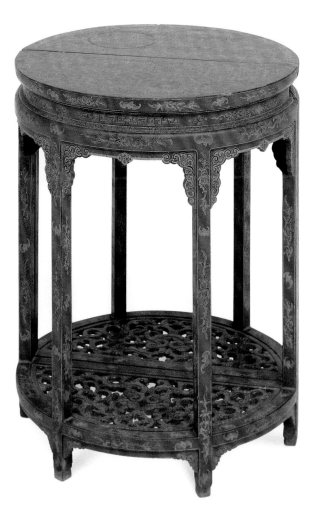

154

Filled Lacquer Banquet Table
with Engraved Gold
(*Qiangjin*) Designs of Clouds
and Dragons

Height 86 cm Length 135 cm
Width 101 cm
Qing court collection

The surface of this table is two-layered. It has a high waist, and the four corners have spandrels. The apron with a pot-door-shaped opening, and the legs form a continuous flow. It has spandrels, outward-curving horse-hoof cabriole legs, and feet in the shape of scrolling clouds. The four sides of the upper level of the surface of the table have water-stopping mouldings, and the middle part has sunflower-style medallions, with two dragons chasing a pearl cut in lines and engraved in gold. The four corners and the four sides are also decorated with two dragons chasing a pearl, and the end edges are decorated with clouds. The lower layer of the surface of the table is carved with twenty-four holes, and the spaces among holes are decorated with clouds. The waist is inlaid with ornamental lattice panels and decorated with dragons. The apron, legs, and feet are decorated with two dragons chasing a pearl. The curved edges of the pot-gate is decorated with gold lacquer.

The structure and decorations of this table are elaborate. The dragons in gold lacquer, in particular, are noble and magnificent, manifesting the air that was unique to the royal family.

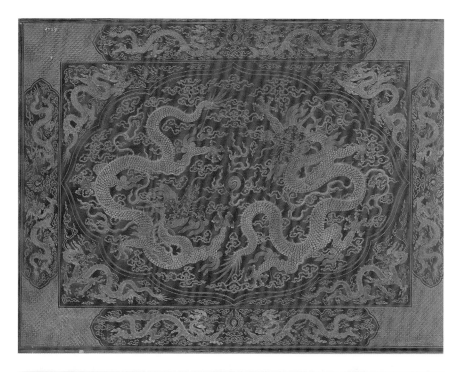

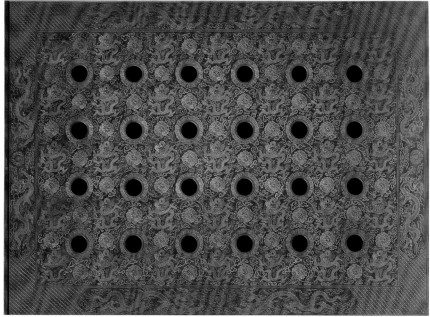

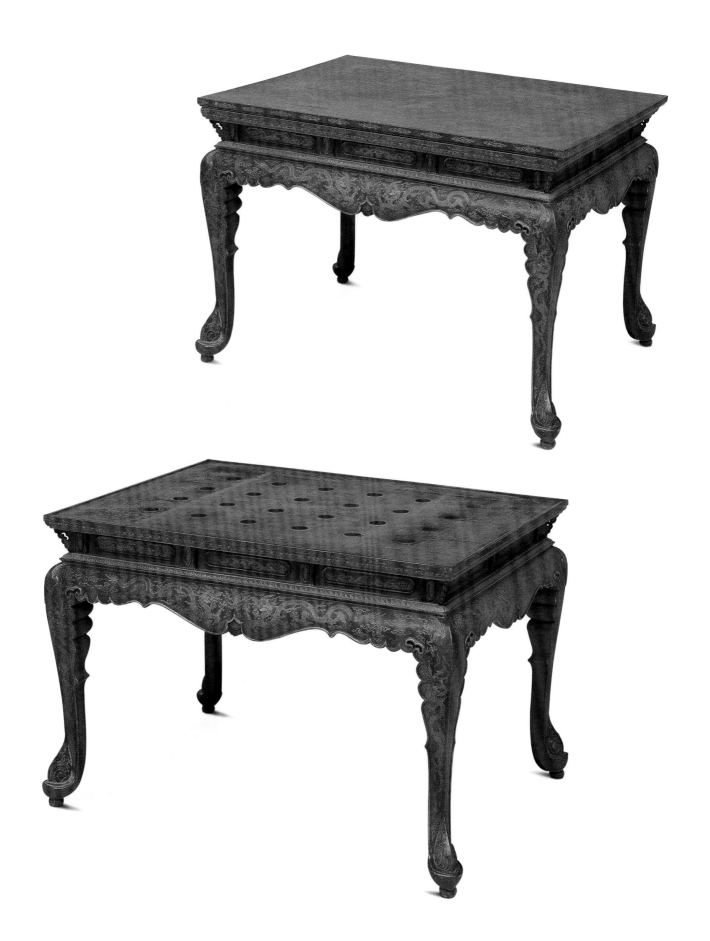

155

Black Lacquer *Kang* (Heatable) Table
with Engraved Gold (*Qiangjin*) Designs of Clouds and Dragons

Height 32 cm Length 118.5 cm
Width 84 cm
Qing court collection

This table has a two-layer surface and a high waist. The four corners have spandrels. The apron with a pot-door-shaped opening and the legs form a continuous flow. The table has a spandrel, cabriole legs, and outward-curving horse-hoof feet with scrolling clouds. The four sides of the upper table surface have water-stopping mouldings, the middle has sunflower-style medallions with two dragons chasing a pearl cut in lines and engraved in gold, the four corners and the four sides are also decorated with two dragons chasing a pearl, and the end edges are decorated with clouds. The lower level of the surface of the table is carved with fifteen holes, and the spaces among holes are decorated with a coiled dragon. The lattices of the waist are inlaid with ornamental panels and decorated with dragons. The apron, legs, and feet are decorated with two dragons chasing a pearl. The curved sides of the pot-door-shaped opening are lacquered in gold.

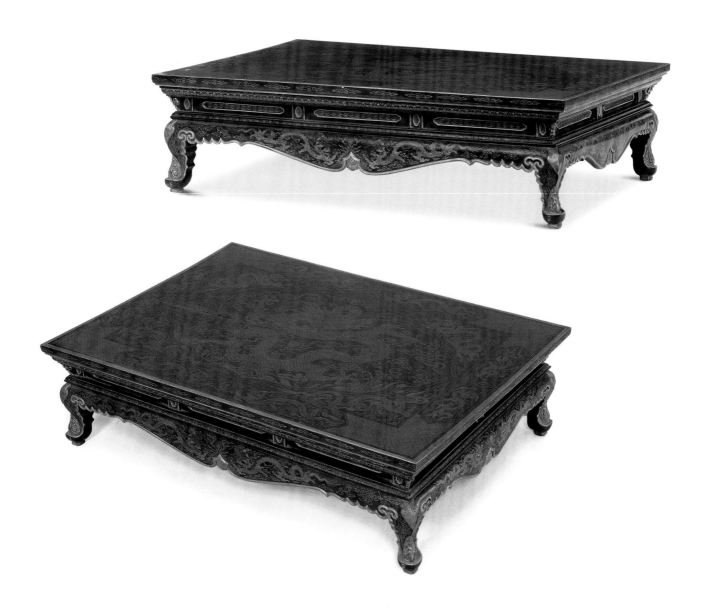

156

Sunflower-shaped Table

with Flowers in Purple Lacquer and Traced with Liquid Gold

Height 89.5 cm
Diameter of Surface 124 cm
Qing court collection

The surface of the table is in the shape of a sunflower, which is decorated with flowers traced with liquid gold, and the end edges of the surface have drawers. Under the surface is a round of flowery aprons carved with *kui*-dragons in openwork. The middle part is a single cylindrical leg decorated with flowers and grass traced with liquid gold. This leg has two sections. The upper section has six spandrels traced with liquid gold to support the surface of the table, and the lower section has six standing spandrels to support the cylindrical post. The top end of the cylindrical post in the lower section has an axis, and the lower end of the cylindrical post in the upper section has round holes, which, when slipped over the axis, can make the table surface turnable. The table is supported by a sunflower-style Buddhist pedestal, and under the seat are aprons with pot-door-shaped openings and turtle feet.

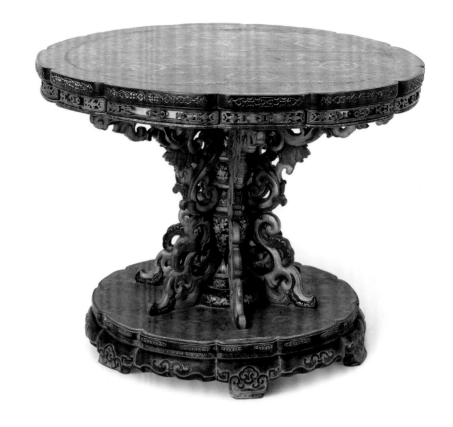

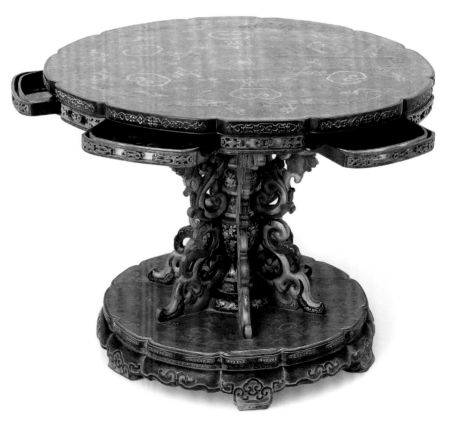

157

Black Lacquer Rectangular Table
Painted in Colour and Inlaid with a Mother-of-pearl Lotus Pond

Height 86 cm Length 161 cm
Width 70 cm
Qing court collection

The surface of the table is rectangular. The apron under the surface and the corner place of the legs of the table have flowery aprons carved with *kui*-dragons in openwork. It has straight legs, the inner end of which is fixed with a giant's arm brace and inward-curving horse-hoof feet. The medallions on the surface of the table are painted with lotus flowers, birds, and rocks; the four sides are decorated with flowers and butterflies, and the spaces between them have a brocade ground inlaid with mother-of-pearl. The apron, legs, and feet are decorated with flowers and butterflies.

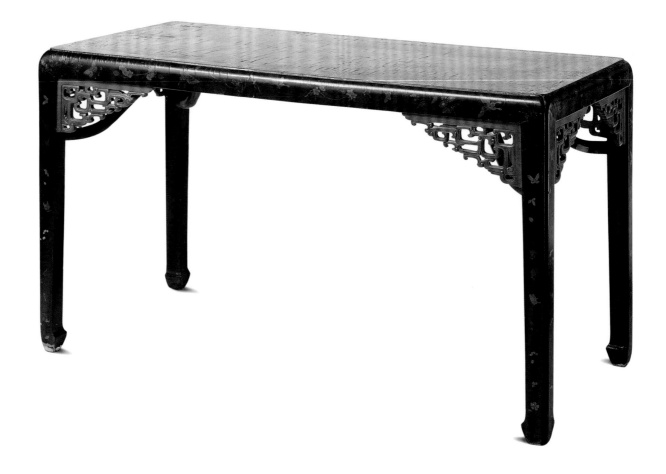

158

Purple Lacquer Banquet Table
with Curling Tendrils Traced with Liquid Gold

Height 82.5 cm Length 100 cm
Width 65.7 cm
Qing court collection

Under the rectangular surface of this long table is a waist. The apron and the outer edges of the legs of the table have raised beadings. The corner place between the apron and legs is fixed with side spandrels carved with curling tendrils in openwork. It has inward-curving horse-hoof feet. The entire body of the table is decorated with flowers traced with liquid gold. The waist has curling tendrils carved in openwork and the lower part has double-layer raised beadings.

This type of long tables is used for dining by emperors and empresses.

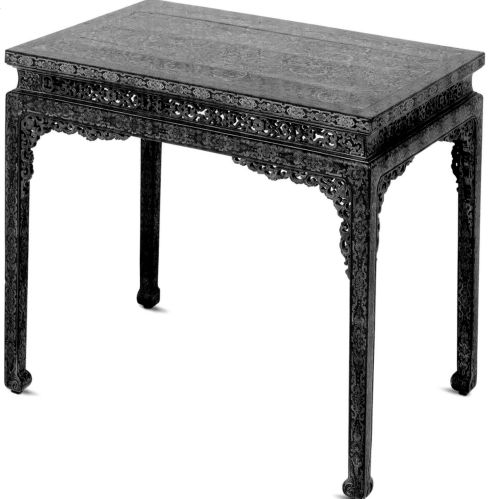

159

Black Lacquer Long Table
with Tree Peonies Traced
with Liquid Gold

Height 84 cm Length 110 cm
Width 38 cm
Qing court collection

The entire body of this long table has a black lacquer ground, which is decorated with flowers traced with liquid gold. The surface of the table is decorated with tree peonies, *lingzhi* fungi, and mountain rocks. The two sides are fixed with a small everted flange on a mud fish's back. The end edges are decorated with clouds and bats traced with liquid gold. The waist has several lattices created by curling tendrils traced with liquid gold, and it has fire-cracker-shaped openings, supported from below by a stepped apron moulding. The apron is decorated with passion flowers traced with liquid gold. The lower part has rectangular spirals and Western-style curling tendrils in openwork. The two ends droop along the legs, forming a leg-protecting apron with its hooked sides traced with lacquer. It has inward-curving horse-hoof feet with angular spirals.

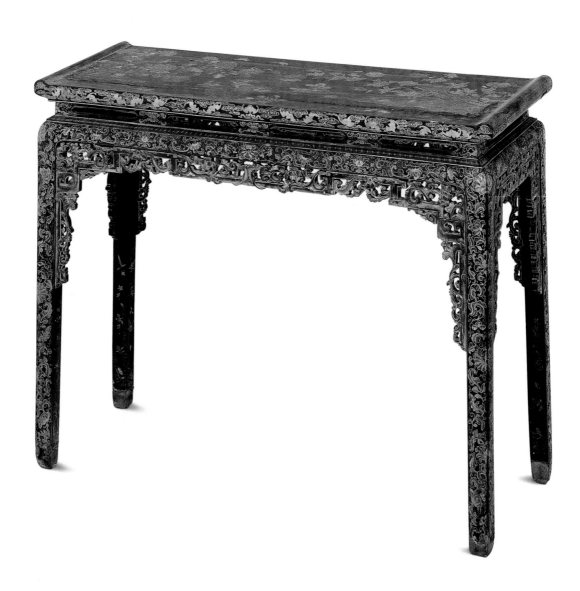

160

Black Lacquer
Kang (Heatable) table
Inlaid with Jade Bats

Height 29.5 cm Length 112 cm
Width 81 cm
Qing court collection

The entire body of this *kang* table has a black lacquer ground. The middle of the surface of the table is decorated with one hundred and twenty "*shou*" (longevity) characters traced with liquid gold. The side edges have a brocade ground carved and filled with swastika (卍) characters traced with liquid gold, inlaid with bats and birthday peaches made in jade, and rounded "*shou*" (longevity) characters traced with liquid gold. The end edges of the surface of the able has a brocade ground with swastikas (卍) traced with liquid gold and a long round medallion, the inside of which is inlaid with bats and birthday peaches made in jade. It has a waist with angular spirals, under which are a stepped apron moulding with lotus petals traced with liquid gold and an apron with clouds. The spandrels, straight legs, and side edges of the apron are traced with liquid gold, and decorated all over with rounded "*shou*" (longevity) characters filled with colour lacquer and traced with liquid gold and birthday peaches and bats made in jade. It has inward-curving horse-hoof feet.

The techniques of making this table is superb, and the decorative patterns are elaborate with an auspicious meaning. It is a piece of fine Qing furniture.

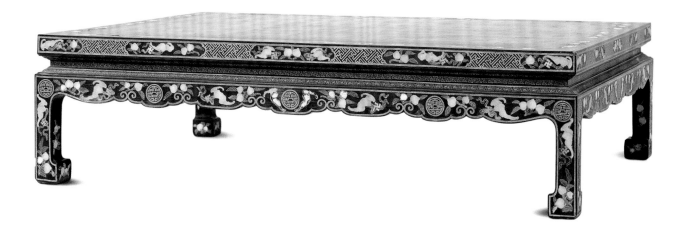

161

Filled Colour Lacquer Long Table
with Phoenixes, Flowers, and Birds

Height 82 cm Length 156.5 cm
Width 49.5 cm

This long table has a table-shaped structure. The two ends of the table are protruded. Underneath the table is a long apron, and the two ends of the cylindrical legs are fixed with apron-head spandrels. The space between the front and rear legs is fixed with double stretchers, and the ends of the feet are fixed with copper foot-protectors. The colour-filling lacquer technique is used for the flowers that decorate the body. The surface of the table is decorated with mountain rocks and flowers, and the end edges, aprons, and legs of the table are decorated with flowers on branches.

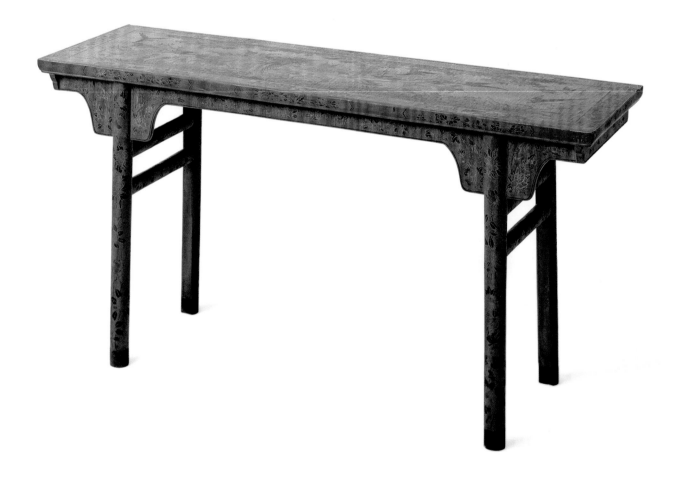

162

Red Lacquer *Kang* (Heatable) Table

Filled and Painted with Swastikas (卐), Clouds, and Bats

Height 33 cm Length 82 cm
Width 61 cm
Qing court collection

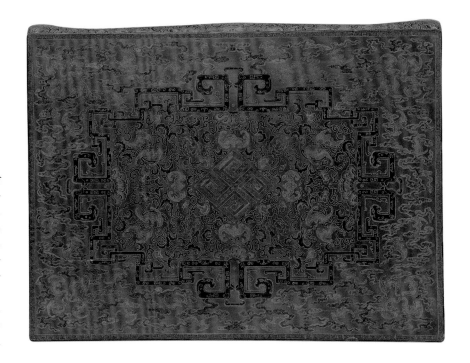

There is a waist under the surface of the table. It has fish belly aprons. The four legs are bulging, and there are outward-curving aprons. The ends of the feet are trimmed to become inward-curving horse-hooves, falling on a continuous floor stretcher. The entire body has a red lacquer ground filled and painted with patterns. The centre of the surface of the table has a medallion with *kui*-dragons, and the medallion is painted with hibiscuses on branches and with bats scattered around. The middle part has swastikas (卐). The outer rings of the medallion are decorated with clouds and bats, and the side edges are decorated with angular spirals. The waist is decorated with honeysuckles. The ice-plate edges of the surface of the table, the legs, and aprons are decorated with lotus flowers on branches and bats, all of which carry the meaning of "fortune and wealth are in abundance".

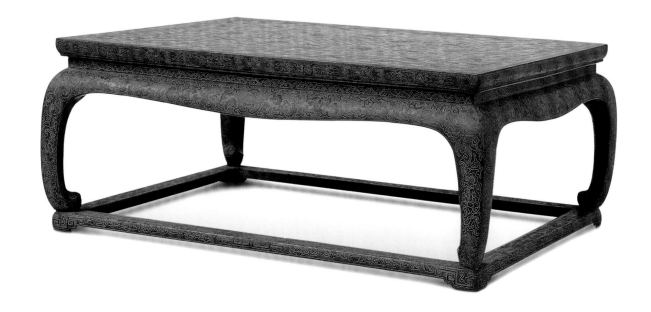

163

Filled Lacquer *Kang* (Heatable) Table
with Engraved Gold (*Qiangjin*) Designs of Clouds and Dragons

Height 36 cm Length 85.5 cm
Width 57 cm
Qing court collection

The surface of the table has a brocade ground with red slanted square lattices and black swastikas (卍). The middle part is decorated with a soaring dragon filled with gold lacquer and engraved in gold, surrounded by floating clouds in five colours. The four sides have lacquered railings. The medallions are made of a brocade ground with coin patterns, and the inside is decorated with a dragon chasing after a pearl. The waist is decorated with two *chi*-dragons engraved in gold and painted with colour lacquer. It has aprons in the shape of *ruyi* cloud patterns, decorated with two dragons chasing a pearl engraved in gold and painted with colour lacquer. The spaces in between have a brocade ground with coins, and the shoulder part is decorated with lotus flowers. It has elephant-nose feet with two *chi*-dragons filled with colour lacquer, and the feet are supported by a pearl from below.

This *kang* table has a ground in pale brownish lacquer. It has plain black lacquer inside. It is rare to find such a fine example of coloured lacquer furniture.

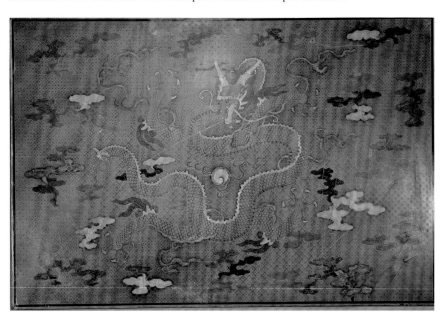

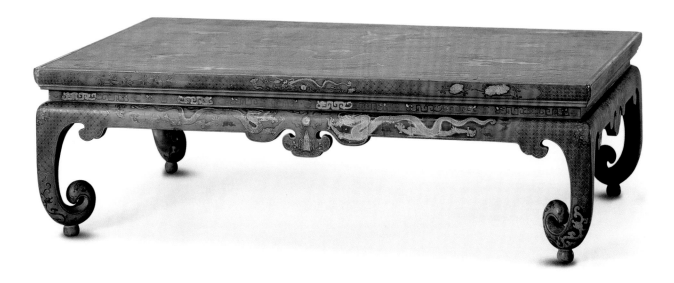

164

Yellow Rosewood *Kang* (Heatable) Table
Inlaid with Mother-of-pearl and *Chi*-dragons

Height 28 cm Length 91.5 cm
Width 60.5 cm

The surface of this table is flat-top and rectangular, and it is inlaid with beaded flowers, forked corners, and medallions made of purple sandalwood. The middle part is inlaid coloured stones with mother-of-pearl *chi*-dragons and flowers, and the sides have whorls and purple stone pearls. The side edges of the surface of the table and the four corners are inlaid with purple sandalwood medallions, and they are inlaid and decorated with mother-of-pearl colour stone hooked lotus flowers, flying cranes, and bright clouds. Under the surface is a flowery apron carved with *chi*-dragons. The spaces on the two ends of the legs have a side board carved with *chi*-dragons in openwork. The four legs shrink to fit into shape. It has feet in the shape of cloud heads.

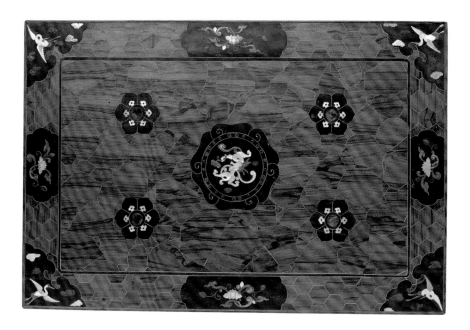

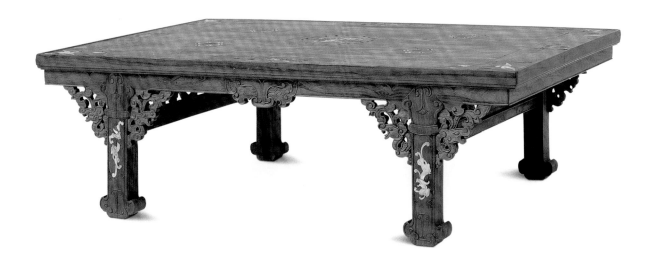

165

Yellow Rosewood Table
with Rolling Clouds

Height 87 cm Length 144 cm
Width 47 cm
Qing court collection

The surface of the table has lattice frames on its four sides. The centre of the table is coated with black lacquer. Under the surface is an apron-head spandrel carved with scrolling clouds, which forms a double-mitred tenon structure with the surface of the table. The centre of the splayed straight legs have double raised beadings, and the spaces between the sides of the two legs are fixed with side stretchers. It has flat-bottom feet, supported from below with a floor stretcher in the shape of a Buddhist pedestal carved with scrolled clouds.

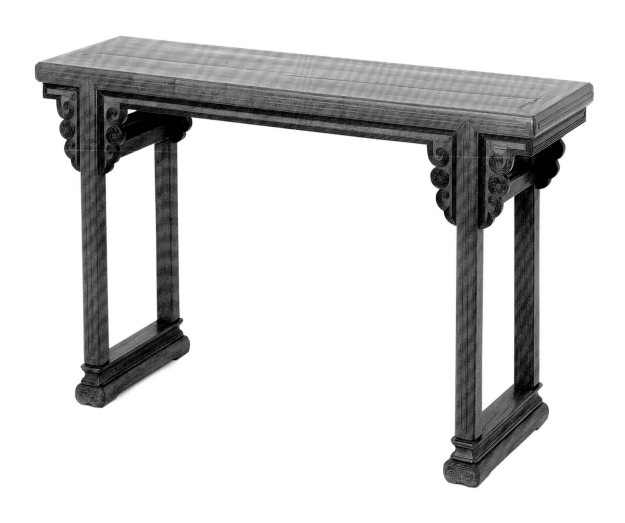

166

Large Purple Sandalwood
Recessed-leg Altar Table
with Passionflowers

Height 97 cm Length 236 cm
Width 84 cm
Qing court collection

The lattice frames of the surface of the table are inlaid with boards, and they have ice-plate edges carved with swastikas (卐). Under the surface is a high waist which is divided into several sections by short posts, and it is inlaid with ornamental panels carved with two dragons in relief. The upper and lower parts of the waist are fixed with stepped apron mouldings with lotus petals. The aprons are thick and strong, outward-curving, and is in the shape of a transformed jade and pearl (yubaozhu) pattern. The upper part has a smoothed ground carved with passion flowers in relief. It has cabriole legs and outward-curving round feet, which are supported by a continuous floor stretcher with turtle feet from below.

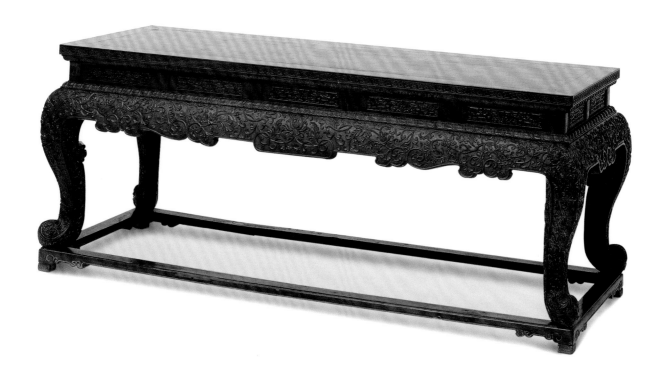

167

Purple Sandalwood *Kang* (Heatable) Table
with Clouds

Height 34 cm Length 94.5 cm
Width 34.5 cm
Qing court collection

The lattice frames of the surface of the table are inlaid with boards, and the sides have ice-plate edges. It has straight aprons and edges with raised beadings. The two ends are carved with apron-head spandrels with *ruyi* cloud head patterns. It has round legs and straight feet. The upper ends of the legs have grooves, joining with the aprons with elongated bridle joints. The spaces between the two side legs are fixed with a side stretcher, which has a sihe inner frame.

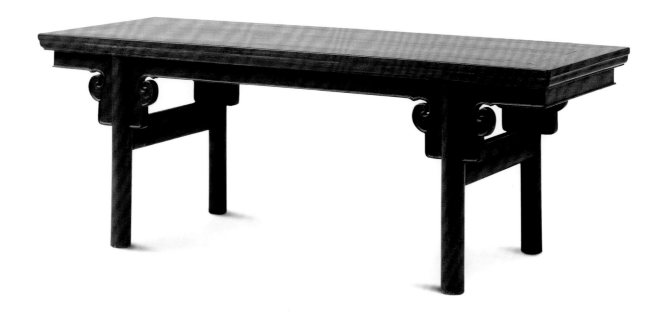

168

Large Purple Sandalwood Trestle Table

with Clouds and Bats

Height 95 cm Length 385.5 cm
Width 52 cm
Qing court collection

This trestle table is made up of two waistless tables and the surface of a recessed-leg table. The surface is made of purple sandalwood pieces joined and stuck together. Clouds and bats are carved all over the end edges. This table has a waist, carved with clouds and bats in openwork. The four legs form the frame, which are inlaid with ornamental panels with openings in the middle, and carved in openwork on the four sides of the openings are clouds, bats, swastika (卍) characters, and birthday peaches, with the auspicious connotations of "fortune and longevity" and "boundless longevity". The lower end of this waisted table has base stretchers, with their feet in the shape of four turtles.

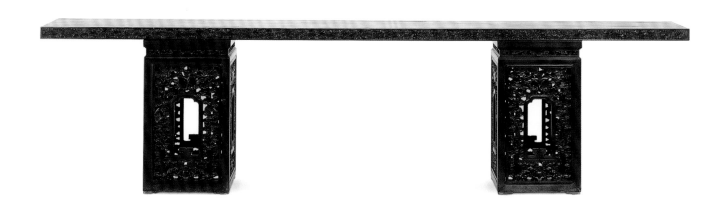

169

Purple Sandalwood Flat-top Narrow
Recessed-leg Table
with Angular Spirals

Height 88.5 cm Length 192.5 cm
Width 42 cm
Qing court collection

The four sides of the surface of the table have lattice frames, inlaid with a central board, and the end edges are carved with angular spirals. Under the surface is a long apron which joins with the apron stoppers on the two ends to form a circle. The upper end of the table has grooves, and an elongated bridle joint structure is used to join with the surface of the table. The upper and lower parts of the spaces between two sides of the legs of the table are fixed with side stretchers, forming a rectangular frame, and fixed inside the frame is a sihe inner frame, which is supported by a waisted floor stretcher under the feet.

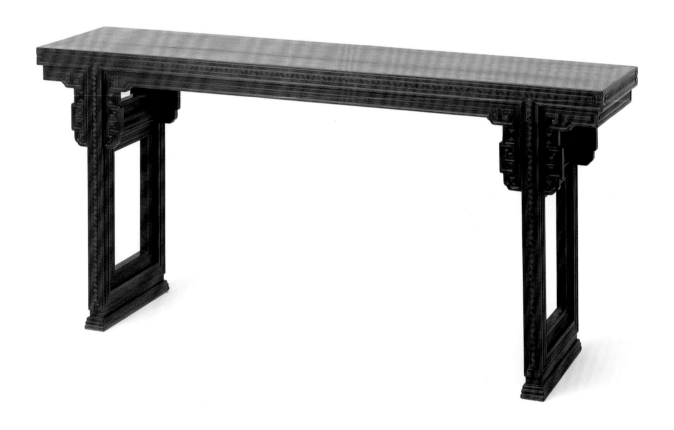

170

Narrow Purple Sandalwood
Rectangular Table
with Clouds

Height 82.5 cm Length 90 cm
Width 36 cm
Qing court collection

The lattice frames of the surface of the table are inlaid with a central board, with their sides having ice-plate edges. It is waistless underneath, with the apron with a pot-door-shaped opening reaches the surface of the table directly. The two ends of the apron are carved with apron-head spandrels with clouds, and the side edges have raised beadings. This table has round legs and straight feet. Fixed on the spaces between the two sides of the legs is a side stretcher inlaid with an ornamental panel. The middle of the ornamental panel has a medallion, carved with upward-curving *ruyi* cloud head patterns, and under the stretcher is an apron carved with flowers.

According to the Qing court archives, this table was used at the Pavilion of Crimson Snow (Jiangxue Xuan) in the Imperial Garden.

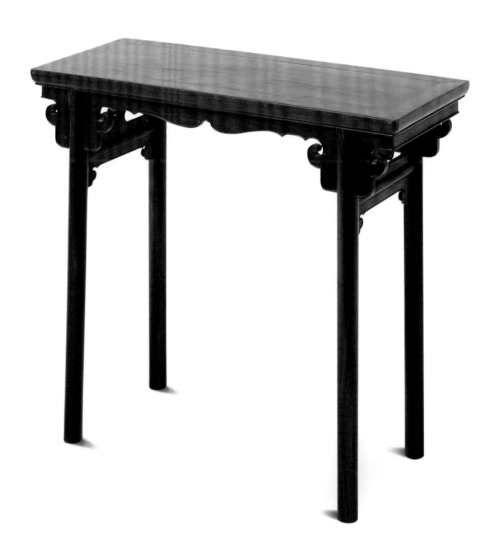

171

Natural Timber Flat-top Narrow Recessed-leg Table

Height 90.5 cm Length 252 cm
Width 69.5 cm
Qing court collection

The surface of this table is made of *nanmu* wood. The aprons, legs, and feet of the table are made by joining and inlaying tree stumps, without any tenons and mortises to join them. The inset panels on the two sides are also patched up with tree stumps, resembling closely to flowers carved in openwork.

172

Writing Table
with Bamboo Inner Skin

Height 86.5 cm Length 194.2 cm
Width 82 cm
Qing court collection

This recessed-leg writing table is made of Chinese fir, and its entire body is wrapped and inlaid with the inner skin of bamboo. An apron is underneath the surface of the table and is carved with an apron with angular spirals, made by joining the straight. The upper ends of the four legs are joined with the surface of the table to support the lower part of the apron. Fixed between the spaces of the two side legs is a humpback stretcher, with feet in the shape of cloud heads.

This writing table uses bamboo inner skin for wrapping and inlaying, which is rarely seen in large-sized writing tables. It truly deserves the claim of a fine piece of the Qing Dynasty furniture.

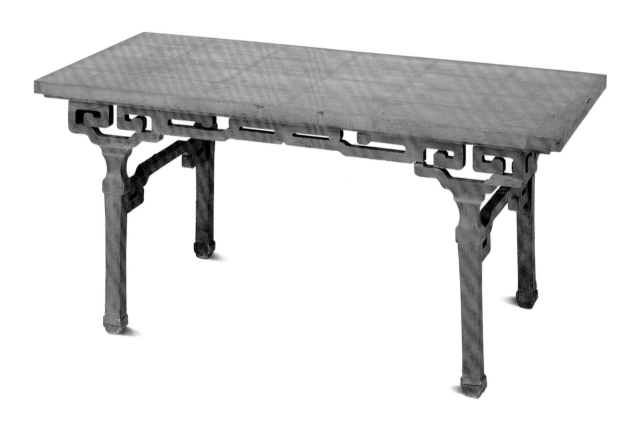

173

Black Lacquer Table
with Mother-of-pearl Inlay

Height 87.4 cm Length 193.5 cm Width 48 cm

The entire body of the table is painted with black lacquer, on which are decorated with inlays of small pieces of mother-of-pearl and thin pieces of gold and silver in the shape of flowers, grass, human figures, and trees. The four edges of the table top have a brocade background with coin patterns, on which are medallions in the shape of water caltrop flowers, and in the medallions are flowers and grass. At the centre of the table top are landscape and human figures. The person who sits against the books in the middle in front of the lake rocks seems to be the master, and the other two people are chatting happily with the master, one sitting and one lying down. The young servants on the two sides are carrying books at the back, holding pots, serving fruits, or brewing tea. The inlays of mountains, rocks, ponds, and banks are all made by sprinkling mother-of-pearl sand. Other furnishings in the cottage and refined articles on the table are all drawn in detail. The end edges of the table top are fully decorated with lotuses on branches. Under the table top are straight aprons, elongated bridle joints and cloud-head aprons and spandrels, which all have medallions with a brocade background and decorations of flowers and plants in different colours. Between the legs on the two sides are mounted with inset panels. The core of the panels is hollowed out making a cluster of ruyi-cloud heads, on which are also fully decorated with flowers and plants. At the very bottom is a continuous floor stretcher which links the two legs. The inside of the table top is painted with red lacquer, in the middle of which around the penetrating transverse braces there is a concave-carved inscription marked "Made in Bingchen year of the reign of Kangxi in the Qing Dynasty", written in regular script and filled with gold. Bingchen refers to the fifteenth year of the reign of Kangxi, which is 1676 A.D.

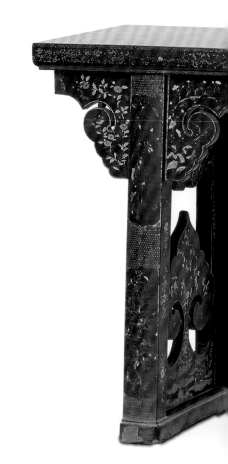

The method of decoration of this table is refined and superb. The mother-of-pearl, gold and silver pieces are thin like a cicada's wings. The designs and patterns in various places should have sketches prepared by famous painters. The decorations are plentiful in this table, but not superfluous. They are attractive and always win people's admiration. The method used is similar to Kangxi's black lacquer shelves with mother-of-pearl of the same time, and the year of production should also be close to each other. It can be regarded as the best quality furniture with thin pieces of mother-of-pearl inlay of the Qing Dynasty.

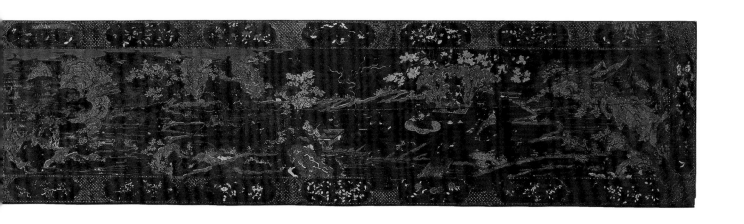

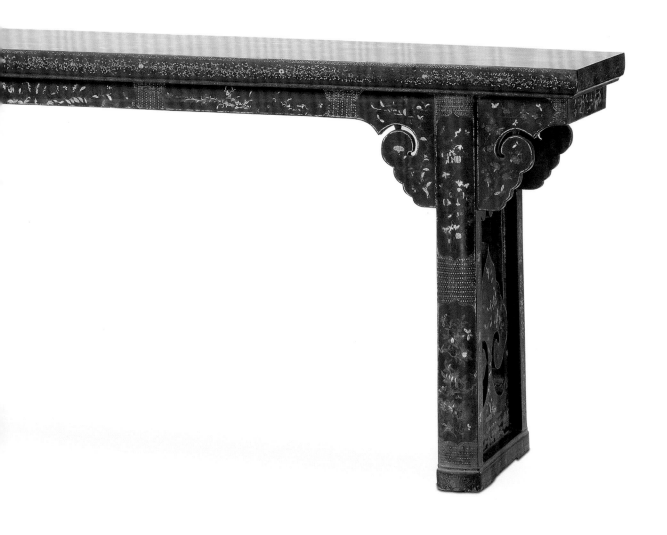

174

Carved Colour Lacquer Table "*Dajibao'an*" (Good Luck and Treasure)

Height 33.5 cm Length 52 cm
Width 32 cm
Qing court collection

The surface of the table is rectangular, with its four fringes stretching outward, like the shape of an overturned plate. Under the surface is a waist. It has four curved legs. The feet are joined with a continuous floor stretcher below. The carved colour lacquer has three colours: cinnabar, yellow, and green. The surface of the table is carved with a courtyard and winding corridors, mountain rocks, and trees. Placed in the middle of the court is a bottle gourd, which is carved with the two characters "*daji*" (good luck) and eight auspicious symbols. The four sides have children playing, and the banners, lanterns, and paintings are carved with the words "*sanyang kaitai*" (the spring comes in full form) and "*wanshou wujiang*" (many happy returns of the day to eternity) respectively. The four sides of the surface of the table are carved with *ruyi* cloud head patterns, the spaces between the apron and the side stretcher have a decorative strut, and the waist, aprons, side stretchers, legs, feet, and floor stretchers are carved with angular spirals. The base of the table is coated with black lacquer, and the centre is carved with the name of the table "*Dajibao'an*" (good luck and treasure) and an inscription in regular script "made in the reign of Qianlong", all filled with gold.

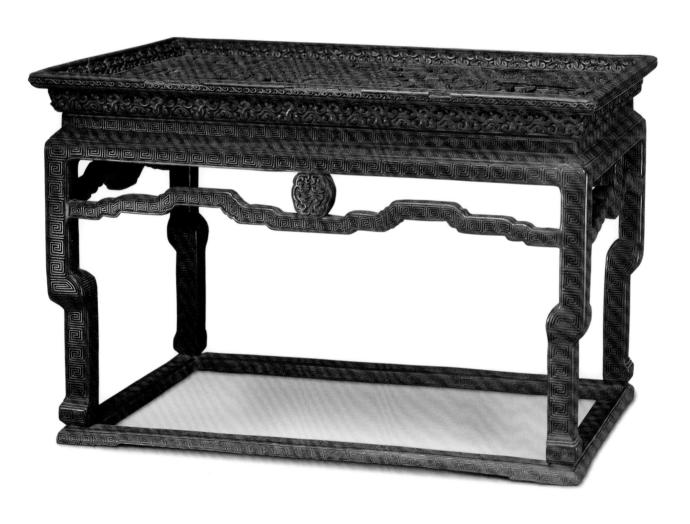

175

Narrow Purple Sandalwood *Kang* (Heatable) Table

Height 32 cm Length 89.5 cm
Width 29 cm
Qing court collection

The lattice frame of the surface of the table is inlaid with a central board, and the end edges of the four sides are made of split mouldings to form a double convex surface. There is no waist under the surface of the table. It has a latticed humpback stretcher. A rectangular sihe inner frame on the stretcher, a pillar-shaped strut, and legs form a side apron. Fixed on the four corners are rectangular spandrels, which intersect with the legs to form a shape of "three spandrels to one leg". The four legs are made of four split mouldings, commonly called "sesame sticks". They all splay outward, showing a shape of "four splittings and eight splays".

The style of this *kang* table is more commonly seen in the bamboo products. It belongs to the Ming style furniture produced in the early Qing period.

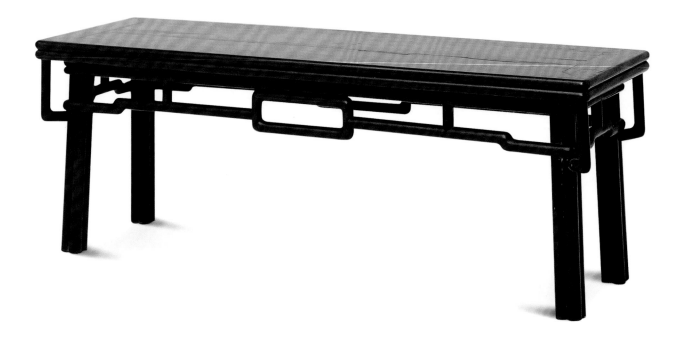

176
Narrow Purple Sandalwood *Kang* (Heatable) Table
with Lotus Flowers

Height 32 cm Length 90 cm
Width 50 cm

The lattice frames of the surface of the table is inlaid with a core board. Under the surface is a waist. It has bulging legs and outward-curving aprons, with inward-curving horse-hoof feet. Dense lotus flowers and lotus seeds are carved on the end edges of the surface of the table, waist, lowered centre aprons, legs, and feet, concealing the ground.

This *kang* table and the purple sandalwood arhat bed with lotus flowers (Picture 82) are a matching set. They are not only the same in quality, but also identical in design, layout, and artistic style. This is a fine piece of Guangdon furniture of the early Qing period.

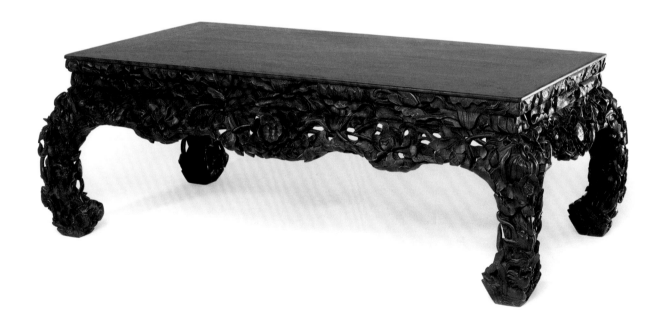

177

Narrow Purple Sandalwood *Kang* (Heatable) Table

Inlaid with the Character "*Shou*" (Longevity) in Enamel

Height 35 cm Length 99.5 cm
Width 37.5 cm
Qing court collection

The lattice frames of the surface of this narrow table are inlaid with a core board. There is no waist under the surface of the table. It has straight legs. The legs of the table and the surface of the able are joined with a mortise corner tenon, and the spaces between the legs have aprons with strings and jade-disk-shaped apron. The middle part has three intact large jade disks, and the two ends are semi-circular. The large jade disks are inlaid with the character "*shou*" (longevity) in enamel. It has inward-curving horse-hoof feet.

The difference between a narrow *kang* table and a *kang* table lies in the different locations where they are placed. A pair of narrow *kang* tables are placed on the two sides of a *kang*, whereas *kang* tables are placed singly in the middle of a *kang*.

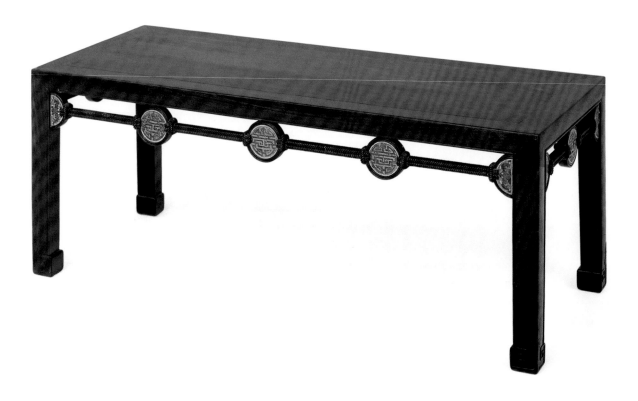

178

Narrow Purple Sandalwood *Kang* (Heatable) Table

Inlaid with Porcelain Pieces

Height 28.5 cm Length 64 cm
Width 28 cm
Qing court collection

The lattice frames of the surface of the narrow table is inlaid with a core board. There is no waist under the surface. The table has square straight legs. The legs of the narrow table and the surface of the table are joined with a mortise corner tenon. In the spaces between the legs is a side stretcher on which are four pillar-shaped struts, carving out five lattices, with each lattice inlaid with green porcelain pieces. The pillar-shaped struts, side stretchers, and legs of the narrow table are levelled with the surface of the table, and this method is called a "straight form". This table has inward-curving horse-hoof feet.

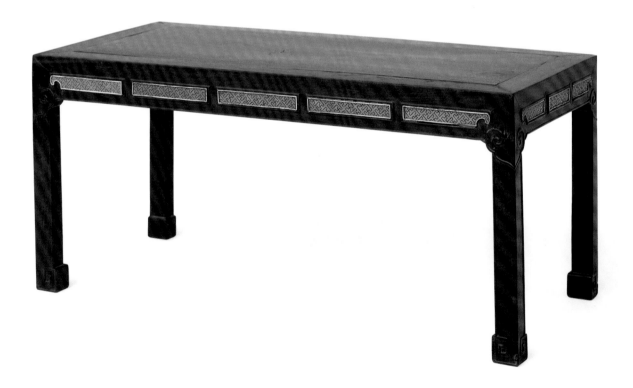

179

Nanmu Wood Incense Stand
Inlaid with Bamboo Strands and Angular Spirals

Height 92 cm Diameter of Surface 42.5 cm
Qing court collection

This incense stand is made of *nanmu* wood, inlaid with bamboo strands and decorated with purple sandalwood strands. The surface of this stand is square, under the surface is a waist wrapped and inlaid with bamboo inner skin, grooves are made and inlaid with jade accessories with *kui-*dragon patterns, and flowery aprons are carved with rectangular spirals. The side edges of the surface of the stand, aprons, legs of the stand are pasted and inlaid into angular spirals with purple sandalwood strands and bamboo strands. The lozenge corners are inlaid with purple sandalwood strands, and the outlines of the angular spirals are also pasted and inlaid with purple sandalwood strands. The feet are supported underneath by a continuous floor stretcher.

The bamboo and purple sandalwood strands used in the making of this stand are all one centimetre thick. The gluing and inlaying of patterns are free of errors and the craftsmanship is extremely superb.

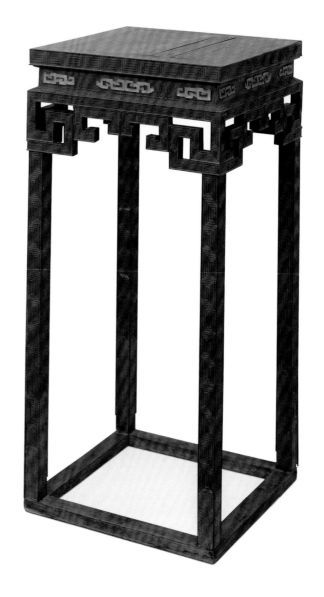

180

Purple Sandalwood Incense Stand

with Passionflowers

Height 88 cm Length 42 cm
Width 31.5 cm
Qing court collection

The four sides of the surface of this stand have water-stopping mouldings. Under the surface is a high waist. It has a rectangular shape opening in which passion flowers are carved in openwork. Fixed on the upper and lower parts of the waist is a stepped apron moulding with lotus petals, and the four corners are decorated with corner aprons carved with flowers. The apron is carved in relief with angular spirals, and it has a corner apron carved with rectangular spirals in openwork. The upper end of the extended legs is carved with wings with scrolling clouds, and the lower part has outward-curving cloud-head feet, under which is a continuous floor stretcher as a support.

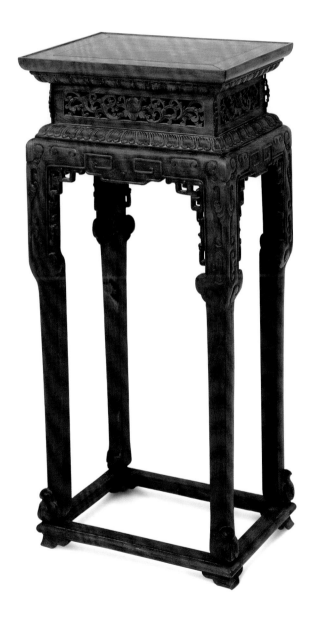

181

Hexagonal Purple Sandalwood Incense Stand

with Passionflowers

Height 87 cm Diameter of Surface 39 cm
Qing court collection

The surface of this stand is hexagonal. The ends of the sides have indented corners, and the end edges are carved with a round of upturned lotus petals. Under the surface is a high waist, inlaid with an ornamental panel carved with passion flowers in openwork. The upper and lower parts of the waist have stepped apron mouldings. The apron is decorated with a round of overturned lotus petals, matching the surface edges, and side edges are carved into *ruyi* cloud heads. It has spandrel cabriole legs and outward-curving feet in the shape of leopard claws, which are supported below by a hexagonal base in the shape of a Buddhist pedestal, with turtle feet.

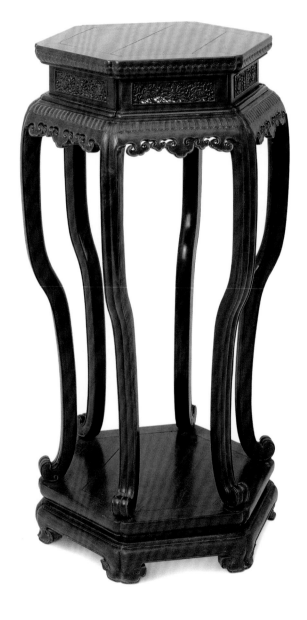

182

Bottle-shaped Purple Sandalwood Incense Stand

Height 104 cm Diameter 35 cm
Qing court collection

The lattice frames of the surface of the stand are inlaid with boards, the four sides have water-stopping mouldings, and the frame-thickening inserts on the end edges are decorated with clouds. Under the surface is a waist in the shape of a precious vase used in worship. The four corners of the vase have spandrels with scrolling clouds, the belly of the vase has medallions with *ruyi* cloud heads, in which cross-shaped flowers are carved, and the base of the vase is fixed with a stepped apron moulding carved with *ruyi* cloud heads. The smoothed ground on the apron is carved with clouds in relief, which reach the spandrel part of the legs. This stand has cabriole legs. Its upper part is a wing with clouds, and its lower end has outward-curving feet with clouds. The feet stand on a round pearl, and below the feet is a continuous floor stretcher with turtle feet.

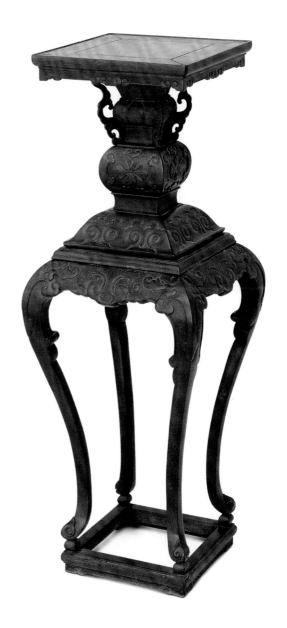

183

Purple Sandalwood Incense Stand
Inlaid with Enamel

Height 112 cm Length 43 cm
Width 38 cm
Qing court collection

The surface of this stand is octagonal, and the lattice frames are inlaid with a central board. Under the surface is a high waist. The waist and aprons are also octagonal, with each side inlaid with cloisonné enamel pieces with flowers on branches. The upper ends of the four legs have spandrels carved with flowers. Under the feet is a continuous floor stretcher.

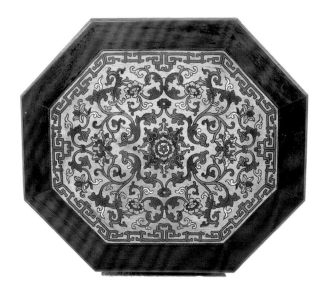

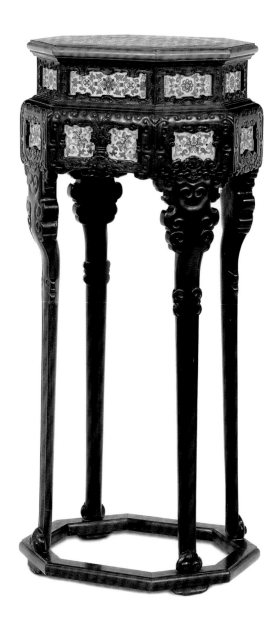

184

Purple Sandalwood Incense Stand
Inlaid with Boxwood

Height 105 cm Diameter of Surface 39 cm
Qing court collection

The surface of the stand have grooves inlaid with a central board of apricot wood. The parts underneath the surface are all made of purple sandalwood inlaid with boxwood. The high waist has a brocade ground with slanted swastika (卍) characters, which are decorated with rectangular spirals. The centre of the waist is a medallion with transformed rectangular spirals, the inside of which is carved with passion flowers. The grounds of the aprons are carved with passion flowers. The middle is a rectangular spiral medallion with angular spirals, and carved on the brocade ground with swastika (卍) characters inside the medallion are *kui*-dragons. The apron-head spandrels are carved with passion flowers, and spandrels are carved with *kui*-dragons. The extended legs have clouds, and the spandrels are carved with animal masks holding rings, under which are hanging chimes, *ruyi* cloud heads. It has outward-curving feet in the shape of cloud heads, and the feet are supported by a continuous floor stretcher from below.

This type of furniture with purple sandalwood inlaid with boxwood and a smoothed ground carved with flowers in relief is rarely seen in the Qing Dynasty. Matching purple sandalwood, which has a dark and heavy colour, with boxwood, which has a light and fresh tone in colour, creates a stark contrast and generates a special visual effect.

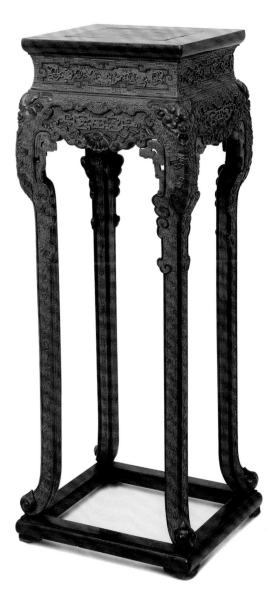

185

Purple Sandalwood Incense Stand
with Cicadas

Height 89.5 cm Diameter of Surface 39 cm
Qing court collection

The lattice frames of the surface of the stand are inlaid with boards. Under the surface is a waist with the four corners carved with angular spirals, and the middle part carved with clouds. The upper and lower parts of the waist have stepped apron mouldings. The aprons are carved with cicadas. Fixed on the spaces between the legs is a humpback stretcher carved with *kui*-dragons, and carved on the stretcher is a core board with sea water. Below the stretcher, there is a spandrel with clouds, and the apron and the side edges of the legs have raised beadings. It has inward-curving horse-hoof feet carved with *kui*-dragons. It is supported below by a square base in the shape of a Buddhist pedestal, and below the base are turtle feet.

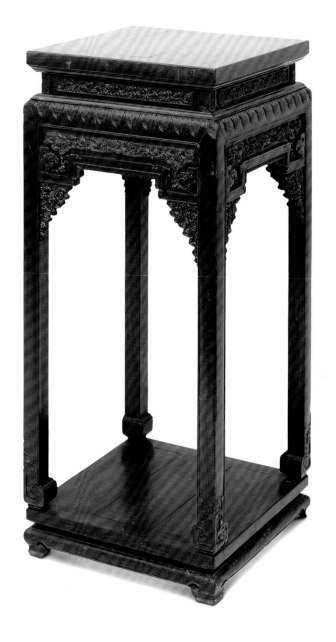

186

Begonia-shaped
Purple Sandalwood
Incense Stand

Height 88 cm Diameter of Surface 39 cm
Qing court collection

 The surface of the stand is in the shape
of a four-petal begonia. Under the surface is
a high waist which follows the form of the
surface. It has a spandrel and an outward-
curving apron. It has cabriole legs with a
wing with clouds, made of split mouldings,
and the legs echo with the surface of the
stand and the indented corners of the high
waist. It has outward-curving horse-hoof
feet, supported by a waisted continuous
floor stretcher from below.

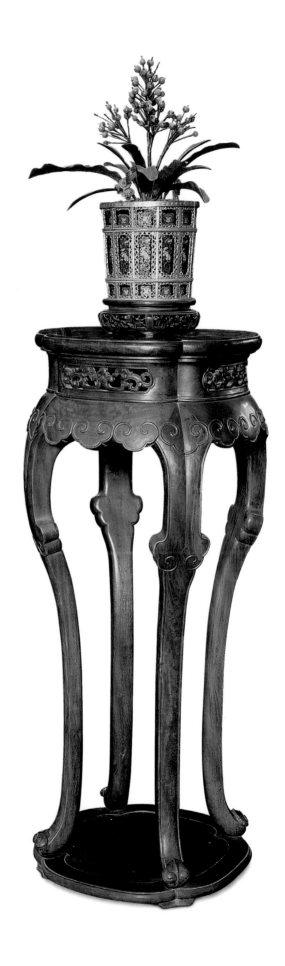

187

Black Lacquer Incense Stand in the Shape of Double-layered *Ruyi* Sceptres Traced with Liquid Gold

Height 98 cm Diameter of Surface 48 cm
Qing court collection

This stand is in the shape of a *ruyi* cloud heads. Its side edges are decorated with scrolling clouds and waves traced with liquid gold. Decorated under the surface is a flowery apron with cloud heads traced with liquid gold. The two ends of its cabriole legs are in the shape of a *ruyi* sceptre, resembling three *ruyi* sceptres standing like a tripod, with the upper part decorated with coiled flowers and scrolling clouds traced with liquid gold. Under the partition board are cabriole legs which are symmetrical with the upper level. Supported from below is a *ruyi*-sceptre-shaped Buddhist pedestal. The side edges of the base are decorated with rectangular spirals, bats, and flowers traced with liquid gold, and the base has turtle feet.

The shape of this stand is new and original. The decorations are magnificent and vivid, exuding a sense of eternal beauty.

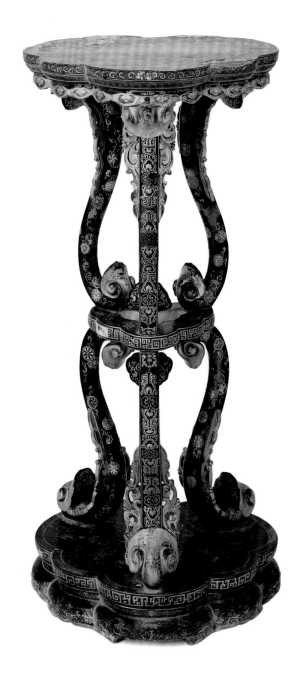

188

Ironwood Lute Stand
with Entwining Peonies

Height 84 cm Length 144.5 cm
Width 30 cm
Qing court collection

This lute stand is made up of three whole boards of ironwood. The outer edges of the boards have a round of raised beadings, while the inside is carved with peonies with entwining branches in relief. The two sides have medallions, and the inside has peonies with entwining branches carved in openwork. It has scrolled-book-style feet.

This stand has clear and natural textures of wood with exquisite carvings and a simple and concise shape. It is a masterpiece of the Ming style furniture in the early Qing period.

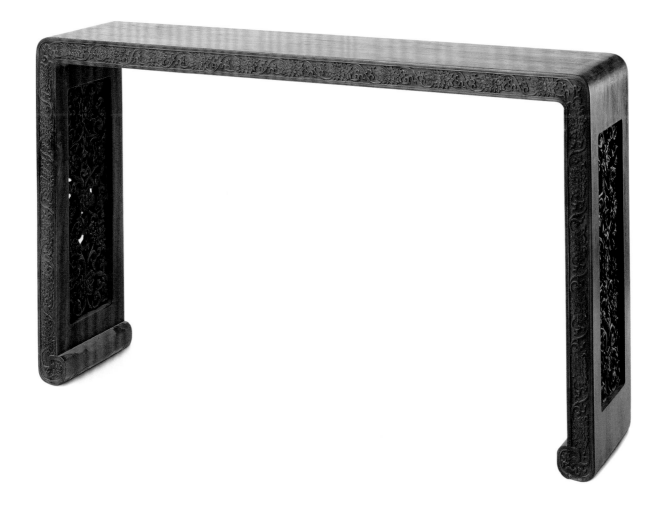

189

Ladder-shaped Stand
with Three Legs Covered
with Gold Lacquer

Height 47 cm Length 88 cm
Width 9 cm
Qing court collection

The surface of the stand is arc-shaped, and the two ends are everted in the shape of waves. The inside of the waist under the surface is inlaid with three aprons, using the high relief carving technique to decorate the painting of "A Hoary Dragon Teaching Its Young Ones" (canglongjiaozi). The outside is carved with *kui*-dragons carved in relief. It has cabriole legs carved into the shape of an animal head spitting water, with the water curling up when the water pillar lands on the ground, forming outward-curving horse-hoof feet.

This arc-shaped stand was used to be leant on by people when they were sitting on the ground, and was popular during the Southern and Northern Dynasties. After the Song Dynasty, it was mainly popular in the minority areas in the north. This stand was used by Qing emperors in their tents when they had outings.

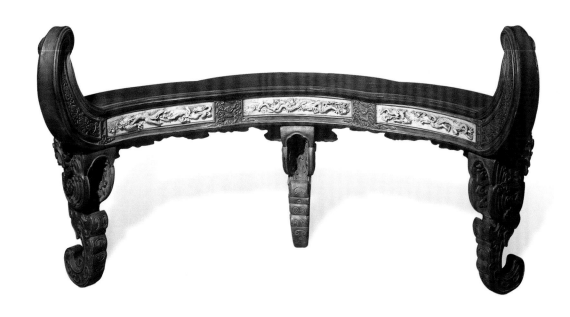

190

Filled Lacquer Double-ringed Table
with Engraved Gold (*Qiangjin*) Designs of Clouds and Dragons

Height 50.5 cm Length 24.4 cm
Width 23 cm
Qing court collection

The surface of the table is in the shape of two rings piling on each other. Under the surface is a waist. It has an apron with a pot-door-shaped opening. The six legs are in the shape of an elephant trunk. It has pearl-like feet, which are supported by a double-ringed floor stretcher below. The entire body has lacquered decorative patterns engraved in gold. The surface of the table is decorated with one red and one blue dragon. The middle part is decorated with a flaming pearl, and the spaces in between are covered with bright clouds and aprons. The side edges are dotted with flowers and butterflies, and the aprons are decorated with flowers on branches. The part below the should and inside the legs and feet is decorated with butterflies. The base is coated with black shiny lacquer, with an inscription carved in the middle "made in the reign of Kangxi in the Qing Dynasty".

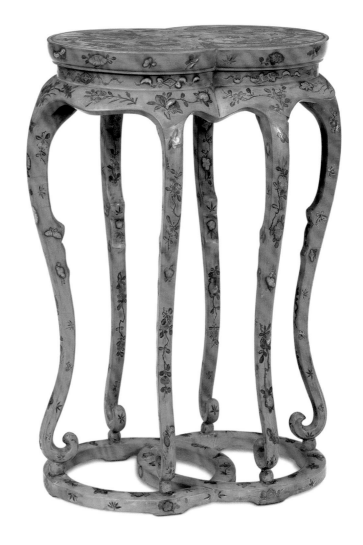

191

Filled Lacquer Square Stool
with Engraved Gold (*Qiangjin*) Designs of Clouds and Dragons

Height 50.4 cm
Diameter of Surface 22.5 cm
Qing court collection

The surface of this stool is square. Under the surface is a waist, cabriole legs, and outward-curving horse-hoof feet, supported from below with a floor stretcher in the shape of a square plate. The entire body has a yellow lacquer ground, decorated with carved flowers engraved in gold. The surface of the stand has a brocade ground with black swastika (卍) square checks. groundThe middle part has a sunflower-shaped medallion which are decorated with engraved gold designs of strolling dragons, bright clouds, miscellaneous treasures, and aprons. Decorated inside the medallions on the four corners are coiled flowers. The waist is carved and filled with *chi*-dragons, and the legs are carved and filled with flowers on branches. The floor stretcher has a brocade ground with black swastika (卍) square checks. The middle has a sunflower-shaped medallion which is decorated with clouds and dragons and aprons engraved in gold. The inside of the stand has black and plain lacquer, and the middle part is engraved with an inscription "made in the year of Kangxi in the Qing Dynasty".

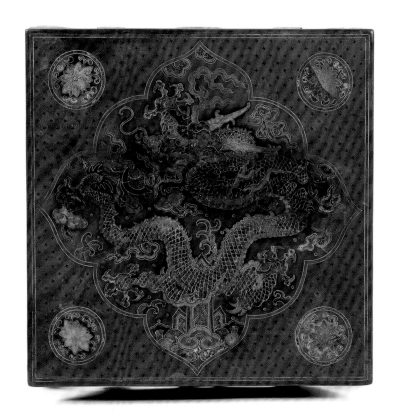

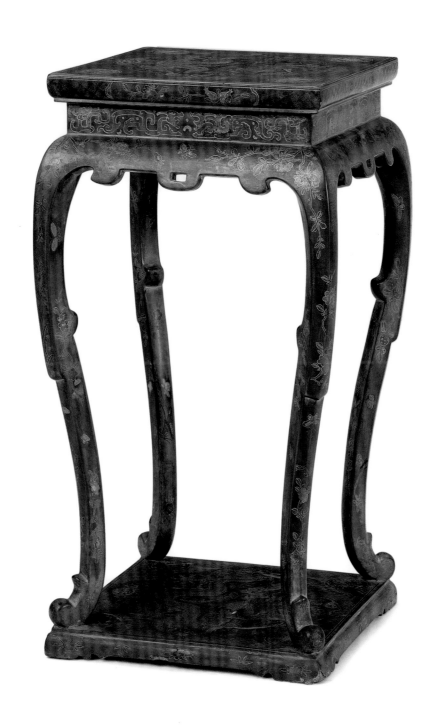

192

Carved Colour Lacquer *Kang* Stool

Height 35 cm Length 94.5 cm
Width 26 cm
Qing court collection

The entire body of this *kang* stool is carved in cinnabar, green, and yellow lacquer. The centre of the surface of the stool is carved with rectangular spirals and Western curling tendrils in relief. The upper part is dotted with bats and catfish, the sides, with angular spirals. The side edges of the surface is carved with bats, birthday peaches, swastika (卍) characters, and rectangular spirals, which extend to the surfaces of the legs, carrying the meaning of "fortune and longevity are boundless". Under the surface is a spandrel carved with rectangular spirals in openwork. The sides between the two legs have a medallion, decorated with upturned *ruyi* cloud heads. The feet have a continuous floor stretcher with sea water as support from below. The inside and middle of the surface of the stool is carved in concave with an inscription "made in the Qianlong years in the Qing Dynasty", written in regular script and traced with liquid gold.

Qing furniture with signatures and inscriptions is extremely rare. This stool has important reference value for the study of furniture craftsmanship during the Qianlong years.

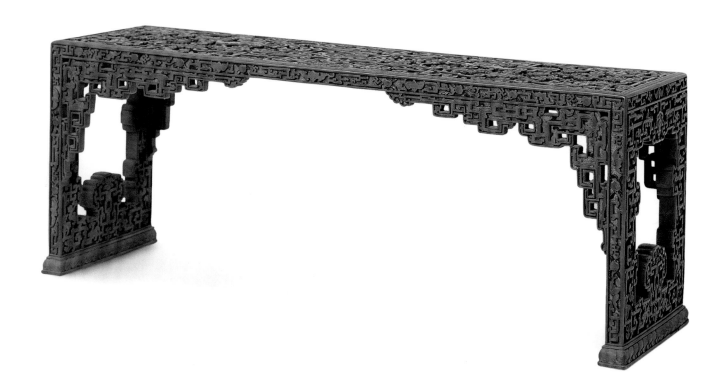

193

Rosewood Compound Cabinet

Total Height 518.5 cm Length 192 cm
Width 80.5 cm
Qing court collection

This compound cabinet has three layers, and the base cabinet has one layer. The top cabinet and the base cabinet have two opposite-opening doors. The core of the board and the two sides of the vertical wall have lozenge-shaped medallions fully carved with clouds and dragons. The round hinges and surface hinges have gilded copper carved flowers. The spaces between the legs have straight aprons, and the four feet have copper wrappers.

This cabinet was used in the Palace of Earthly Tranquility (Kunning Gong). It is large and heavy, and has dense carvings and decorations. Vertical cabinets with three layers on its top are rarely seen. Only the royal family could spent so much labour and effort in making this heavy piece of furniture.

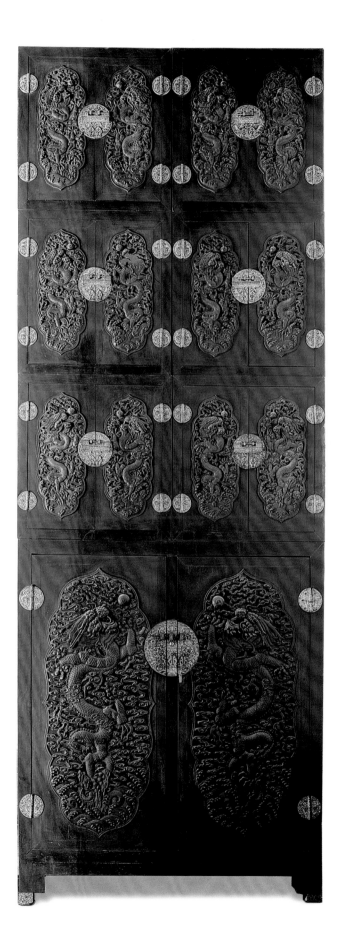

194

Purple Sandalwood Bow Cabinet

with Dragons

Height 230 cm Length 195 cm
Width 112 cm
Qing court collection

The top of this cabinet has a Vairocana hat in the shape of a *ruyi* sceptre head. The front side of the body of the cabinet is divided into two layers, all with two opposite-opening doors. The door panels are decorated with dragons. The core boards of the vertical wall on the two sides of the body of the cabinet are covered with carvings of two dragons chasing a pearl, and the four sides are all decorated with ornamental panels. The legs of the cabinet under the doors have outward-curving aprons, which are covered with carvings of two dragons chasing a pearl. The middle part of the aprons have dividing-the-heart motif. It has four outward-curving feet.

This cabinet was specially made for the Palace of Earthly Tranquility (Kunning Gong). It was mainly used to store ritual objects used in Shamanistic worship, such as bows and arrows. The shape of this cabinet is extraordinary, and its carving is lively and excellent. It is an early Qing Dynasty masterpiece of hardwood furniture.

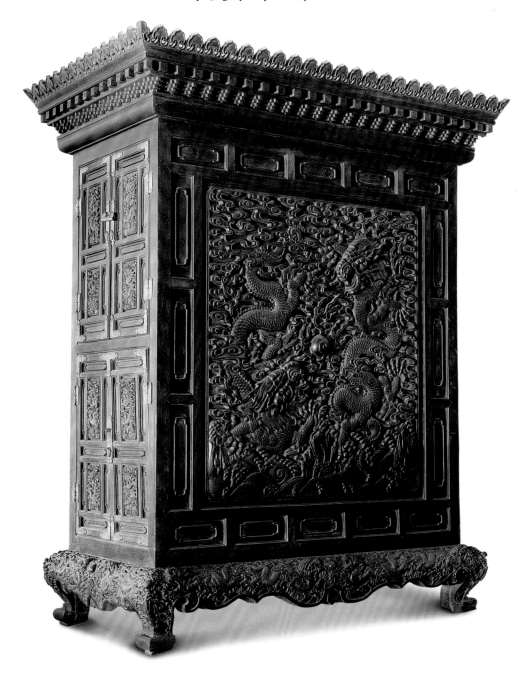

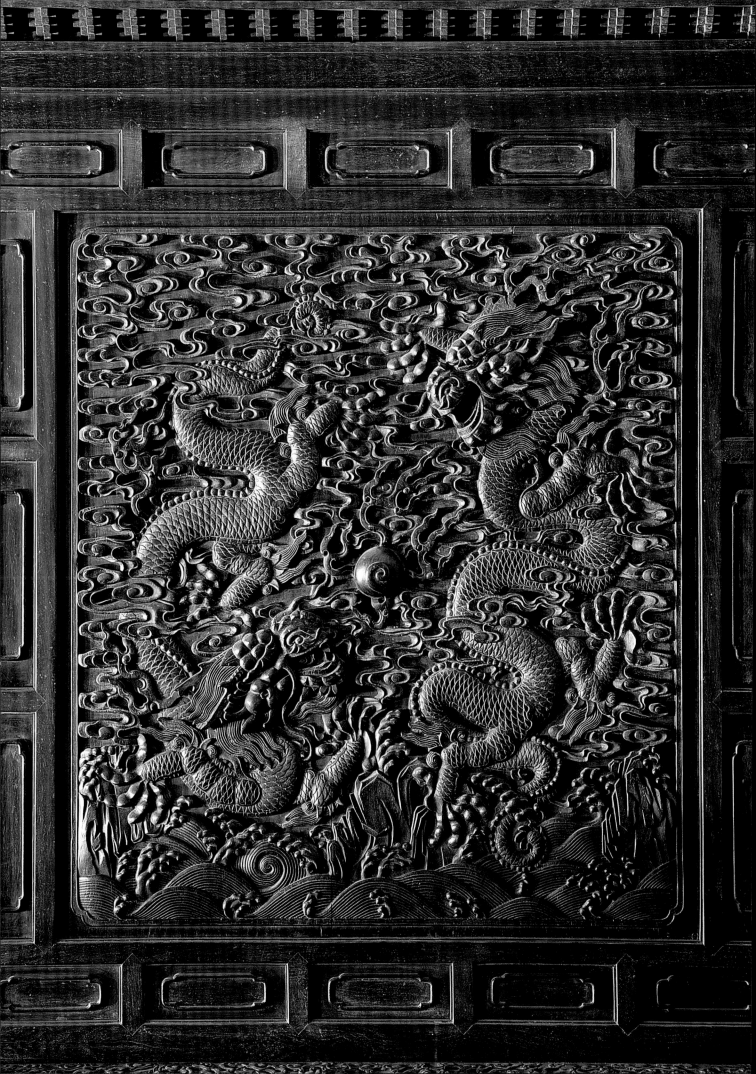

195

Small Yellow Rosewood Cabinet Shelf

Height 48.5 cm Length 39 cm
Width 29.5 cm
Qing court collection

This small shelf is in the shape of a flushed cube. The front side has two opposite-opening doors. The door frames are decorated with angular spirals and inlaid and pasted with bamboo strands. Glass is inlaid inside the frames and is in the shape of a symmetrical pair of " 弓 " (bow) characters. The shelf inside is divided into left and right sections, and each section has three small drawers which hang systematically from top to bottom. The two side boards are also decorated with angular spirals and inlaid inside with glass. It has inward-curving feet with rectangular spirals.

According to the Qing court archives, this shelf was used at the Hall of Joyful Longevity (Leshou Tang).

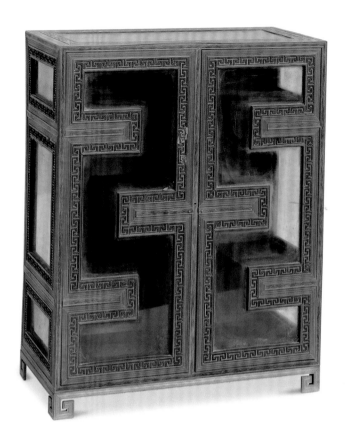

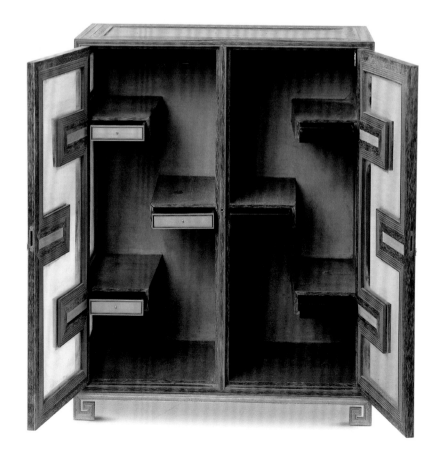

246

196

Small Purple Sandalwood Cabinet

Inlaid with Porcelain

Height 89 cm Length 42 cm
Width 21 cm
Qing court collection

This small cabinet closely resembles a compound cabinet, and is made from a single piece of purple sandalwood. The front side has three levels and six opposite-opening doors. The frames are inlaid with modelled and coloured porcelain pieces, including paintings of flowers and birds such as "camellia ribbons", "peaches in spring and mynas", "peonies and phoenixes", and "roses and cocks", carrying the meanings of "having a successful official career" (guanyunhengtong), "the phoenix bowing towards the sun" (danfengchaoyang), and "fame and fortune" (gongmingfugui), etc. The frames have angular spirals and are inlaid with removable copper hinges gilded in gold and surface hinges. Under the doors hang two aprons inlaid with porcelain flowers. The boards of the two sides have four layers and are inlaid with ornamental panels which are carved with patterns of "the five blessings holding up longevity" (wufupengshou) and "the spring of fortune is long-lasting" (fuquanmianchang), the latter of which is composed of bats, coins, and endless knots.

The colour porcelain of this cabinet is created through the colour porcelain kiln firing process so that the painting is higher than the plain surface to enhance a three-dimensional impression. This cabinet is the only one of its kind in the furniture collection of the Palace Museum.

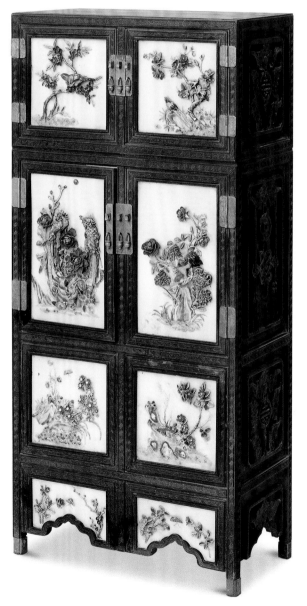

197

Purple Sandalwood Cabinet Shelf

Height 254 cm Length 119 cm
Width 49 cm
Qing court collection

The shelf of the upper part of this cabinet shelf is divided into two sections. The upper section has two square-shaped shelf, and the lower section has four rectangular shelves. Between the shelves are posts, which do not have any inset panels. Each shelf is fixed with a sihe inner frame in the shape of a fish belly. Under the shelf is the cabinet, which has two opposite-opening doors, and the door leaves are inlaid with a plain core board. The middle part of the cabinet has a vertical bolt, copper hinges, and pulls. The base stretcher is inlaid with a lowered centre apron carved with angular spirals. This cabinet has square legs and straight feet.

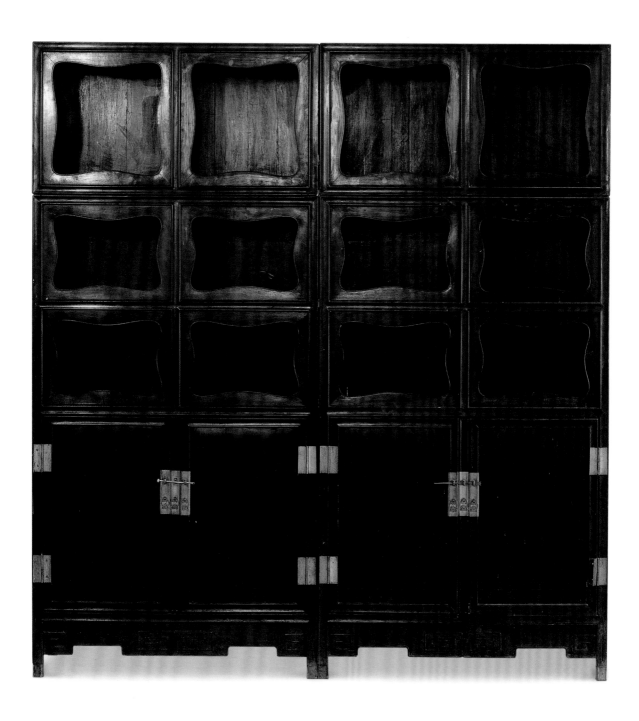

198

Purple Sandalwood Compound Cabinet

with Eight Immortals and Eight Auspicious Symbols

Height 161 cm Length 89.5 cm
Width 35.5 cm
Qing court collection

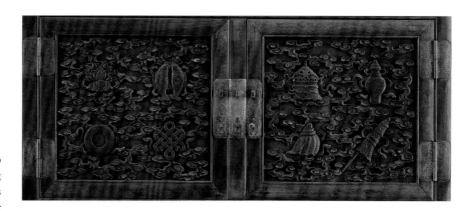

This compound cabinet has two sections, each with two opposite-opening doors, and the middle has vertical bolts added. The door frames have grooves for the inlaying of core boards. The upper section has a smoothed ground carved with clouds, interspersed with eight auspicious symbols of Buddhism, including the wheel of the dharma, conch shell, victory banner, parasol, lotus flower, treasure vase, fish pair, and the endless knot. The lower section is carved with clouds, interlaced with the ritual objects held by the Taoist Eight Immortals, including bottlegourds, fans, treasured swords, flower baskets, Chinese vertical bamboo flutes, fishing drums, court tablets, and lotus flowers. The hill-shaped boards on both sides are carved with a brocade-knotted bottlegourd and a bat chime. Inlaid on the frames and the vertical bolts are surface hinges, metal hinges, and pulls. Between the legs are arc-shaped aprons, the two ends are carved with angular spirals, and the lower part has a copper foot-wrapper.

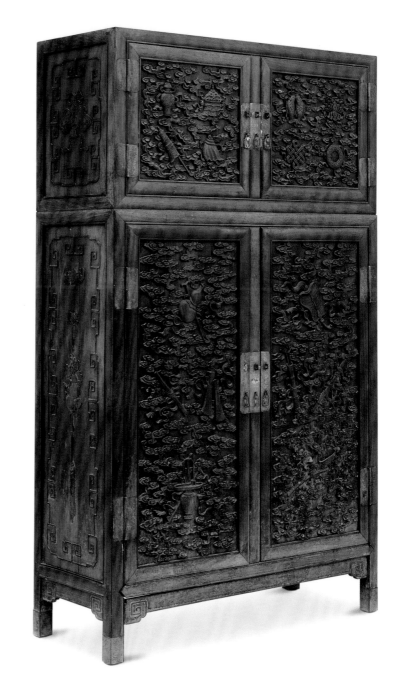

199

Purple Sandalwood Vertical Cabinet
with Ritual Objects of the Eight Immortals

Height 162 cm Length 90 cm
Width 35.5 cm
Qing court collection

This vertical cabinet has two opposite-opening doors. The door frame has grooves to inlay a board. The smoothed ground is carved with clouds interspersed with the ritual objects of the Eight Immortals, carrying the connotation of wishing somebody a long life. The frames are inlaid with copper hinges and metal hinges, and fixed with a pull in the shape of clouds. The cabinet belly under the doors is a concealed storage area, and the cover of this area can be seen when the cabinet doors are opened. The smoothed ground outside the concealed storage is carved with seas, water, rivers, cliffs, clouds, and bats, meaning "blessings as boundless as the East Sea" (*furudonghai*). Carved on the hill-shaped boards on the two sides of the body of the cabinet are rectangular spirals interspersed with brocade-knotted bottlegourds. Fixed on the spaces between the legs are aprons with angular spirals, and the feet are wrapped with copper protectors.

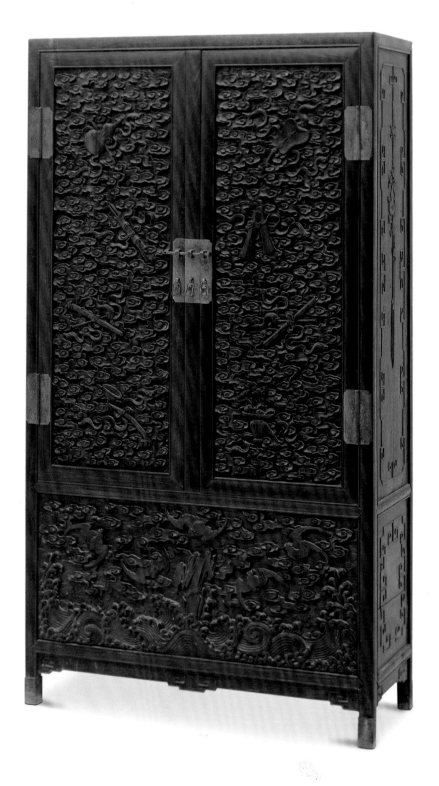

200

Purple Sandalwood Vertical Cabinet
with Passionflowers

Height 164 cm Length 102 cm
Width 35 cm
Qing court collection

This vertical cabinet is divided into two sections, each having two opposite-opening doors, with the addition of a vertical bolt in the middle. The door frames have grooves for the inlaying of core boards, and the smoothed ground is carved with passion flowers in relief. The frames are inlaid and fixed with copper hinges and removable hinges, and fixed with pull rings in the shape of clouds. The inside of the door is fixed with a board, and it has drawers. Fixed under the doors are aprons with passion flowers and curling tendrils. The feet are wrapped with copper protectors.

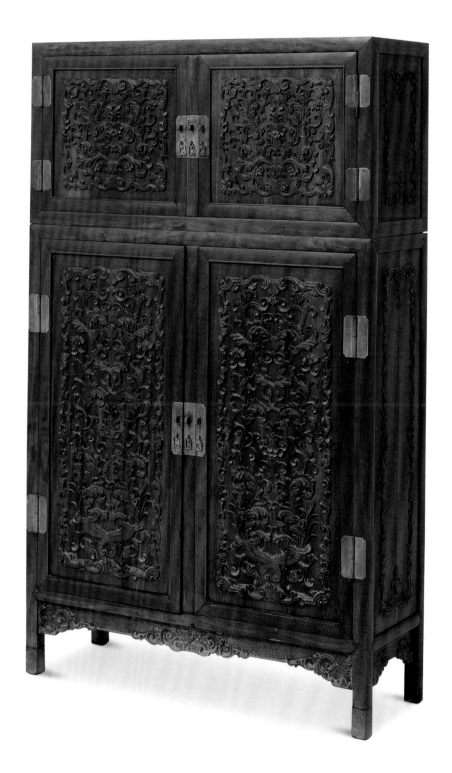

201

Cabinet Carved
with Black Lacquer Edges
and Cinnabar Lacquer
Centre and Decorated
with Sea Water and Dragons

Height 61 cm Length 38.7 cm
Width 16.7 cm
Qing court collection

This cabinet has the upper and lower layers divided by a horizontal shelf. Each layer has two opposite-opening doors. Placed near the base is a drawer, which can be pushed and pulled to open it. The front side of the cabinet has red lacquer and is carved with sea water and swimming dragons. The two sides and the surface of the top have red lacquer and are carved with falling flowers and flowing water. The frames and horizontal checks are painted with black lacquer and carved with cloud bands and angular spirals. The surface of the lower level drawer has sea water and swimming dragons carved in black lacquer. The inside of the cabinet is painted with red lacquer.

The shape of this cabinet is neat and unique, the decorations and carving are refined, and this cabinet is a representative piece of carved lacquer furniture in the middle period of the Qing Dynasty.

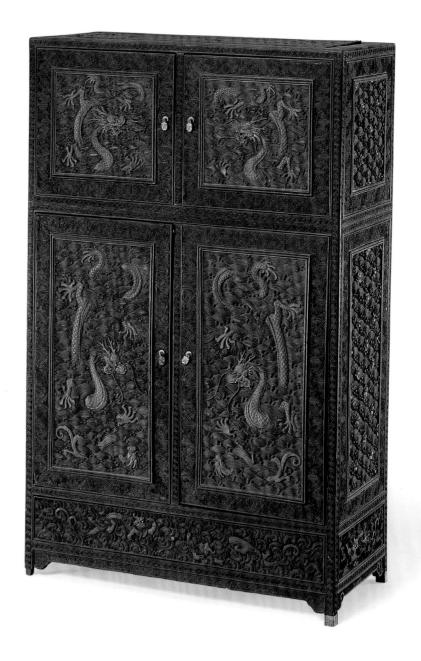

252

202

Small Carved Colour Lacquer Cabinet for Antique Objects

Height 62.5 cm Length 37.9 cm
Width 22.2 cm
Qing court collection

This cabinet is vertical, with opposite-opening doors, and placed in the middle is a post. The carved colour lacquer include colours such as cinnabar, yellow, green, and white. The cabinet doors and the surfaces of the two sides are carved in high relief with elegant ornaments in a study, such as flower vases and incense burners. The frames are carved with flowers on branches and sweetgrass. The cabinet inside is painted with black lacquer. It has three layers and two drawers, which are decorated with rounded flowers traced with liquid gold.

The lacquer quality of this cabinet is fine, and the paintings carved in high relief use the partial colour-adding method. The cabinet is fresh and bright, and the workmanship is superb, showing new heights of achievement in the lacquer carving techniques achieved in the Qing Dynasty.

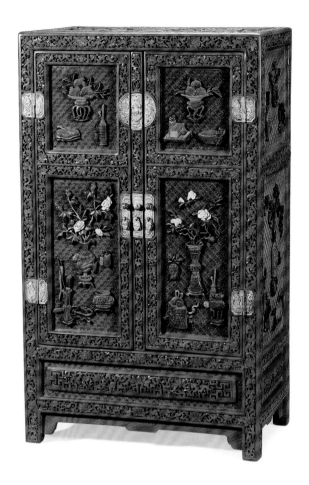

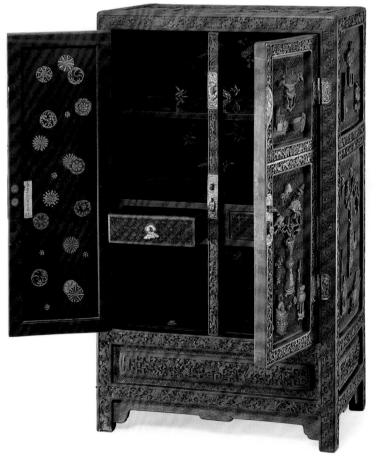

203

Top Cabinet
with a Black Lacquer Ground Decorated with the Pattern of Two Dragons Chasing a Pearl

Height 90 cm Length 92 cm
Width 75.5 cm
Qing court collection

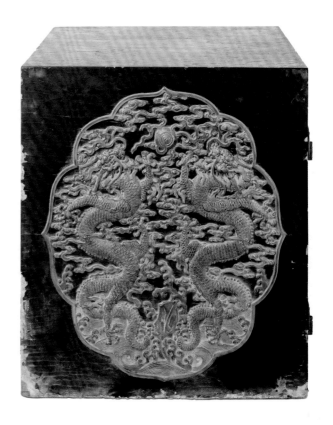

The top cabinet is in a straight form and has two opposite-opening doors. The entire body is painted with black lacquer. The middle of the door board has a lozenge-shaped medallion in paint piling lacquer craftsmanship, and the inside is decorated with the pattern of two dragons chasing a pearl and pasted with gold. One side of the cabinet also has a lozenge-shaped medallion, decorated with two dragons chasing a pearl stacked with cement and pasted with gold.

At present, there are eight extant cabinets. They were originally the top cabinets of the vertical cabinets on the two sides of the Western *kang* in the Palace of Earthly Tranquility (Kunning Gong). Every two cabinets are combined into one layer, piling up two layers to place them on a base cabinet. The height of this cabinet is 518.5 centimeters, reaching directly to the ceiling. According to the Qing court archive, in the eighteenth year of Qianlong (1753 A.D.), due to the fact that the lacquer surface of the base cabinet of the large cabinet in the Palace of Earthly Tranquility (Kunning Gong) was seriously damaged as a result of long-term use, the original cabinets were removed and stored, and another pair of large yellow rosewood cabinets was placed in the original place. As the surface of the lacquer yellow in the base cabinets was seriously damaged, the base cabinets were used for other purposes, only leaving behind these eight top cabinets.

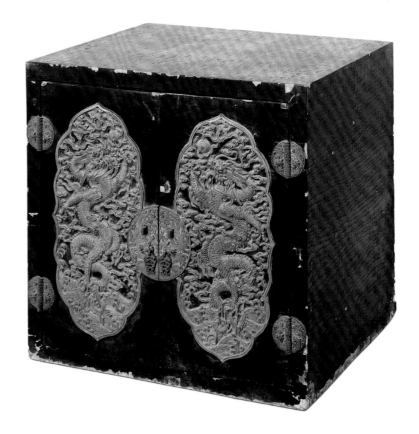

204

Purple Sandalwood Shelf

with Landscape and Figure Paintings

Height 182 cm Length 109 cm
Width 35 cm
Qing court collection

This cabinet is in the shape of a flushed cube. Fixed on the shelf is telescopic lozenge-shaped knotted transoms. Under the shelf are two large drawers and four small drawers, all inlaid with copper pulls. Under the drawers are opposite-opening cabinet doors, with a vertical bolt in the middle, and the frames in the four corners are decorated with double convex surface edge beadings. Inside the frames are grooves inlaid with a core board. Carved on one door is a painting of "Playing a Game of Chess under the Shade of a Tung Tree", and the other door is carved with a painting "Watching a Waterfall". Under the doors is a base support in the shape of a Buddhist pedestal.

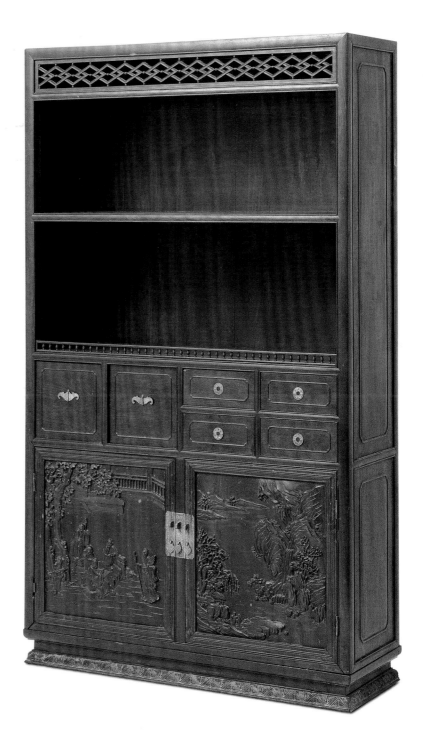

205

Purple Sandalwood Cabinet
with Western Flowers

Height 193.5 cm Length 109 cm
Width 35.2 cm
Qing court collection

The shelves of the cabinet are in a straight form. The upper part has two layers, outlining the sides with strings. Under each layer are four purple sandalwood drawers in dark fringe with burl wood cores carved with western flowers. The lower part has opposite-opening doors, the core board is carved with western flowers, and the metal hinges, surface hinges, and metal pulls are made by carvings of flowers and gilded copper. The spaces between the legs are fixed with plain aprons, the edges on the sides have convex mouldings, and the middle part has a *ruyi* sceptre head with hanging-down passion flowers. The four feet have copper protectors carved with flowers and gilded with gold.

The shape of this cabinet is square, combining the East and West in its carving and decoration. The use of birch and burl wood on the faces of drawers forms a delightful contrast with the heavy colour of the purple sandalwood.

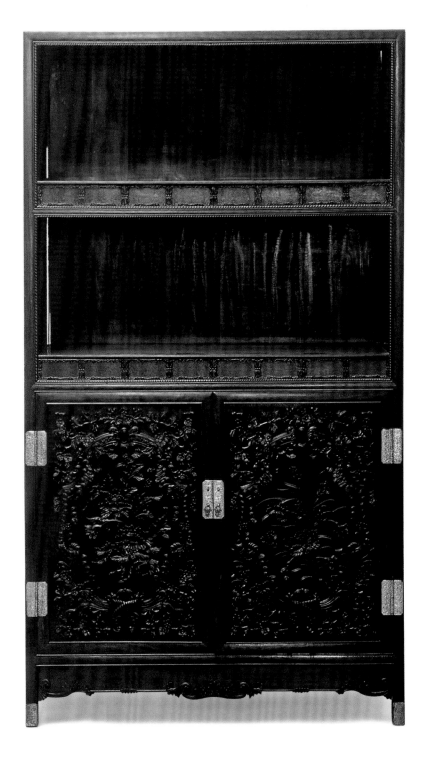

206

Purple Sandalwood Cabinet
with Lattice Doors

Height 193.5 cm Length 101.5 cm
Width 35 cm
Qing court collection

This cabinet is in the shape of a flushed cube. The upper and lower layers are shelves, and the four sides are open. The middle two layers are the cabinet. They have the same structure but their locations are different. Each layer has two shelves. One shelf has three vertical stretchers on three sides, with no doors at the front side. The other shelf has doors like a lattice window. Under the shelf is a spandrel, and the four feet are straight.

It appears that this cabinet let in air on four sides, and it also has railings. That is why it is also called a "food cupboard (qisimao)". But its style and structure is clearly different from the frames of Ming-style "food cupboards (qisimao)".

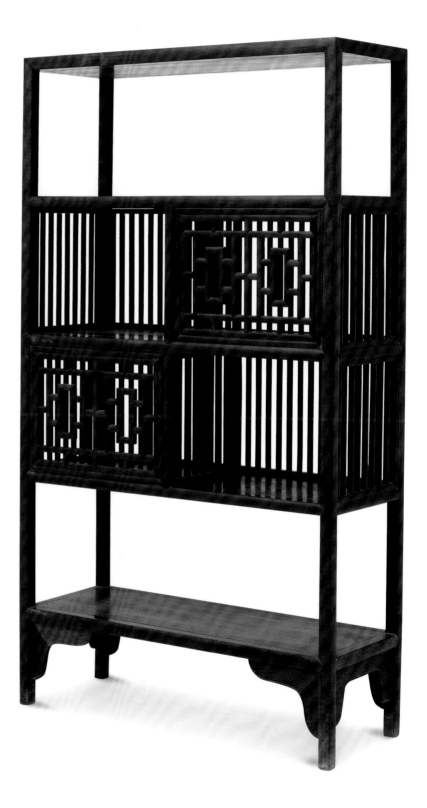

207

Purple Sandalwood Cabinet
with Dragons

Height 162 cm Length 112 cm
Width 38 cm
Qing court collection

This cabinet is in the shape of a flushed cube. The middle part of the upper two levels have three drawers, and the surfaces of the drawers have a round of indented corner ornamental mouldings. Fixed on the centre is a copper pull. The side edges of the shelves are inlaid with sihe inner frames carved with flowers. The lower part is the cabinet, with two opposite-opening doors. The central board is carved with clouds and dragons. The four sides of the cabinet doors have frame lattices, fixed with removable copper hinges and copper lock knots. The hill-shaped board on the two sides have the upper and lower sections, carved with mountains, water, towers, pavilions, trees, and people. Under the doors of the cabinet is an apron carved with angular spirals, and the middle part has a hanging-down lowered centre apron.

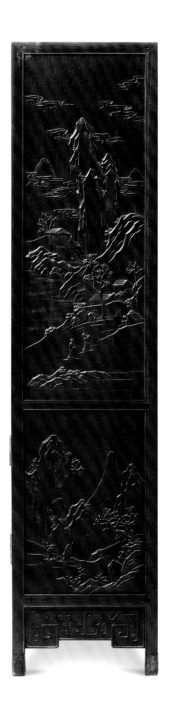

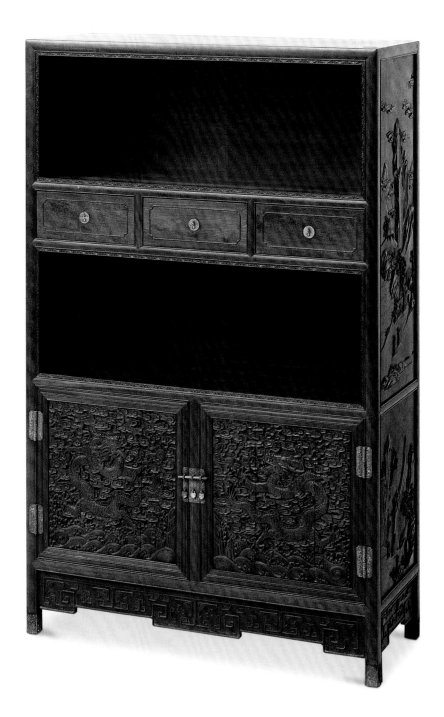

208

Purple Sandalwood Cabinet
Inlaid with Enamel

Height 185 cm Length 96 cm
Width 42 cm
Qing court collection

This cabinet is in the shape of a flushed cube. The miniature curio cabinet in the upper part has five holes. The front and the two sides are in openwork. The upper part of each hole is inlaid with enamel arch-shaped aprons carved with rectangular spirals and passion flowers. The lower part is fixed with a short railing. The inside of the rear board of the shelf is inlaid with a glass mirror. Under the shelves are two drawers, and the surfaces of the drawers are inlaid with carved copper passion flowers in openwork. Further down is the cabinet. The doors of the cabinet are inlaid with painted enamel carved with clouds and dragons in openwork. The two sides of the body of the cabinet are inlaid with enamel ornamental panels with cloud and bat patterns. Below the cabinet is an enamel apron with entwining lotus flower patterns.

This cabinet was originally displayed at the Palace of Longevity and Good Health.

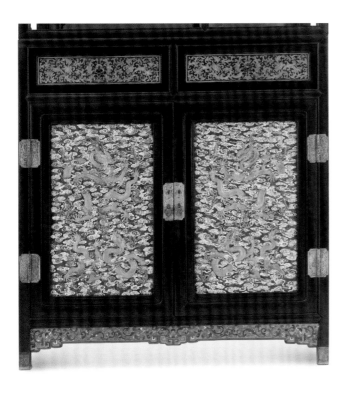

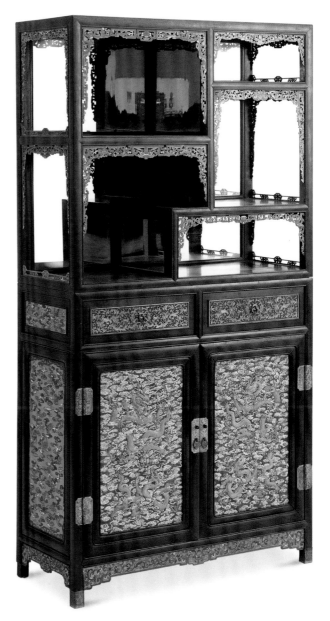

209

Cabinet
with a Lacquer Ground
Inlaid with Bamboo Veneer

Height 110.5 cm Length 94.5 cm Width 25.5 cm
Qing court collection

This cabinet is made of wood, wrapped in Hunan bamboo veneer and decorated with carved cinnabar lacquer. It is in the shape of a flushed cube, with shelves in the upper part and cabinets in the lower part. The cross vertical frames and the stretcher part are carved until the bamboo veneer has the outline of a lozenge, just like a medallion. The four sides of the holes on the upper part of each shelf are decorated and lacquered with sihe inner frames with clouds. The lower part has four doors placed on a row. The two opposite-opening doors in the middle can be opened. Fixed on the frames are removable copper hinges with carved flowers and surface hinges. A scene of antique objects are carved on the boards of the four doors with a groundbamboo ground. The four legs are straight and downward, and they are wrapped with copper leg-protectors in the shape of cloud heads. Under the shelves are bases.

This cabinet was originally stored in the Hall of Fulfilled Wishes (Ruyi Guan).

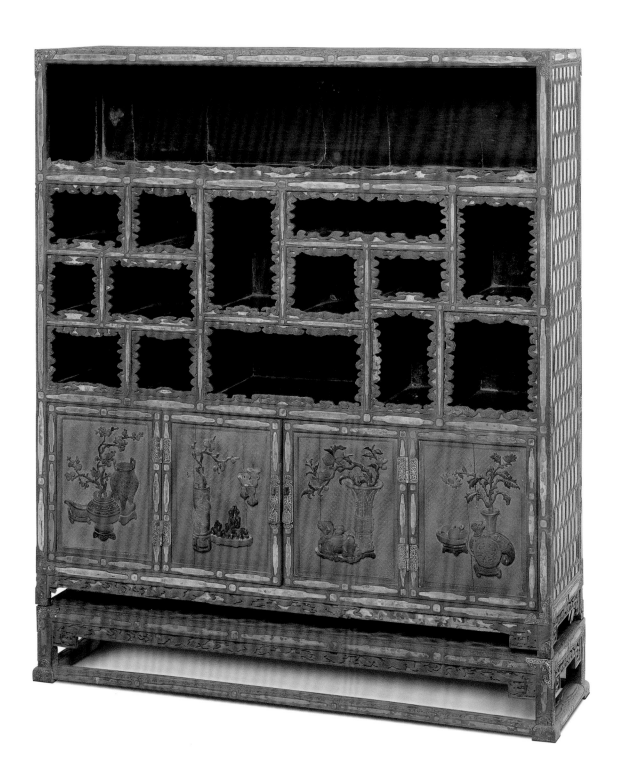

210

Cabinet
with Engraved Gold
(*Qiangjin*) Designs of
Entwining Lotus Branches

Height 166 cm Length 94 cm
Width 48 cm
Qing court collection

This cabinet is in the shape of a flushed cube. The front surface is divided into the upper, middle, and lower parts. The upper part has two layers and is open on all sides. The middle part is divided into three rows and has three drawers in the middle with medallions with indented corners. The middle is inlaid with a begonia-shaped pull, and the two sides each have a door, with decorations the same as those on the surfaces of the drawers. The front side of the lower part has a fish-belly-shaped sihe inner frames, and the three sides are fixed with boards. The entire body of the cabinet has a red lacquer ground. The frame structure of the front side is decorated with engraved gold designs of entwining lotus branches and two *kui*-dragons chasing a pearl. The hill-shaped boards on the two sides are decorated with plum blossoms and green bamboo engraved in gold. The spaces between the legs are fixed with a humpback stretcher apron, joining with the horizontal belts of the upper part with two groups of double pillar-shaped struts. The feet are wrapped in copper covers.

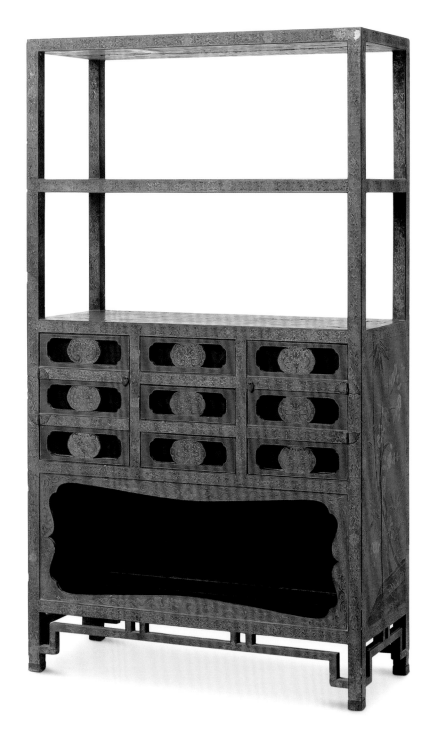

211

Black-lacquered Shelf for Antique Objects
with Rectangular Spirals

Height 159 cm Length 160 cm
Width 32 cm
Qing court collection

This cabinet has a shelf for antique objects. The shelf has small shelves, each at different heights with different sizes in openwork. The exterior of the frames has convex surface edge beadings, and the spaces in between are decorated with flowery aprons with rectangular spirals. All the edge mouldings and the side edges of the aprons are decorated with gold lacquer. The four frames of the table frame on the two sides reach the ground. The feet have rectangular spirals.

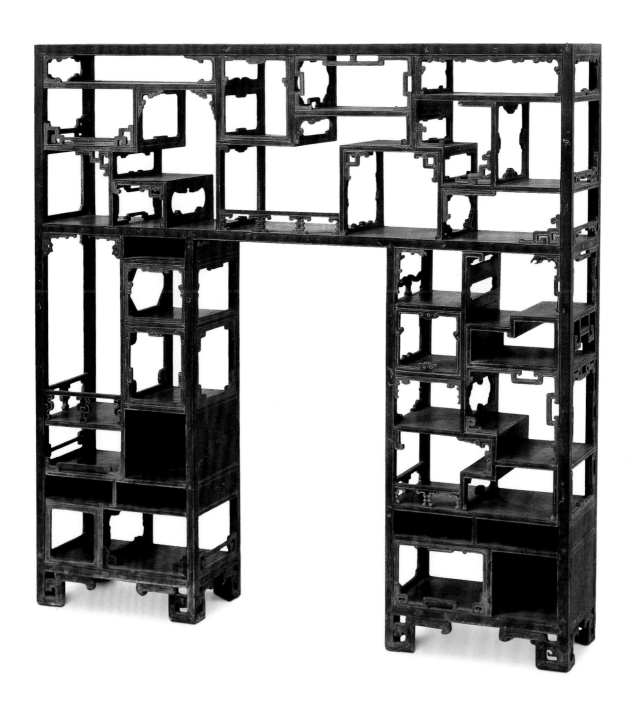

212

Black Lacquer
Cabinet Shelf

Height 249.5 cm Length 127.5 cm
Width 64 cm
Qing court collection

The four frames of the shelves are in a square shape, and the entire body of the shelf is coated with black lacquer. It is divided into three parts. The upper part has two drawers, the lower part has a layer of flat drawers. The rear is inlaid with boards, and the left, right, and the front sides are open, with only two sides of the upper part inlaid with lattice shelves by " 十 " (cross) characters. Fixed between the legs are straight aprons, and the feet have copper protectors.

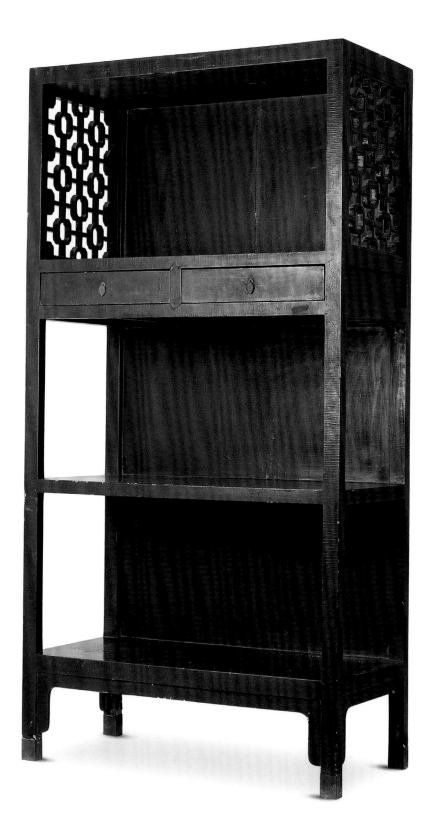

213

Black Lacquer Book Shelf
Inlaid with Mother-of-pearl and Decorated with Landscape and Flowers

Height 223 cm Length 114 cm
Width 57.5 cm
Qing court collection

This book shelf is open on four sides. Fixed between the legs are arc-shaped aprons with upturned lotus leaves, and the feet are covered with brass. The edges of the frames are inlaid with a medallion with a brocade ground decorated with thin mother-of-pearl in five colours and gold and silver pieces. Inlaid inside the medallion are landscapes, figures, flowers, fruit, grass, and insects in mother-of-pearl. On the base's surface of the middle layer is engraved with an inscription "made in the *guichou* year in the reign of Kangxi in the Qing Dynasty". *Guichou* year in the reign of Kangxi was the twelfth year in the reign of Kangxi, which was 1673 A.D.

This shelf is one of a pair. The craftsmanship is exquisite. What is so special about this shelf is that the mother-of-pearl and the gold and silver pieces are extremely thin. The many beautiful patterns in such a small area shows a high level of craftsmanship.

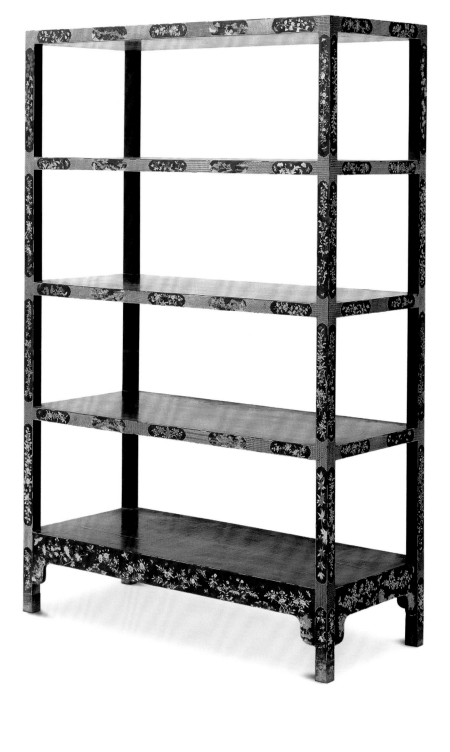

214

Cypress Ice Box

Height 82 cm Length 91 cm
Width 90 cm
Qing court collection

This ice box has a pair of box lids, and on the lids are four medallions with copper coins, for lifting up the box lids. The four walls inside the box are warped and inlaid with lead sheaths. It also has a layer of drawers, formed by two rectangular drawers. The outside walls of the ice box have three copper stubs, and fixed on the two side surfaces are copper handles. Under the box is a cypress base, and the surface of the base, the four corners of the waist, the bulging legs and spandrels are all wrapped and inlaid with copper pieces. The feet below are linked to a continuous floor stretcher.

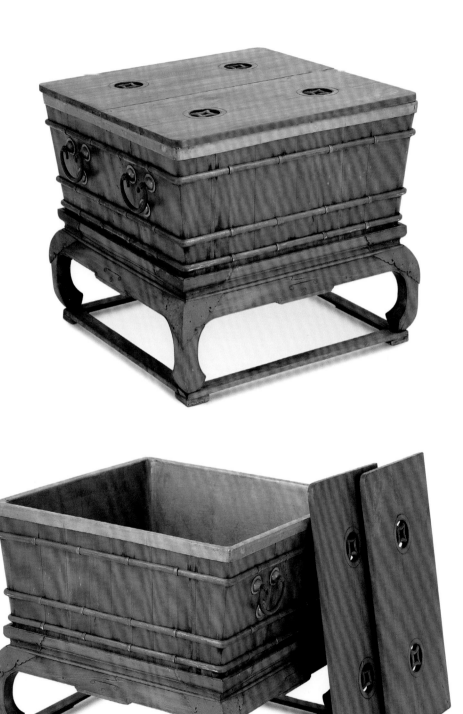

215

Red Lacquer Chest
with Clouds and Dragons
Traced with Liquid Gold

Height 117.5 cm Length 73.5 cm
Width 57.5 cm
Qing court collection

There is a lock knot on the surface of the front side of the chest. Fixed on the two sides are handles. The base has two pierced holes to make it convenient to thread a string through them for moving the chest. The base support has a waist, bulging legs, outward-curving aprons, and inward-curving horse-hoof feet standing on a continuous floor stretcher. The entire body has two kinds of gold and black hooks to decorate sea water, cliffs, clouds, and dragons.

The style of clouds and dragons and the colours of the lacquer of this chest are characteristic of the Kangxi period of the Qing Dynasty. Its making is exquisite, and its decorations are smooth and fluent. It is an excellent example of Qing Dynasty lacquer furniture.

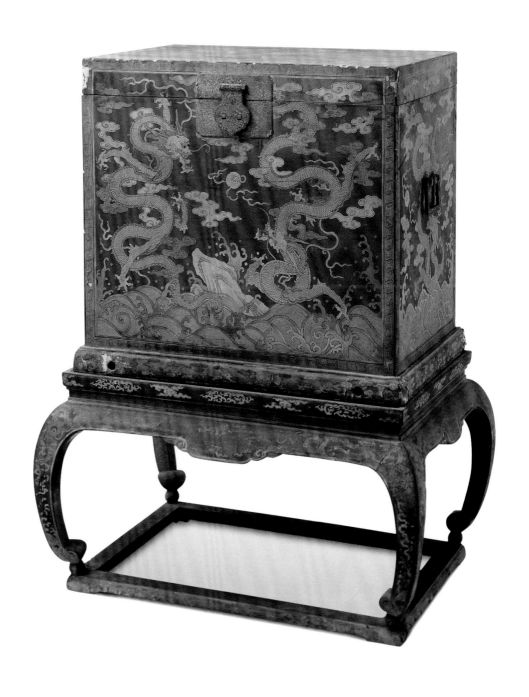

216

Black Lacquer
Chest Set

with Clouds and Dragons Traced with Liquid Gold

Height of the External Chest 49 cm
Length 189 cm Width 50 cm
Height of the Internal Chest 35.5 cm
Length 178 cm Width 40.5 cm

This chest set has external and internal layers. The decorations on both layers are the same, with black and plain lacquer inside, without exposing the wood. The two ends of the body of the chest of each layer all have copper handles. On the surface of the lid of the external chest has a parallel inscription "in an auspicious month of the first year of the reign of Yongzheng, three hundred stems of grass produced in Xiaoling were stored inside" in Manchu and Han languages traced with liquid gold,. Below the external chest is a base inlaid with frame-thickening inserts, and under the four corners of the internal chest are pillar-shaped struts, aligning with the frame-thickening inserts so that they can be placed into the mouth of the frame-thickening inserts. The walls of the internal chest are higher, the lid is narrower, and it has vertical walls. The first year of Yongzheng is 1723 A.D.

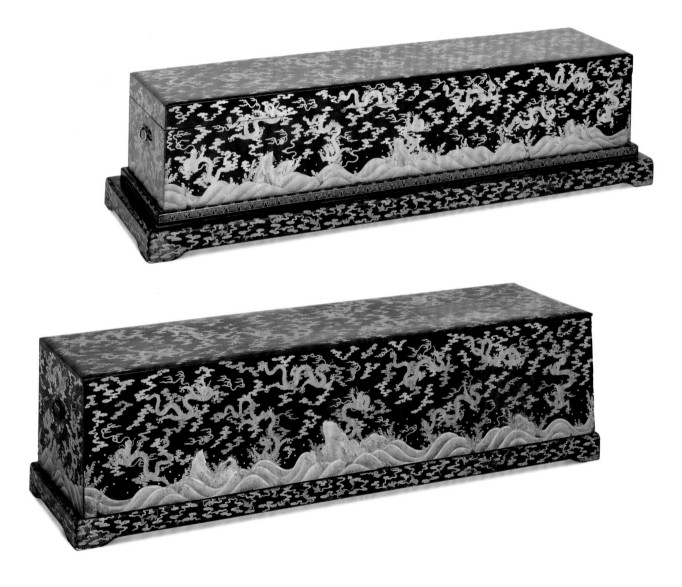

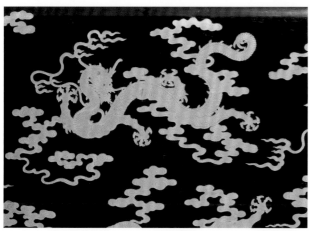

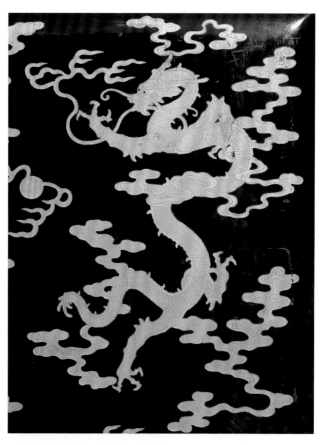

217

Filled Lacquer Stationery Box
with Engraved Gold (*Qiangjin*) Clouds and Dragons

Height 55.5 cm Length 52.5 cm
Width 42 cm
Qing court collection

The front side of this stationery box was originally two opposite-opening doors. One of the doors had been damaged. The doors are equipped with copper decorations. Fixed on the two sides of the box are copper handles. There are ten drawers inside the doors. The base of the box has feet in the shape of cloud heads. The entire body of the box is decorated with two dragons chasing a pearl engraved in gold. The lower part has sea water and cliffs, interspersed with clouds. The surfaces of the drawers have a brocade ground with lacquered slanted swastikas (卐) traced with liquid gold.

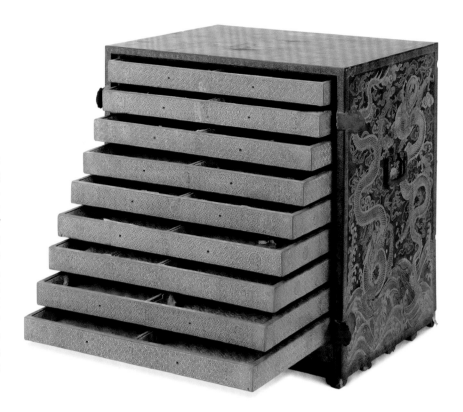

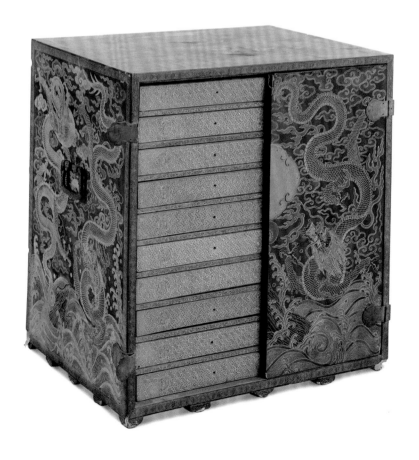

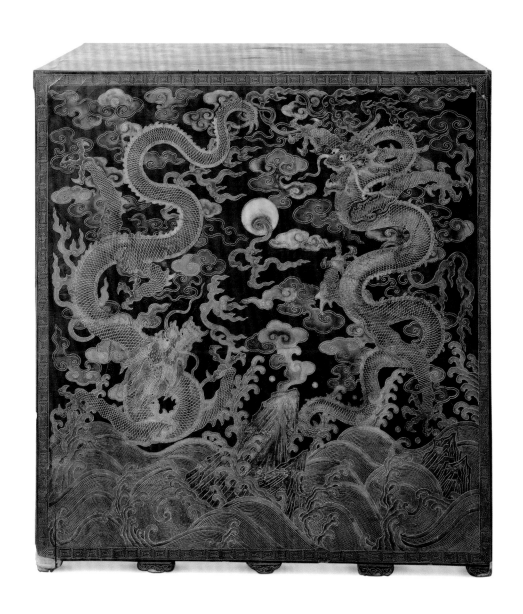

218

Purple Sandalwood Screen
Inlaid with Mother-of-pearl and Written with the Princes' Poems Celebrating the Emperor's Birthday

Height 356 cm
Width 1,128 cm
Qing court collection

This screen has dual purple sandalwood frames. The front side of the central panel has a paper ground on which a poem is written in azurite, 56 words in each panel, being a poem written for Emperor Kangxi by his sixteen sons to celebrate his 60th birthday. The back of the screen has a beige silk ground on which 10,000 "*shou* 壽" (longevity) characters are embroidered in different forms with coloured threads, and each is trimmed with fine black threads. The top of the frame is adorned with a lintel board with an openwork carving of a frontal view dragon holding a pearl. On the front of the screen, the four sides are decorated with mother-of-pearl *kui*-dragons, the inner frame is adorned with bats (meaning "happiness") and "*shou* 壽" (longevity) characters traced with liquid gold, and the front and rear of the apron board have relief carvings of two dragons holding up the "*shou* 壽" (longevity) character. Underneath the side stretcher are gold-plated brass side spandrels and gold-plated brass-clad feet.

The screen comprises a set of 32 panels which are divided into two groups, with each group containing 16 panels. One group displays the poems written by the emperor's sons, and the other by his grandsons. It was a birthday gift presented to Emperor Kangxi at his 60th birthday by his sons and grandsons.

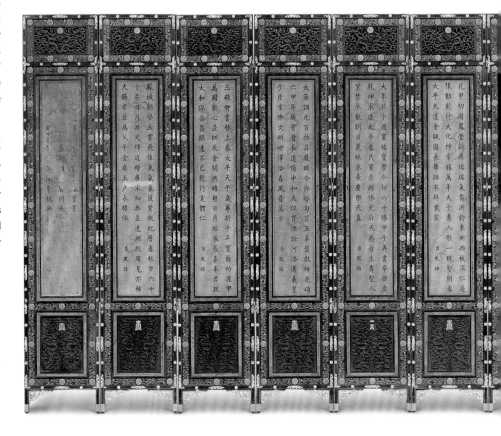

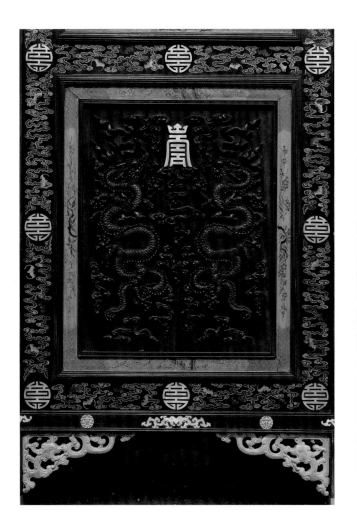

鈞運更昌舜日常明光八表
地同悠久恩重君親慶永長
億侍吾皇
　　　臣胤禛

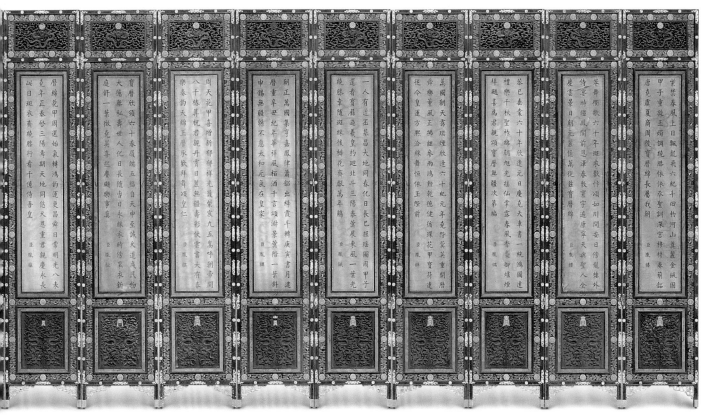

219

Purple Sandalwood Screen
Inlaid with Sixteen Jade Arhats

Height 195.5 cm
Width 944 cm
Qing court collection

This screen has sixteen panels with purple sandalwood frames. On the front of each panel, an arhat made in jade pieces is inlaid on the black lacquer ground, and a eulogy of the arhat is written on the upper corner. The back of each panel has flowers and plants trace with liquid gold and stuck on the black lacquer ground. The apron board is carved with scrolling lotuses, and the feet of the screen are placed underneath.

The screen looks grand, and its craftsmanship is exquisite. It was originally placed in the Building of Luminous Clouds (Yunguang Lou), the garden in the Palace of Tranquility and Longevity (Ningshou Gong).

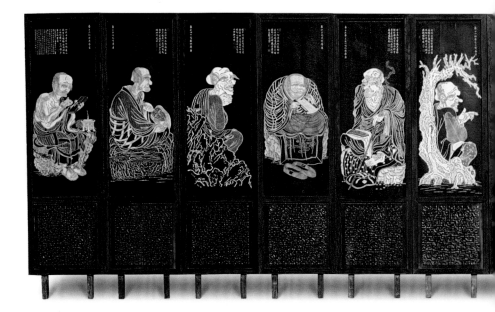

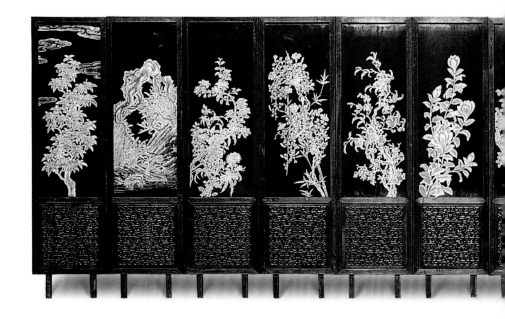

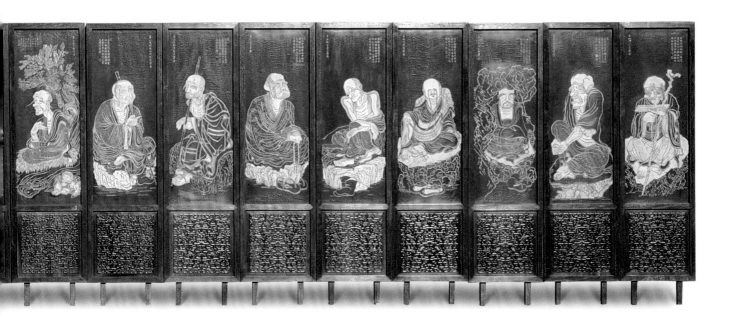

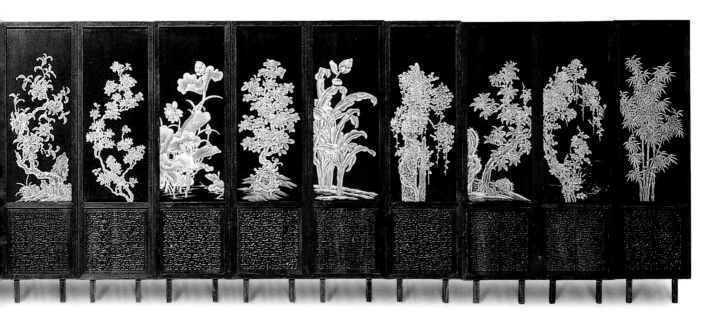

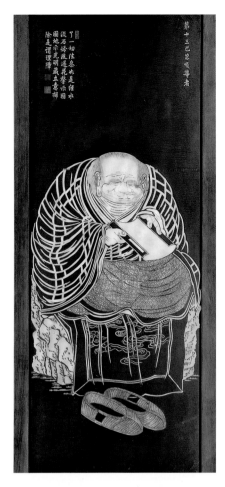

第十三已揭尊者

了一切法泉水是經水
從石礀風過花聲示圖
圖地示先明藏立意搏
除是循理障

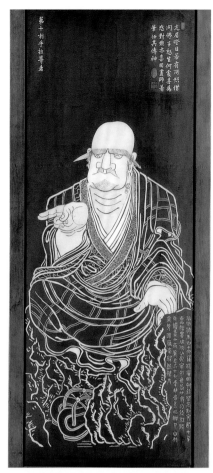

第十諾矩羅尊者

尤眉眨目若有所似攜
閱佛手起生何菱臺鳥
忽對跏亦喜圖畫師著
筆任其傳神

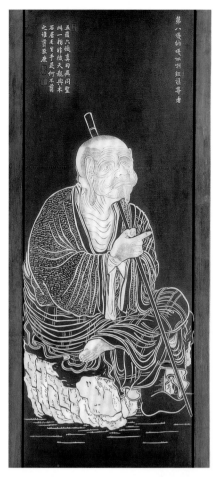

第八嚩阇羅弗多羅尊者

五藏六微真與同聖
此一搭非彼天龍興木
石居足生手足何不有
之讀首聚廬

276

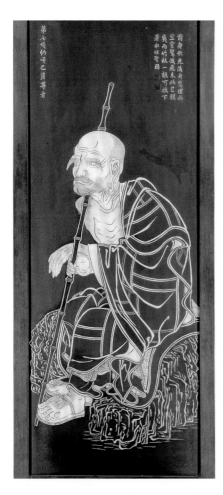

第七哦拘巴提尊者

前身依先滿舟慈理己
至宜驚微飛来此鐵
無而竹秋一根可放下
齊音住聖因

第四哦禮婆尊者

磯石側勝于萬以烏惟
是上人话非照局王
先地以手抉之誰云横
禅玉以題

第一阿羅遵尊者

未枝百柏秋林一谷笋
書貝帆注日槽脑阿刺
吃迹各有而記祀則不
無而那文字

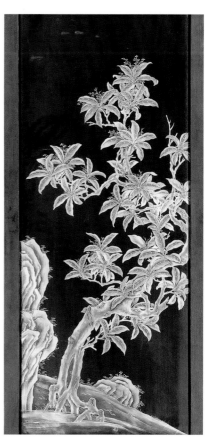

277

220

Screen
with Emperor Kangxi's Copying of Mi Fu's "Rhapsody on a Heavenly Horse (tianmafu)"

Height 310 cm
Width 640 cm
Qing court collection

This screen has ten panels which are completely under a brocade veneer with a check pattern, without exposing any wood structure. The brocade of each panel overlaps with the neighbouring one so that the two panels form one whole unit and can be folded up. The lintel boards, lower ornamental panels, and lower aprons are all carved with *kui*-dragons. The feet are brass-clad. The central panel is made of paper, on which Emperor Kangxi himself wrote a preface on the first panel. From the second to the ninth panels, the Emperor copied the full text of Mi Fu's "Rhapsody on a Heavenly Horse". There are two square seals at the end of the text with seal marks "*qinggong taibao*" and "*Dong Qichang shu*", but both are fake. On the last panel, there is the postscript written by Shen Quan, a calligrapher at the time of Kangxi. The apron boards are also mounted with check pattern brocade, and a black lacquer panel is mounted at the centre on each board. Flying animals, galloping lions, running dragons, flying phoenixes, and Chinese unicorns, all in pairs, are refinedly carved on the panels and trace with liquid gold. On every other panel there is a poem or rhapsody written by famous scholars glorifying the extraordinary animals. The rear of the central panels of the screen is pasted with gold paper, on which are poems written by ten favourite officials or literati of Kangxi's time. These poems are mostly praises for the emperors. The rear of the apron boards are engraved with the songs or poems on bamboo composed by famous literati of the Tang Dynasty.

The screen was originally set in the Hall of Sincere Solemnity, (Chengsu Dian) the rear resting hall behind the Fasting Palace (Zhai Gong) inside the Forbidden City.

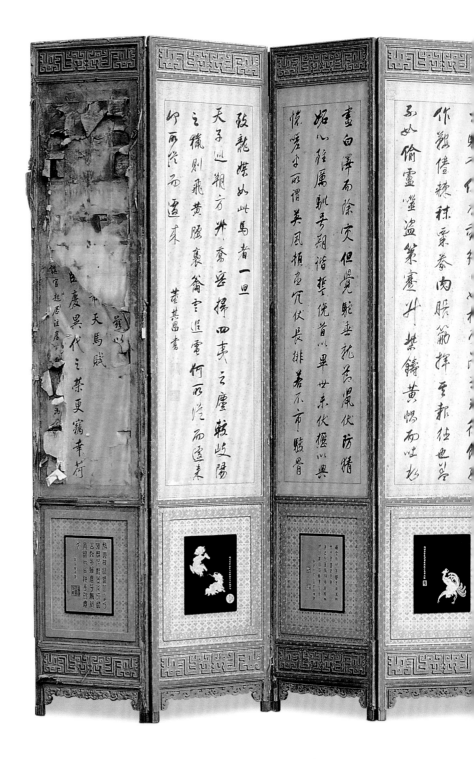

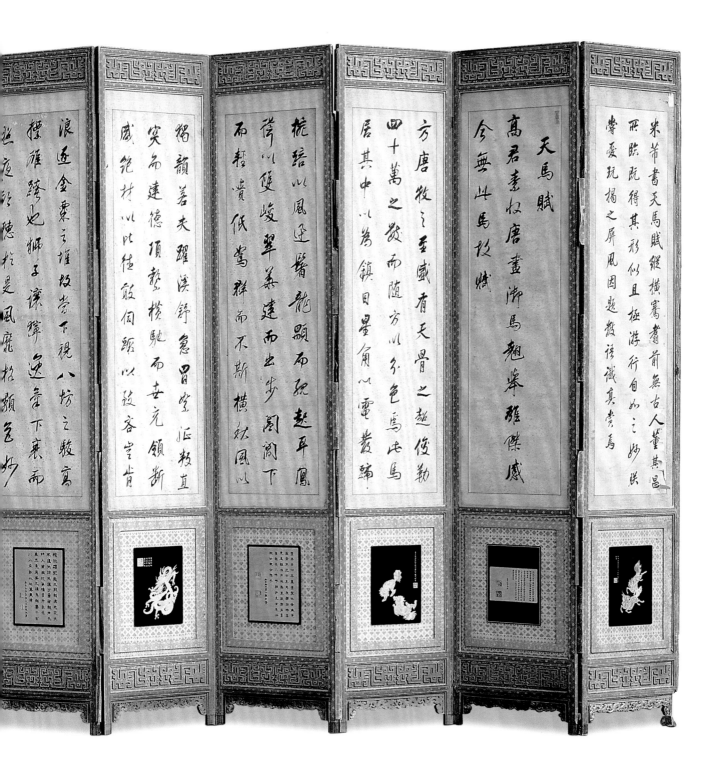

221

Purple Sandalwood Screen
with the Lacquer Central Panel Inlaid
with Jade Flowers

Height 237 cm
Width 304 cm
Qing court collection

This screen has nine panels. When spread, it has the shape of the character "八" (eight). Its frame is made of purple sandalwood. The front of each central panel has a beige lacquer ground which is inlaid with jade flowers such as camellias, pomegranates, Chinese wisteria, plum blossoms, sacred bamboo, peonies, magnolias, chrysanthemums, and wintersweet. On each of these panels, there is also a poem written by Emperor Qianlong. The rear of the central panels has a black lacquer ground with clouds and bats trace with liquid gold. The two sides and top and bottom of the screen have purple sandalwood medallions carved with passion flowers. The frame of the screen is set with spandrels inlaid with copper threads in twisted rope patterns. The screen has a Vairocana cap with a *ruyi* cloud rim and medallions with passion flower carvings. At the bottom of the screen is a three-layered wooden base.

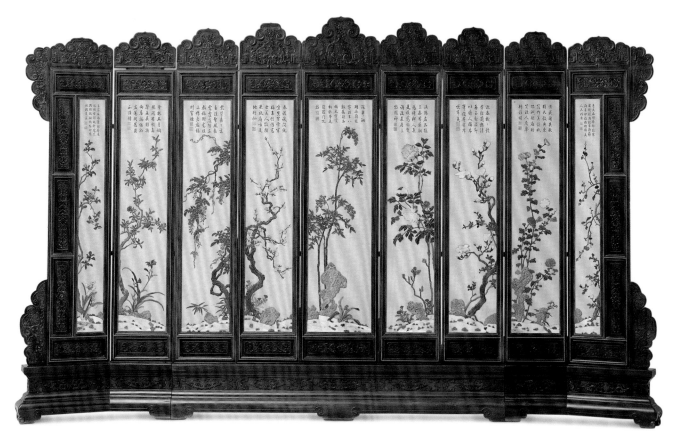

222

Purple Sandalwood Screen
with the Lacquer Centre
Inlaid with a Painting of Five Ethics in Enamel

Height 294 cm
Width 395 cm
Qing court collection

This screen has five panels arranged in the form of a mountain range. Its side base are made of purple sandalwood; the screen cap and hanging spandrels have openwork carvings of floating clouds, bats, and chimes. The central panels are made of cloisonné enamel displaying a painting of "Five Ethics" throughout the panels. The painting depicts mountain in in the distance as well as near views; a stream traverses the whole work. Five species of birds including the phoenix, crane, mandarin duck, wagtail, and warbler, together with the mountains, water, trees, stones, and various kinds of flowers and plants, are employed to imply the five ethics, i.e. human relations: that between the ruler and the ruled – a sense of honour and justice; that between parents and children – a matter of blood relation ; that between husband and wife – respect for different responsibilities; that between siblings – respect for seniority; and that between friends – a matter of trust. The screen has a Buddhist pedestal in the shape of the character " 八 " (eight).

Based on the record, this screen was a tribute from Guangdong during the period of Emperor Qianlong. It was originally set in the Palace of Eternal Longevity (Shou'an Gong), behind the throne in the main hall. The screen cap has rich and superb carvings and ornaments, the craftsmanship is exquisite, and the designs in the central panel are unique among the many screens that are adorned with auspicious objects and landscapes.

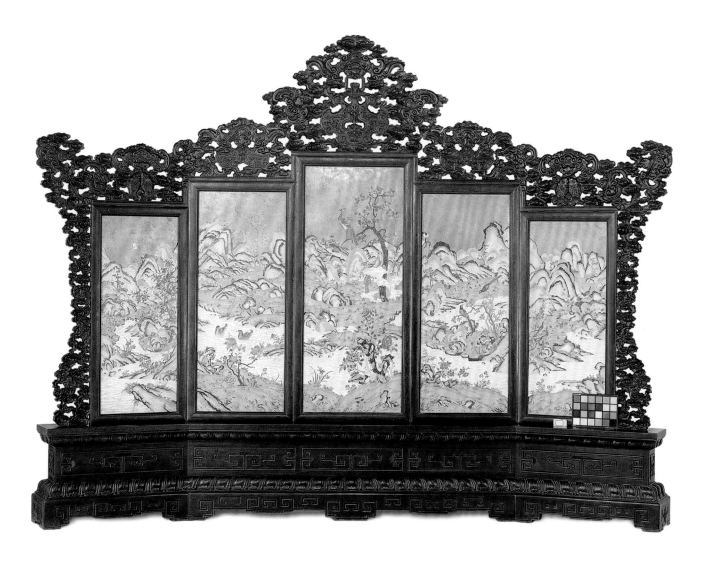

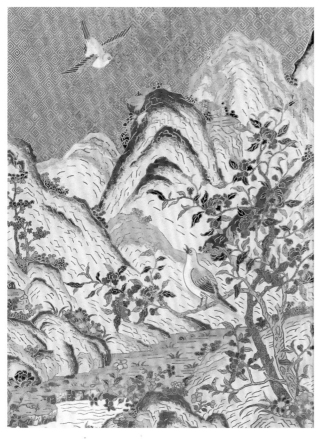
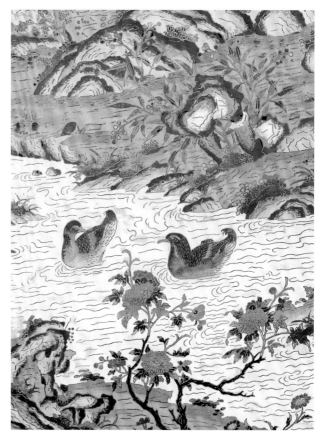
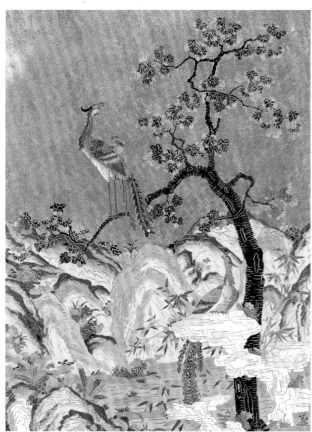
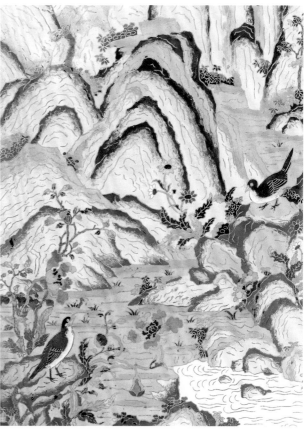

223

Purple Sandalwood Screen
with Dragons of Boxwood

Height 306 cm
Width 356 cm
Qing court collection

This screen has three panels arranged in the form of a mountain range, and the frame of the screen is plain. On the central panels, clouds are carved in purple sandalwood and dragons in boxwood; the four edges of each panel are brocaded with swastikas (卍). The screen cap and standing spandrels have carvings of phoenixes, and the bottom is a Buddhist pedestal which is in the shape of the character "八" (eight) and adorned with interlocking plantain leaf patterns.

The screen was originally set in the Palace of Universal Happiness (Xiantu Gong), behind the throne in the main hall. The carving is excellent, and the dragons and phoenixes look smooth, natural, and sharp with their contrasting colours. A screen that has such high quality of materials and craftsmanship like this one is rare even in the palace.

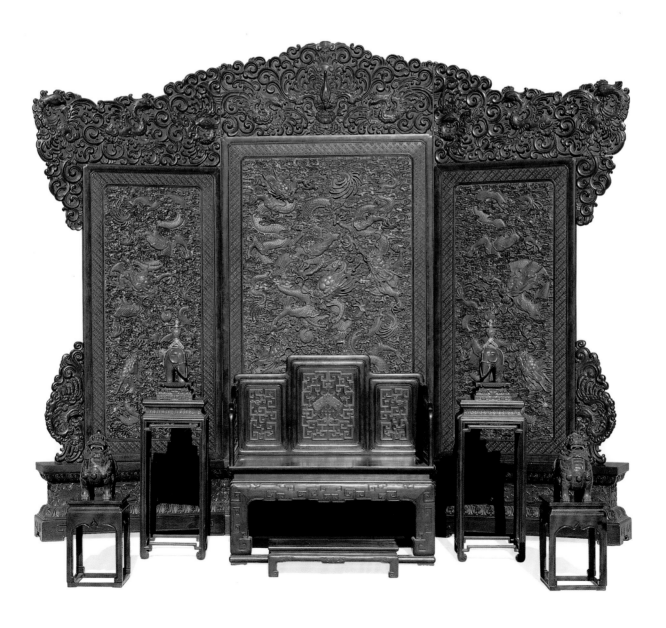

224

Purple Sandalwood Screen
with Calligraphy and Paintings of Boxwood

Height 264 cm
Width 290 cm
Qing court collection

This screen has five panels arranged in the form of a mountain range, and its base is in the shape of the character "八" (eight). The lintel boards, ornamental panels, and apron boards are all adorned with carvings made of boxwood. The five central panels are mounted with works of calligraphy and paintings respectively. The middle panel has a poem written by Emperor Qianlong, on each of its two sides is a landscape painting, while the left and right panels have couplets. As shown in the Emperor Qianlong's poem, he and his birth mother (Empress Dowager Chongqing) went to the Mountain Resort in Chengde in July 1761 A.D. for her 70th birthday. It was raining at that time and the Emperor, who started off the journey first, was anxious about his mother as the carriage might jolt badly. He thus wrote the poem "Rain" and ordered Dong Bangda, a court painter, to depict the landscape along the way in a painting. He later instructed officials to mount both the poem and the painting on this screen.

The screen is neatly and carefully done and is adorned with meticulous carvings and sharp colour contrast. The poem and the painting are well matched and their artistic conception is vividly portrayed.

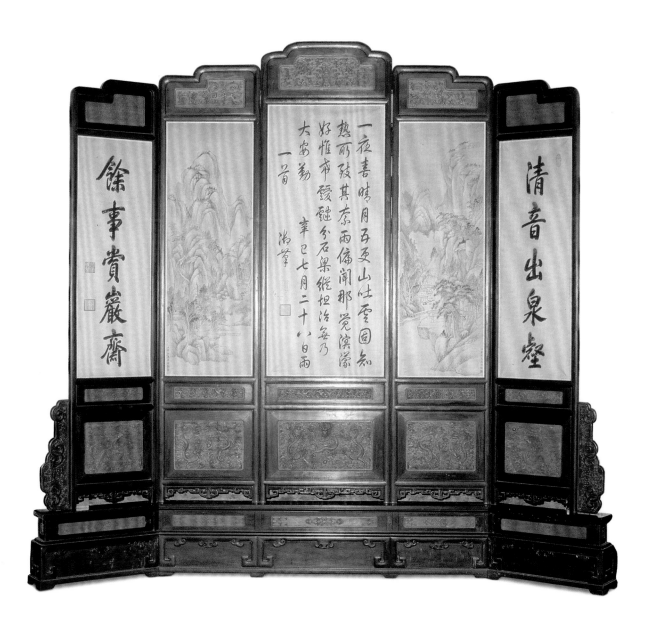

225

Purple Sandalwood Screen
with Nine Dragons Embroidered
with Gold

Height 275 cm
Width 375 cm
Qing court collection

This screen has nine panels, and the side base are made of purple sandalwood. The central panels have a beige silk ground on which coloured patterns of waves, cliffs, clouds, bats, and the ritual objects of the Eight Immortals are embroidered. At the centre of the panels, nine dragons are embroidered with golden couching stitch. The lintel boards are joined and framed with rectangular spiral patterns, and have cloud patterns in gold lacquer and coloured paint. Floating panels with raised centres and recessed sides are mounted below the central panels. The raised centre is adorned with landscape scenery trace with liquid gold, and surrounded by various types of ball-shaped flowers in gold lacquer and colour painting. The bottom is a three-layer Buddhist pedestal which is in the shape of the character " 八 " (eight), and which has a high waist decorated with different kinds of flowers traced with liquid gold or coloured paint.

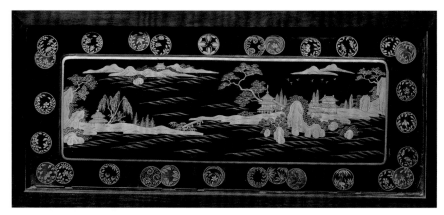

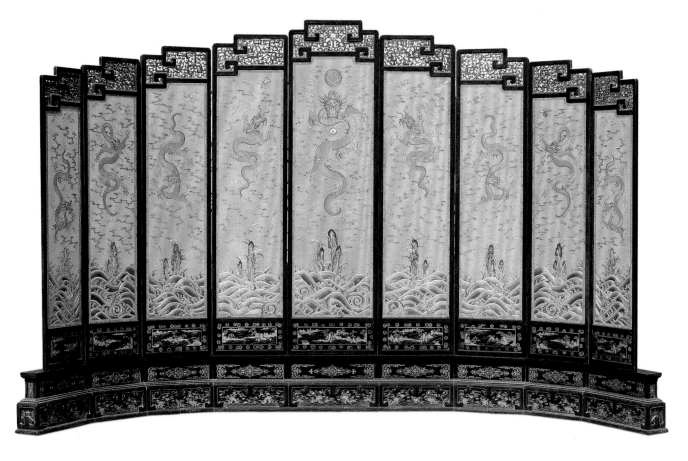

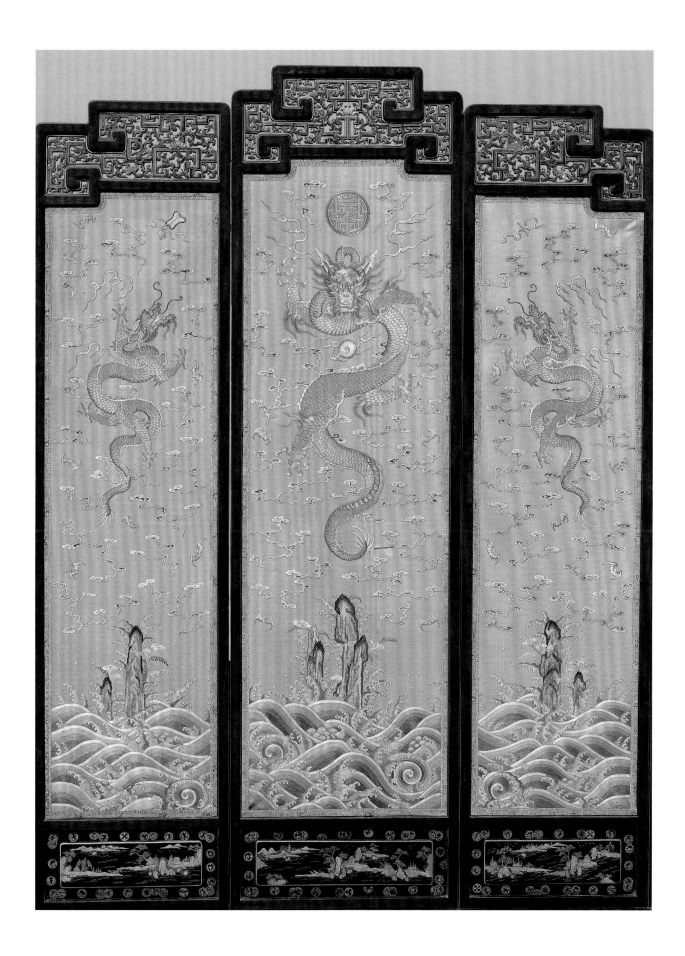

226

Screen
with a Landscape Painting Carved
in Cinnabar Lacquer

Height 195 cm
Width 250 cm
Qing court collection

This screen has three panels. The central panels use blue lacquer as the base. The lower parts of the panels are carved in cinnabar lacquer with landscape scenery, trees, stones, pavilions, and towers depicted throughout. The upper part is carved with a poem written by Emperor Qianlong. The back of the screen has a black lacquer background, decorated with a landscape painting traced with liquid gold. At the top, the screen has a three-section Vairocana cap with a cloud-dragon motif. At the lower part, the screen has standing spandrels on its two sides which are engraved with a cloud-dragon motif. The screen has a Buddhist pedestal.

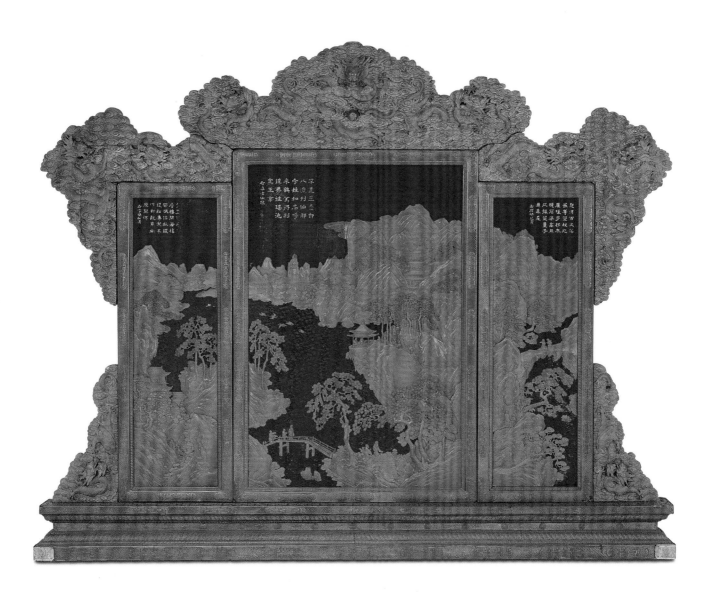

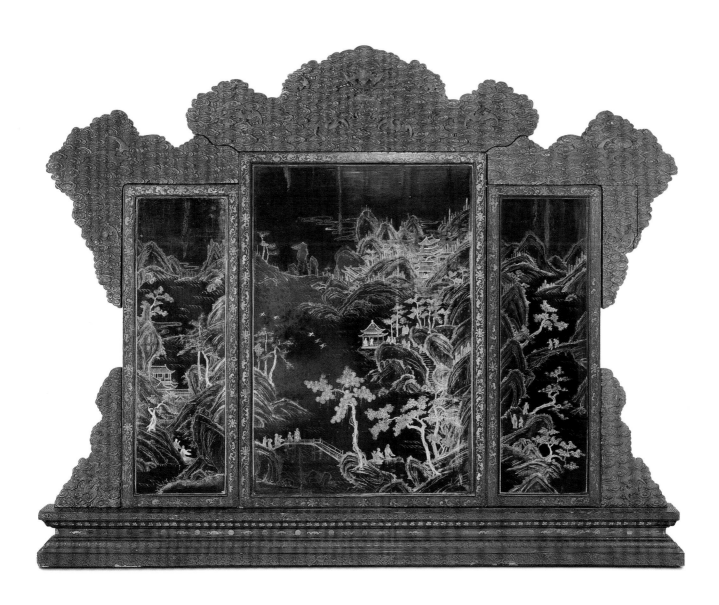

227

Folding Screen
with a Painting of Human Figures, Flowers, and Birds with
Lacquer Engraving, Traced with Liquid Gold,
and Painted in Colour

Height 323.5 cm
Width 600 cm
Qing court collection

This screen has twelve panels, each of which is connected to another panel with
hooks, and it can be folded. The front of the central panels is a colour painting of the
"Immortals Offering Birthday Blessings (qunxianzhushou)". In the painting, immortals
from different abodes gather together on a celestial mountain; the Mother Queen of the
West is coming in a carriage over the clouds. The back of the central panels is a colour
painting of "A Hundred Birds Paying Homage to the Phoenixes (bainiaochaofeng)". In the
painting, a phoenix is painted at the centre, and auspicious birds such as mandarin ducks,
paradise flycatchers, orioles, and mynas, as well as various kinds of flowers, intersperse all
around. A round of antique objects is carved on both sides, and the interior and exterior are
decorated with a round of floral edges traced with liquid gold.

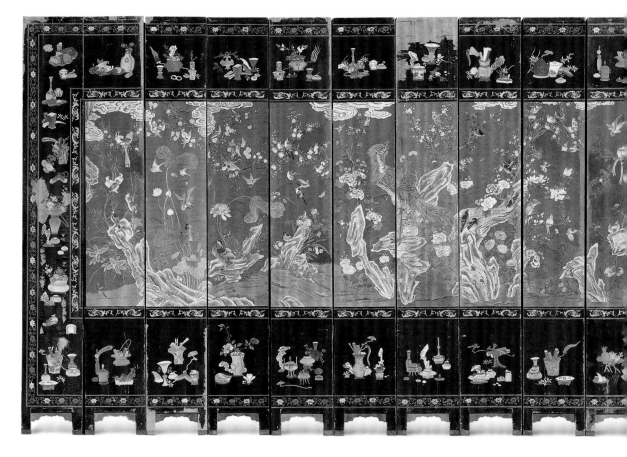

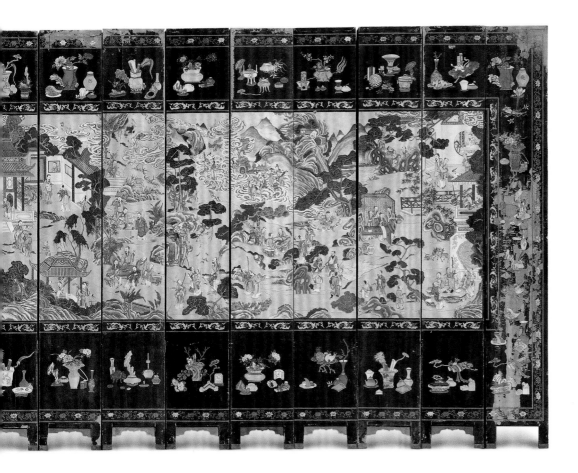

228

Yellow Rosewood Removable Panel Screen
Inlaid with an Ivory and *Jichi* Wood Landscape Painting

Height of Screen 172 cm Height of Stand 39 cm
Width 212 cm
Qing court collection

This screen has a yellow rosewood frame. The central panel has carvings of landscape and human figures made of ivory and *jichi* wood. The frame and the standing spandrels have low-lying centres, and are carved with angular spirals. The screen has a base in the shape of a Buddhist pedestal, the upper part of which has relief carving of flowers, and the lower part of which is carved with scrolling clouds. The screen has tortoise feet.

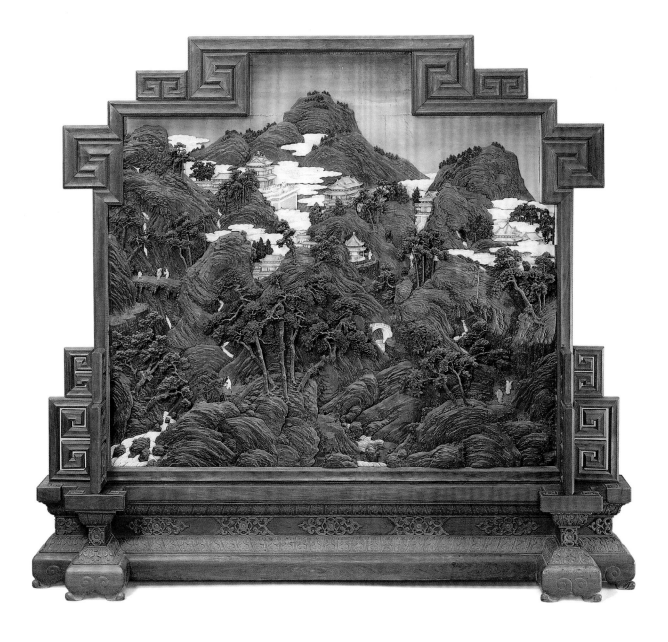

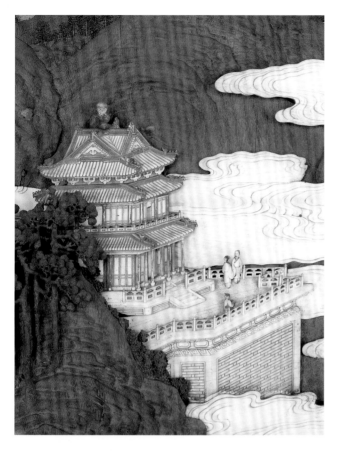

229

Yellow Rosewood Removable Panel Screen
Inlaid with a Jade Ring

Height 107 cm
Width 82 cm
Qing court collection

This screen has a yellow rosewood side base. The centre of the central panel is inlaid with a jade ring, which has a purple sandalwood round medallion at the centre. The medallion is carved with the symbol for "*qian*" (representing heaven) in the eight trigrams of Daoism, as well as the pattern of a pair of *kui*-dragons. At the back there is a poem written by Emperor Qianlong. The central panel, standing spandrel, ornamental panel, slanted apron, and base stand are all carved with *kui*-dragons.

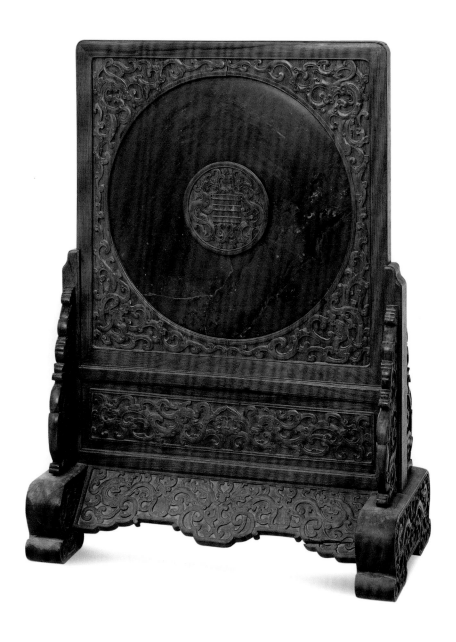

230

Purple Sandalwood Removable Panel Screen
with a Landscape Painting
Inlaid with Kingfisher Feathers and Stained Ivory

Height 145.5 cm
Width 100 cm
Qing court collection

This screen has a purple sandalwood side base with carvings. Under the glass cover of the central panel, the trees, stones, water, and bank are made of kingfisher feathers, and the human figures, houses, and boats are carved out of stained ivory, depicting scenes of outings in festivals and ceremonies.

The screen was originally placed in the Pavilion for Reading (Yueshi Lou) in the Palace of Tranquility and Longevity (Ningshou Gong). It is colourful and has meticulous carvings implying auspiciousness. It is in typical palace style.

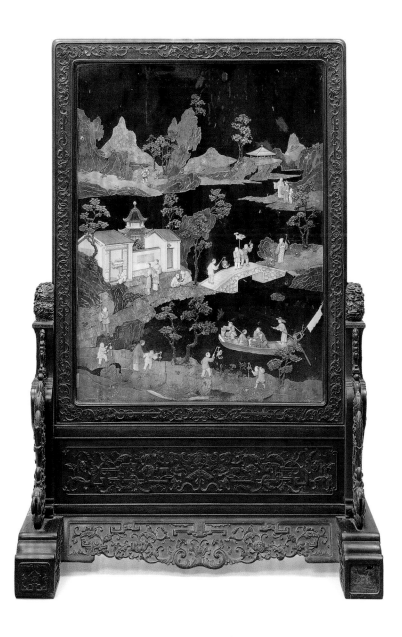

231

Purple Sandalwood Removable Panel Screen
with a Painting of Human Figures
Inlaid with *Jichi* Wood and White Jade

Height 52 cm
Width 50 cm
Qing court collection

This screen has a purple sandalwood side base. In the central panel, the trees, small boats, mountains, and rocks are carved with *jichi* wood, and there are also inlaid jade verandas, pavilions, terraces, and three old men who are respectively holding a peach, a gourd, and a walking stick, implying "fortune, prosperity and longevity". At the back of the screen, there is a square lead tube with glass on one side which can hold water for fishkeeping. The stand of the screen is in the shape of the character "八" (eight). The standing spandrel, ornamental panel, and slanted apron are all carved with the rectangular spiral patterns; the outer sides of the posts of the stand are carved with elegant ornaments, and the heads of the posts are carved with angular spirals.

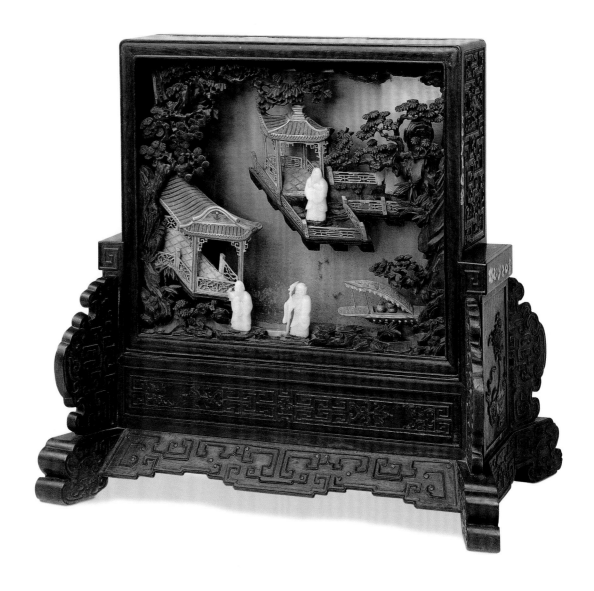

232

Purple Sandalwood Removable Panel Screen

with a Painting of Immortals Offering Birthday Congratulations Inlaid with Kingfisher Feathers and Stained Ivory

Height 150 cm
Width 98 cm
Qing court collection

This screen has a purple sandalwood side base, and the frame has a brocade ground carved with western flowers. In the central panel, the four sides of the glass cover are mounted with an inner frame which is in gold-plated brass. Under the cover, there are designs made of kingfisher feathers and stained ivory. The upper design is the "House beside the Water" (haiwutianchou), and the lower design is the "Painting of Immortals Offering Birthday Congratulations" (baxianzhushou), both implying auspicious wishes of longevity. The screen frame is inserted into the grooves of the screen posts, and is supported by the two pairs of standing spandrels. Between the posts there are the apron board, ornamental board, and slanted apron which are fully decorated with carvings of *kui*-dragons and Western flowers.

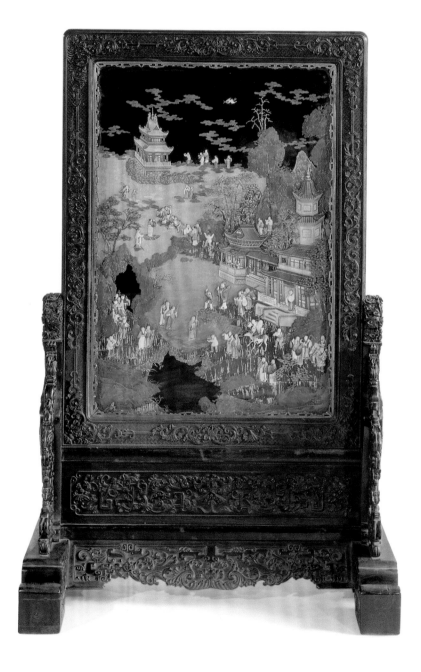

233

Purple Sandalwood Removable Panel Screen
with a Painting of Thin and Long Bamboo
Inlaid with Kingfisher Feathers

Height 220 cm
Width 116.5 cm
Qing court collection

This screen has a purple sandalwood side base. Both sides of the screen cap have openwork carvings of Western flowers, and the frame of the screen is engraved with the rectangular spiral patterns. Under the glass cover of the central panel, there are some thin and long bamboo poles which are made of kingfisher feathers and inlaid into a black lacquer ground, displaying an ambience of elegance and virtuousness. The medallion of the apron board is inlaid with a decorative board in cloisonné enamel which has designs of rectangular spirals and scrolling flowers.

Inlaying kingfisher feathers is a craft employed as decoration and is usually found alongside other craftworks. It is rather rare to be used by itself as in this case.

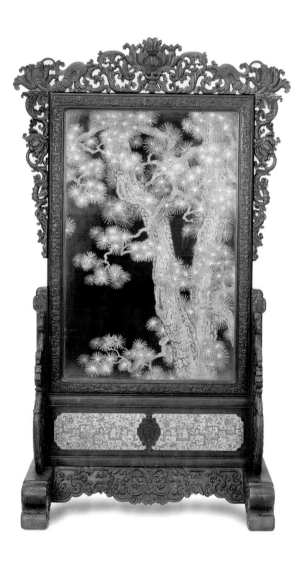
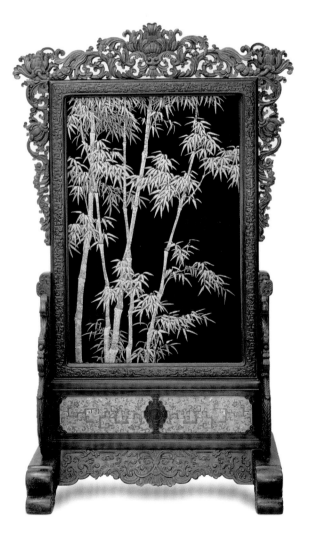

234

Purple Sandalwood Removable Panel Screen

Inlaid with a Wooden *Lingzhi* Fungus

Height 101 cm
Width 95 cm
Qing court collection

This screen has a purple sandalwood side base. The front of the central panel is Inlaid with a wooden *lingzhi* fungus, a plant regarded as immortal in ancient China and therefore often employed to imply longevity. The back of the central panel has a poem trace with liquid gold which was written by Emperor Qianlong in clerical script to praise the *lingzhi* fungus. The poem is followed by an inscription "*Qianlong jiawu yuti*" (imperial inscribed in the year *jiawu* of the Qianlong period) and two stamps in which the characters are written in seal script. The standing spandrels are plain, the ornamental panel is carved with the *ruyi* cloud heads, and the slanted apron is carved with angular spirals. At the centre is a concave moulding with lowered centre apron. The year of *jiawu* is the 39th year of Qianlong, or 1774 A.D.

235

Purple Sandalwood Removable Panel Screen
with an Ivory-inlaid Painting of Three Goats Playing with a Baby

Height 60 cm
Width 33.8 cm
Qing court collection

The side base of this removable panel screen are made of purple sandalwood, and its frame has a plain surface and double edge beadings. The central screen has a painting of three goats playing with a baby carved in ivory. Under the pine tree and plum tree and before the curved railing with bamboo and rocks, a child is riding on the back of a goat, another child is holding a fan, a goat is accompanying them, and yet another child is holding a tree branch to drive a goat. As *yang* (goat) and *yang* (sun) are homophonic, this painting therefore rhymes with the hexagram *san yang kai tai* (the spring comes in full form) in the *Book of Changes*, carrying the auspicious connotation of "everything takes on a new look". The back of the screen has a yellow silk ground sprinkled in gold. It has a five-character poem by the Tang poet Zhu Yanling entitled "Mountain in Autumn is Clear as the Sky" (qiushanjitianjing), written in regular script. The ornamental panel is carved with *ruyi* cloud heads.

This screen was originally in the Palace of Longevity and Good Health. The surface of the painting of the central panel was based on a draft of the Qing painter Yao Zonghan, and was completed with the use of several artistic techniques, such as ivory carving, dyeing, and sprinkling of golden sand. The craftsmanship is exquisite, and it was obviously displayed prominently in the Qing court.

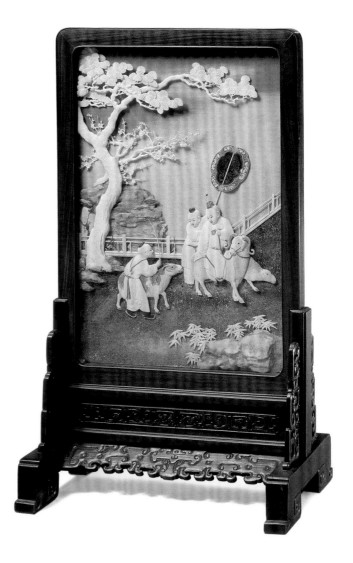

236

Purple Sandalwood Removable Panel Screen

with a Painting of Arhats Inlaid with Ivory

Height 114.5 cm
Width 127.5 cm
Qing court collection

The side base of this removable panel screen are made of purple sandalwood. The screen frame has raised beadings. The central panel is ivory with portraits of the Buddhist arhats carved. The expressions, postures, and clothes of the arhats are all different, and the spaces among these arhats are inlaid with *baibao* (a hundred precious) stones to complement the trees, rocks, pavilions, and platforms. It also has an inscription of a poem by Emperor Qianlong entitled "Eulogy on arhats". The back of the screen has a painting of "The Sun Rises from the Middle of the Sea" traced with liquid gold. The ornamental panel, standing spandrel, and slanted apron are all carved with rectangular spirals and dragons, and they have a Buddhist pedestal support from below.

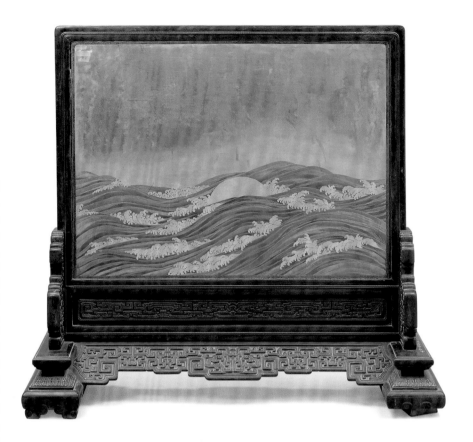

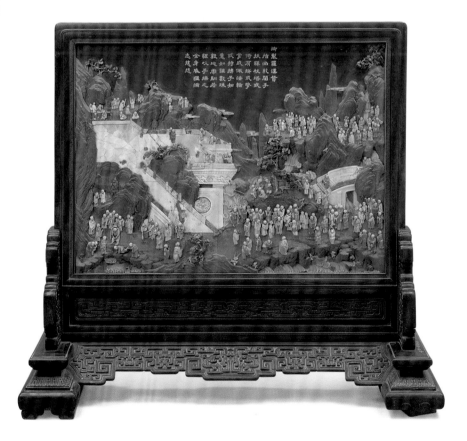

237

Purple Sandalwood Removable Panel Screen
with a Painting of two Dragons Playing around in the Sea
Inlaid with Jade

Height 156 cm
Width 234 cm
Qing court collection

The side base of this removable panel screen are made of purple sandalwood. The front side of the central panel has a copper frame which is inlaid with a painting "Two Dragons Playing Around in the Sea" carved in blue jade. The back is painted with the same contents traced with liquid gold. The frame is carved with cicadas, the top of the screen is carved in ivory with a frontal view dragon, and the standing spandrel is carved with clouds and dragons. Under the screen is a waist. The base and apron are carved with clouds and dragons.

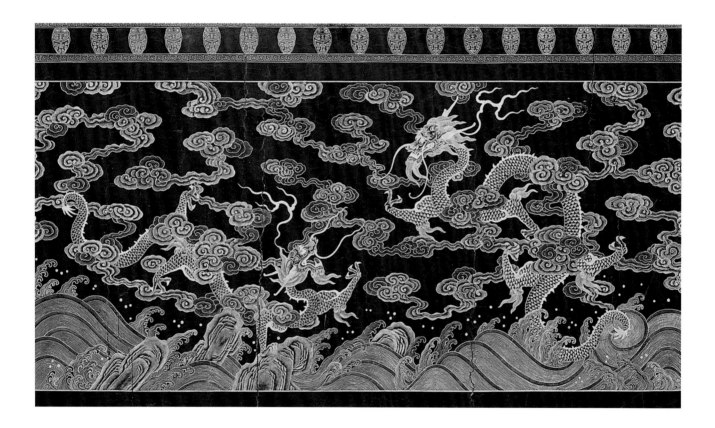

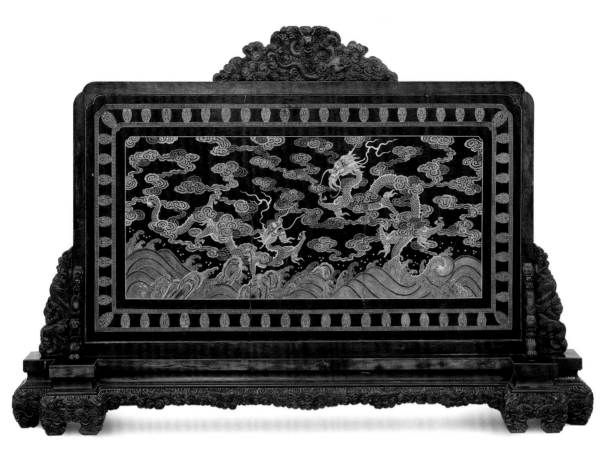

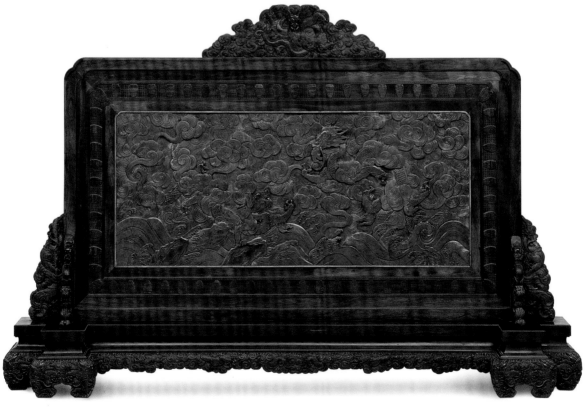

238

Purple Sandalwood Removable Panel Screen
with a Scenery Painting Inlaid with Bamboo

Height 70.5 cm
Width 62 cm
Qing court collection

This removable panel screen has a purple sandalwood side base. The two sides of the central panel are all inlaid with landscape carved in bamboo. On the one side is a painting of a villa on a mountain. The swaying branches and leaves of the pines and cypresses in the painting are vivid, and the carving on the flowery windows of the villa are shown in detail. On the other side is a painting of someone watching a waterfall. The slanting posture of the pines and cypresses, the meandering of the vines, and the water vapour and the changing clouds are drawn in a lively way, detailed and resembling their original spirit. The frames of the screen are plain. The edges of the inner sides have double mouldings. The ornamental panels are carved with rectangular spirals. It has a potbottle style standing spandrel with *chi*-dragons, and the slanted apron has a *ruyi* sceptre head hanging down in the middle.

This screen was originally placed at the Palace of Longevity and Peace. The layout of the paintings is well structured, and the craftsmanship is refined and exquisite.

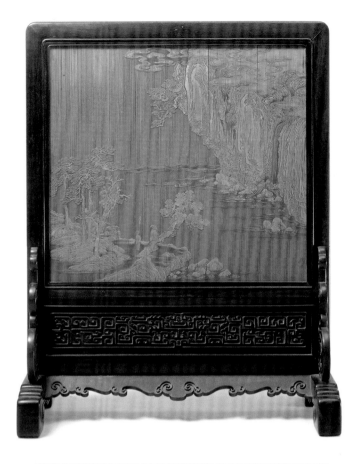

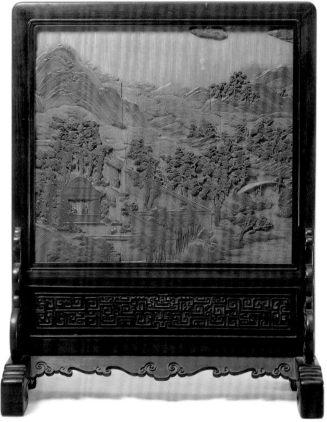

239

Purple Sandalwood Removable Panel Screen
with the Thirteen *Hongs* in Guangzhou
with Ivory Inlay

Height 141 cm
Width 83 cm
Qing court collection

This removable panel screen has a purple sandalwood side base. The middle of the frame is carved with clouds, bats, and brocade knots, and the side edges have convex mouldings. Inside the frame is a lacquer ground inlaid with a dyed ivory core board with a scenery picture of the thirteen *hongs* in Guangzhou. In the picture there are trade *hongs* dotted about and trade ships coming and going in an endless stream, showing the bustling scene of Guangzhou as a foreign trade port. On the screen base is a screen post carved with scrolling clouds, supported in the front and at the back by standing aprons. The spaces between the screen posts are two side stretchers, and in the middle is an ornamental panel carved with *kui*-phoenixes. Under the panel are a split apron carved with scrolling clouds and feet in the shape of a scrolled book.

The "thirteen *hongs*" refers to trade monopolies set up in Guangzhou in the Qing Dynasty and appointed by the Qing government to engage in foreign trade.

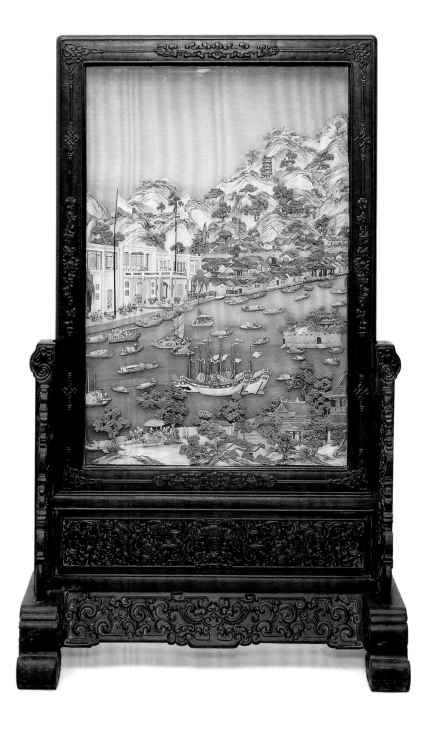

240

Purple Sandalwood Removable Panel Screen

with a Painting of Five Blessings Extending Longevity Inlaid with *Jichi* Wood

Height 185 cm
Width 85 cm
Qing court collection

The side base of this removable panel screen are made of purple sandalwood. The front side of the central panel is inlaid with copper edges. The outside edges are carved with angular spirals, and inside the edges *jichi* wood is used to carve mountains, water, towers, pavilions, figures, fairy cranes, and *lingzhi* fungi. The upper part of the blue lacquer ground has four characters "*wufutianshou*" (five blessings extending longevity). The back side has a black lacquer ground, painted with flowers on branches traced with liquid gold. The middle of the screen stand is carved with *kui*-dragons and coiled flowers. The standing spandrel, ornamental panel, and slanted apron are all carved with scrolling clouds and *chi*-dragons.

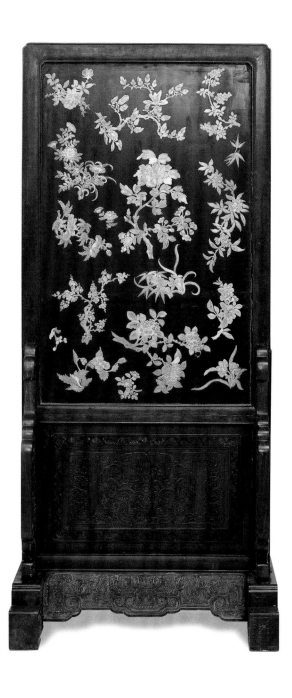

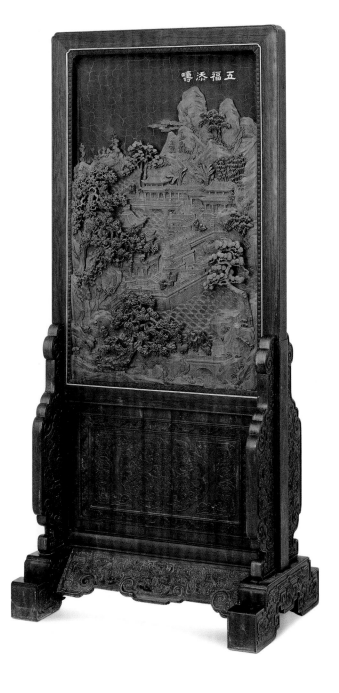

241

Black Lacquer Removable Panel Screen

Inlaid with a Hundred Treasures

Height 20 cm
Width 22 cm
Qing court collection

This removable panel screen has a black lacquer side base. One side of the central panel is inlaid with mother-of-pearl, ivory, jade, and agate to form fingered citrons, chrysanthemums, and red leaves. Another side has a carved cinnabar lacquer medallion, in which a brocade ground is carved with flowers and birds. The screen and the base are jointly made of one piece of wood. It has a Ming-style embracingdrum base and a standing spandrel.

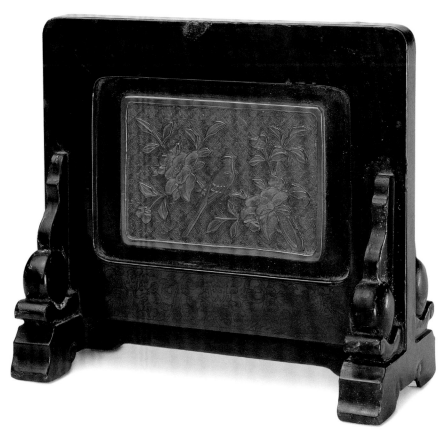

242

Black Lacquer Removable Panel Screen
Inlaid with Mother-of-pearl and Decorated with Bamboo and Plum blossoms

Height 57 cm
Width 63 cm
Qing court collection

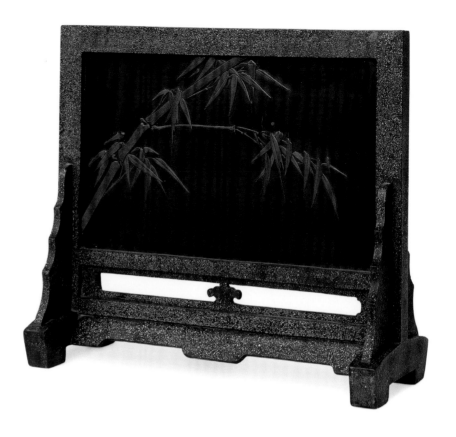

The frame and base of the removable panel screen have a black lacquer ground sprinkled with mother-of-pearl. One side of the central panel is inlaid with plum trees and bamboo joints carved in wood and mother-of-pearl plum blossoms. The other side is inlaid with brownish bamboo joints carved in bamboo. The frame and the base are joined together as a single unit. This removable panel screen has a standing spandrel with flowery edges and a long strip with through holes under the cross beam. The middle part has upward-curving cloud heads to support the upper beam, and the centre of the slanted apron has hanging-down lowered centre aprons.

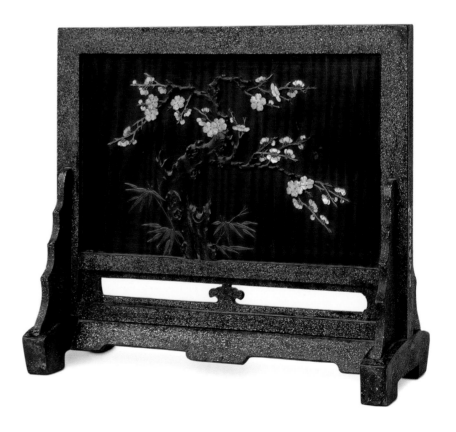

243

Carved Colour Lacquer Removable Panel Screen

with Antique Objects, Landscape, and Human Figures

Height 74.6 cm
Width 49.4 cm
Qing court collection

This removable panel screen is carved in cinnabar, green, and yellow lacquer. Carved on one side of the central panel is a painting of antique objects, such as flower vases and incense burners. The other side of the screen is carved with a vast sky with bright colours like belts, huge waves, and the Eight Immortals standing high on a platform, cupping their hands to meet the God of Longevity who comes by riding on the cranes, which carries the meaning of "the Eight Immortals offer birthday congratulations" (baxianzhushou). The frontal and back edges of the screen have medallions which are carved with flowers, and the outside of the medallions are carved with rectangular spirals. The ornamental panel of the screen base are carved with two dragons chasing a pearl, and the apron is carved with clouds and bats.

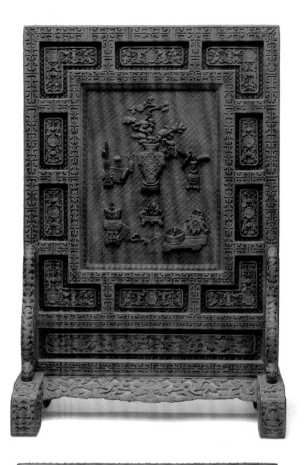

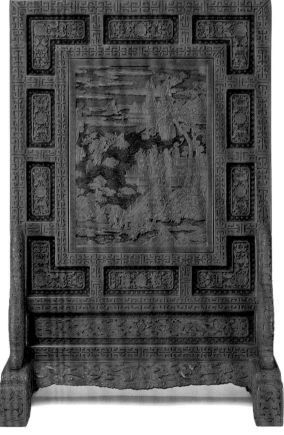

244

Yellow Rosewood Hanging Screen
Inlaid with Enamel Frames and Decorated with a Painting of Westerners

Height 95.3 cm
Width 70 cm
Qing court collection

This hanging screen has a frame made of yellow rosewood which are inlaid with painted enamel pieces with Western curling tendrils and long brocade knots. The upper part has a gilded hanging ring. The central panel has a glass painting, which is an oil painting of landscape and figures. The drawing of mountains, water, trees, and rocks is in the typical Chinese traditional style, but the figures and boats are Western in style.

This screen is likely the work of a Chinese painter who modelled his work from Western oil painting in the late Qing period.

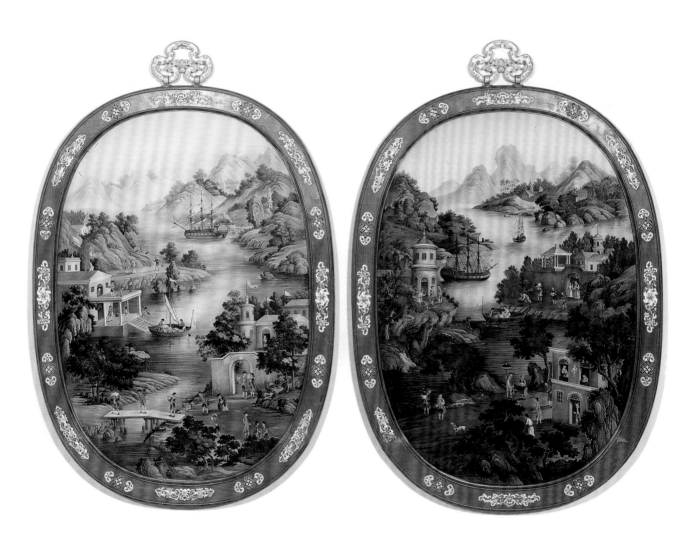

Purple Sandalwood Hanging Screens
with Lacquer in the Centre and the Characters "*Fu*" (Fortune) and "*Shou*" (Longevity) (A Pair)

Height 130 cm
Width 60 cm
Qing court collection

These two pieces of hanging screens are in a pair. The purple sandalwood frame is inlaid with dyed ivory. The central panel has a black lacquer ground which are inlaid with copper characters "*fu*" (blessing) and "*shou*" (longevity) respectively. The side edges of the strokes and paintings have a vertical wall, the inside of which is fixed with a painting of pine trees, cypress trees, and arhats with a dyed ivory. Carved on the upper parts of the two characters "*fu*" (blessing) and "*shou*" (longevity) is a poem written by Emperor Qianlong carved in ivory.

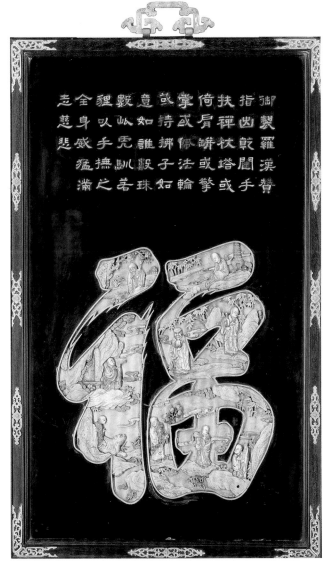

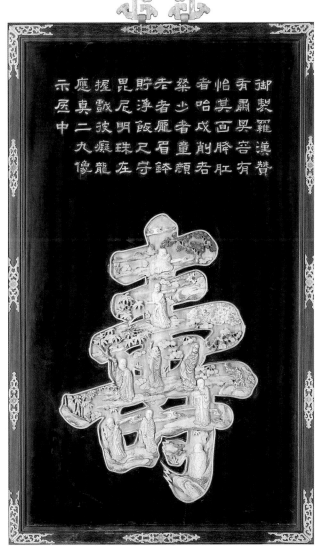

246

Purple Sandalwood Hanging Screen
Inlaid with Gold Osmanthus Flowers and the Moon

Height 163 cm
Width 119.4 cm
Qing court colloction

This hanging screen has a purple sandalwood frame carved with rectangular spirals. It has copper double hanging rings in the shape of a *ruyi* sceptre head with clouds and bats. The central panel has a blue lacquer ground on which decorations of cinnamons, rocks on slopes, floating clouds, and a bright moon are made with the technique of hammering the thin sheets of gold to illustrate the beautiful autumn. The upper left-hand corner of the central screen has a poem composed by Emperor Qianlong and written by Li Shiyao.

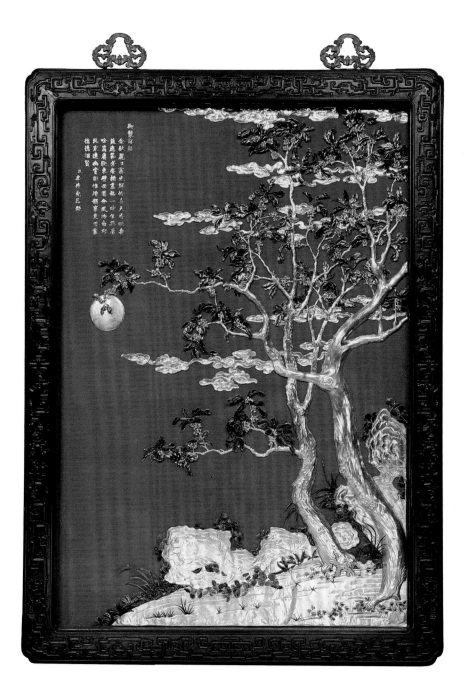

247

Purple Sandalwood Hanging Screen
with Lacquer in the Centre and a Landscape Painting

Height 146 cm
Width 90 cm
Qing court collection

This hanging screen has a purple sandalwood frame, a copper *ruyi*-sceptre-shaped hanging ring, and hanging hook nails. The inside of the screen frame is inlaid with an inner frame with angular spirals, and the central panel has a rich-coloured lacquer ground. The *baibao* (a hundred precious) stones inlaying technique is used to create a scene of mountains, water, towers, and pavilions. In the picture the distant mountains and foregrounded rivers are well arranged, the clouds and vapour permeate the mountains, forest trees are verdant and set off each other, the boats and junks go back and forth on the water, and pavilions, platforms, and towers adorn the shore.

This hanging screen was originally displayed at the main hall of the Hall of Imperial Supremacy (Huangji Dian) in the Palace of Tranquility and Longevity (Ningshou Gong). It is well-structured, rich in colour, and elaborate in its decorations and carvings. It is a rare piece of artwork handed down to the present.

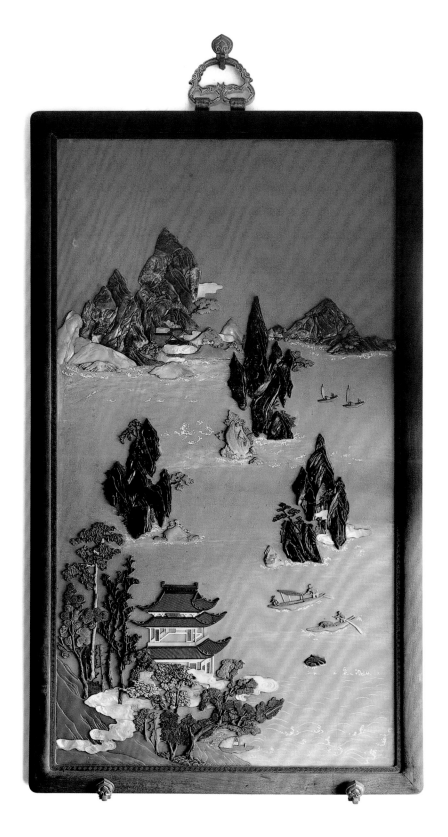

248

Carved Cinnabar Lacquer Hanging Screen
Inlaid with Mother-of-pearl and Decorated with a Landscape Painting

Height 71.5 cm
Width 103 cm
Qing court collection

The frame of this hanging screen is carved in cinnabar lacquer, and is decorated with lotus flowers with entwining branches. The inner side is carved with angular spirals. The central panel has a black lacquer ground, and thin mother-of-pearl inlays are used to inlay an exquisite landscape scene. In the picture are range upon range of hills with no ripples. In the distance are towering Buddhist temples, and nearby are arched bridges and cruising boats. The flowery trees and drooping willows adorn the sloping shores, with the towers, platforms, pavilions, and pleasure boats setting off each other.

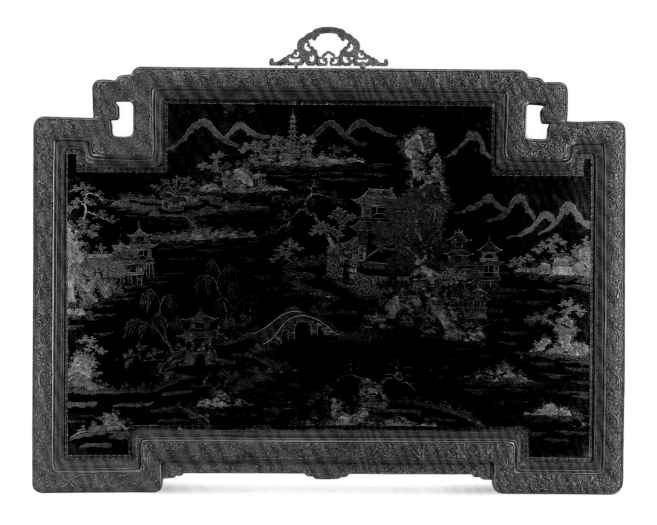

249

Purple Sandalwood Lacquer-centred Hanging Screen
with a Painting of the "Emperor Tang Ming Huang Trying out a Horse" Traced with Liquid Gold

Height 87 cm
Width 55 cm
Qing court collection

This hanging screen is rectangular and has a purple sandalwood frame. The central panel has a black lacquer ground, on which is a copy of a famous painting by the Tang painter Han Gan entitled "A Painting of Emperor Tang Ming Huang Trying out a Horse", traced with liquid gold and silver and with the application of the technique of painting with colour lacquer. Also added are the seals of the various dynasties that were in the original painting. The screen also has the addition of contents such as "A Postscript to the Painting of Emperor Tang Ming Huang Trying out a Horse" and "to be kept and appreciated by children and grandchildren forever" (zizisunsunyongbaojianzhi) by Emperor Qianlong, and seals appreciated and collected by Emperor Qianlong.

The craftsmanship of this screen is superb, and the artistry is close to the original work. It is of high historical and artistic value and can be regarded as a typical lacquer hanging screen.

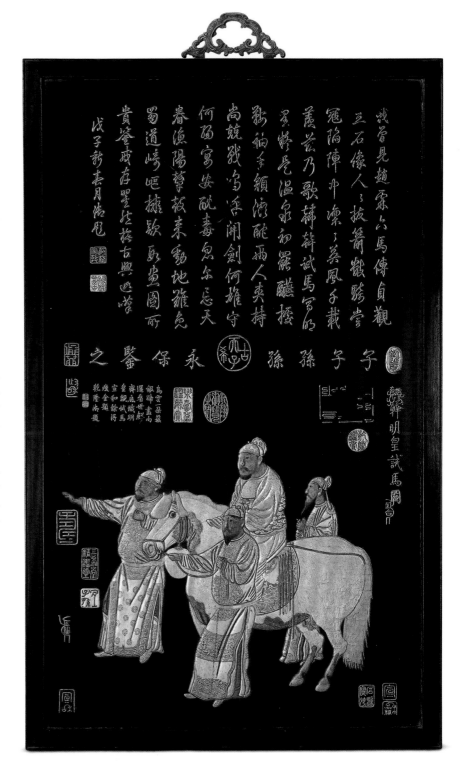

250

Purple Sandalwood Palace Lantern
with a Phoenix Head

Total Height 195 cm
Diameter of Stand 35 cm
Qing court collection

The retractable rod of this palace lantern is made of purple sandalwood. The head of the rod has a phoenix carved in openwork. The base stand is in the shape of a Buddhist pedestal. It has a base mound in the shape of a bottle, with a standing spandrel with curling tendrils. The palace lantern is in the shape of a square bottlegourd. The purple sandalwood frames are inlaid with glass, which is painted with the characters "*daji*" (good luck). The top of the lantern is in the shape of a Vairocana hat. Its four corners hang down, under which are net-braiding red tassels.

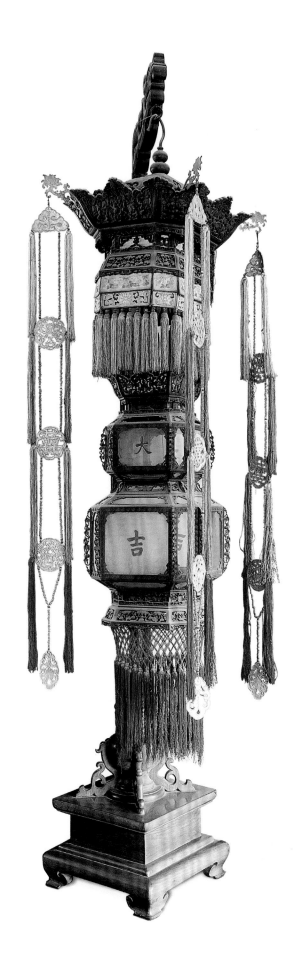

Purple Sandalwood Palace Lantern in Glass (Two Items)

Height 58 cm
Width 19.5 cm
Qing court collection

The side base of these two palace lanterns are made of purple sandalwood. One is in the shape of a pavilion. The top of the lantern is carved with passion flowers in openwork. The upper part of the body of the lantern has eaves, and its lower part has a platform. Hanging under the eaves are aprons carved in openwork. The four corners have posts in the shape of a bottle. The glass on the body of the lantern has two dragons and two "*xi* 囍" (double happiness) characters painted in colour on it. The lantern is single-poled. The other lantern is similar in shape to this lantern. The top of the lantern is carved with passion flowers. Its square body is inlaid with flowery aprons with rectangular spirals carved in openwork, and the glass is inlaid with two dragons and two "*xi* 囍" (double happiness) characters in colour. The lantern stand is waisted, and has openwork holes resembling the ones on a shaft of a writing brush. It has cabriole legs which stand on a square humpback continuous floor stretcher from below.

These two palace lanterns were used in the Palace of Earthly Tranquility. They are also called "table lanterns" since they can be placed on tables. The shape of these two palace lanterns is new and the structure is delicate, with meticulous carvings implying auspiciousness.

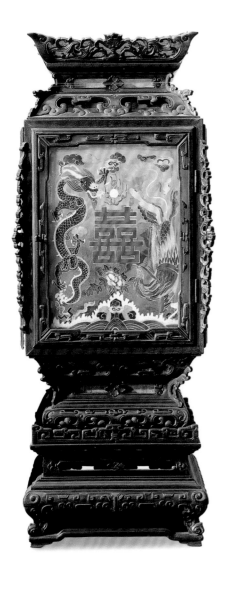

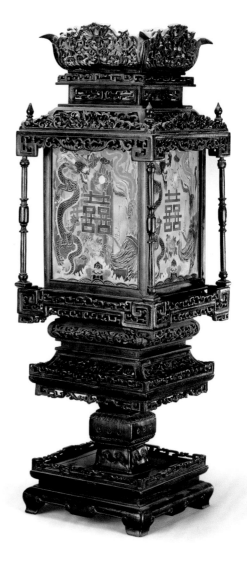

252

Court Attendants' Round Fan

Height 255 cm Diameter 45 cm
Qing court collection

The shaft and base of this court fan are made of purple sandalwood. The surface of the fan is tied to a wooden board with peacock feathers painted in colour. The copper gilded *tunkou* is inlaid with turquoise, and a base is in the shape of a Buddhist pedestal, on which a base is erected in the shape of an upturned and downturned lotus petals. The four sides have standing spandrels carved with rectangular spirals in openwork.

Court fans are usually placed on the two sides of a throne seat. Though the feather decorations on the surface of this court fan are not genuine, the way they were painted make them seem almost real. The use of copper, the dark colour of the purple sandalwood, and the multicolour of the surface of the fan complement each other, giving the piece a strong decorative effect.

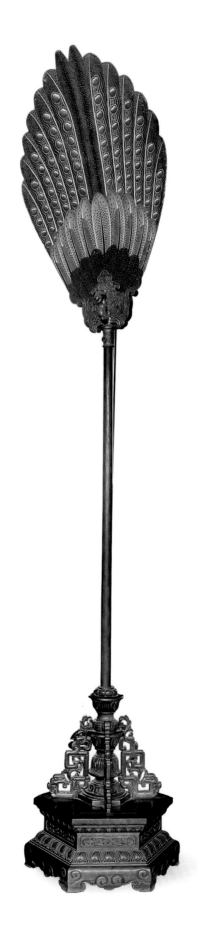

253

Mahogany Basin Stand

with a *Kui*-phoenix

Height 75 cm Diameter 84 cm
Qing court collection

The six cabriole legs of the basin stand are carved into the shape of a *kui*-phoenix with its head raised and its tail coiled. The head of the phoenix is raised upward, its body is bent, and the tail part naturally forms an outward-curving foot. The upper part of the leg is joined with a side stretcher. The lower part of the leg, where it coils, is joined with a round stretcher. Fixed on the spaces between the stretchers is a round board carved with flowers.

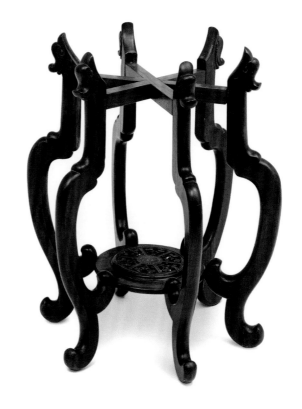

254

Mahogany Washbasin Stand Carved

with Bamboo Joints

Height 52 cm Diameter 51 cm
Qing court collection

The entire body of this washbasin stand is carved in round with bamboo joints on the back of a turtle. The upper and lower parts of the stand have a stretcher decorated with two layers of ice. The upper level stretcher is used to place the body of the basin. Below the stand are five splayed feet.

This washbasin stand was originally located in the South Three Places (Nansansuo) in the Forbidden City.

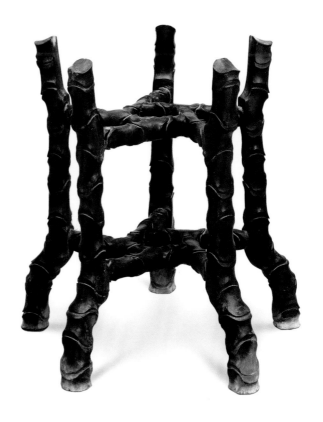

255

Purple Sandalwood Washbasin Stand
with the Towel Rack Decorated
with Dragons

Height 180 cm
Qing court collection

Each of the two ends of the top rail of the rear post of this washbasin stand has carved dragon heads which turn back to look at each other. The lower side of the top rail is inlaid with an arch-shaped apron with a pot-door-shaped opening, and its two sides are fixed with side spandrels with clouds and dragons. The middle of the stand's frame is inlaid with a central panel carved with clouds and dragons. A side stretcher is located under the frame. Fixed on the empty spaces separating the two is an apron with a pot-door-shaped opening. The washbasin stand is fixed with two groups of side stretchers, formed by intersecting and combining the three side stretchers. Fixed on the place where the upper level of the side stretcher joins with the legs is a side spandrel. The six legs of this stand are straight.

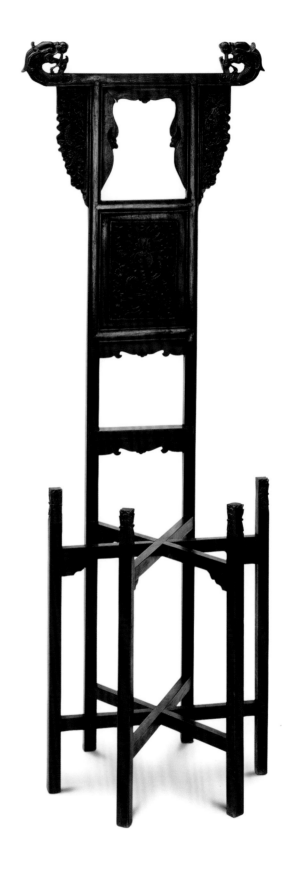

256

Suanzhi Wood Clothes
Rack Carved
with Dragons

Height 200 cm Width 256 cm
Qing court collection

This clothes rack is made of *suanzhi* wood. The two ends of the top rail are carved with two dragon heads turning back to look at each other. The lower parts of the dragon heads have hanging spandrels carved with clouds in openwork. The central panel is fixed with three sections of ornamental panels carved with two dragons chasing a pearl in openwork. Under the ornamental panels are decorative struts carved with dragons in openwork, and the struts are joined with a side stretcher underneath. The two ends of the lower part of the side stretcher have side spandrels carved with clouds and dragons in openwork. The back and front of the posts on two sides are supported by standing aprons, erected on the base, and the ground of the standing aprons, base, and slanted aprons are all carved with clouds and dragons.

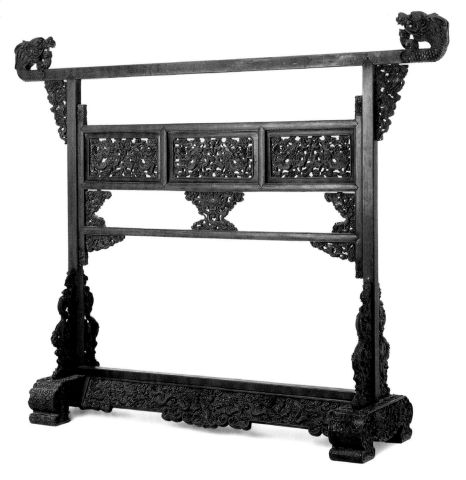

Carved Cinnabar Lacquer Three-piece Set

Height 12.8 cm Length 42.8 cm
Width 13.1 cm
Qing court collection

This three-piece set is composed of a stove, a bottle, and a box, and it is matched with a narrow table. They are all carved with red lacquer. The brocade ground of the surface of the narrow table and side surfaces are carved with flowers and leaves. It has four inward-curving feet, which are joined with a side stretcher. Placed inside the stove is a copper container. The outside of this container is carved with *kui*-dragons, the top of its lid is inlaid with a button with blue jade clouds and bats, and the base has a brocade which is densely carved. Placed in the bottle are a gilded copper shovel and chopsticks. The outside of the bottle is carved with *kui*-dragons and plantain leaves. The box is in a round shape, and its outside walls are carved with geometrical patterns.

This three-piece set was originally stored at the Hall of Sincere Solemnity (Chengsu Dian) in the Fasting Palace (Zhaigong) inside the Forbidden City. The so-called "three-piece set" (sanshi) refers to the utensils used in burning sandalwood to cleanse the air, which usually include a stove, a bottle, and a box. The stove is a burner, the box is the receptacle in which the sandalwood is placed, and the chopsticks and shovel are placed in the bottle.

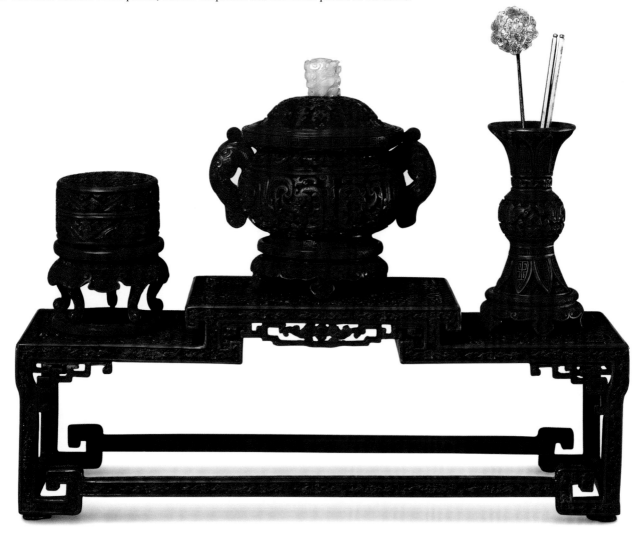

258

Purple Sandalwood Footstool

Height 17 cm Length 72.5 cm
Width 36 cm
Qing court collection

This footstool is in the shape of a round waist. The outside edges of the surface of the pedestal extends outward with arched mouldings. The mouldings of the inside edges match those of the outside edges. The centre of the footstool is inlaid with a board. Below the edges of the surface are a waist, bulging legs, outward-curving aprons, and inward-curving horse-hoof feet.

A footstool is a tool for resting the feet in front of a high seat with hanging legs or a bed. In front of a throne, in particular, there is usually a matching footstool.

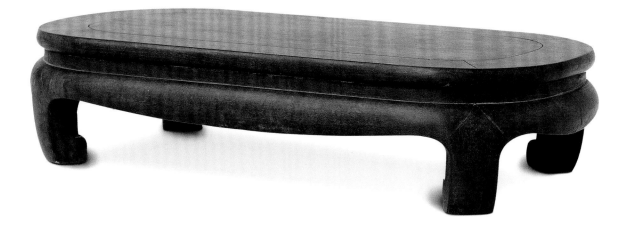

259

Mahogany Footstool
Inlaid with Mother-of-pearl

Height 17 cm Length 63 cm
Width 31 cm
Qing court collection

The surface of a footstool has lattice frames on four corners, inlaid with plain core boards, and it has ice-plate side edges. Under the surface is a concave-moulding waist, and the straight aprons and the inner side of the straight legs have raised beadings which form a circle. Inlaid on the aprons and the surface of the legs are mother-of-pearl ritual objects of the Eight Immortals or flowers. This footstool has square straight legs and inward-curving horse-hoof feet with angular spirals.

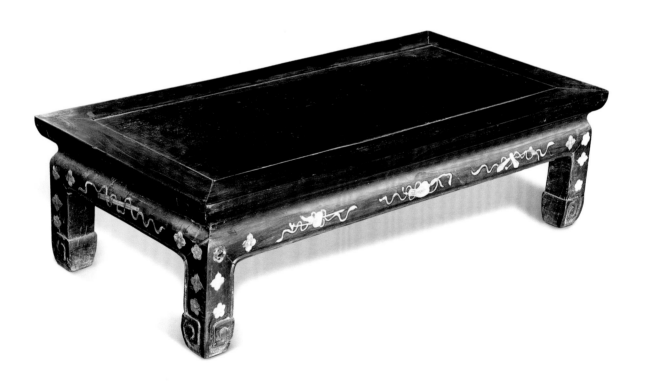

TERMS OF FURNITURE COMPONENTS

1. canopy bed

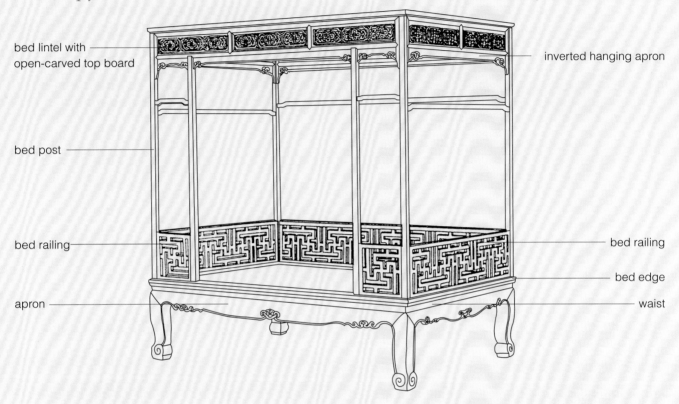

bed lintel with open-carved top board

inverted hanging apron

bed post

bed railing

bed railing

bed edge

apron

waist

2. folding chair

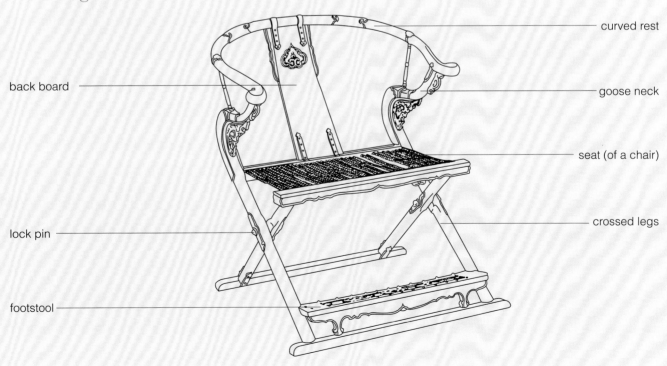

back board

curved rest

goose neck

seat (of a chair)

lock pin

crossed legs

footstool

3. southern official's hat armchair

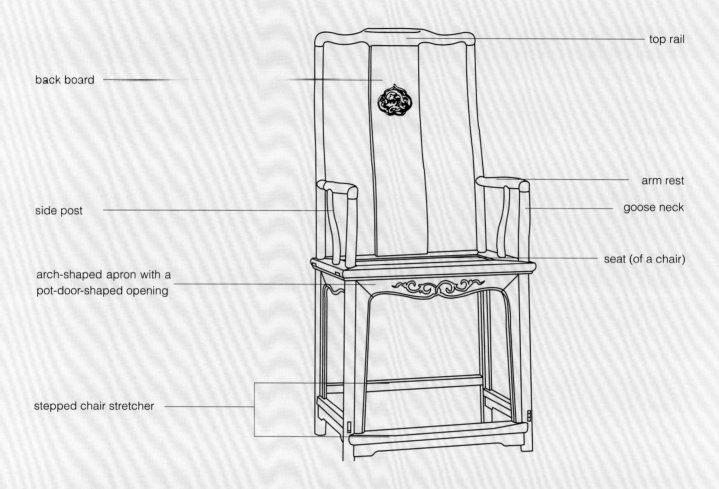

top rail

back board

arm rest

goose neck

side post

seat (of a chair)

arch-shaped apron with a
pot-door-shaped opening

stepped chair stretcher

4. square stool

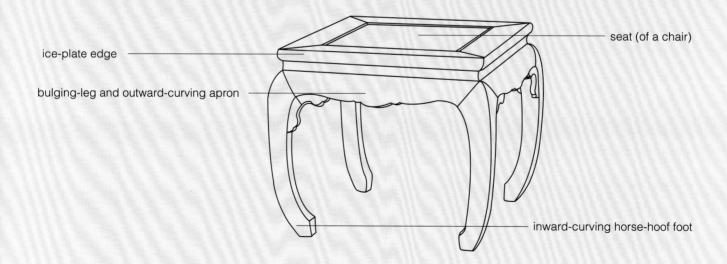

seat (of a chair)

ice-plate edge

bulging-leg and outward-curving apron

inward-curving horse-hoof foot

5. square table

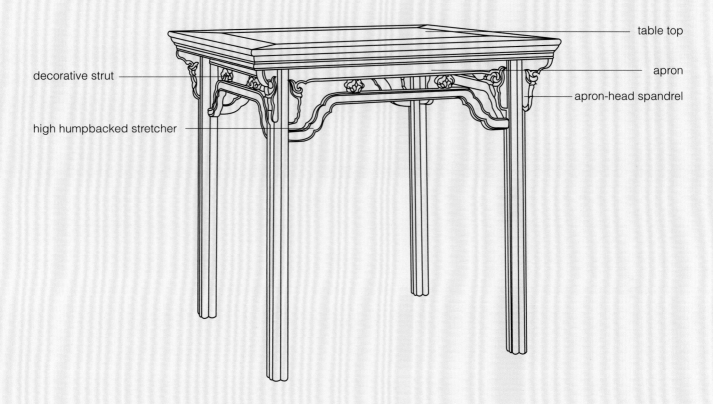

table top

decorative strut

apron

apron-head spandrel

high humpbacked stretcher

6. small narrow table

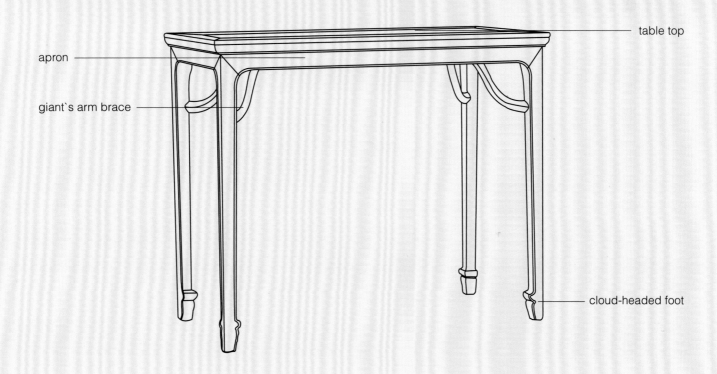

table top

apron

giant`s arm brace

cloud-headed foot

7. banquet table

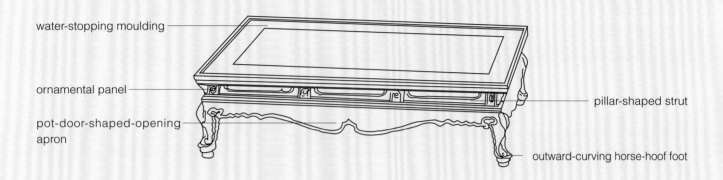

water-stopping moulding

ornamental panel

pot-door-shaped-opening apron

pillar-shaped strut

outward-curving horse-hoof foot

8. coffer

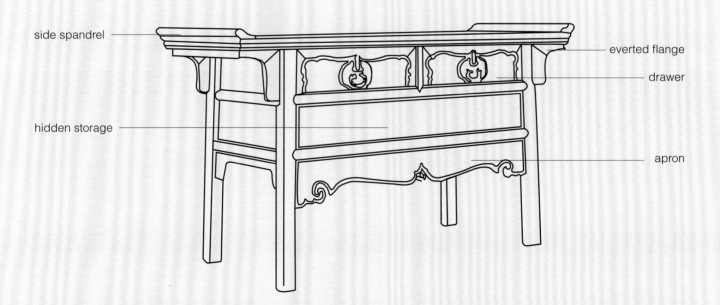

side spandrel

hidden storage

everted flange

drawer

apron

9. cabinet

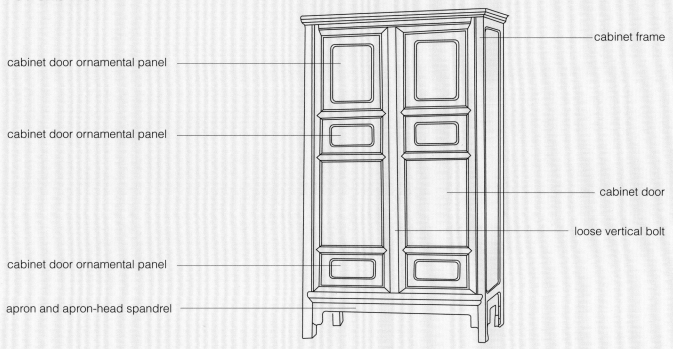

cabinet door ornamental panel

cabinet door ornamental panel

cabinet door ornamental panel

apron and apron-head spandrel

cabinet frame

cabinet door

loose vertical bolt

10. removable panel screen

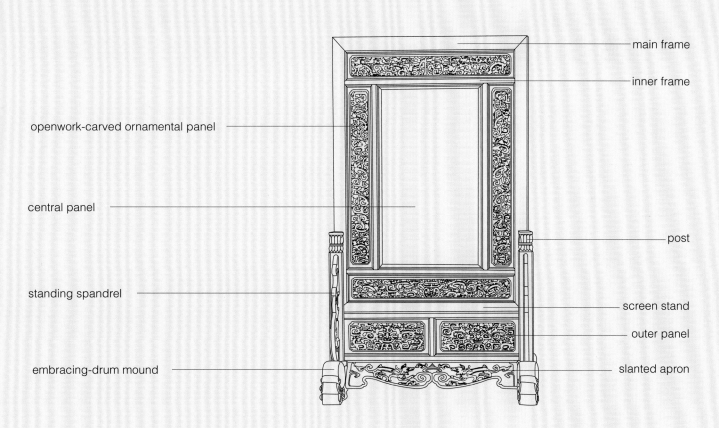

openwork-carved ornamental panel

central panel

standing spandrel

embracing-drum mound

main frame

inner frame

post

screen stand

outer panel

slanted apron

DIAGRAMS SHOWING THE TENON-AND-MORTISE JOINERY STRUCTURES

1. inserted-shoulder tenon

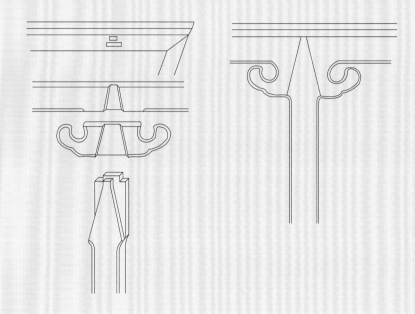

2. double-mitered tenon

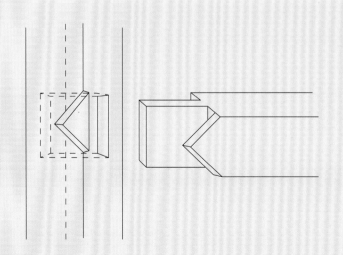

3. embracing-shoulder tenon

4. the making of a tenon-and-mortise frame

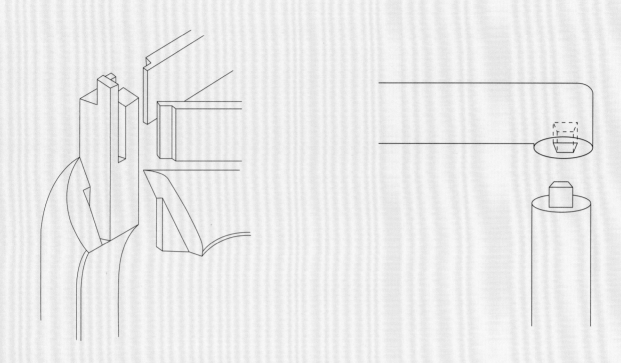

5. dumplings-corner tenon

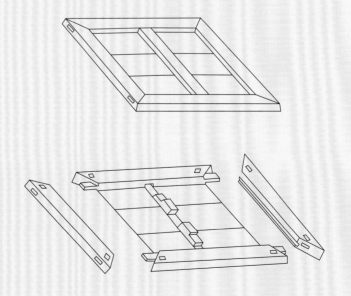

6. diagram showing the use of a giant's arm brace

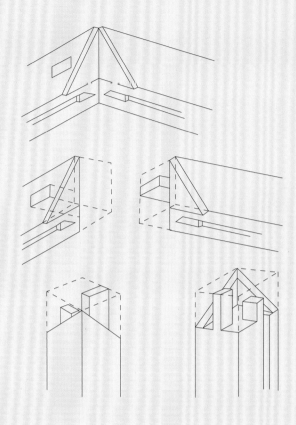

7. giant's arm brace

8. chuck tenon

Dynastic Chronology of Chinese History

Xia Dynasty	Around 2070 B.C.—1600 B.C.
Shang Dynasty	1600 B.C.—1046 B.C.
Zhou Dynasty	
Western Zhou Dynasty	1046 B.C.—771 B.C.
Eastern Zhou Dynasty	770 B.C.—256 B.C.
Spring and Autumn Period	770—476 B.C.
Warring States Period	475 B.C.—221 B.C.
Qin Dynasty	221 B.C.—206 B.C.
Han Dynasty	
Western Han Dynasty	206 B.C.—23A.D.
Eastern Han Dynasty	25—220
Three Kingdoms	
Kingdom of Wei	220—265
Kingdom of Shu	221—263
Kingdom of Wu	222—280
Western Jin Dynasty	265—316
Eastern Jin Dynasty Sixteen States	
Eastern Jin Dynasty	317—420
Sixteen States Periods	304—439
Southern and Northern Dynasties	
Southern Dynasties	
Song Dynasty	420—479
Qi Dynasty	479—502
Liang Dynasty	502—557
Chen Dynasty	557—589
Northern Dynasties	
Northern Wei Dynasty	386—534
Eastern Wei Dynasty	534—550
Northern Qi Dynasty	550—577
Western Wei Dynasty	535—556
Northern Zhou Dynasty	557—581
Sui Dynasty	581—618
Tang Dynasty	618—907
Five Dynasties Ten States Periods	
Later Liang Dynasty	907—923
Later Tang Dynasty	923—936
Later Jin Dynasty	936—947
Later Han Dynasty	947—950
Later Zhou Dynasty	951—960
Ten States Periods	902—979
Song Dynasty	
Northern Song Dynasty	960—1127
Southern Song Dynasty	1127—1279
Liao Dynasty	907—1125
Western Xia Dynasty	1038—1227
Jin Dynasty	1115—1234
Yuan Dynasty	1206—1368
Ming Dynasty	1368—1644
Qing Dynasty	1616—1911
Republic of China	1912—1949
Founding of the People's Republic of China on October 1, 1949	